ONE WEEK LO

3 0 MAR

Visual Culture and Tourism

Edited by
David Crouch and Nina Lübbren

Oxford • New York

First published in 2003 by
Berg
Editorial offices:
1st Floor, Angel Court, 81 St Clements Street, Oxford, OX4 1AW, UK
838 Broadway, Third Floor, New York, NY 10003-4812, USA

Berg is an imprint of Oxford International Publishers Ltd.

Library of Congress Cataloging-in-Publication Data
Visual culture and tourism / edited by David Crouch and Nina Lübbren –
English ed.
 p. cm.
Includes bibliographical references and index.
 ISBN 1-85973-583-5 (cloth) – ISBN 1-85973-588-6 (paper)
 1. Tourism–Social aspects. 2. Tourism and art. I. Lübbren,
Nina. II. Crouch, David, 1948-

G155.A1V58 2003
338.4′791–dc21
 2003000653

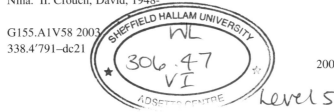

British Library Cataloguing-in-Publication Data
A catalogue record for this book is available from the British Library.

ISBN 1 85973 583 5 (Cloth)
 1 85973 588 6 (Paper)

Typeset by JS Typesetting Ltd, Wellingborough, Northants.
Printed in the United Kingdom by Biddles Ltd, Guildford and King's Lynn.

www.bergpublishers.com

Contents

List of Illustrations

Notes on Contributors

Roger Balm teaches in the Department of Geography at Rutgers University, New Jersey (US). His recent publications focus on geographic art and imagery as evidence of environmental conditions and on early twentieth-century uses of photography in geographic research. In 2001, he was a Faculty Fellow at the Rutgers Center for Historical Analysis, conducting research on the geoaesthetics of industry.

Deborah Cherry is Professor of the History of Art at the University of Sussex (UK). She has published widely on nineteenth-century British art, and her publications include *Painting Women: Victorian Women Artists* (Routledge, 1993) and *Beyond the Frame: Feminism and Visual Culture, Britain, 1850–1900* (Routledge, 2000). She is currently writing a study of the allure of the Victorian period for recent and contemporary culture.

David Crouch is Professor of Cultural Geography, Tourism and Leisure at the University of Derby (UK) and Visiting Professor of Geography and Tourism and the University of Karlstad (Sweden). He is the editor of *Leisure/Tourism Geographies: Practices and Knowledges* (Routledge, 1999), and the author of *The Art of Allotments* (Five Leaves, 2001). Academic papers include 'Everyday Abstraction and the Art of Peter Lanyon', *Ecumene* (1999, with Mark Toogood). He has also written widely on cultural geography and tourism/leisure.

Davide Deriu is completing a PhD on photography and urban representations at the Bartlett School, University College London (UK). He has taught history and theory of architecture at the Bartlett School, at the University of Westminster, and at the Kent Institute of Art and Design. He has also contributed to international art exhibitions in France and Thailand.

Simon Evans teaches in the School of Design and Communication Systems at Anglia Polytechnic University in Chelmsford (UK). He has written numerous papers and chapters in edited collections on eco-tourism and policy.

Bradley Fratello completed his PhD in Art History at Washington University in St Louis (US) in 2001. His current research focuses on the posthumous canonization of Jean-François Millet. He was a Visiting Assistant Professor at Pennsylvania State University during the year 2002–03.

Briavel Holcomb teaches in the Department of Urban Studies in the Bloustein School of Planning and Public Policy at Rutgers University, New Jersey (US). Her teaching and research interests have migrated from urban redevelopment to economic development, gender, tourism and, most recently, cyberspace. Her most recent publications are on gender and tourism in Latin America, media images for urban marketing and online marketing of small-island states for tourism.

Peter Howard teaches heritage courses at the University of Plymouth in Exeter. He is a landscape specialist, the author of *Landscapes: The Artists' Vision* (Routledge, 1991), and the editor of the *International Journal of Heritage Studies*. He is currently working on methods of conserving ways of life.

Daniel Jewesbury is an artist and writer based in Belfast and recently completed his PhD research at the University of Ulster (Northern Ireland). He contributes regularly to a number of visual art publications, including *Art Monthly* and *Flash Art*, and has written catalogues for artists including Willie Doherty and Roddy Buchanan. His work, which uses a variety of media, including video, photography and radio, has been exhibited across Europe. It explores issues of identity and 'non-belonging', often in the context of public space. He is currently researching a project based on John Masters' novel *Bhowani Junction*, the first part of which is an artist's book, of lives between lines, published by Book Works, London (2001).

Eeva Jokinen is Professor in Women's Studies in the Department of Social Sciences and Philosophy, University of Jyväskylä (Finland). Her current research interests concern the institution of marriage in Nordic welfare societies, sexuality and gendered parenthood. She has co-authored three articles on tourism, knowledge and sexuality with Soile Veijola: 'The Body in Tourism', *Theory, Culture & Society* 3 (1994); 'The Disoriented Tourist', in C. Rojek and J. Urry (eds), *Touring Cultures*, 1997; and 'The Death of the Tourist: Seven Improvisations', *European Journal of Cultural Studies* 3 (1998).

Robin Lenman is Senior Lecturer in the Department of History at the University of Warwick (UK). His publications include *Artists and Society in Germany 1850–1914* (Manchester University Press, 1997). He is the general editor of *The Oxford Companion to the Photograph* (forthcoming).

Notes on Contributors

Nina Lübbren is Senior Lecturer in Art History at Anglia Polytechnic University in Cambridge (UK). She is the author of *Rural Artists' Colonies in Europe, 1870–1910* (Manchester University Press, 2001). She was a 2002–3 Leverhulme Research Fellow and is writing a book on visual narrative in nineteenth-century painting.

Stephen F. Mills is Senior Lecturer in the School of American Studies at Keele University, Staffordshire (UK). Recent publications include 'Imagining the Frontier', in P.J. Davies (ed.), *Representing and Imagining America* (Keele University Press, 1996); 'American Theme Parks and the Landscapes of Mass Culture', *American Studies Today* (1999, online at http://www/americansc.org.uk); *The American Landscape* (Chicago: Fitzroy Dearborn, 2000); and 'Landscape Simulation and the Open-Air Museum', *Landscapes* (1, 2000).

Annelies Moors is an anthropologist and Chair of the Institute of the Study of Islam in the Modern World (ISIM) at the University of Amsterdam (Netherlands). She is the author of *Women, Property, and Islam: Palestinian Experiences 1920–1990* (Cambridge University Press, 1995) and the co-editor of *Discourse and Palestine: Power, Text, and Context* (Het Spinhuis, 1995), and has published in edited volumes and journals on gendering Orientalism, debating Islamic family law, writing life stories, visualizing the nation-gender nexus, and wearing gold. She is currently writing on the body politics of photography (Palestine) and on (un)veiling the face (Yemen), and is developing a research project on the cultural politics of migrant domestic labour (centring on Asia/the Middle East).

Griselda Pollock is Professor of the Social and Critical Histories of Art, and Director of the AHRB Centre for Cultural Analysis, Theory and History at the University of Leeds (UK). She is also actively involved with the development of the Centre for Jewish Studies at the University of Leeds. She has written extensively on issues of sexual and cultural difference. She currently researches questions about representation, trauma and the Holocaust from feminist Jewish perspectives. Recent publications include *Differencing the Canon: Feminist Desire and the Writing of Art's Histories* (1999) and *Looking Back to the Future* (2000). She is preparing a monograph on Charlotte Salomon's *Life or Theatre?*

Doug Sandle is a chartered psychologist and Reader in Visual Studies at the Leeds School of Art, Architecture and Design, Leeds Metropolitan University (UK). His previous research and teaching interests have been in the psychology of visual art, aesthetics and design. He is the editor of *Development and Diversity: New Applications in Art Therapy* (Free Association Press, 1998). He was born and raised on the Isle of Man.

Martin Spaul is Senior Lecturer in multimedia systems at Anglia Polytechnic University (UK). His principal research interests are in visual culture and heritage. He is currently engaged in research on the visual and verbal rhetorics that frame woodland leisure and heritage sites.

Renée Tobe is a PhD candidate in architecture at Cambridge University (UK). Her doctoral research concerns architecture and film and focuses on London in the 1960s. Her main interests lie in the interaction between aspects of popular culture and the actual built environment. She is a practising architect, trained at the Architectural Association, and an artist who has exhibited her work internationally. Her publications include *Intuitions and Process* (1989), *Disrupted Borders* (1993) and *Ecstatic Antibodies* (1990).

Soile Veijola is Assistant Professor of Tourism in the Department of Business, Economics and Tourism at the University of Lapland (Finland). Her main research interests are sociological narration, social modalities and cultural studies of tourism and sports. She has co-authored three articles on tourism, knowing and sexual difference with Eeva Jokinen (see Jokinen).

Introduction

David Crouch and *Nina Lübbren*

This book brings together two distinctive cultural formations: visual culture and tourism. Each of these configurations has generated a large volume of critical and theoretical discussion on its own, but the ways in which the two interact have been examined much less frequently. Scattered studies have appeared on the inter-relationship of visual culture and tourism but this is the first volume that focuses entirely upon some of the diverse ways in which visual practices and representations have been implicated in the rituals and experiences of tourism. In doing so, the book aims to make a significant contribution to the ongoing debates surrounding visual culture and tourism while avoiding the premature closing of questions that deserve to remain open.

Both the fields of visual culture and tourism studies extend across disciplinary boundaries and have attracted the attention of writers from a variety of specialist backgrounds. The heterogeneous character of the inquiry is reflected in the professional affiliations of our authors, which range from geography, art history and tourism studies to history, anthropology and urban studies as well as touching upon the practices of fine art, photography and architecture. Each chapter brings its own particular perspective to bear on the investigation, and, as will become apparent even to the casual browser, there is no consensus regarding either the methodologies and theories employed or the choice of objects for study, or even the basic definitions of the key terms of visual culture and tourism. Rather than gloss over the dissensions and attempt to impose a misleading conformity on a multifarious body of texts, we have chosen to affirm the contrasts as positive and even necessary factors in a multidisciplinary exchange. We do not, in this introductory chapter, seek to determine or to define: rather, we wish to explore the respective and relational processes of visual culture and tourism. It is with these issues in mind that we have structured our introduction along the lines of a dialogue between an art historian (Nina Lübbren) and a cultural geographer (David Crouch). We invite our readers to make connections, identify implications and ponder contradictions across an even wider range of disciplines.

Visual Culture and Tourism: An Art Historian's Perspective

Visual Culture: Origins and Definitions

Before embarking on an exploration of the links between tourism and image making, it may be useful to offer a brief outline of what the term 'visual culture' has come to mean. This term initially arose out of efforts to revive and update the scholarly discipline of art history in the 1970s. The art historian Svetlana Alpers is generally credited with coining and disseminating the term 'visual culture' to give a name to the context of 'image-making devices' and 'visual skills' of a particular culture as they impinged upon the making of art (Evans and Hall 1999: 5; but see Walker and Chaplin 1997: 6 n.2).

Art historians such as Alpers, Michael Baxandall and T. J. Clark recreated cultural contexts in order to illuminate what remained central to their quest: the works of art (Baxandall 1972, 1980; Clark 1973a, 1973b, 1984; Alpers 1983). Later writers of the 1980s and 1990s, by contrast, increasingly questioned the centrality of 'Art' and turned their attention to the context for its own sake. The late Nicholas Green criticized art history for retaining 'a set of texts [that] designated *art* as the fulcrum for cultural analysis' (Green 1990: 3). In its place, Green proposed an 'interdiscursive approach to the visual' that would permit us to grasp the 'interdependence of cultural practices along with their mutually reinforcing results' (Green 1990: 4).

In the 1990s and early 2000s, a growing number of books, journals, conferences and new academic departments have transformed visual culture from a context or subtext into the central field of inquiry, incorporating the term in their titles. Journals include *Visual Culture in Britain* (2000–), and *Journal of Visual Culture* (2002–). These initiatives herald a new commitment to the category of visual culture. However, it is a category that is still in flux and has not yet (some may argue, fortunately not yet) resulted in any stable definitions or disciplinary demarcations. Writers on visual culture share an allegiance to the multidisciplinary and multimedial character of the field; however, in other respects they can diverge widely.

Some writers apply the phrase 'visual culture' to all visual aspects of culture. They use it as an umbrella term to signal the broadening of the range of objects beyond the established categories of fine art and habitually produce lists of the various images and media that include film, television, video, advertising, photography, fine art, design, and digital imagery (Jenks 1995: 16, 2000: 7; Carson and Pajaczkowska 2000: 1; Sturken and Cartwright 2001: 4, 279; see also Walker and Chaplin 1997: 32). Other scholars avoid the taxonomy of objects and argue that the new field of visual culture is less about artefacts than about the connections between and across various cultural practices of meaning making (Mitchell 1995:

210; Rogoff 1998: 11 and 2000: 28–33; Mirzoeff 1999: 4–5, 13; Evans and Hall 1999: 3–4). On the one hand, these latter writers emphasize the constructive role of audiences in producing meanings, shifting the inquiry from a singular object or corpus of objects to the dynamic relationship between visual 'events' and their consumers. On the other hand, there is a theoretical emphasis on 'vision', 'visuality' and the 'visual turn' in cultural studies of the 1990s. By the early 2000s, the field of visual culture is beginning to expand into less obviously visual arenas. As Irit Rogoff argues, the intertextual relay among the different manifestations of the visual does not stop at the optical but incorporates 'interpretations of the audio, the spatial, and the psychic dynamics of spectatorships' (2000: 28).

This wider field of inquiry lends itself particularly well to the illumination of certain touristic practices. Not only can the visual objects of tourism come under scrutiny in and of themselves (objects such as postcards or advertising images), but the larger network of links among objects and practices, expectations and the experience of real sites, ideologies and personal interventions, may be explored.

Visual Representation and Tourism

There are a number of ways in which scholars have begun to discuss visual imagery and tourism. One way derives from anthropology and attends to the objects produced by touristic 'hosts' (Smith 1978) for touristic consumption, in particular those from Third World countries. Writers in this field initially aimed to study the artefacts made and used by 'tribal' peoples as part of their 'traditional' social rituals and contexts; however, in the course of their investigations in the field, scholars came upon a rather different sort of production, that of craft objects produced and marketed specifically within a tourist economy and to cater to touristic tastes. This kind of production, sometimes disparagingly or ironically referred to as 'airport art', 'tourist art' or 'souvenir art', was appropriated for anthropology and became part of a general shift towards recognizing the ways in which so-called 'traditional' communities were caught up in the processes of modernity and postcolonialism rather than embalming them in the past for anthropological study (see, for example, Smith 1975; Graburn 1976, 1983; Jules-Rosette 1984; Evans-Pritchard 1989; Phillips 1995; Phillips and Steiner 1999).

Another way of studying visual images and tourism derives from the history of art and photography, and focuses on the image-making activities of tourists themselves, especially (indeed, almost exclusively) Western tourists from the late nineteenth century to today. The first study to discuss visual images produced by European artists in the context of tourism was Fred Orton and Griselda Pollock's seminal discussion of Paul Gauguin and Emile Bernard's paintings of Brittany in the 1880s in the light of contemporary tourist literature, in particular guidebooks

(Orton and Pollock 1980). The authors argued that the painters represented the region as a primitive and exotic place, removed from the upheavals of modernity, and that this mode of imaging the province formed part of a touristic, metropolitan practice that had little to do with the actual economic and modernising forces at work in Brittany.

Orton and Pollock's article was much anthologized but little was published in response to its arguments concerning the intersection of art with tourism until around a decade later (but see Märker et al. 1981). During the 1990s, a small but growing number of scattered books and articles appeared that linked painting and photography to the practices of tourism (Green 1990; Lenman 1990; J. D. Herbert 1990, 1998; Pollock 1992, 1998; R. L. Herbert 1994; Taylor 1994; Chard and Langdon 1996; Crawshaw and Urry 1997; Lübbren 1999). The prime impetus given to the field of the study of the visual in the context of tourism were two sociological studies, Dean MacCannell's *The Tourist* (1999; first published in 1976) and John Urry's *The Tourist Gaze* (1990).

MacCannell argued that visual spectacle was central to the rituals of modern tourism. Urry presented a sustained and wide-ranging argument on the structuring function of the gaze for touristic expectations, experiences and memories. Following MacCannell and Urry, almost every historian of art and photography has agreed that images play a crucial and formative role in the practices of tourism. It is thus not simply a matter of misrepresentation in the Marxist sense if images show the scenery of a particular site as something quite different from what can be deduced through the study of archival and other historical material. In their early article, for example, Orton and Pollock juxtaposed guidebook descriptions of the Breton village of Pont-Aven as idyllic and economic statistics attesting to the relative agricultural prosperity of the province with paintings showing the region to be underdeveloped and poor. It remains crucial to gather as much historical evidence as possible in order to gauge the way that images affirm, deny or renegotiate economic realities, and authors of case studies continue to present meticulous research findings to counterbalance artists' representations in this way (for example, Herbert 1994). However, the point is not whether the historical material is any more 'truthful' than the image produced by artists in paintings or by tourist promoters on postcards. As Peter Burke writes, taking up the German cultural critic Siegfried Kracauer's arguments of the 1920s, cultural history is the history of the social imagination (cited by J. Richards, *Visual Culture in Britain*, 2000: 9). Tourists do not necessarily respond to economic and social realities; they do, however, respond strongly to the images that are in circulation about their touristic destinations (see, however, Pocock 1982).

The crucial role of images in structuring tourist experience initiated by Urry may be supplemented with an equally powerful, if less-quoted trope proposed by the sociologist Rob Shields in his book *Places on the Margin* (Shields 1991).

Shields argues that people's perceptions of particular places are indebted to what he calls 'place-myths'. Place-myths are conglomerates of place-images, that is, stereotypes and clichés associated with particular locations, in circulation within a society. Place-myths need not necessarily be faithful to the actual realities of a site; they derive their durability, spread and impact from repetition and widespread dissemination. Although Shields discusses pictures only incidentally, it would appear that visual images may constitute crucial components of a place-myth (Lübbren 2001). An image can evoke a particular association or category of place in a powerful synecdochal and iconic way. That is, the image can conjure up an entire site, region and structure of experience by representing only a fragment (say, a palm tree or a local in costume), and the image can also address viewers directly by virtue of a mimetic visual language. The great majority of touristic images tend not to be paintings or other objects of 'high art' but ephemeral relics of advertising, commercial exchange or personal souvenir making. As MacCannell was the first to suggest, tourists travel in order to collect images, and these images are both objective and material (postcards, snapshots, videos) as well as subjective and immaterial (hopes, dreams, visions).

Finally, it should perhaps be noted that despite the growing interest in the links between tourism and images, there remains a tendency to disparage tourism even among those scholars who have devoted a great deal of attention to the phenomenon. John Taylor, for example, in his otherwise astute analysis of tourism and landscape photography, divides individuals into 'travellers' (who gaze contemplatively at their surroundings), 'tourists' (who accumulate shallow glances), and 'trippers' (who see everything in blinks, blurs or 'snaps') (Taylor 1994: 14). The literary historian James Buzard argues that this disparaging attitude towards tourists came into existence at the same time as tourism; indeed, what he terms 'anti-tourism' is simply another aspect of the overall formation of tourism and subject to the same commodifications, rituals and hierarchies as is 'tourism' (Buzard 1993: 4). This volume hopes to build on such insights in order to move beyond the hierarchies of gazes and glances, tourists and travellers.

Visual Culture in the Spaces of Tourism: A Geographer's Perspective

Visual Culture in the Spaces of Tourism

Visual culture is consumed in spaces. Geographical thought is an important component of understanding the consumption of, or encounter with, visual culture. Tourism has frequently been depicted, and theorized, as a journey (De Burlo and Hollinshead 2002): a journey to and in places, identities and experiences. Across

these different dimensions there has been an emphasis on the visuality involved in numerous facets of what tourism concerns, both materially and metaphorically. Materially, tourism is visually represented as significantly physical, involving space, visiting particular 'concrete' places. Metaphorically, visual culture may construct ideas and desires of the experience of tourism, and of particular imagined places.

However, as Bender argues, vision is far from 'realism'; visual culture is far from a self-evident reproduction of reality and is instead highly problematic (Bender 1993: 21–2). As we come to discover in terms of tourism, its wrapping in visual culture, and also its encounter in practice are not straightforward. Similarly, space is not straightforward in the encounter of the individual as tourist.

The visual culture of tourism can be encountered across a wide spectrum of media, including advertising, site design and location, and their informing motifs in painting, photography and travel brochures. Touristic modes encompass the Grand Tour, Blackpool and the Taj Mahal, backpacking and the package tour, white-water rafting and theme parks, coach trips and rambling, heritage parks, hotels, beaches. Tourism is popularly referred to as 'being there'. We might problematize this as 'being where', geographically and subjectively, raising the significance of the construction and constitution of space in the experience. The interaction between visual culture and tourism have been argued to be in the forefront of contemporary cultural identity (Lash and Urry 1994; Rojek and Urry 1997).

In this section, I problematize what visual culture may 'say' about tourism in terms of its construction, constitution and practice. I discuss what tourism may say about visual culture, about its power, for example. How important is tourism in the development of visual culture and, of course, vice versa? Attention is drawn to the dynamic of tourism and of visual culture in contemporary culture. Key further questions include the following:

- Does visual culture invent, re-invent, spaces/places and experiences of tourism, or is it a resource in a more complex process?
- Does visual culture rather interpret sites, providing them ready for animation by the tourist?
- How is visual culture drawn into the dynamic of what the tourist does in the consumption, or practice, of tourism; who constructs the visual culture of tourism?
- Business, television, literature, paintings and advertising provide narratives of interpretation available for consumption by the tourist.

Tourism is something that business and cultural institutions do, and they draw upon visual culture in its pursuit. More recently, it has been argued that tourism is

instead something that people do, and for which activity business 'provides' some of the resources (Crouch 1999). In either case, how is visual culture *enacted* in doing tourism? De Certeau's arguments concerning the experience of space and its possibilities of resistance are pertinent here (De Certeau 1984). However, there is also the possibility that visual culture, like the different but overlapping notions of landscape and space, may be encountered more generally, in ways in which work is done in the process of the encounter the tourist makes (Crouch and Malm 2003). This notion resembles Miller's argument concerning the experience, or practice and performance, of consumption that reaches well beyond the limits of purchase (Miller 1998). Miller argues that in the practice of consumption the consumer makes sense of things, of objects, after the act of purchase gives them value, in an active process of engagement. Through such processes, some things seem to matter, rather than essentially through their object-power separate from consumption. In tourism, I argue that this action or practice of consumption pre-empts the moment of experience in anticipation as well as after the event. Furthermore, visual consumption occurs alongside and amongst numerous other components of practice.

This larger perspective of the consumption process problematizes the working of visual culture. Consumption happens in the complexities of time and ways of encounter. Vision happens alongside, or amongst, multisensual encounters. Sensual encounters are engaged expressively rather than in isolation; vision is not made 'alone'. To prioritize the visual is to reify it. Moreover, the visual does not prefigure. The individual encounters the world in the act of doing and draws upon numerous contexts in the process. Visual material is part of the resource the individual may use. Particular visual images may trigger characteristics of the encounter but not prefigure them. The individual may instead incorporate visual material – paintings, photographs, televisual images, brochures – along with other contextual elements in the process of *refiguring* (Crouch and Matless 1996; Crouch 2001).

The extent to which visual culture constitutes information or knowledge for the tourist emerges as a central question. On the one hand, the visual cultures of tourism may be grasped as both contextualizing representations (in painting, for example), prioritizing destinations, directing or suggesting ways of seeing, and providing points of departure for the tourist. On the other hand, visual culture may constitute the 'site/sight' itself, as in New York's and Bilbao's Guggenheim museums, Little Bighorn's commemoration site, a Balinese festival. If tourism is problematized as sightseeing, then the borders between a particular form of visual culture (painting, for example) and spectacles become ambiguous. In what follows, I identify key lines of interpretation of tourism in relation to sites, destinations, visuality and their cultural relatedness in order to try and construct a critical interpretation of visual culture in contemporary tourism.

Interpretations of Tourism and Visual Culture

Baudrillard argued the importance of 'strategies of desire' (Baudrillard 1981: 85) through which consumers' – in other words, tourists' – needs are mobilized and their nascent interest captured in a process of consumption before consumption. These strategies, he argued, consist of the signs onto which the value of products are conveyed in the process of seduction. For tourism, these signs may include brochures of destinations, films and a recycling of artwork in various forms, as well as the sites themselves, their power displayed and systematized through their display and communication. Arguably, the power of signs shifts from the objects themselves to their circulation in representations, their fuller consumption dominated by their sign value, their value invested in anticipation.

Tourism is frequently promoted as a seduction process (Rojek 1995). People are allured to go touring, enticed to particular cultures, sites and sights across the world through visual culture and the agencies of the tourism industry, and numerous others who collude in this – writers, film-makers, advertising agencies and governments. Desire is engaged, perhaps produced, in this process. Space and its cultural use/content and context can be used to entrap desire. Like bodies, space becomes inscribed with significance, and both figurations are powerfully deployed in tourism's visual culture. The two are not unrelated. Spaces may be signified in the visual depiction and representation of the body – lying on the beach as a symbol of what to do, what it feels like, to be a tourist; similarly, bodies may be signified in relation to places as in the Club culture of Ibiza (Game 1991).

A familiar interpretation of what happens in tourism is as follows. People seek out signs and their power as part of their tourism, they gaze at the objects brought to them in the signs, gazing at their translation at least one step removed from a visceral and emotional encounter with the objects themselves. Visual culture is all-powerful in this process. The gaze is a familiar component within tourism analysis (Urry 1990, 2002).

The gaze's power in tourism geographies and sociologies relates to its engagement of the tourist as a detached observer, consuming – prioritizing – signs. The visual culture of the sites themselves is part of this signifying material. In an application of Foucault's discourse on the gaze, the producers of sites such as heritage or themed locations use visual culture, drawing upon motifs from diverse cultural material to construct the tourism sight. The tourist participates in the provided gaze and, on cue, follows its lead in the structuring of space, culture and the spectacle. Even the written text parodies visual content (and this combination frequently accompanies tourism material): 'The language of views and panoramas prescribed a certain visual structure of the experience. The healthiness of the site was condensed with the actual process of looking at it, of absorbing it and moving around it with your eyes' (Green 1990: 88). There are critical consequences here

for the exertion of power, through the visual, over the sites and cultures to which they may relate. Visual culture becomes implicated in the possibility of its temporary ownership as 'tourism presupposes the exchange of finance for temporary visual property which visitors can acquire when they have temporary rights of possession of places away from home' (Lash and Urry 1994: 271).

Moreover, visual culture, implicated in this process of constructing tourism, may be deconstructed from its originary meaning or 'aura' (by the artist, the photographer) and be rendered completely different as socially (re)produced (Benjamin 1973; Urry 1990: 84–5). It is rendered part of everyday aesthetisization. However, constituted by the authority of the tourism industry, for example, visual culture can be used to assert power over the tourist as part of a scopic regime of contemporary culture, exercised by cultural mediators. Visuality, the power of gazing and the visual contexts through which gazing happens can also lend power to the tourist, *vis-à-vis* the scene, the place, the culture objectified in the gaze by virtue of the distancing, detaching and objectifying character (Urry 1990). At the same time, the institutional deployment of visual culture becomes increasingly diverse, yet no less powerful, in its advanced adaptation to distinct market segmentation (Lash and Urry 1994: 273). This can produce a formal language of the visual (Dann 1996). Perhaps most significantly, particular constructions of tourism places and desires – through the targeted depiction of temples, for example – accompany a process of deploying myth that resonates with deep cultural meanings of landscape and of, for example, national identity (Selwyn 1996).

MacCannell (1999) argued powerfully for acknowledging the signification of tourist sites as locations of the authentic, where people could 'feel' their lives authenticated. Building his argument on the interpretation of tourism as *sightseeing*, MacCannell (1999) argues that the baggage of visual culture is constructed to deliver to the tourist what is understood to be authentic, even though this may be a staged authenticity, achieved through the skilful manipulation of artefacts and signs. Indeed, artefacts, even constructed ones, become translated into commodities for tourism, privileged as 'markers'. He calls this *constructed recognition*: 'Sightseers have the capacity to recognize sights by transforming them into one of their markers . . . not permitted to attach the . . . marker to the sight according to [their] own method of recognition' (MacCannell 1999: 123–4). He cites the (inauthentic) application of paintings to the design of particular sites, and the use of travel posters in restaurants. Moreover, he argues that tourists' photographs are programmed by the markers; the 'Kodakization' of tourism includes the clearly marked site from which to see, the direction of view, even the framing in a circuit of visual culture. Indeed, visual culture in use as the construction and representation of the Other has been a powerful critique of the institutional and postcolonial treatment and manipulation of tourism in the construction of cultural dependency (Said 1979), although Said (1994) more recently argues that the same material can be reworked as the tools of resistance.

More generally, visual culture is appropriated in the inscription of places for tourism. Painting, Urry (1990) argues more recently, implies a power of visual culture in relation to the observer through its 'mastery of the scene'. Photographs become a scopically constructed form of visual culture whose power is to convey and reproduce the hegemony of the visual. Paradoxically, photography has come to produce what Urry (1990; see also Urry 2000) calls 'mobile signs' and images that constitute the visual culture of the late twentieth century. Unrestrained by the prolonged stasis of the painter and earlier photographic technologies, photography accompanies and records contemporary mobility, or at least multiple points of reference.

For both MacCannell and Urry, the use of visual culture in tourism is not merely interesting, but claims to be part of a cultural process of tourism and identity formation in contemporary society. Tourists, like those they observe, become entrapped in the discourse of the scopic regime. Following Baudrillard's construction of desire, this might suggest that people come to respond to their life through the provided spectoral seduction, along prefigured rules. For Lash and Urry (1994), this 'making use' of signs 'out there' becomes a focus for reflexivity on the subject's own life. They argue that this is a process of aesthetic reflexivity – self-interpretation and the interpretation of social background practices stimulated through design-intensive practices exemplified in tourism's themed sites where the design of sites/sights can help tourists play with place myths, and identities in their own lives (Lash and Urry 1994: 5, 6). Lash and Urry take us beyond Baudrillard's sign-seduction to focus upon individuals' making sense of visual material amongst other material in an active process. Yet they do not take us beyond a world 'fixed' by a particular access to visual culture, the standard gaze. Cohen and Taylor (1992) argue for a much more subject-centred experience of tourism, less dependent on a particular construction of visual culture, in an everyday sense of practising, constituting, changing, adjusting. Like Willis and Fiske, they identify cultural material, not least visual culture, as resources whose use may subvert and refigure prefigured meanings (Fiske 1989; Willis 1990; Wall 2000; Crouch 2000).

Aesthetic reflexivity may, then, involve the deconstruction of prefigured meanings (Lash and Urry 1994). Phil Crang (1996) critiqued the power of meaning composed of free-floating signifiers through which the world is 'made sense' of. In contradistinction to the argued power of prefigured meanings, it may be claimed that human subjects live their lives, do tourism, live space, encounter each other, work through their own lives, in a negotiation of the world around them. Thus, visual culture can be reconsidered in terms of a more complex practice of subjectivities. In a critical consideration of semiotics as 'flow' there is a persistent question of the use people make of signs, and of the process through which that use occurs (see, for example, Game 1991). One may argue that people practise and 'perform'

places and their lives. Places and other visual culture of tourism are lived, played, given anxiety, *encountered* in a self-construction of being a tourist.

Not only consuming available visual culture, tourists produce their own, exemplified in their photographs (Crawshaw and Urry 1997). *Their own* visual material may not conform to the visual culture that already exists. Mike Crang argues that photographs can be produced through individual experience, not by following prefigured representations (Crang 1997). He argues that photographs themselves become transformed from merely visual artefacts to objects that are constituted in and convey subjectivities in their circulation as holiday snaps. Thus, one may argue that visual culture can be part of a mutually enriching encounter in a multiple circulation of artefacts and practices. Across disciplines, there is a move to reinstate subjects as participatory agents rather than as actors in prefigured structures of meaning, to problematize the power of particular, usually institutional, contexts, using so-called 'non-representational' theories (Thrift 1996).

With this has come a renewed interest in notions of desire: subjective emotional and physical experience, of making sense of visual material in relation to physical and bodily engagement: making sense of visual culture through an engagement with places, sites and sights 'with both feet' rather than only two eyes (Game 1991). Tourism becomes a valuable prism through which to consider these conceptual developments, with the focus on the tourist. Encountering water and rock at speed in white water rafting becomes much more than the tourist poster suggests (Cloke and Perkins 1998). Moreover, gazing from a tourist site is increasingly put aside as mobilities of tourism become observed as more complex, the car as well as the train reconstituting aspects of encounter (Urry 1990). Television makes us rethink these practices once again (Urry 1990). Representations become malleable and may be disrupted by practice, and given their own signification in the process.

Visual culture may become significant more through a process of practice and refiguring than as 'completed' object, a resource through which identities may be felt, practised, rediscovered and challenged. The power of the asserted contextuality of visual culture may also be open to challenge. Visual culture may provide material from which people constitute their own metaphors. The visual culture of tourism is fluid and may be refigured as a subjective, materialist or embodied semiotics (Game 1991; Crouch 2001). Both tourism and visual culture may be considered processes, processes of knowledge, experience and identities, and examples of processes of individual becoming rather than merely of being (Ingold 2000). To draw upon Ingold, the individual does not merely inhabit space, landscape or visual culture, but dwells in relation to them, in a process of becoming (Crouch 2003; Grosz 1999). The self and the object are refigured in the process of encounter and performance (Edensor 2001; see also Crouch 2001).

In embodied practice or performance, the individual encounters the world multi-sensually and multi-dimensionally (Crouch 2001). Embodied encounter is

more than simply adding up the components of the senses. The individual is expressive, and this provides a useful orientation for thinking through relations between touch, gesture, haptic vision and other sensualities and their mobilization of *feelings of doing* (Merleau-Ponty 1962; Harre 1993; Radley 1995).

Moreover, the *production* of visual culture is in part a process of touring, it encompasses exploration, imagination and an exercise in and of identity (Matless 1992; Crouch and Toogood 1999). The artist, for example, can be engaged in a process that is much more than merely a visual act. In the art of Peter Lanyon, for instance, visual images are constructed and constituted through walking, turning, bending and expressively engaging places, engaging in the process his awareness of other visual cultures, especially those of paintings and local artefacts (Crouch and Toogood 1999).

Similarly, the *production* of visual culture is partly a process of touring, an imaginative exploration and an exercise in and of identity (Matless 1992; Crouch and Toogood 1999). Similarly, the production of tourism is in part a process of encounter, with space, landscape and its visual cultures of representation. Being a tourist is to produce, not only to consume, landscape, place and visual material (Crouch 1999; Edensor 1998, 2001). The character of performance, the body-expression rendered in relation to an object, *colours* that object with the character of the individual performing and her relation with the space. The expressive and poetic character of much visual culture offers a potential mutual encounter with the tourist as she engages in the poetic (Birkeland 1999). Photographs and other material culture are fragments of the encounter the tourist as individual makes.

Anne Game writes autobiographically of her effort to read the 'unseen' codes of a place in walking the Pennines of northern Britain and whilst lying, playing and swimming on Sydney's Bondi Beach (Game 1991). She identifies a very different signification of Bondi from that written into the posters that promote it as a holiday resort. In what de Certeau called 'the pain and pleasure of the body', the individual goes beyond the immediate, the prefigured and the practical (De Certeau 1984: 105). At the same time the tourist can be careful, wary and concerned, despite the apparent exoticism of her encounters, using the encounter of tourism to hold on to identity, to the security of the familiar, in a considered but also reconsidered and reworked past. In both 'holding on' and in 'going further', the tourist makes use and sense of visual culture in her own way. The visual culture of tourism does not act on a *tabula rasa* but is encountered in a broader process in combination with other components of the encounter. This is *flirting with space, flirting with visual culture* rather than being merely seduced by it (Crouch 2002). The tourist produces her own visual culture in the process. As Evans and Hall (1999: 3) argue, 'the scrupulously pure project of the structuralist moment of semiotics, which conceives of language as a system of signs immanent to a single or bounded group of texts and studied independently of . . . particular utterances or human subjects,

needs to be both augmented and qualified'. The ways in which visual culture and 'being a tourist' work together present fascinating challenges for work across the disciplines.

The Chapters

The chapters are set out in two main parts: *Sites and Images*, and *Practices and Encounters*. The first part presents discussions on and investigations of the images that arguably prefigure, shape or inform tourism or touristic experience. Following that, the second section seeks to animate the images, myths and texts of tourism through a variety of discourses on tourist practices and encounters.

Part I: Sites and Images

Picture postcards provide one of the principal and most striking instances of the link between visual culture and tourism, yet they have remained, for the most part, rather undertheorized (but see Schor 1992). Annelies Moors addresses this theoretical *desideratum* in her chapter on the politics of representation in Palestinian/ Israeli postcards. Moors asks the question how such a seemingly trivial commercial medium as the postcard can be implicated in the complex politics of the contested territory of Palestine and Israel.

Deborah Cherry also points to the political underpinnings of tourism, focusing in particular on the link between tourism and the discourse of European imperialist expansion in the mid-nineteenth century. Cherry traces this crucial connection between tourism and colonialism across a range of images of the French colony of Algeria. She argues that European image producers imposed a Western visual system onto their pictures and employed strategies of 'pictorializing' and 'framing' the region. However, contradictions arose when artists and writers actually travelled to the place.

Postcards, paintings and images in newspapers circulate among a variety of audiences, including tourists and armchair tourists. Monuments are fixed to a site rather more permanently and engage different sorts of viewing and touring practices. Bradley Fratello examines the functions and ideological roles of two nineteenth-century monuments to the painter Jean-François Millet, one erected in the forest of Fontainebleau (site of Millet's mature career) and the other in the artist's native village of Cherbourg. Fratello argues that in these statues, diverse French post-1871 ideas on art, nature and religion merge.

Open-air museums come under critical scrutiny in Stephen F. Mills's chapter. Mills argues that curators of open-air museums believe they are presenting 'history' but are, in effect, producing 'heritage' because of their dependence on the visual

dimension. By subscribing to a naive belief that 'seeing is believing', open-air museums avoid the issue of visual interpretation and mediation. Mills also offers a critical assessment of the value of visual engagement for historical inquiry in general.

Three photographic enterprises and three regions of Britain (Scotland, Cornwall and the Thames) provide the focus for Robin Lenman's chapter on the link between the tourist industry and commercial photography. Lenman shows how each photographic enterprise fed into and was predicated upon the place-myths associated with a particular region. Two crucial insights emerge from this chapter: firstly, tourist images change over time and from place to place, and secondly, images do not work in isolation from texts.

While Lenman focuses on three case studies in depth, Peter Howard leads the reader across the map of Europe. Howard's chapter examines the landscape paintings that depict sites in continental Europe and were exhibited at the Royal Academy in London during the twentieth century (with a comparison to the early nineteenth century). The argument links shifts in artistic taste to shifts in touristic preferences for particular regions. Howard addresses two related developments: that tourists tend to follow where artists have led, and that places, once discovered for art, are not abandoned but continue to be part of the expanded map of art and tourism.

Nina Lübbren's chapter, following on from Howard's analysis of shifts in artistic landscape preference, examines two particular and opposing place-myths in depth, that of the 'north' and the 'south' of Europe. Lübbren detects a shift that took place around 1900 and affected both subject matter and style in images of northern and Mediterranean coastal regions. The chapter argues that we cannot adequately account for this change by stylistic, art-historical reasoning alone but that the shift is bound up with wide-reaching contemporary changes in patterns of leisure and tourism.

A picture essay by Davide Deriu separates the two chapter parts. It is designed to emphasize visual over textual rhetoric, and is made up of four photographs taken from an exhibition dealing with the touristic representations of Bangkok. Deriu, one of the exhibition's organisers, provides a brief introduction to the project as well as a commentary on the individual images.

Part II: Practices and Encounters

Roger Balm and Briavel Holcomb contemplate the complex ways in which sites containing significant archaeological remains are reconstructed and rendered for tourism. Their examples are Machu Picchu in Mexico and the Valley of the Kings in Egypt. The authors argue that the dominant images we have of these places go

back to a handful of so-called 'iconic predecessors', that is, key photographs taken by the first (Western) locators of the sites. This chapter explores the afterlife of these pioneer images within both the commercial exploitation of the sites and the subjective imagination of tourists.

Choosing not to become a tourist may provide a means of self-reflection. In the narrative arising from her decision not to visit Auschwitz, Griselda Pollock is concerned with the visual culture of tourist sites and their filmic representations. The author argues that the reconstructed site of today's Auschwitz may provide more of a memorable tourist experience rather than a pilgrimage of memory, and that the experience to be had there depends on the motivations and life histories of individual visitors. Pollock confronts the questions, 'is seeing knowing?', and 'how can spectacularization be achieved and sustained in a supremely problematic tourist site, such as Auschwitz?'

Using a series of photographs, Doug Sandle narrates the story of a photo-booth on the Isle of Man in the middle decades of the twentieth century. Sandle's argument concerns the role of the photograph not as passive record nor in later memory but in negotiation of the self, of culture and of social exchange. Holiday photographs represent the present for the future consumption of the past, and part of their function is to glamourize the ordinary and to portray the self as a 'holiday-other'.

Simon Evans and Martin Spaul's chapter examines the visual culture of tourist woodlands through a discussion of the 'authentic' and the 'commodified'. Basing their discussion on representative small leisure venues in East Anglia (UK), the authors examine how the desire to construct woodlands as visually amenable heritage sites can conflict with the realities of managing these same forests in order to preserve their ancient character. The authors argue for a revised account of the 'visual' – one that takes into account extra-visual components and historical contingencies. Once the tourist is at the site, encountering the place, vision is combined, chaotically, with other forms of sensory as well as intellectual engagement.

Approaching London Bridge in Arizona similarly engages dislocations and numerous dimensions of place and time. In Daniel Jewesbury's chapter, the concepts of authenticity, class / power and identity provide frameworks for making sense of the cultural and physical re-location of the former Thames bridge to the American desert. The author employs Foucault's notion of a heterotopia to evaluate tourist sites and their ideology. Jewesbury bases his theoretical arguments on his own experience as a visitor and as the maker of video narratives.

Television may not seem an obvious candidate for an examination of the implications of touristic viewing. However, Renée Tobe makes a compelling case for reading certain structures of televisual gazing as paradigms of touristic gazing. The argument that tourism begins at home, with the anticipation and imagining of

potential holiday sights and experiences (Urry 1990), can be extended to the imaginative activity of viewers before the box. Television may be part of the seduction process of tourism, be it in terms of travel programmes, documentaries or dramas set in tourist locations. Tobe's argument, based on an analysis of David Lynch's TV series *Twin Peaks*, goes further still, in emphasizing not only television's ability to bring the exotic into every home but also the televisual attractions of the mundane and everyday, especially when the ordinary is presented as historically authentic (compare Mill's argument in his chapter on open-air museums).

Eeva Jokinen and Soile Veijola address constructions and memories of space, time and the gendered body. The authors focus on a tourist site that is significant to Finland's sense of national identity, the Koli mountain on the Finnish-Russian border. This chapter is oriented around identities of bodies and borders, or 'East' and 'West', and the power of being at sites where borders are felt to exert their pressure. Jokinen and Veijola approach complex conceptual issues by means of an imaginative textual collage, interweaving autobiograpy, personal family snapshots, historical data and a subtle rereading of key theoretical texts.

Acknowledgements

The chapters collected in this volume arise from a conference held at Anglia Polytechnic University in Cambridge that was organized by the editors of the present volume. The book has been augmented by a number of contributions solicited independently, in order to round out the debate. We would like to acknowledge our grateful debt to the people who helped to make the conference a success, in particular Tory Young, Penelope Kenrick and our student helpers.

References

Alpers, S. (1983), *The Art of Describing: Dutch Art in the Seventeenth Century*, Chicago: University of Chicago Press.

Baudrillard, J. (1981), *For a Critique of the Economy of the Sign*, St Louis, MO: Telos Press.

Baxandall, M. (1972), *Painting and Experience in Fifteenth-Century Italy: A Primer in the Social History of Pictorial Style*, Oxford: Oxford University Press.

Baxandall, M. (1980), *The Limewood Sculptors of Renaissance Germany*, New Haven and London: Yale University Press.

Bender, B. (ed.) (1993), *Landscape: Politics and Perspectives*, Oxford: Berg.

Benjamin, W. (1973), *Illuminations*, Glasgow: Fontana.

Birkeland, I. (1999), 'The Mytho-Poetic in Northern Travel', in D. Crouch (ed.), *Leisure/Tourism Geographies*, London: Routledge.

Buzard, J. (1993), *The Beaten Track: European Tourism, Literature, and the Ways to Culture, 1800–1918*, Oxford: Clarendon Press.

Carson, F. and Pajaczkowska, C. (eds) (2000), *Feminist Visual Culture*, Edinburgh: Edinburgh University Press.

Chard, C. and Langdon, H. (eds) (1996), *Travel, Pleasure and Imaginative Geography, 1600–1830*, New Haven and London: Yale University Press.

Clark, T. J. (1973a), *The Absolute Bourgeois: Artists and Politics in France, 1848–51*, London: Thames & Hudson.

Clark, T. J. (1973b), *Image of the People: Gustave Courbet and the 1848 Revolution*, London: Thames & Hudson.

Clark, T. J. (1984), *The Painting of Modern Life: Paris in the Art of Manet and His Followers*, London: Thames & Hudson.

Cloke, P. and Perkins, H. C. (1998), 'Cracking the Canyon with the Awesome Foursome: Representations of Adventure Tourism in New Zealand', *Environment and Planning D: Society and Space* 16: 185–218.

Cohen, S. and Taylor, L. (1992), *Escape Attempts*, rev. edn, London: Routledge.

Crang, M. (1997), 'Picturing Practices: Research through the Tourist Gaze', *Progress in Human Geography* 21, 3: 359–73.

Crang, P. (1996), 'Popular Geographies: Guest Editorial', *Environment and Planning D: Society and Space*, 14: 631–3.

Crawshaw, C. and Urry, J. (1997), 'Tourism and the Photographic Eye', in C. Rojek and J. Urry (eds), *Touring Cultures: Transformations of Travel and Theory*, London and New York: Routledge.

Crouch, D. (ed.) (1999), *Leisure/Tourism Geographies: Practice and Geographical Knowledge*, London: Routledge.

Crouch, D. (2000), 'Introduction to Popular Culture and Popular Texts', in I. Cook, D. Crouch, S. Naylor and J. Ryan (eds), *Cultural Turns/Geographical Turns*, London: Longman.

Crouch, D. (2001), 'Spatialities and the Feeling of Doing', *Social and Cultural Geography* 2, 1: 61–75.

Crouch, D. (2002), 'Flirting with Space', in C. Cartier and A. Lew (eds), *Seductions of Place*, London: Routledge.

Crouch, D. (2003), 'Space-ing and the Everyday: Entanglements with the Mundane', *Environment and Planning D: Society and Space* (in press).

Crouch, D. and Malm, C. (2003), 'Landscape: A Gentle Politics', in G. Rose (ed.), *Politics and Landscape*, Edinburgh: Black Dog.

Crouch, D. and Matless, D. (1996) 'Refiguring Geography: The Parish Maps of Common Ground', *Transactions of the Institute of British Geographers*, New Series 21, 1: 236–55.

Crouch, D. and Toogood, M. (1999), 'Everyday Abstraction: Geographical Knowledge in the Art of Peter Lanyon', *Ecumene* 6, 1: 72–89.

Dann, G. (1996), *The Language of Tourism: A Sociolinguistic Perspective*, Wallingford: CAB International.

De Burlo, C. and Hollinshead, K. (eds) (2002), *Journeys into Otherness*, Bristol: Channel View Press.

De Certeau, M. (1984), *The Practice of Everyday Life*, trans. S. Rendell, Berkeley: University of California Press.

Edensor, T. (1998*)*, *Touring the Taj*, London: Routledge.

Edensor, T. (2001), 'Performing Tourism, Staging Tourism: (Re)producing Tourist Space and Practice', *Tourist Studies*, 1, 1: 59–81.

Evans, J. and Hall, S. (eds) (1999), *Visual Culture: The Reader*, London, Thousand Oaks and New Delhi: Sage.

Evans-Pritchard, D. (1989), 'How "They" See "Us": Native American Images of Tourists', *Annals of Tourism Research*, 16: 89–105.

Fiske, J. (1989), *Understanding Popular Culture,* London: Routledge.

Game, A. (1991), *Undoing Sociology: Towards a Deconstructive Sociology*, Milton Keynes: Open University Press.

Graburn, N. H. H. (1976), *Ethnic and Tourist Arts: Cultural Expressions from the Fourth World*, Berkeley: University of California Press.

Graburn, N. H. H. (1983), 'The Anthropology of Tourism', *Annals of Tourism Research*, 10, 1: special issue.

Green, N. (1990), *The Spectacle of Nature: Landscape and Bourgeois Culture in Nineteenth-Century France*, Manchester and New York: Manchester University Press.

Grosz, E. (1999), 'Thinking the New: Of Futures Yet Unthought', in E. Grosz (ed.), *Becomings: Explorations in Time, Memory and Futures*, Ithaca and New York: Cornell University Press.

Harre, R. (1993), *The Discursive Mind*, Oxford: Basil Blackwell.

Herbert, J. D. (1990), 'Painters and Tourists: Matisse and Derain on the Mediterranean Shore', in J. Freeman (ed.), *The Fauve Landscape*, Los Angeles: Los Angeles County Museum of Art

Herbert, J. D. (1998), 'Reconsiderations of Matisse and Derain on the Classical Landscape', in R. Thomson (ed.), *Framing France: The Representation of Landscape in France, 1870–1914*, Manchester and New York: Manchester University Press.

Herbert, R. L. (1994), *Monet on the Normandy Coast: Tourism and Painting, 1867–1886*, New Haven and London: Yale University Press.

Ingold, T. (2000), *The Perception of the Environment: Essays in Livelihood, Dwelling and Skill*, London: Routledge.

Jay, M. (1993), *Downcast Eyes: The Denigration of Vision in Twentieth-Century French Thought,* Berkeley: University of California Press.

Jenks, C. (ed.) (1995), *Visual Culture*, London and New York: Routledge.

Jules-Rosette, B. (1984), *The Messages of Tourist Art: An African Semiotic System in Comparative Perspective*, New York: Plenum Press.

Lash, S. and Urry, J. (1994), *Economies of Signs and Space*, London: Sage.

Lenman, R. (1990), 'Art and Tourism in Southern Germany, 1850–1930', in A. Marwick (ed.), *The Arts, Literature and Society*, London and New York: Routledge.

Lübbren, N. (1999), 'Touristenlandschaften: Die Moderne auf dem Lande', *Anzeiger des Germanischen Nationalmuseums*, Nuremberg, 63–9.

Lübbren, N. (2001), *Rural Artists' Colonies in Europe, 1870–1910*, Manchester: Manchester University Press.

MacCannell, D. (1999), *The Tourist: A New Theory of the Leisure Class*, new edn with foreword by L. Lippard, Berkeley: University of California Press.

Märker, P., Wagner, M., Brinkhus, G. and Garthe-Hochschild, H.-M. (1981), *Mit dem Auge des Touristen: Zur Geschichte des Reisebildes*, Tübingen: Kunsthalle, in association with Kunsthistorisches Institut der Universität Tübingen.

Matless, D. (1992), 'An Occasion for Geography', *Environment and Planning D: Society and Space* 10: 41–56.

Merleau-Ponty, M. (1962), *The Phenomenology of Perception,* London: Routledge.

Miller, D. (ed.) (1998), *Material Culture: Why Some Things Matter*, London: Routledge.

Mirzoeff, N. (1999), *An Introduction to Visual Culture*, London and New York: Routledge.

Mitchell, W. J. T. (1995), 'What is Visual Culture?', in I. Lavin (ed.), *Meaning in the Visual Arts: Views from the Outside. A Centennial Commemoration of Erwin Panofsky (1892–1968)*, Princeton, New Jersey: Institute for Advanced Study.

Orton, F. and Pollock, G. (1980), 'Les Données bretonnantes: la prairie de représentation', *Art History*, 3, 3: 314–44.

Osborne, P. D. (2000), *Travelling Light: Photography, Travel and Visual Culture*, Manchester and New York: Manchester University Press.

Phillips, R. (1995), 'Why Not Tourist Art? Significant Silences in Native American Museum Representations', in G. Prakash (ed.), *After Colonialism: Imperial Histories and Postcolonial Displacements*, Princeton: Princeton University Press.

Phillips, R. B. and Steiner, C. B. (eds) (1999), *Unpacking Culture: Art and Commodity in Colonial and Postcolonial Worlds*, Berkeley, Los Angeles and London: University of California Press.

Pocock, D. (1982), 'Valued Landscape in Memory: The View from Prebends' Bridge', *Transactions of the Institute of British Geographers*, 7: 354–64.

Pollock, G. (1992), *Avant-garde Gambits 1888–1893: Gender and the Colour of Art History*, London: Thames & Hudson.

Pollock, G. (1998), 'On Not Seeing Provence: Van Gogh and the Landscape of Consolation, 1888–9', in R. Thomson (ed.), *Framing France: The Representation of Landscape in France, 1870–1914*, Manchester and New York: Manchester University Press.

Radley, A. (1995), 'The Elusory Body and Social Constructionist Theory', *Body and Society*, 12: 3–23.

Rogoff, I. (2000), *Terra Infirma: Geography's Visual Culture*, London and New York: Routledge.

Rojek, C. (1995), *Decentring Leisure: Rethinking Leisure Theory*, London: Sage.

Rojek, C. and Urry, J. (1997), *Touring Cultures: Transformations of Travel and Theory*, London: Routledge.

Said, E. (1985), *Orientalism*, Harmondsworth: Penguin.

Said, E. (1994), *Culture and Imperialism*, London: Routledge.

Schor, N. (1992), '*Cartes Postales*: Representing Paris', *Critical Inquiry*, 18, Winter: 188–244.

Selwyn, T. (1996), *The Tourist Image: Myth and Myth-making in Tourism*, Chichester: Wiley.

Shields, R. (1991), *Places on the Margin: Alternative Geographies of Modernity*, London: Routledge.

Smith, D. R. (1975), 'The Palauan Storyboards: From Traditional Architecture to Airport Art', *Expedition*, Fall: 2–17.

Smith, V. L. (ed.) (1978), *Hosts and Guests: The Anthropology of Tourism*, Oxford: Basil Blackwell.

Sturken, M. and Cartwright, L. (2001), *Practices of Looking: An Introduction to Visual Culture*, Oxford: Oxford University Press.

Taylor, J. (1994), *A Dream of England: Landscape, Photography and the Tourist's Imagination*, Manchester and New York: Manchester University Press.

Thrift, N. (1996), *Spatial Formations*, London: Sage.

Urry, J. (1990), *The Tourist Gaze: Leisure and Travel in Contemporary Societies*, London, Newbury Park, New Delhi: Sage.

Urry, J. (2000), *Sociology Beyond Societies: Mobilities for the Twenty-First Century*, London: Routledge.

Walker, J. A. and Chaplin, S. (1997), *Visual Culture: An Introduction*, Manchester and New York: Manchester University Press.

Wall, M. (2000), 'The Popular and Geography: Music and Racialised Identities in Aotearoa/New Zealand', in I. Cook, D. Crouch, S. Naylor and J. Ryan (eds), *Cultural Turns/Geographical Turns*, London: Longman.

Willis, P. (1990), *Common Culture: Symbolic Work at Play in the Everyday Cultures of the Young*, Milton Keynes: Open University Press.

Part I
Sites and Images

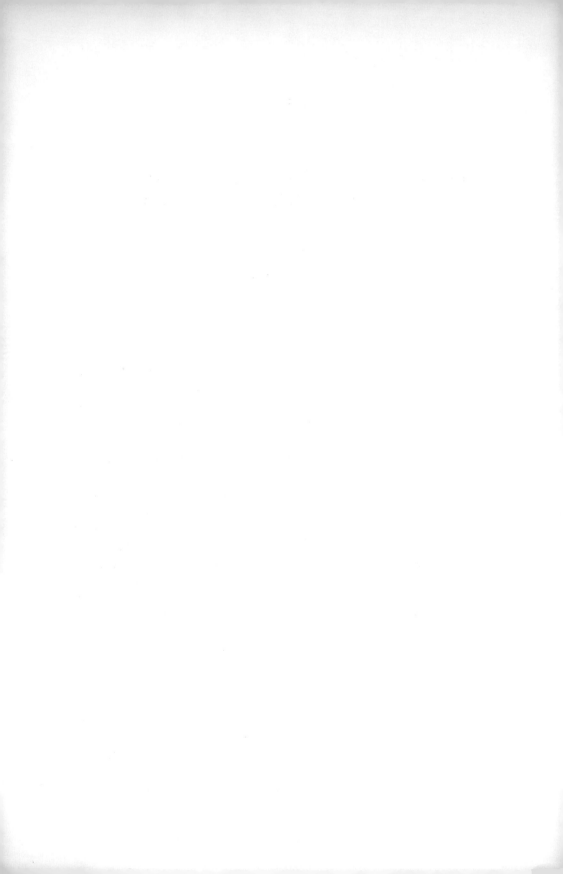



$$-1-$$

From 'Women's Lib.' to 'Palestinian Women': The Politics of Picture Postcards in Palestine/Israel
Annelies Moors

Introduction

Picture postcards are a strong example of the link between visual culture and tourism, the two central terms of this collection of essays. Already highly popular by the first decade of the twentieth century, they can be considered as one of the earliest forms of visual mass media. Circulating widely and avidly collected, they were a major means of communicating the visual imagery of the inhabitants of Palestine to a largely Euro-American public. Although other media of visual communication have rapidly gained prominence, large numbers of picture post-cards continue to be produced for the international tourist market.[1]

Dealing with a setting of national conflict, as this chapter does, raises the question how such an apparently trivial commodity as a picture postcard may be implicated in politics.[2] In what follows, I address this issue by analysing the ways in which picture postcards participate in the construction of particular collective identities. As images of women have been widely employed to demarcate community boundaries, I focus on the ways in which women are represented. Categorizing women along lines of ethnicity, religion, and nationality, and representing specific categories in particular styles, these postcards are engaged in the production of the nation.[3]

After a note on the politics of photography, I begin with a brief analysis of one particular Israeli postcard that has as a caption on the front *Women's Lib.* and represents, as the text on the reverse states, an 'Arab woman with firewood on her head' (Figure 1.1). I chose this postcard as it contains in a condensed manner a number of elements more generally present in Israeli representations of Palestinian-Arab women. These elements are highlighted when *Women's Lib.* is placed in a postcard rack, as it were, and compared with picture postcards depicting Jewish-Israeli women.[4] I then trace the genealogies of the contrasting modes in which Palestinian-Arab and Jewish-Israeli women are represented. As it turns out, there

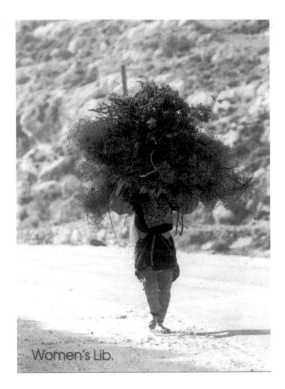

Figure 1.1 *Women's Lib*; caption at lower right:'People of Israel'; caption on reverse: 'Arab Woman with Fire Wood on her Head'; picture postcard, produced by Palphot Ltd 052-555238. Printed in Israel. (Photo: Lev Borodulin.)

are structural continuities between depictions of Palestinian Arabs on Israeli postcards and those of the inhabitants of 'the Holy Land' on early twentieth-century picture postcards. By contrast, representations of Jewish Israelis are quite different from these turn-of-the-century postcards; they trace their genealogy to Zionist postcard production in the 1920s and the 1930s. In the last section, I shift the perspective and locate *Women's Lib.* in a Palestinian context. First, I discuss the possibility of a Palestinian public reading *Women's Lib.* in an alternative way. Next, turning from reception to production, I analyse how one particular Palestinian postcard producer, Maha Saca, well aware of imagery such as *Women's Lib.*, employs a different style of constructing images of 'Palestinian women'.

A Note on the Politics of Photography

The picture postcards I discuss are all reproductions of photographs that claim a realist style of representation. This invites a brief note on the politics of photography.

It has been argued that photography is a particularly powerful technology that turns vision into supervision and surveillance. Photography's claims to transparency and immediacy, and its ensuing naturalizing effects are often singled out to link heightened visibility with institutionalized forms of repression (Tagg 1988). Whereas such a perspective works well for particular genres of photography, it is too rigid and one sided for the picture postcards I am dealing with here. This is not to deny that these cards participate in the production of relations of domination, yet they do so less directly and in more ambivalent ways, for there are also moments at which subversion and resistance are at stake. Modern vision has not only constituted persons as observed observers within the regime of surveillance, but also as subject spectators for the consumption of images; they are not only made visible, but also engage the field of the visual (Lalvani 1996: 171).

First, at the moment of production the positionality of the image producers and its implications for the political effects of heightened visibility need to be discussed. The very indexical claims of photography, its alleged objectivity and its professed status as document, in short, its 'truth effects', can be employed for very different aims. Heightened visibility, or rather, making visible does not only work for institutionalized power; subaltern groups also make use of photography's indexical qualities to engage in ideological struggles through the production of alternative visual imagery. Depending upon the positionality of the image producers, heightened visibility then is not necessarily only panoptical but can also be employed to undermine established ways of seeing. Both the early Zionist postcards and those produced by Maha Saca (albeit in very different ways) aim at presenting alternative styles of representation.

Second, at the moment of reception a particular image may have divergent meanings for different audiences. Photographs are constructed to enable particular readings and disable others, but such closures are never absolute. Captions may strongly direct audiences towards particular preferred readings but they are never able to capture everything present in a photograph. The very need, indeed, to provide captions points to the inherently polysemic nature of photographs.[5] Meaning then, is not only produced by photographers, but also by the audience, which may employ a variety of means to resist, subvert or modify preferred readings. Still, actually to engage in subversive readings and counter-hegemonic interpretations, a public needs, in one way or another (through experiential or other forms of knowledge) to have access to alternative modes of understanding. In discussing the possibility of oppositional readings of '*Women's Lib.*', this is brought to the fore.

Third, the ways in which photographs propose a variety of readings may differ considerably depending on the genre involved. There are not only major differences between, for instance, art photography, press photography and picture postcards, but the latter may also be subdivided, such as into those produced for a

local public and those aiming for the international tourist market.[6] The picture postcards I discuss here participate in the naturalist claims of photography and are mainly produced for an international public, both by commercial postcard producers and by organizations or individuals with more explicit political motivations. Commercial postcard producers aim at providing their clients with those images they think will be attractive to them. More politically motivated producers work visually to foreground the message they intend to convey. Yet lines of demarcation are often blurred. Commercial producers and their audiences are part of particular settings in which certain ways of seeing, linked to particular political visions, have become normalized, and politically inspired producers also have to take the expectations of their intended audiences into account if they want successfully to convey their message. Hence, the (implicit) rhetorical messages of these postcards are not necessarily unitary and one dimensional. In attempting to attract as large an audience as possible, postcard producers may incorporate elements they expect to be attractive to different publics. Such images or sets of images then can have different readings 'built into them', as it were.

Women's Lib.: an Israeli Postcard

In the mid-1980s, *Women's Lib.* (Figure 1.1) was widely available at Israeli postcard stands. With all text provided in English, this large-format card, produced by a major Israeli postcard producer, Palphot, was clearly intended for the international tourist market. *Women's Lib.* shows the image of a woman carrying a large load of firewood on her head. Dressed in colourful, possibly embroidered clothes, she is walking next to an asphalt road in a mountainous area. Her face remains invisible, hidden by the firewood. The caption on the reverse, 'Arab woman with firewood on her head' not only further highlights the centrality of the act of carrying wood, but also designates the woman as belonging to a particular category, that of 'Arab'.[7] On the front, in large black letters, the caption *Women's Lib.* stands out. In the lower right hand corner, we see in smaller white print and less visible, 'People of Israel', the name of the series of which this postcard is a part.

Women's Lib. is one of a large number of picture postcards that present people in Israel to an international tourist public. It may be interesting to analyse such cards individually but they gain particular saliency when seen as part of a large archive of Israeli picture postcards. Doing so enables an analysis of the ways in which people are categorized and invites an investigation of patterns of similarities and differences in their representations.[8] Taking a cursory look at the images of women on picture postcards and their captions, Jewish-Israeli women are obviously the norm. Whereas a considerable number of cards label women as

'Arab', and especially as 'Bedouin', very few categorize women as Jewish. These differences in labelling tally with consistent patterns of contrast in the ways in which these different categories of women are imaged.

Palestinian-Arab women are almost always depicted in long, colourful dresses (as in *Women's Lib.*), often wear lots of jewellery (especially in the case of those designated as Bedouin), are accompanied by objects such as waterjugs, and placed in a setting of deserts, camels, and tents. Combinations of these elements present them first and foremost as exotic; there is, in fact, a postcard series called 'Exotica'. This, however, is not the whole story. For although some of these women are depicted in a pose that is intended to be attractive to the viewer, in other cases this is not the main thrust of the image. A large number of cards of Palestinian-Arab women show them engaged in some form of labour, in particular that of carrying loads on their heads. In the case of *Women's Lib.*, for instance, the woman's face is invisible and the focus is not so much on her body in itself, but on the act of carrying firewood on the head. Whereas in some cases such work tends to be aestheticized (especially when women are depicted carrying an earthenware waterjug), often such representations of women at work create associations with poverty, drudgery, dirt and backwardness. Textual expressions referring to the static and timeless nature of Arab society work in similar ambivalent ways. Captions linking women's present-day activities to those of biblical times may evoke feelings of nostalgia but also lend themselves to being employed as proof of backwardness. This is the case, for example, with a postcard bearing the caption 'As in Biblical times' on the front, and on the reverse 'A Bedouin (Nomad) woman tends her flock of sheep near her home – as in days gone by.' In the case of *Women's Lib.*, there is yet another element at stake. The caption 'Women's Lib.', an American term used in particular in the 1970s to refer to women's liberation, functions here in a violently ironic mode to highlight Arab women's gender subordination.

Comparing such style of representing Palestinian-Arab women with the ways in which unmarked (Jewish-Israeli) women are depicted brings various contrasts to the fore. Jewish-Israeli women tend to be presented either in some leisurely activity, such as sunbathing, or in somewhat 'unusual' activities and occupations, for instance, as kibbutzniks, policewomen, soldiers or paratroopers. Often they are either scantily dressed or in some sort of uniform that downplays gender difference; images of Israeli women in 'traditional dress' are conspicuously absent. Whether they are depicted in a context of recreation and relaxation, or as taking part in military and other such activities, the contrast with Arab women stands out: they are able to refrain from the drudgery of work or to engage in professions that in many settings were and are still seen as a male prerogative. This does not mean that gender is irrelevant. Images of, for instance, the series 'The Israeli soldier' include postcards of male soldiers with headings such as 'Steel . . . man . . . steel'

and those of female soldiers with texts such as 'Basic training is over. No more wiping the smile off our faces.' Yet, in contrast to representations of Palestinian-Arab women, these postcards of Jewish-Israeli women, on the whole, highlight their modernity.

Still, the demands of the tourist discourse lead to a particular paradox. For there is an inherent tension between the presence of Palestinian Arabs on these postcards and the notion of Israel as the Jewish state, reflected in such Zionist slogans as 'a land without a people for a people without a land'. Apparently, the tourist discourse has its own rationale. Some visitors have religious motivations or feel a strong emotional tie to Zionism and the state of Israel; to them postcards with biblical connotations and series such as 'The Israeli Soldier' are particularly attractive. Many, however, also look for some exotic element. In that respect, the presence of Palestinian Arabs, and especially that of the Bedouin, is welcome, for no other category is quite as exotic.[9] It is true that various means are employed to marginalize their presence. They are defined as living in the past, if not in biblical times, and are often labelled as Bedouin, a notion that separates them from Palestinian Arabs while simultaneously undermining notions of rootedness in the land.[10] Still, it is hard to deny that the very presence of 'Arabs' on Israeli picture postcards can have a critical edge. Whereas the inclusion of 'Arabs' in a series 'People of Israel' may be seen as an annexationary move, it can also be employed to raise questions about the history of their presence and, hence, to invite a discussion about citizenship and political rights.

Genealogies of Nation and Gender

The genealogies of these styles of representation may be traced to the turn of the twentieth century for postcard imagery of Palestinian-Arab women, and to the 1920s and 1930s for those of Jewish-Israeli women. Schemes of contrast central to Israeli postcards also come to the fore when comparing these earlier sets of postcards, even if the ways in which particular aspects are highlighted differ.

Living in the Past

During the first decades of the twentieth century, picture postcards of Palestine enjoyed a tremendous popularity, in Palestine itself as well as in Europe and the US. The development of new printing techniques made it possible to produce large numbers of such cards relatively cheaply, and the growth of international tourism stimulated demand. Yet, the imagery on such picture postcards conveyed a message of stasis and timelessness. In fact, many postcards produced in the early twentieth century reproduced photographs taken 30 or 40 years earlier. This was, however,

not deemed problematic, for Palestine was seen as a 'living museum', its population representing the lifestyles of the past.

Biblical connotations were central to forging the link between the present-day population and a distant past. In the nineteenth and early twentieth centuries, many travellers to Palestine also had religious motivations, and travel guides, such as the Baedekers, recommended the Bible as the best source of information for those visiting the Holy Land.[11] It did not take long for photographers to turn such notions into commercial profit. Selecting scenes for their correspondence with biblical imagery, they provided these visitors with the imagery they came to look for. In order to ground biblical connections further, captions and texts referring to biblical persons and events were used, highlighting the static nature of Palestinian society. The text on the reverse of a postcard showing two women grinding corn, for instance, states: 'Palestine in some respects cannot be said to have progressed. Here we see the picture of two women grinding corn with the simple apparatus as mentioned by our Lord nineteen hundred years ago: "Two women shall be grinding at the mill; one shall be taken and the other left."' Working with the assumption that the appearance and lifestyles of the present-day inhabitants of Palestine had not changed since biblical times, photographers and postcard producers actually produced large series of postcards that were constructed in such a way as to leave out all traces of change.

A major effect of this denial of coevalness and 'spatialisation of time' (Fabian 1983) was to create difference and distance between the viewer and those depicted. This was less obviously the case in the nineteenth and early twentieth century than in the period thereafter. From the 1830s on, artists involved in biblical painting debated the link between the contemporary population of Palestine and the early Christians. Whereas biblical figures had previously been depicted as European or classical in appearance, a new style of biblical painting turned to the actual Palestinian-Arab population of the Holy Land (or, more generally, the Arab world) and their material culture as sources of inspiration. Some, however, saw the 'islamization' or 'arabization' of sacred figures as dangerous in its focus on appearance rather than substance, on costume rather than spirit (Warner 1984: 32–5). In a similar vein, biblical archaeologists of the 1920s saw the distant past as part of European history, but kept the present population 'at a distance', as it were, evaluating the Muslim presence as a degeneration of the past (Davidson 1996). Representing the population of Palestine as similar in appearance and life style to the first Christians works against such notions. In the later part of the twentieth century, however, debates about who may represent the early Christians no longer had such a potentially critical impact; by then the main effect of displacing Palestinian-Arabs to the biblical past was indeed to produce difference and distance.

Whereas all of Palestine was to resemble the Holy Land, some categories of the population were seen as more 'biblical' than others. In the course of the nineteenth

century, the practice of dividing the population of Palestine along lines of religion, race or habitat, linked to evolutionary notions of ranking became increasingly popular. Typologies based on such notions rapidly gained widespread currency and were to remain influential amongst the general public long after they had become discredited in academic circles. Photography was particularly implicated as it was seen as the ideal medium to map people in terms of external appearances. Hence, photographers represented different categories of the population as 'types', that is the construction of one or more persons as anonymous exemplars of a specific group, often specified in the caption as such. In Palestine, such types were mainly represented as mildly exotic 'Orientals' through the use of particular styles of dress (veils and robes) and attributes, such as waterjugs; captions designated them as 'Mohammedan women', 'Jewish woman of Jerusalem'. 'Jerusalem. Bedouin women', 'Bethlehem girls' and so on.[12]

Still, again the closure was not quite as complete as the above may suggest. For one thing, it is much harder photographically to represent 'types' than had been the case in drawing. For whereas in drawing one could combine elements from different images, in photography the problem is that even rigorously staged photographs always exude the power of contingency. Photographers themselves did not take the division of the population in types on the basis of appearance very seriously. Using the very same models to represent different categories of the population, they constructed types through attributes and attire, or simply through their captions, rather than through their physiognomy.[13] The ways in which producers struggled with the (lack of) typicality is well expressed in the text accompanying a photograph (also available as a picture postcard), titled 'The Spinning Woman', produced by the American Colony and reproduced in the *National Geographic Magazine*: 'This woman belongs to a class like that of the people of Jericho, neither Bedouin nor peasant, but a compound of both. Her costume, like her blood, is a mixture, her dress is Bedouin in character but her headdress is similar to that worn by the peasant women' (Whiting 1914: 299).[14]

Israeli postcards of Palestinian-Arabs are in many ways similar to these early ones. It is true that the theatrically posed studio pictures are no longer current, even if some of the modern postcards employ models obviously posing with similar props. The point, however, is that these Israeli postcards also systematically displace the Palestinian-Arab population to previous times, often, in very similar ways, highlighting biblical connections. Yet, there are also striking differences. Differentiations in terms of religion have become rare; Palestinian-Arabs are described as 'Arab' and more often as 'Bedouin'. Most importantly, the label 'Jewish' has not only largely disappeared but Jewish-Israeli women are no longer depicted in a mildly exotic style, similar to 'Muslim women'. This great rupture in the depiction of Jewish women relates to major political transformations: the development of the Zionist movement and the establishment of the state of Israel.

Looking towards the Future

Whereas images of Jews on early twentieth-century postcards were either similar to those of other sections of the Palestinian population or invoked Christian anti-Semitic notions, the development of the Zionist movement was to bring about a radical break with such imagery.[15] Constructed in contrast to the Jewish Diaspora culture, these new Jewish immigrants were represented as the epitome of modernity, with the notion of the 'pioneer' at its centre. Images of these pioneers centred on their involvement in physical labour, in particular in agriculture, in such a way as to underline their dedication to the project of development and modernity. Images abound of self-confident young people with a vision, whose commitment to change is highlighted through visual means, such as the angle from which the picture is taken and the sharp contrast between light and dark. In the case of Jewish immigrant women, modernity is also constructed with reference to notions of gender equality, visually expressed through their dressing styles, such as wearing shorts, their comportment, and the activities they engage in. Biblical connotations were not absent, but the new Jewish immigrants were seen as consciously and actively creating biblical links as part of a new culture, rather than simply living them.[16] Postcards of such pioneers became increasingly common when Zionist organizations started to produce and disseminate these from the 1920s on (Oren 1995). Such postcard series often had an explicit political aim; 'We build up Palestine', an early Palphot series from the 1930s, was, for instance, used as propaganda in *aliya* (immigration) campaigns. Captions such as 'Joy in Work', 'The Gardener', 'Jewish Shepherd in Galilee' and 'Jewish Builders' further underline the message.[17]

While the pioneer image of the 1920s and 1930s was part of an oppositional discourse rejecting European anti-Semitic imagery, images of Jewish-Israeli women on Israeli postcards of the 1980s largely converge with Western notions. A comparison of these postcards with the early Zionist pioneer imagery, reveals striking similarities. Cards such as those of kibbutzniks working in the fields, can actually be seen as another version of the early Zionist pioneer cards. The different political context, however, has had an impact. Whereas in the case of early Zionist imagery, the Jewishness of those depicted is underlined in the captions, after the establishment of the state of Israel, such need is no longer felt. Political transformations have also induced different styles of representation. If the early pioneer cards were often inspired by forms of Socialist-Zionism employing Soviet Realism as a visual mode of representation, this is no longer the case. After the 1967 war, and later, with the demise of labour Zionism, pictures of soldiers, often fusing the military and the religious, have become increasingly popular.[18]

Palestinian Perspectives

Commercial photographers and postcard publishers construct images matching the expectations of their clients, largely a Euro-American tourist-cum-pilgrim public, who tend to associate with Israeli self-representations. But what happens when people who have been adversely affected by Zionism and Israeli statehood discuss these images? As differently positioned groups have different sorts of knowledge available to them, Palestinian audiences may read this imagery in an alternative, perhaps even oppositional way.[19]

While pictures of Israeli soldiers evoke a strong oppositional response, Palestinian reactions to *Women's Lib.* are more ambivalent. In their comments on *Women's Lib.*, there was one point that Palestinians consistently brought to the fore: the colourful style of dress that they saw as a central element of Palestinian culture, and more specifically, as an emblem of the Palestinian rural heritage. Picture postcards of peasant women fit well with a Palestinian nationalist discourse that has constructed the peasantry as a national signifier (Swedenburg 1992; Tamari 1992). Whereas this has been the case in many anticolonial forms of discourse, rootedness in the land and steadfastness have become particularly emphasized in the Palestinian nationalist discourse because of the continual threat of dispossession and exile. If the peasantry was a highly suitable metaphor of the nation, this is the more so for peasant women. That is because women have become defined as the reproducers of the Palestinian community, not only in the sense of bringing forth the new generation, but also as the primary transmitters of customs and traditions to the new generation.[20]

Still, Palestinian readings of *Women's Lib.* do not simply celebrate this image as metaphor of the Palestinian nation. For the plastic slippers the woman is wearing and especially the enormous load of firewood she is carrying are considered as indications of poverty and harsh living conditions, if not underdevelopment and backwardness. It is true that Palestinian imagery also depicts women carrying things on their heads, but in that case it is often food that has positive and festive connotations. There are also other interpretations, such as carrying firewood as an indication of the great strength of rural women, but on the whole most women would not like to be depicted in this way. More pointedly, when Palestinians know that *Women's Lib.* is an Israeli postcard, the intentions of the producers of such a postcard are questioned. For Palestinians are well aware of Israeli attempts to define their own presence as a civilizing mission; Palestinian viewers have developed considerable skills in reading such cards through the eyes of Western audiences, as it were. Captions, such as 'Women's Lib.', further strengthen such suspicions.

Maha Saca's 'Palestinian Women'

Not only Palestinian audiences are producers of meaning, Palestinian organizations and individuals have also become engaged in the production of picture postcards with a political edge. Maha Saca from Beit Jala on the West Bank, for instance, who had started to collect traditional Palestinian dresses and artefacts in the 1980s, began to depict these on picture postcards and posters from the early 1990s on in order to reach a wider public, both Palestinian and foreign.[21] Her aim was to inform these publics about the Palestinian cultural heritage and, in the case of foreigners, to convince them of the historical presence and national rights of the Palestinian people. Discussing her project, Maha Saca strongly underlined that these dresses formed material proof of the existence of a Palestinian cultural heritage. More crucially, she pointed out that as different parts of historical Palestine previously had their own styles of modelling and embroidery, dresses in such different styles may be seen as evidence of a former Palestinian presence in particular locales. By collecting dresses from different areas and disseminating them on picture postcards, Maha Saca reclaims, as it were, these areas as territory belonging to the Palestinian nation.

Yet, for material culture to work as a convincing argument for territorial claims, the 'nationality' of these cultural products needs to be securely anchored. To underline that the dresses on her postcards are part of a Palestinian national heritage, Maha Saca ensures that these cards have the word 'Palestinian' included in their captions. For instance, a postcard with the caption 'Jaffa', bears the following text on the reverse: 'Palestinian women near Jaffa in the traditional costumes of Majdel, Safiriyya, Beit-Dajan, Yabnah and Yazour' (Figure 1.2). These are the names of villages that were all destroyed in 1948 or emptied of their inhabitants. At the same time, the unity-in-diversity theme is enhanced by the ways in which the dresses are connected to the women wearing them. Whereas in the case of the dresses, differences in style, colour and so on are highlighted, the women modelling them are presented as virtually interchangeable with each other. Such a way of presenting 'women in costume' is different from that on turn-of-the-century postcards, where the women themselves were labelled in terms of religious and ethnic differences.

Furthermore, whereas the dresses stand for a rural tradition, the women wearing these dresses are not older peasant women, but women who present themselves as modern, urban, and civilized, using fashionable make-up and wearing modern shoes. They do not use hair coverings to express modesty, but playfully to underline their attractiveness. Also, they remain far removed from certain types of women's work. The way in which they hold the, obviously never used, earthenware waterjugs, displaces the notion of carrying water with earthenware as prop or

Figure 1.2 *Palestinian Women near Jaffa in the traditional costumes of Majdel, Safiriyyah, Beit-Dajan, Yabnah and Yazour* (caption on reverse, also in Arabic); picture postcard, prepared and produced by Maha Saca, Bethlehem, P.O. Box 146; copyright reserved for Maha Saca; printed by H. Abudalo. (Reprinted with kind permission from Maha Saca.)

ornament. Maha Saca is outspoken about her choice of women who are to model these dresses and the style of presentation: 'I chose beautiful girls to present these beautiful dresses, to show our culture. We do not need to show backwardness, because the West has already done that.' In daily life, mainly elderly rural women still wear embroidered dresses, but Maha Saca did not consider it expedient to depict these women on her postcards because that would have made it too easy for a Western audience to link Palestinian heritage with poverty and backwardness. To counteract the effects of cards such as *Women's Lib.*, she employs a different style of representation, connecting the rural heritage embroidered dresses stand for with an urban modernity embodied by the models.

Concluding Remarks

Although picture postcards are generally considered a trivial, lowbrow item, they nonetheless are implicated in the politics of producing the nation. First, politically inspired postcard producers have been involved in particular ways of constructing

the nation. In the 1920s and 1930s, Zionist postcard producers visually constructed the pioneer image in contrast to existing imagery of Diaspora Jews. Placed next to the imagery of Palestinian-Arab women, who were depicted as timeless, traditional and subordinated to their menfolk, they stand out as epitomes of modernity. Maha Saca's Palestinian postcards are also explicitly political. In linking rural heritage and urban modernity, she subverts notions of Palestinian women as primitive and backward, while at the same time participating in the production of a particular urban middle-class notion of femininity as normative.

Commercial postcard production is also political, albeit in a different sense. Commercial postcard producers in Israel do not include Palestinian Arabs because they intend to express a particular political stance; they do so because they expect these postcards to sell well to particular sections of their clientele.[22] Here, it is the effect of their work that is at stake. Turn-of-the century postcards differentiated women along lines of religion, ethnicity and habitat in a style of representation that located them collectively as living in the past. Israeli postcards, in contrast, create a major contrast between modern, unmarked Jewish-Israeli women who are usually labelled according to locality, as common in the tourist discourse (the construction of particular places as touristic), versus 'Arab' or, more often, 'Bedouin' women, firmly located in the past.

Still, effects are not unitary, but also depend on the audience involved. Postcards of Israeli women in the military have little appeal to Palestinians; Israeli postcards of 'Arabs' or 'Bedouin' are more open to divergent interpretations. For those with the relevant experiential knowledge they may be seen as evidence of a (former) Palestinian presence, pointing to a history of dispossession and exile. Yet at the same time that Palestinians point to colourful dresses as material expression of Palestinian identity, they are also aware that these images are not free-floating, but are part of the Israeli picture postcard industry. With this in mind, postcard producers such as Maha Saca model these dresses on 'Palestinian women' who are selected to embody urban modernity.

Acknowledgement

This chapter is part of a research project on the body politics of photography, which has been funded by the ESR (Foundation for Economic, Socio-cultural and Environmental Sciences), which is subsidized by the Netherlands Organization of Scientific Research (NWO). Parts of this chapter have previously been published as Moors and Wachlin (1995) and Moors (2000). Special thanks are due to Steven Wachlin for photo-historical research.

Notes

1. For a history of the picture postcard, see Staff (1979).
2. For a study of picture postcards as a form of the culture of war, see Huss (2000).
3. Whereas the members of a nation often see themselves as bound by primordial ties, this chapter is premised on the notion that the nation is not a natural entity, but is actively produced (Anderson 1983).
4. These cards were all widely available at Israeli postcard stands in the mid- and late 1980s.
5. As argued by, for instance, Benjamin (1999) and Barthes (1977).
6. Comparing how Great Basin Indians were depicted on picture postcards produced for the local market versus those produced for the tourist market during the first two decades of the twentieth century, Albers and James (1990) argue that the latter were far more stereotypical than the former.
7. It remains up in the air, however, whether the photograph is taken in Israel or on the West Bank. Other cards in the series 'People of Israel' include those with 'Judea' in the caption, defining the occupied West Bank as part of Israel.
8. This approach is similar to that of Prochaska (1992). His article deals with Algerians at work and includes a comparison with cards depicting Europeans at work. It may also be compared to Cohen (1995) who presents a more quantitatively oriented analysis of representations of Arabs and Jews on postcards in Israel.
9. The other most likely category to express exoticism, the *mizrahim* (the Jews from the Arab world) are rarely represented in such ways, because their assimilation to Euro-American Jewishness is the norm (see Shohat 1988).
10. The Israeli state has employed the divide-and-rule principle with respect to the Palestinian Arab population. One category that has received special attention is the Bedouin, who, in contrast to other Palestinian-Arabs, may serve in the Israeli army. Still, the Bedouin have also had to face harsh state repression. Large parts of their grazing grounds and flocks have been confiscated, and they have been forcibly settled in badly serviced communities.
11. For instance, 'The Bible supplies us with the best and most accurate information regarding Palestine, extending back to a very remote period and should be carefully consulted at every place of importance as he proceeds on his journey' (Baedeker 1876: ix).
12. The caption 'Christian women' is not often found. However, there is a large number of cards of 'Women from Nazareth' and especially 'Bethlehem women' which carry heavy connotations of Christian history.
13. For the crucial importance of captions in constructing types, see Edwards (1990).

14. The American Colony was a religious group started by pilgrims from the US and Sweden. From the turn of the century until the end of the British Mandate, the American Colony Photo Department was one of the most successful and diversified commercial photographic studios in Palestine.

15. Anti-Semitic notions were particularly current in the case of men, often elderly men sitting on their luggage, represented as the 'Wandering Jew' (for such images in art, see Sylvain 1980).

16. For constructions of the pioneer in early Israeli films, see Shohat (1988).

17. From an interview with the owners of Palphot it is evident that these early pioneers were seen as marvellous models: 'All those famous postcards showing muscular men building Jewish cities in the desert and robust maidens merrily harvesting fruit in the kibbutz orchards certainly did their part in promoting to world Jewry, if in a rather romantic way, the idea of Jewish independence' (Bearfield 1985: 5).

18. In the same interview (see n.17), the owners of Palphot stated that their all-time best-selling postcard was probably 'the one showing the troops at the Western Wall during the Six Day War'. According to their estimation, they very rapidly sold about 10,000 copies (Bearfield 1985).

19. The following is based on extensive discussions with Palestinians, especially with Palestinian women intellectuals, about the ways in which Palestinian women are represented on different genres of photographs and picture postcards.

20. A great variety of nationalist movements, organizations and institutions use embroidered dress as symbol or emblem. See, for instance, postcards and posters produced by the General Union of Palestinian Women in the early 1970s, the logos of the various women committees in the occupied territories in the 1980s, and the imagery used by Bir Zeit University at its Internet site.

21. I interviewed Maha Saca in Bethlehem, June 1998. Her project is discussed more extensively in Moors (2000).

22. Interestingly, when establishing their postcard firm in 1935, the founders of Palphot saw the exotic Middle East and the religious places as obvious subjects to depict on their picture postcards. As the pioneers only constituted a very limited market, they had their eye on the tourist and pilgrim trade for their firm's viability.

References

Albers, P. and James, W. (1990), 'Private and Public Images: A Study of Photographic Contrasts in Postcard Pictures of Great Basin Indians, 1898–1919', *Visual Anthropology*, 3, 2–3: 343–66.

Anderson, B. (1983), *Imagined Communities. Reflections on the Origin and Spread of Nationalism*. London: Verso.

Baedeker, K. (ed.) (1876), *Palestine and Syria. Handbook for Travellers*, Leipzig: Karl Baedeker.

Barthes, R. (1977), *Image, Music, Text*, New York: Hill & Wang.

Bearfield, L. (1985), 'The Nation's Family Album', *The Jerusalem Post*, 2 January: 5.

Benjamin, W. (1999), 'Little History of Photography', in W. Benjamin, *Selected Writings*, vol. 2, Cambridge, MA and London: Belknap Press.

Cohen, E. (1995), 'The representation of Arabs and Jews on postcards in Israel', *History of Photography*, 19, 3: 210–21.

Davidson, L. (1996), 'Biblical Archaeology and the Press: Shaping American Perceptions of Palestine in the First Decade of the Mandate', *Biblical Archaeologist*, 59, 2: 104–14.

Edwards, E. (1990), 'Photographic 'Types': The Pursuit of Method', *Visual Anthropology*, 3, 2–3: 235–59.

Fabian, J. (1983), *Time and the Other: How Anthropology Makes its Object*, New York: Columbia University Press.

Huss, M.-M. (2000), *Histoire de la famille. Cartes postales et culture de guerre*, Paris : Noesis.

Lalvani, S. (1996), *Photography, Vision and the Production of Modern Bodies*, New York: State University of New York Press.

Moors, A. (2000), 'Embodying the Nation: Maha Saca's Post-Intifada Postcards', *Ethnic and Racial Studies*, 23, 5: 871–87.

Moors, A. and Wachlin, S. (1995), 'Dealing with the Past, Creating a Presence: Picture Postcards of Palestine', in A. Moors, T. van Teeffelen, I. A. Ghazaleh and S. Kanaana (eds), *Discourse and Palestine: Power, Text and Context*, Amsterdam: Het Spinhuis.

Oren, R. (1995), 'Zionist Photography, 1910–1941: Constructing a Landscape', *History of Photography*, 19, 3: 201–10.

Prochaska, D. (1990), 'The Archive of Algérie Imaginaire', *History and Anthropology*, 4: 373–420.

Shohat, E. (1988), 'Sephardim in Israel: Zionism from the Standpoint of its Jewish Victims', *Social Text*, 19/20: 1–37.

Shohat, E. (1989), *Israeli Cinema: East/West and the Politics of Representation*, Austin: University of Texas Press.

Silvain, G. (1980), *Images et traditions juives*, Paris: Editions Astrid.

Staff, F. (1979), *The Picture Postcard and its Origins*, London: Lutterworth Press.

Swedenburg, T. (1990), 'The Palestinian Peasant as National Signifier', *Anthropological Quarterly*, 63, 1: 18–30.

Tagg, J. (1988), *The Burden of Representation: Essays on Photographies and Histories*, Amherst: University of Massachusetts Press.

Tamari, S. (1992), 'Soul of the Nation: The Fallah in the Eyes of the Urban Intelligentsia', *Review of Middle East Studies*, 5: 74–84.

Warner, M. (1984), 'The Question of Faith: Orientalism, Christianity and Islam', in M. Stevens (ed.), *The Orientalists: Delacroix to Matisse*, London: Royal Academy of Arts.

Whiting, J. (1914), 'Village Life in the Holy Land', *National Geographic Magazine*, 25, 3: 249–314.

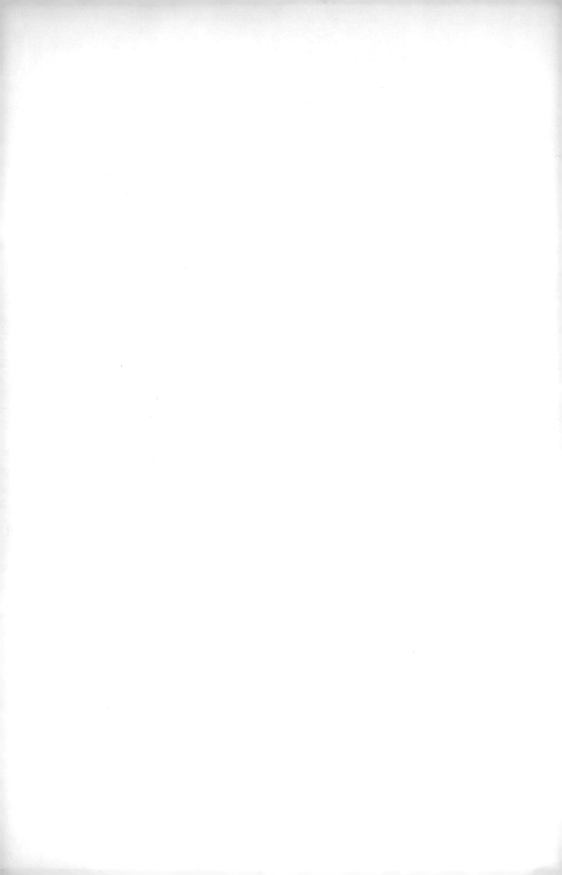

–2–

Algeria In and Out of the Frame: Visuality and Cultural Tourism in the Nineteenth Century
Deborah Cherry

Timothy Mitchell (1988: 57) has indicated that from the moment of the French invasion, when French travel agents sold places on board a boat moored in the harbour at Algiers close enough to witness the city's bombardment, Algeria became a tourist destination for European travellers. In 1830, the French invaded a land then under the rule of the Ottoman Empire. Following two decades of brutal and genocidal warfare in which French armies secured control over the hinterland around Algiers and localized resistance, at the mid-century Algeria was promoted and enjoyed as a holiday resort for those in search of winter sun, picturesque exoticism, or a cure for tuberculosis. A regular and relatively fast passage crossed the Mediterranean; and in Algeria, the building of an infrastructure of roads and railways facilitated movement inland as well as to the east and west of the principal city (Laroui 1970, 1977; Benoune 1988; Prochaska 1990). Algeria quickly became the *mise-en-scène* for a flood of paintings, engravings and photographs, illustrated histories, guidebooks and artists' handbooks, as well as maps, archaeological reports, geographical charts, and a kind of tourism in which visual pleasures and ocular excitements were at a premium. Significant, too, were the exchanges between visual languages, the relays between elite and popular forms, the intermediality of this visualization of Algeria. Also conspicuous was the incursion of the visual, the introduction of Western visual systems that not only framed but made intelligible a strange and unfamiliar land. As Michel Foucault (1982) suggested, crossing the threshold of visibility is to enter the domain of power/knowledge. This is the work of visuality in the disciplinary society of the West. But more was at stake: the techniques of the observer, the technologies of vision and what I will call here the strategies of 'pictorializing' and 'framing'. It was not just that Algeria entered into visuality, more that it was pictured within the aesthetic frameworks of Western Europe. Coinciding with profound changes to religious and cultural life, social organization, the landscape and patterns of settlement, this disposition of landscapes and peoples into artistic compositions helped to disavow the chaotic interventions and traumatic transformations of colonization. Pictorializing was central to and formative of what

Gayatri Chakravorty Spivak (1985: 253) has called 'the planned epistemic violence of the imperialist project'.

Discussions of nineteenth-century travel and its cultural products from guidebooks and images to travel narratives and maps have emphasized the intersections between imperialism and visuality. Mary Louise Pratt's ground-breaking *Imperial Eyes*, which analysed the prevalence of a trope that she called 'the monarch-of-all-I-survey', drew attention to the need for the imperial metropolis 'to present and re-present its peripheries and its others continually to itself'(1992: 1–10, 204–5). John Urry (1990: 4, 1995: 1–2) has traced the development of 'eyewitness observation' with its increasing visualisation of experience and the rise of 'the tourist gaze'. To understand something of these complex processes in the Algerian situation, it will also be helpful to resituate a concept that has come to have a wide currency in postcolonial studies, that of travelling theory. In *The World, the Text and the Critic*, Edward Said explained that just as people travel, so too does theory. Far from being universal, theory is, he explained, culturally and historically specific. He warned of the dangers when Western theories are imposed on cultures and histories to which they are alien (1983: 226–7). Although Said was thinking about the currency of contemporary ideas, his concept can also be usefully deployed to consider the historical movement of Western visual systems. Said suggests that as a move to a new environment is 'never unimpeded', this 'complicates any account of the transplantation, transference, circulation and commerce of theories and ideas'. So, too, with Western visuality. In their transit to and encounter with the Maghreb, these highly specific visual systems were destabilized, mutating and changing. But more than this, they met resistance and refusal.

Mise-en-scène

In the 1830s and 1840s, French artists accompanied military and diplomatic interventions in Algeria and often travelled under armed guard; in the relative tranquillity of the 1850s and onwards, they settled, buying houses and acquiring land.[1] The visual forms and languages of Europe were introduced with French colonization. For the French, the 'allure of empire' (Porterfield 1999) engendered innumerable landscapes, lion hunts, desert caravans, wild horsemen, and military subjects alongside countless scenes of the harem, the *hammam,* and the slave market. In an authoritative overview of French Orientalism, Roger Benjamin has emphasized the example of Delacroix, the 'Gérôme paradigm', the impact of Fromentin's accounts of his travels as well as his paintings with their subject matter of dashing horsemen, wild landscapes and urban scenes, and the critical writings of Théophile Gautier, whose *Voyage pittoresque en Algérie* was published in 1845 (Benjamin 1997: 7–31). Hundreds of paintings, engravings and photographs of Algerian scenes were put into circulation. Working in the new medium of

photography and with the support of the Ministre de la Guerre, the Paris-based photographer J. B. Moulin set out to photograph Algeria. His *Souvenirs de l'Algérie* or *L'Algérie photographiée*, comprised an inventory of his subjects and a text full of historical and descriptive notes, tips for tourists, and remarks on the climate. Moulin collected an already familiar set of images: urban centres (mostly Algiers), romantic ruins, picturesque sites, oases, Arab villages, French settlements including a model farm, and portraits of civil and military officials. Photographs of indigenous chiefs, dancing women, and an assortment of what were catalogued as 'mœurs et costumes/manners and costumes' were included although Moulin was well aware, as he admitted, of 'la répugnance des Arabs à laisser reproduire leur image' / the Arabs' repugnance for having their images reproduced (Moulin 1859). Moulin's repertory also included female nudes, odalisques, slaves and a matching series of *France Photographed* (Bibliothèque Nationale de France, Paris). This repetition of sites, figures and itineraries across a wide range of visual media, along with the proliferating literatures of illustrated colonial histories and tourist guides, was characteristic of travel culture that was, as Said (1978, 1991: 23) commented of Orientalism, 'after all a system for citing works and authors' .

French guides to and engravings of Algeria were certainly available in Britain, the visual materials being distributed primarily by Ernest Gambart, whose London business as a publisher, importer of European prints, and dealer in French art was established by 1843 (Maas 1975: 34). So celebrated were the battle paintings of the French artist, Horace Vernet, that one writer claimed that Algeria had been 'long known to the English only as the scene of those picturesque and bloody wars illustrated by [his] daring pencil' (Parkes 1859: 64). Travelling through France (to catch the boat at Marseilles), British tourists bound for Algiers would have an opportunity to visit the exhibition rooms and bookshops of Paris. By the 1850s, a number of illustrated guidebooks to Algeria were being published in English (Morrell 1854) and British artists and writers were visiting and settling in Algiers, joining a British community well established by the end of the century. For some, like Fred Walker, a brief sojourn had little impact on an established career. At mid-century, a circle of British women actively promoted Algeria as a tourist destination and artistic resource. Holidaying in Algiers with her family in the winter of 1856–7, Barbara Leigh Smith met and soon married a French *colon*, Eugène Bodichon, whose writings contributed to the development of French imperial policy. Among those who stayed with her were the artists Eliza Fox, Gertrude Jekyll and Sophia Lady Dunbar, the feminist activist Bessie Rayner Parkes, and the travel writer Matilda Betham-Edwards (Hirsch 1999; Cherry 2000).[2] The latter soon turned her hand to writing books on her excursions to and in Algeria , illustrating them with reproductions of art works by her friends (Figure 2.1). This group of women produced paintings and watercolours, some of which were shown at Gambart's French Gallery in London, illustrated travel books, and articles

accompanied by sketches and drawings published in a range of papers from the feminist magazine, *The English Woman's Journal*, to general interest journals such as *The Illustrated Times* and *Once a Week*. Turning travel into text with remarkable alacrity, Bessie Rayner Parkes' essay for *The Illustrated Times* was written soon after her arrival in January 1857; 'An Englishwoman's Notions of Algiers: How Hard it was to Get There' was interlaced with drawings, probably by Barbara Leigh Smith. These works visualized a recently colonized land, less for its colonizers than for an educated middle-class market in London, informed on events taking place. The British press provided detailed coverage and comment on Algeria as well as regular features on the pleasures of travel and tourism. Essays, such as that by Parkes, which inscribed a particularly 'English' perspective as well as debates on French colonization and denunciations of French brutality, stirred up an intense nationalism as well as a sense of imperial superiority. Although the British declined the Amir 'Abd al-Qadir's appeals for assistance, his long resistance, imprisonment and exile prompted a romantic sympathy for him.

The presence and practices of French artists, as well as the circuits of Parisian dealers and exhibitions, critics and audiences, might lead to a conclusion that the pictorializing of Algeria was an integral part of the processes of colonization by a specific European power. Considering British artists complicates the view. For it both confirms the power and place of visual culture in the workings of imperialism while opening up questions that shift the dynamics of power from the more familiar binary of colony and metropole. There were commonalities, overlaps and departures between French and British visualizatons of Algeria. Travel literature in English and French described the landscape in terms of pictorial composition, and narrators often positioned themselves and their readers as viewers of pictorial scenes that unfolded before them. Reading about Algeria, in common with viewing scenes of it in the exhibition rooms, could heighten the anticipation of travel, or substitute for it altogether. Travel writers in both languages utilized a markedly pictorial language. While the French delighted in the *esquisse* and *croquis*, the British conveyed thumb-nail studies. Both deployed first person narratives, letter and diary formats to give a sense of intimacy and proximity to the teller of the tale as well as a shared viewpoint from which the scene could be savoured.

At the opening of Pauline de Noirfontaine's *Algérie: un regard écrit* of 1856, to take but one example, the author states her aim, 'en tracent sur mon calepin quelques esquisses jetées au hasard, sans cadre ni lien, comme on jette sur une palette des couleurs épaizes et non broyées, des croquis inachevés et nebuleux' (in tracing in my notebook some random, unconnected and unframed sketches, just as one throws on one's palette thick and unmixed colours, unfinished and nebulous sketches).

Algeria offers an inexhaustible storehouse of images; its ocular delights and pictorial offerings may be relished by the sea or in the mountains where the

traveller will arrive 'à l'extremité du plateau d'où on découvrait un de ces tableaux de poésie locale, qui invitent un artiste à prendre ses pinceaux' (at the extremity of the plateau from where one would discover one of these pictures of local poetry that invite an artist to take up the brush). Commenting on perhaps the most renowned vista for the tourist in Algeria, the bay of Algiers with its old town on the top of the hill and new buildings by the port, the scene is offered as an extensive panorama, framed by the ever-changing surface of the sea and luxuriant vegetation in a description which lyricizes Algeria's profusion of flowers and shrubs (Noirfontaine 1856: préface, 6, 202). Charles Desprez's *L'hiver à Alger: lettres d'un compère à sa commère* of 1861, called by the author 'une esquisse nouvelle' (a new sketch), includes descriptions of views out of windows and first-hand accounts of days spent writing, drawing, reading, and walking in the countryside. Barbara Bodichon's *Algeria Considered as a Winter Residence for the English*, published in 1858, combined translations from French of her husband's numerous publications on Algeria with a wealth of travel tips, hints for artists, and travellers' tales provided by her sisters. Like its French and English competitors, this guidebook offered a distinctively pictorial way of seeing. Algeria is presented as a plenitude of visual delights: '[t]he scenery of Algeria is very beautiful, and offers great attractions to the tourist and the artist'; '[t]here is plenty to see and sketch in the environs [of Algiers]'. *Petit récits* in the first person ecstatically describe glimpses out of the windows that 'will furnish me with many a subject', and the 'ever varying compositions of olive, cypress, Moorish houses, aloes, cacti and before us groups of Arabs, *ad libitum* . . . backed by the blue sea' (Bodichon 1858: 75–90). Barbara Bodichon's (1860) essay, 'Algiers: first impressions', is a series of compositional vignettes: the town seen from the sea, prospects out of windows and from the terrace, extensive panoramas of the bay and surrounding countryside.

Writers on both sides of the Channel conjured views in terms of foreground, background, distant horizons and framing devices such as trees; they recommended sketching the scenery, drawing, and photography as among the many pleasures of the location. To British and French visitors alike, the colony was presented as frame after frame of artistically arranged compositions: quick sketches of the scenery, glimpses out of windows, formal panoramas from high vantage points and extensive vistas of supposedly empty space. As vision became elided with knowing, difference was simultaneously racialized and visualized. French and British artists participated in ethnographic studies that were largely preoccupied with mapping the ethnic diversity of Algiers and in differentiating Arabs from Kabyls. French colonial theory and policy subscribed to a racialized distinction between the two, characterizing the Kabyls as settlers who were amenable to the French civilizing mission and demonizing the Arabs as intractable (Lorcin 1995). Landscapists offered up Algeria as a seemingly boundless yet highly repetitive visual spectacle of vast swathes of apparently barren and uninhabited land, desert

vistas or dilapidated ruins. Different registers of the visual were engaged to target heterogeneous audiences: scenes of the mining settlements were circulated in print culture, but not in the elite forms of exhibited paintings. The *colonies agricoles* (much discussed in French histories) featured on maps but only very rarely in visual imagery. There were numerous exchanges between the visual domains of photography, tourist picture postcards, and paintings. Whereas art-historical accounts tend to foreground painting, assigning tourist materials to a discrete area called 'context', the emphasis here on the reciprocities between media and the historical specificity of pictorial visuality for artists and audiences assists an understanding of the continuum as well as the distinct registers of visual culture.

If there were similarities between French and British visual culture, there were also distinct departures. Tourist literature in French was well under way in the 1840s. Specific to French culture were histories of the colonization of Algeria and pictures of military conquest. Horace Vernet produced a number of battle paintings, including *Le siège de Constantine, Combat de l'Habrah* and the famous *Prize de la Smalah d'Abd-el-Kader* which was over 21 metres long and depicted the surrender of the resistance leader and wager of a holy *jihad* against the French, the Amir, 'Abd el Qadir. Shown at the Paris Salon, the painting was transferred to the Galleries of Military History at Versailles. Linda Nochlin has drawn attention to the violence and sensuality favoured by French Orientalists (Nochlin 1991). Whereas British artists like J. F. Lewis fashioned a highly charged sexual exoticism when living and working in Cairo, French male artists from Delacroix to Matisse painted harem and bath scenes in or inspired by visits to Morocco and Algeria. The imagery of Maghrebi women unveiled as well as disrobed extended across French visual culture from photographs and later postcards to fine art images of slave markets, odalisques and female nudes. As Sara Suleri and Rey Chow have suggested, colonizing desires to translate opacity into visibility, to search behind the veil for the secrets of the Orient , were played out on the bodies, faces and pictorializing images of 'Oriental' women (Suleri 1992; Chow 1993).

Disposition

Disavowing the violent dislocation of colonization, pictorializing disposed of and fostered a disposition of land and peoples into artistically arranged compositions. Homi Bhabha's attention to the multiple significations of 'disposal' and 'the strategies that articulate the range of meanings from "dispose to disposition"' is particularly helpful here. According to *The Oxford English Dictionary*, disposal conveys several meanings in which power and regulation coincide, including the 'action of arranging, ordering or regulating by right of power or possession', 'action of disposing of, settling or definitely dealing with' and '[p]ower or right to

dispose of', where 'dispose' may signify both making arrangements for and getting rid of. 'Disposition' may signify setting in order and arranging, to have at one's disposal, inclination, physical aptitude or constitution. Taking up these multiple significations in a discussion of colonial authority, Bhabha (1994: 109–10) argues:

> Transparency is the action of the distribution and arrangement of differential spaces, positions, knowledges in relation to each other, relative to a discriminatory, not inherent, sense of order. This effects a regulation of spaces and places that is authoritatively assigned; it puts the addressee into the proper frame or condition for some action or result. Such a mode of governance addresses itself to a form of conduct that equivocates between the sense of disposal, as the bestowal of a frame of reference and disposition as mental inclination, a frame of mind.

This metamorphosis of land into landscape and of people into figure paintings, into the categories of Western art, was achieved by the use of artistic procedures already well established outside Algeria. These artistic and literary framings may be identified among the 'rules of recognition' distinguished by Bhabha as the characteristic procedures, forms and modes of address of colonial discourse, all of which call for common consent. In painting, these 'rules' regulated the disposition of the scene, provided points of view and offered authoritative frames of reference that allowed the strange to be presented within the boundaries of the familiar. Indeed, it is this containment that allowed the images to be recognized as art within the exhibition gallery, dealer's shop or drawing room in the metropolitan centres of Paris or London as well as in the colony itself. This 'regulation of spaces and places' that was, as Bhabha indicates, 'authoritatively assigned', profoundly changed the visual form of Algeria and the disposition of its countryside, settlements and populations.

British artists and writers give little indication of the profound changes taking place in Algerian agriculture, the countryside and the built environment, or the transformation of social organization, cultural and religious life. Paintings in particular represented a land before or after colonization, rather than a society caught up in and traumatized by its chaotic intervention. They depict a society set in archaic ways and in which time moves slowly, a culture in the thrall of Islam, a place that is alien and strange, and yet perceptible, remote yet brought into focus in the frame of visual art and tourist imagery. What is brought into view is boundariless scenery stretching far into the distance, that seemingly 'uninscribed' land that in colonial discourse is available for exploitation. Equally, what is pictorialized may be construed as the aftermath of intervention, when peasants tend their flocks on the scrub lands and hillsides to which European agri-business exiled them. It is the vacancy of these views that lends them to Spivak's analysis of 'worlding a world on supposedly uninscribed territory' (Spivak 1990: 1). Painters and writers extol exotic scenery, decaying ruins, brilliant colour, local typologies. Whereas

travel writers gave a sense of comprehensive coverage through their vignettes of the population and their sketches of Algeria's history and geography, artists often presented collections of views in a solo show. Reviewing an exhibition of Algerian subjects by Barbara Bodichon at the French Gallery in London in 1864, one commentator considered:

> The drawings, like other series which have preceded them [,] represent scenes in Algeria, and comprize views of the towns and district about Algiers; of that angry sea, as it were, of hills and mountains, the homes of the hardy Kabyles; and of various points along the coast, with its azure Mediterranean and glowing golden shore; together with representations of forts, chateaux, villages and tombs; of the luxuriant growths of flowers, palms, aloes, prickly pears and giant plants of all kinds; and of the climactic phenomena and strange aspects of the sky from wind, rain, etc. (*The Illustrated London News*, 16 July 1864: 55)

Although prolific, and by this date renowned for such works, Bodichon's repertory was by no means as extensive or comprehensive as was here suggested. While some titles hinted at a particularity of place – the views of Algiers, the Hydra Valley, the Plain of the Metijda, Point Pescade or the old walls of Mansoura – others such as *Arab Tomb near Algiers* (exhibited London, 1859), *Cactus Grove* (Hastings Museum and Art Gallery, exhibited London 1859), *Interior Court of An Old Moorish House* (exhibited London, 1861), and *The Province of Oran, Algiers* (exhibited London, 1866) were decidedly imprecise and could work synecdochially. Views of Tlemcen, the magnificent Gorge of the Chiffa in the Atlas Mountains, or the Roman aqueduct near Cherchel testified to a European predilection for locations already well known from guidebooks, tourist itineraries, antecedent imagery, colonial histories or archaeological reports. For a Western woman artist, travel experiences and the choice of artistic subjects were as much charged by colonial formations of sexual and racial difference as by visual precedents and citational procedures. For her figure paintings, Eliza Fox drew on elite contacts in feminine social circles, the wife of the French governor general, in the words of one contemporary, rendering her 'much assistance in obtaining insight into the native Arab life' (Clayton, 1876, 2: 86). Well aware that many Algerians disliked sitting to artists and disapproved of figurative painting on the grounds of religious belief, Western artists in Algiers perennially complained of the difficulties in securing models.

In (the) Visible

What entered visuality, where and when, was as important as what did not. It is well known that writings and pictures of the Maghreb were selective and

stereotypical, exclusive rather than inclusive, fashioned by the particularities of Western vision. But there is more at stake than the tattered fabric of Orientalism with its myopia and aporia. In Britain, as in France, much of the Maghreb simply eluded visual culture and visuality. These invisibilities and opacities put visual representation into question, throwing doubt on its claims to re-present and to be representative, casting uncertainty on its classifications and its typologies of the typical. They do more. They mark a resistance and refusal in the Maghreb to come to terms with, to accommodate, the project of Western visuality.

Artists returned time and again to the bay of Algiers. An image by Bodichon, reproduced as the frontispiece to Betham-Edwards' *A Winter with the Swallows*, was produced within and consciously echoed a well established visual language already circulating in print culture (Figure 2.1). Repetition enabled recognition. By taking a distant view, Bodichon, like so many others, strove to reconcile the visual disjunctions between the new buildings, boulevards and harbour of French Algiers and the old city higher up the hill. From the 1830s, the French attempted to reorganize the city of al-Jaza'ir by imposing a distinctive architectural style and a geometrical grid of streets and squares. By demolishing existing structures and living patterns, the French hoped to 'establish a visual order that symbolized

Figure 2.1 Barbara Leigh Smith Bodichon, *Algiers*, title page image of Matilda Betham-Edwards, *A Winter with the Swallows*, London, 1867, The British Library, London.

colonial power relations'. The city and its architectures became, as Zeynep Çelik (1996: 202–5) has indicated, 'contested terrains in the confrontation between colonizer and colonized'. In depicting Algiers, Bodichon also portrayed 'Telegraph Hill' and the water tower. These were novel views that may have registered some of the changes brought by the French. An unusual subject in visual culture, the telegraph was often discussed in tourist literature and visitors' correspondence, becoming a sign of the convenience and modernity of Algiers. Colonization was not only transforming the landscape but relations of space and time. In a compelling essay on time, space and the geometries of power, Doreen Massey has challenged David Harvey's views that the sense of increasing speed in the pace of life and the disappearance of spatial barriers so that 'the world seems to collapse inwards' was brought about by the expansion of capitalism and development of technology. For Massey (1993: 59–69), attentive to questions of gender and imperialism, 'time-space compression' was a distinctive and particularly local experience for the Western traveller and colonist.

While Bodichon occasionally depicted the fertile agricultural areas of Algeria, her watercolours more usually testify to a common fascination with the desert and the mountains, or the rocky slopes and scrub lands to which native farmers had been displaced; difficult to cultivate, they provided some grazing for goats and sheep. Finished watercolours were enhanced by an elongated format, and sketches were made across the double opening of a book to reveal extended panoramas of seemingly uninhabited, unsettled, uncultivated, empty land. If an expansive, uninterrupted view was a well known aesthetic pleasure, it also facilitated fantasies of possession and exploitation. In print and in paint, in line with a fundamental principle of European military, commercial and imperial desire, Algeria was perceived as an uninscribed, uninhabited earth awaiting intervention and cultivation. Surviving sketchbooks indicate that pictorial emptiness was carefully managed. In rapid studies made while travelling in the winter of 1866–7, Bodichon noted with a few quick lines of a pencil the tents and fixtures of a settlement. Written notes signal a human presence: 'early morning', 'all asleep in the tents', while the colour jottings point to future use in the studio. Yet surviving watercolours, donated by her travelling companion Matilda Betham-Edwards to the Hastings Museum and Art Gallery, suggesting that they date from this excursion, portray vacant spaces cleared of habitation or cultivation, vast vistas across which the gaze can sweep uninterrupted, its path managed by the disposition of the elements, the arrangement of the planes of the composition.

For British and French visitors, Algeria's history was in ruins, its monuments disintegrating: visiting Tipasa, one of the most famous sites, in 1860, Richard Cobden noted that the wreckage of the past scattered across the site (Hobson 1968: 286). Linda Nochlin (1991: 38) has draw attention to the imagery of dereliction and decay : '[n]eglected, ill-repaired architecture functions . . . as a standard topos

for commenting on the corruption of contemporary Islamic society'. Barbara Bodichon's *Roman Aqueduct near Cherchel, Ancient Julia Caesarea* portrays the great bridge of a massive aqueduct built in the second century as part of an extensive building programme which took place from 25 BCE in the reign of Juba II, but now in ruins. The baths were fed by an aqueduct of mid-second century construction that conduited water from a source in the Atlas mountains. A daring piece of engineering, the aqueduct included a three-tier bridge of 10 arches and a great bridge, pictured by Bodichon, 228 metres long and 26 metres high with 25 arches on the first level and 29 on the second. Reviewers who encountered the picture at the French Gallery in London in 1861 considered that this portrayal of a crumbling ruin against the declining rays of a sunset evoked melancholy and desolation, one critic commenting: 'The profiles of the ruinous and deeply toned arches are strongly relieved against a sunset sky of greenish blue, falling into orange, and intersected by long bars of purple cloud. The solitary stork and the tall rushes gently blowing in the evening breeze, heighten the desolation of the scene' (*Spectator*, 20 April 1861: 417). Far from the sublimity evoked by David Roberts' watercolours of massive structures crumbling into ruins or the attention to detail characteristic of topography, this is a scene imbued with romantic sentiments about the past.

Ruins, like disrepair, could suggest the dereliction of North African regimes and the corresponding need for firm Western intervention to ensure, among other things, the preservation of an architectural heritage. Such a representation reduces Algeria to the vestiges of a glorious past, the relics of which only remain, so facilitating comparisons between ancient grandeur and recent decline. The decaying aqueduct evokes imagery of the surviving monuments of Rome as well as the majestic painting by Hubert Robert of the Pont du Gard (1787, Louvre, Paris), which Bodichon may well have seen. Such visual precedents, like the fragment of architecture itself, summon not the Ottoman Empire whose 300 years of dominion over Algeria ended in 1830; rather they (re)inscribe Algeria into a European history and artistic legacy. To portray Algeria's Roman ruins was to locate the colony's far distant past, a move that not only disavowed the immediate present but demarked this land from the modernity of the West. Osman Benchérif has suggested that support for French invasion and colonization could be justified as the repossession by Christian Europe of the ancient Roman empire in North Africa. He notes a long tradition of writing about the sacred mission of Christian Europe to restore the light of civilization to the provinces of ancient Rome in which Islam represents the forces of desecration, destruction and fanaticism (Benchérif 1997). In the broad spectrum of responses, the imagery of Roman ruins could well have evoked reflections on current events and the ancient past, as well as meditations on the longstanding conflicts between Christianity and Islam.

Rules of Recognition

European artists working in Algeria in the mid-nineteenth century drew on the available artistic resources of existing traditions, known as much through studying and copying as visiting exhibitions. They drew on extant visual conventions, making an eclectic and diverse use of the art of the past as well as contemporary prints, paintings and photographs. Algeria was framed and reinscribed within the already known. The laws of perspective and the precedents of pictorial composition invoked the validating authority of the traditions and histories of Western art. As I have already suggested, these artistic precedents may be included among the 'rules of recognition', defined by Homi Bhabha as 'those social texts of epistemic, ethnocentric, nationalist intelligibility which cohere in an address to authority'. Bhabha (1994: 110) argues that 'the acknowledgement of authority depends on the immediate – unmediated – visibility of its rules of recognition'.

Tried and tested compositional formulae recur time and again. An artist with very little formal art education, Barbara Bodichon makes use of an unsophisticated technique that exposes the making of landscape with particular clarity. Some images use a pictorial format very loosely derived from the art of Claude Lorrain and his British followers in which the landscape is formally organized into contrasting bands of light and shade and in which trees or architecture frame or punctuate the scene to lead the gaze across and into the pictorial field. In this artist's *Roman Aqueduct, Algeria* (Girton College Cambridge), a tall tree to the left introduces the aqueduct, a note of interest in the middle ground. Disposed horizontally, this arrangement could be pressed into service for the rendition of desert scenes and interior plains. These frames of reference also offered points of view: a high exteriorized vantage point for an extended panorama could permit, even encourage, imperialist fantasies of unbounded possession. A lower viewpoint for towering mountains could inspire sensations of sublimity and awe. Other compositional frames extended accessibility: a path through a cactus grove, mimicking a winding trail through a woodland copse, invites the spectator to enter the scene. Sweeping vistas of seashore and hinterland conjured memories of the glittering coastlines of the Mediterranean.

These diverse artistic references provided a framework of recognition, in which the strange, unfamiliar, exotic and unusual was presented within the compass of the already known. They also offered visual precedents and an art-historical authority that visually encompassed Algeria within the artistic traditions of Europe so as to differentiate it from the Ottoman Empire. Such visual moves played into longstanding fantasies about the Maghreb as a liminal area that could be a part of Europe, a boundary between two continents and/or Europe's other, fantasies that oscillated between like and unlike, familiar and strange, desire and denial,

colonized and resistant. In using these rules of recognition, the chaos wrought by colonial intervention could be positioned beyond the frame. Colonial violence was thus disavowed by the formal ordering of space and time lent by pictorial frameworks that provided still, contemplative scenes with still, contemplative figures to add scale to a monument, or give distance to a view. It was not only that, as Homi Bhabha (1994: 111) has indicated, that 'colonial domination is achieved through a process of disavowal that denies the chaos of its intervention'. Rather the aesthetic became a central mechanism of this disavowal, a refuge from the threat of the other.

Images of Algerians at prayer, conversing, dancing, playing games or reposing participated in that relentless specification of difference which Sara Suleri has described as 'a hysterical overabundance of the documentation of a racial vision' (Suleri, 1992: 18). Even when engaged in activity, they seem caught in stasis, pinned onto the surface of paper or canvas. Native figures were often portrayed as immobile as the architecture they accompany. In common with much Orientalist painting, there is a general impression of a population arrested in time and space. Occasionally, a shepherd tends his sheep on a mountainside or a goatherd wanders through scrubland with his flocks. Such corporeal atrophy could play into an imperialist discourse on indolence that was, as Anne McClintock (1995: 252–3) has indicated, as much a discourse on work in which productive labour and responsibility for it were allocated to Europeans.

In racialized contrast and often in gendered opposition, movement is frequently (but not always) assigned to Western figures, in paintings as well as in travel narratives. Numerous images in paint and print present Europeans travelling through the terrain, walking, on horseback, by carriage, or painting and sketching. In Bodichon's *Sisters Working in our Field* (1858–60, private collection), two members of the Order of Charity of St Vincent de Paul are portrayed actively working the land. In *Near Algiers* (Hastings Museum and Art Gallery), two nuns from this same order are exercising that distinctly European privilege of moving through the landscape at leisure. Catholic sisterhoods, as Reina Lewis has indicated, were surrounded by controversy. To many British, but not to French, gallerygoers, and a measure of the distance between the two audiences, images of nuns would have recalled the mid-century altercations about Catholicism and the Anglo-Catholic revival. Furthermore, in feminist debate in Britain, they could also offer exemplars of 'women's mission to women', embodying what were perceived as the specifically feminine values of charity and caring (Lewis 1996). Perhaps most of all, over and above distinctions between Catholicism and Anglicanism, the Sisters could represent the sacred mission of a mythically united Christian Europe (Benchérif 1997). Images of the Sisters and of 'Arabs at Prayer' staged a visual encounter between Christian forces and the unvanquished beliefs of Islam.

Inside and Outside the Frame

To represent North Africa within the Western conventions of landscape was to
subject it to the rules of recognition, to frame it within a pre-existing pictorial order.
In *The Truth in Painting*, Jacques Derrida indicated that the placing of a frame
entails much more than the making of a container, an edge or a border. Framing,
he contends, is a field of force, a violent enclosing that subjects both the inner
field and the boundary to the pressures of restraint, demarcation and definition.
Taking up Derrida's insights, it can be argued that pictorializing attempted a
violent enclosing of Algerian land and peoples within the frameworks of Western
aesthetics and visual conventions. The aesthetic is of paramount importance in the
'worlding' of Algeria, for it is one of the mechanisms that produce the work of art
as art, which make it 'into an object to be understood' as art. In elaborating his
theory of frame, Derrida is commenting on Kant's theories of aesthetic judgement.
He contends that 'the value oppositions which dominate the philosophy of art
(before and since Kant) depend . . . in their pertinence, their rigor, their purity, their
propriety', on the *parergon*. The *parergon* – from the Greek, meaning 'around'
(*par*) 'the work' (*ergon*) – may be perceived as a mobile, regulatory borderline,
which moves according to the laws of supplementarity to mark 'the limit between
the work and absence of work' and so designate what is within (and without)
the realm of art. Framing thus circumscribes the field of art and delimits its
meanings as art. In the making of landscape, a double framing was involved: the
visual framing of artistic convention and the presentation which was entailed in
making an image into art, making it into 'an object to be understood' (1987: 55,
69–74).

Public exhibitions in the nineteenth century demanded that the work of art be
presented within a frame; watercolours would have been additionally bordered by
a mount, perhaps edged with gold. The frame isolates the art object from others
while making it like them, a framed object for public display. Framing was one of
the principal means for transforming the artwork into a finished piece suitable for
public display, and artists often took considerable trouble with framing and
frequently had frames made up to their own designs. In contrast to magazine
articles, where text was often wrapped round sketches, art work inserted into full-
length travel books was generally separated from the text by some sort of frame or
border. Indeed, travel guides like colonial histories made much of their repro-
ductions of fine-art works, which they isolated on separate pages. The frame acted
as a border between what may be said to be inside and integral to the work of art
and that which may be said to be extraneous to it. By enclosing and thus demarking
a pictorial field from matters and interests that may be construed as extraneous to
it, framing, as Derrida has advised, plays into idealist and formalist aesthetics in
which the object is apprehended in and for itself, considered as an art object

without continuity or connection to material reality, sensory perception or geographical space. Framing may be construed as a movement of violence that forcefully disconnected the works of art from the colonial situations in which they had been produced.

Yet, framing is a process that is not always or necessarily achieved; disjunctions occur, Derrida writes, when 'the frame fits badly'. The frame could be destroyed by the very forces that imposed it. Derrida writes of a 'gesture of framing, which, by introducing the *bord,* does violence to the inside of the system and twists its proper articulations out of shape'. At the same time this field of force pushes the devices of restraint along (with) the borderlines to breaking point, so much so that the frames split: 'a certain repeated dislocation, a regulated, irrepressible dislocation . . . makes the frame in general crack, undoes it at the corners in its quoins and joints, turns its internal limit into an external limit . . .' The frame is much more than a simple division between inside and outside. A distinct entity in itself, a third component in what is otherwise a binary opposition, the frame moves between both fields: seemingly fixed and rigid, it is both highly mobile and subject to movement and fracture. The very force of framing (in all senses), which is that of the epistemic violence of imperialism, causes its dislocation. The setting of a *bord* or border not only marks a limit but also precipitates the overflowing of the boundary and of the meanings for the field delimited by the frame, thus *débordement*, a textual movement of overspillage, dispersal and deferral. Framing could thus generate seepage, contamination, mutation, hybridization as fields intermingled.

The framings of Western visual culture worked rather as supplementary to produce images that were neither Africa nor Europe, but comprized of an admixture of elements. Architectural motifs, such as the domed tombs of the saints of Islam, added to and displaced architectural fragments of ancient Rome. While pine trees and precipitous mountains are familiar elements in Western landscape painting, the specific ranges and their disposition to the plains are geographically distinct. The aloes, asphodels, cacti, palms, rushes and bamboo signal a Mediterranean or Maghrebi location as do the native figures in local dress. The images considered here are hybridized, forged in an encounter between several cultures and patched together from disparate, dissonant elements that, in the logic of supplementarity, jostle against, add to, replace, and break into one another. To identify these views as hybridized is to invoke Homi Bhabha's powerful analysis of hybridity as 'the sign of the productivity of colonial power, its shifting forces and fixities' and a register of the uncertainty and precariousness of its authority. Bhabha's compelling retheorization of colonial authority accounts for its agility, its indirectness, its dispersals into adjacent cultural forms. In the case of Barbara Bodichon, the hybridized artistic forms of her landscapes register tensions arising from the encounter of the genre of artistic topography with the colonial context: at once a

portrayal of a location, even in the most generalized form the view must stand and be recognized as 'Algeria'. It must thus be framed by the 'rules of recognition'. Yet, running through the travel texts and visual images considered here are equivocations of visuality and resistance, irresolutions in the visual field between the familiar and the strange, home and away. The mutation of Western artistic forms and framings that took place in Algeria may also indicate a disruptive force within visual representation that breaks the frame of imperial authority as well as refusals to Western visual culture. Hybridity breeds uncertainty, for there are no guarantees that authority will transfer in the colonial context, and it proliferates difference to an excess beyond representation. For Western artists and travellers, readers and audiences, Algeria was simultaneously inside the frame and far beyond it.

Notes

1. Delacroix travelled with an official diplomatic mission to Morocco from January to July 1832, visiting Algiers briefly. Adrian Dauzat, Théodore Frère and Eugène Flandin were among those who accompanied military expeditions to Algeria in the later 1830s, Théodore Chassériau visited in the 1840s, Eugène Fromentin in 1846, 1847 and 1852.
2. For these women's activism in the British women's movement and an extended disucssion of gender in the colonial context, see Cherry (2000).

References

Benchérif, O. (1997), *The Image of Algeria in Anglo-American Writings 1785–1962*, New York: University Press of America.

Benjamin, R. (1997), *Orientalism: Delacroix to Klee*, Sydney: Art Gallery of New South Wales.

Benoune, M. (1988), *The Making of Contemporary Algeria, 1830–1987,* Cambridge: Cambridge University Press.

Betham-Edwards, M. (1867), *A Winter with the Swallows*, London: Hurst & Blackett.

Bhabha, H. (1994), *The Location of Culture*, London and New York : Routledge.

Bodichon, B. (ed.), (1858), *Algeria considered as a Winter Resort for the English*, London: English Women's Journal.

Bodichon, B. (1860), 'Algiers: First Impressions', *English Woman's Journal*, 6: 21–32.

Çelik, Z. (1996), 'Colonialism, Orientalism and the Canon', *Art Bulletin*, 78: 202–5.

Cherry, D. (2000), *Beyond the Frame: Feminism and Visual Culture, Britain, 1850–1900*, London and New York: Routledge.

Chow, R. (1993), *Writing Diaspora: Tactics of Intervention in Contemporary Cultural Studies*, Bloomington: Indiana University Press.

Clayton, E. (1876), *English Female Artists,* London: Tinsley.

Derrida, J. (1987), *The Truth in Painting*, Chicago: University of Chicago Press.

Desprez, C. (1861), *L'hiver à Alger: lettres d'un compère à sa commère*, Meaux: Imprimerie Carro.

Foucault, M. (1982), *Discipline and Punish: The Birth of the Prison*, Harmonds-worth: Penguin.

Hirsch, P. (1999), *Barbara Leigh Smith Bodichon*, London: Pimlico.

Hobson, J. A. (1968), *Richard Cobden: The International Man*, London: E. Benn.

Laroui, A. (1977), *The History of the Maghrib: An Interpretive Essay*, Princeton: Princeton University Press.

Lewis, R. (1996), *Gendering Orientalism*, London and New York: Routledge.

Lorcin, P. (1995), *Imperial Identities: Stereotyping, Prejudice and Race in Colonial Algeria,* London and New York: I. B. Taurus.

Maas, J. S. (1975), *Gambart: Prince of the Victorian Art World*, London: Barrie & Jenkins.

Massey, M. (1993), 'Power Geometry and a Progressive Sense of Place', in J. Bird, B. Curtis, T. Putnam, G. Robertson and L. Tickner (eds), *Mapping the Futures: Local Cultures, Global Change*, London and New York: Routledge.

McClintock, A. (1995), *Imperial Leather: Race, Gender and Sexuality in the Colonial Conquest,* New York : Routledge.

Mitchell, T. (1988), *Colonising Egypt*, Cambridge: Cambridge University Press.

Morrell, J. R. (1854), *Algeria*, London: Nathanial Cooke.

Moulin, J. B. (1859), *Souvenirs de l'Algérie*, Paris: Moulin.

Moulin, J. B. (1860), *L'Algérie photographiée*, Paris: Moulin.

Nochlin, L. (1991), 'The Imaginary Orient', in *The Politics of Vision: Essays on Nineteenth-century Art and Society*, London: Thames & Hudson.

Noirfontaine, P. de (1856), *Algérie: un regard écrit*, Le Havre: A. Lemale.

Parkes, B. R. (1857), 'An Englishwoman's Notions of Algiers: How Hard it was to Get There', *Illustrated Times*, 14 March: 164–5.

[Parkes, B. R.] (1859), 'Review of *Algeria Considered*', *The English Woman's Journal*, 3: 64–6.

Porterfield, T. (1999), *The Allure of Empire*, Princeton: Princeton University Press.

Pratt, M. L. (1992), *Imperial Eyes: Travel Writing and Transculturation*, London and New York: Routledge.

Prochaska, D. (1990), *Making Algeria French: Colonialism in Bône, 1870–1920*, Cambridge: Cambridge University Press.

Said, E. (1983), *The World, The Text and The Critic*, Cambridge and London: Harvard University Press.

Said, E. (1991), *Orientalism,* London: Penguin.

Spivak, G. C. (1985), 'The Rani of Sirmur: An Essay in Reading the Archives', *History and Theory*, 24: 247–72.

Spivak, G. C. (1990), *The Postcolonial Critic*, London and New York: Routledge.

Suleri, S. (1992), *The Rhetoric of English India*, Chicago and London: University of Chicago Press.

Urry, J. (1990), *The Tourist Gaze: Leisure and Travel in Contemporary Societies*, London: Sage.

Urry, J. (1995), *Consuming Places,* London: Routledge.

-3-

Henri Chapu's Provincial Monuments to Jean-François Millet: Legitimizing the Peasant-Painter through Tourism
Bradley Fratello

In July 1876, American journalist Ernest Longfellow travelled to lower Normandy to visit Thomas Couture in Villiers le Bel, where the artist often spent his summers. Disembarking from the train, Longfellow boarded an omnibus that took him and his companion from the station to the village and admired the countryside as they passed.

> When, at one point, we passed some peasants at their noonday meal under the shadow of their cart, which was tipped up with its shafts in the air, while the good horse, with harness off, browsed hard by, 'Ah,' I involuntarily thought, 'what a perfect Millet!' So it is that the familiarity born of books and pictures gives an added charm to travel. (Longfellow 1883: 233)

Longfellow mentioned no particular painting that this Norman scene evoked, but precise correspondence of details was not his primary concern. Instead, the author indicated his ability to read the charms of the countryside through his appreciation of Jean-François Millet's (1814–75) art as what has been called a 'semiotic tourist' (MacCannell 1976). Paradoxically, Longfellow's claim of aesthetic sensitivity offered him access not to elevated domains but to the common world of peasants. Identifying 'a perfect Millet' in nature authenticated Long-fellow's vision of country life – life as Millet and, supposedly, peasants themselves would have seen it. Such are the contrasting values built into Millet's manufactured persona, the peasant-painter. The term, employed by Millet's friend and biographer Alfred Sensier, implies the artist's ability to bridge the gap between nature and culture, rural and urban. It thus played a crucial role in linking Millet with the romantic brand of nature tourism developing in the late nineteenth century.

This chapter examines the role tourism played in posthumously connecting Millet with his two provincial homes: Barbizon, where he painted most of his mature works, and Cherbourg, the town nearest his natal village of Gruchy in Normandy. Longfellow's association of the countryside with Millet came through

a chance sighting of peasants resting in a field, but subsequent tourists did not have to rely on fate for similar opportunities. With his erection of two sculpted monuments, the *Monument to Millet and Rousseau* (inaugurated 1884) and the *Monument to J.-F. Millet* ([Figure 3.1], inaugurated 1892), Henri Chapu (1833–91) guaranteed visitors to Millet's hometowns an encounter that would satisfy their desire to commune with nature through their image of Millet as a simple, pious painter of peasants. The artist's role as an intercessor between urban tourists and nature added to the touristic *cachet* of the towns while forging an image of Millet that would appeal to the broadest range of admirers and universalize his appeal as one of the modern masters of French painting.

At mid-century, Millet had the reputation of a socialist troublemaker. His stark images of peasants engaged in the monotonous, sometimes brutal chores of rural life disrupted urban fantasies of life in the country and provoked hostile responses from critics who preferred the flowery, neo-Rococo style favoured during the Second Empire (Clark 1973: 72–98; Herbert 1976). By the mid-1860s, the tone of

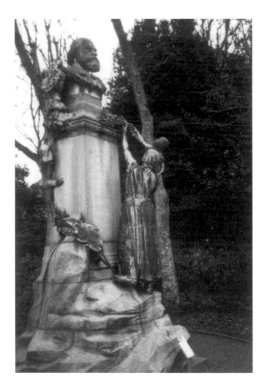

Figure 3.1 Henri Chapu, *Monument to Jean-François Millet,* inaugurated 22 September 1892. Jardin publique, Cherbourg. (Photo: archive of author.)

his work softened, bringing higher prices and official recognition including a retrospective tribute at the *Exposition Universelle de 1867* and the Cross of the Legion of Honour in 1868 (Moreau-Nélaton 1921: III, 18–44). Millet may have set the course for his canonization with his later works, but he could not have imagined the fame, honour and astronomical prices that he and his imagery would command in the last quarter of the nineteenth century. With many of his works already lost to foreign, particularly American, collectors by the 1880s, the French paid unprecedented sums to keep others at home. The *Gleaners* entered the Louvre in 1890, bequeathed to the state by a widow from Reims who paid 300,000 francs for it in 1888. The *Angelus* returned to France from America in 1891 for 850,000 francs after being lost at auction 18 months earlier, where it had fetched the highest price ever for a painting. Including the duty, the Americans figured that they had paid 3,500 dollars per square inch (Meixner 1995: 72).

These exorbitant prices owed much to the romanticized account of the artist's life forged after his death (McWilliam 1999: 437–47). The heroic, albeit exaggerated, story of Millet's life first manifested itself as a biography, *La vie et l'œuvre de Jean-François Millet*. Written primarily by Sensier, who died in 1877, the book's final chapters took shape through the efforts of Republican art bureaucrat Paul Mantz, who published it in 1881. Continuing with the campaign to popularize Millet, Mantz staged a retrospective exhibition of his work at the École des beaux-arts in spring 1887: it remained the largest gathering of Millet's art until 1975. With its accompanying catalogue, including a laudatory essay penned by Mantz, the exhibition showcased Millet's work for a wide public and set the stage for his appeal to patrons, the next generation of artists and the public into the next century. Defusing the polemical implications that some viewers perceived in Millet's work and character took pride of place in remaking his image (Salé 1998: 18). The resulting persona stressed Millet's simplicity, his piety, his distance from mid-century political debates and his closeness to nature, all of which manifested themselves in the tributes to his memory – written, exhibited, and sculpted, produced in the early, politically volatile years of the Third Republic. Chapu's two sculptures to Millet played an integral role in establishing this reputation for the deceased artist. They interacted with contemporary tourism practices and debates over the cultural importance of the French countryside to blur the distinction between celebrated artist and saint, resulting in a focus of admiration suitable for viewers of diverse, even opposed, political persuasions.

Born of the political vacuum left by the collapse of the Second Empire during the Franco-Prussian War, France's Third Republic quickly thereafter endured the domestic tragedy of the Paris Commune, the violent suppression of which resulted in the deaths of over 25,000 French men and women. The events of *l'année terrible* led to a profound reassessment of the values of the Second Empire.

Napoleon III's regime came to symbolize decadence, wild and irresponsible financial speculation and faithlessness. Its demise spurred a widespread return to *l'ordre morale* – an amalgam of utopian fantasies that either prophesied a brilliant, technological and rationalized future or recalled a nostalgic, traditional and pious French past as remedies to the troubles of the present (Mainardi 1993). These two visions represented the split between opposed political factions: while Republicans struggled to replace the Empire with a representative democracy that would avoid the autocratic pitfalls of Imperial rule, conservatives, including both Clericals and Legitimists, believed that the model for France's future glory lay in its past: in a return to monarchical rule that proscribed a powerful temporal role for the Catholic church. These two groups struggled for legislative power during the early years of the regime, with Republicans establishing a stable political base only in the late 1870s.

Paris had borne the brunt of the traumas of 1870–1. Sacked by the Prussians, the capital also suffered massive physical damage during the Commune: reclaiming the city from the Communards came only through widespread destruction that razed both the Hôtel de Ville and the Tuileries Palace. Thus, while urban congestion, crime and pollution had long plagued Paris and spurred the desire to get away, escaping to the country in the late nineteenth century assumed even stronger overtones of nostalgia for days gone by (McMillan 1995; McWilliam 1996). In letters to Sensier, Millet evoked these contrasting perceptions of city and country while he and his family weathered the war and the Commune in remote Cherbourg:

C'est toujours une petite chance que Barbizon et nos maisons n'aient pas été dévastés . . . Je n'ose pas penser à l'entrée des Allemands à Paris, ni à tout ce qu'ils y peuvent faire. Quand ce pauvre Paris reprendra-t-il une allure un peu régulière? (Millet, in Moreau-Nélaton 1921: III, 68)

(There is always a small chance that Barbizon and our homes have not been devastated . . . I dare not think of the entrance of the Germans into Paris, or of all that they could do there. When will poor Paris regain a semblance of regularity?)[1]

Est-ce assez horrible, ce que ces misérables de la Commune ont fait de Paris? Ce sont des monstruosités sans précédent. Auprès de ceux-ci les Vandales étaient des conservateurs. Au moins ne ravageaient-ils que chez les autres. O les monstrueux scélérats! (Millet, in Moreau-Nélaton 1921: III, 73)

(Isn't it bad enough what those miserable Communards have done to Paris? These monstrosities are without precedent. Compared to them, the Vandals were preservationists. At least they did their pillaging in other people's homes. Oh, these monstrous scoundrels!)

Prenez, mon cher Sensier, autant de plaisir que vous pourrez aux choses de la nature; car c'est toujours le solide. Je tâche, pour ma part, d'écarter . . . de mon esprit toutes ces horreurs, auxquelles je ne peux rien, pour me jeter dans le travail . . . Ce pays-ci est réellement bien impressionnant et a beaucoup d'aspects d'autrefois. (Millet, in Moreau-Nélaton, 1921: III, 72)

(My dear Sensier, take as much pleasure as you can from things in nature. They are always reliable. I take it upon myself to avert my mind from all of these horrors, about which I can do nothing but throw myself into work. The country here is truly impressive and has many of the aspects of days gone by.)

Millet's belief that he could escape the nation's troubles by immersing himself in nature indicated his adoption of traditional values that replaced the modern, international and commercialising trends of the Second Empire.

The reactionary call for *l'ordre morale* and its opposed manifestations, however, did not neatly split along urban and rural lines. Even Paris, the centre of French modernity, could symbolize both a bright future through engineering wonders such as the Eiffel Tower, and the seat of French tradition as reflected in images of Notre Dame (Thomson 1994). Similarly, the French countryside could support either ideology. For Republicans, the country represented decentralized power dispersed among the nation's citizens, and independent land ownership. Conservatives, however, imagined a monarch presiding over a supposedly unquestioning, homogenized Catholic body politic faithfully serving a feudal system in which church and state controlled much French real estate. The Right based its vision on exaggerated, xenophobic fears of Jews and Protestants taking power contrasted with equally distorted notions of an ancient, religiously purer golden age.

Republicans and conservatives thus clamoured for cultural hegemony by erecting monuments to 'heroes' representing their opposed versions of France's past in hopes of promoting a similar future: June Hargrove has referred to them as 'weapons of advocacy' in a culture war waged between right and left (Hargrove 1991: 50). Statues honouring artists, scientists and statesmen promoted Republican values of hard work, rational thought and personal, moral responsibility, whereas others commemorating saints, martyrs and Gallic heroes upheld faith in God and the defence of the French race. While Paris provided the centre stage for this cultural contest, provincial monuments conveyed similar ideas to rural Frenchmen.

[The] spread of Republican statuary indicated the advance of the regime in the country, the rallying of the various towns and villages through most of France to the regime, and the process was no less real if done by each locale on its own initiative – on the contrary. (Cohen 1989: 512)

It is through these cultural and political lenses that Chapu's monuments to Millet must be read to determine what the painter's newly constructed identity signified. A thorn in the Second Empire's side for over a decade, Millet perfectly suited campaigns to reject that regime's values. Millet's peasant life and his depictions of country folk made ideal material for the propaganda campaigns of the early Third Republic. Moreover, his close ties to both Paris, where he exhibited his paintings, and the provinces, where he painted them, made him the perfect vehicle for inserting these ideological battles into the touristic experience for his ever-expanding circle of admirers.

Mantz, a progressive art critic during the Second Empire, had long defended Millet's work. When the Salon jury rejected *Death and the Woodcutter* in 1859, Mantz defended the painter in the *Gazette des beaux-arts* with words of praise and a reproduction of the image. Mantz served as the *Directeur des beaux-arts* for most of 1882 and continued to publish books and articles supporting some of the artists who today take pride of place in the modern French canon (Bouillon et al. 1990: 19–22). Chief among them was Millet. In the catalogue of the Millet retrospective, Mantz evoked an apologetic, if self-effacing tone that played on the guilty conscience of a nation that had earlier rejected the artist's peasant images for more decadent visual indulgences.

> Au moment où la bataille est définitivement gagnée et alors que Millet reçoit à l'école des beaux-arts un hommage longtemps attendu, il y aurait peut-être quelque mauvaise grâce à insister sur les longues injustices qui ont été le cortège de sa vie. (Mantz 1887: 7)

> (At the moment when the battle is definitively won, and now that Millet receives a long-awaited homage from the École des beaux-arts, it would perhaps be ungracious to insist on the long injustices that have accompanied his life.)

Mantz's participation on the subscription committee to erect the Cherbourg monument – a monument funded through the admission fee charged at the 1887 Millet retrospective that he had organized – firmly situates Chapu's second work within the Republican cultural project, and implies the same affiliation for the Barbizon monument (Anonymous 1887: 283). Inaugurated on 14 April 1884, the *Monument to Millet and Rousseau* shared that date with a monument in Cahors dedicated to Léon Gambetta (1838–82), founder of the Third Republic, a coincidence duly noted in press coverage of the event (Valter 1884: 2). Similarly, the 22 September 1892 marked the centennial of the First Republic, and the Mayor of Cherbourg called it the perfect day to dedicate such a tribute:

> En ce jour de fête où la Nation célèbre le centenaire de la première proclamation de sa souveraineté, nous sommes heureux de pouvoir rendre hommage par l'inauguration de

sa statue, à l'humble paysan que son talent a élevé à une célébrité, que bien des princes n'ont pas atteint. Il n'était pas possible de trouver une date plus mémorable, plus à propos pour cette cérémonie si en rapport avec l'esprit moderne de suppression des privilèges de naissance. (C. S. 1892: 1)

(On this day of celebration, when the Nation celebrates the centennial of the first proclamation of its sovereignty, we are happy to be able to pay homage, with the inauguration of his statue, to the humble peasant whose talent raised him to a celebrity that even princes have not attained. It was impossible to find a date more memorable, more fitting, for this ceremony with regards to the modern spirit of the suppression of the privileges of birth.)

Just prior to the Mayor's speech, the Cherbourg monument had been unveiled from beneath a *tricolore* while the local army band played *La Marseillaise*. Although green drapery had covered the Barbizon monument, doubtless to harmonize with the sylvan setting, the national anthem accompanied its unveiling as well. More patriotic ceremonies – ceremonies linking Millet with Republican nationalism – would have been difficult to arrange (Harris 1999: 247–8).

The second speaker at the Cherbourg inauguration, however, characterized Millet and his achievements differently. Armand Véel, a local sculptor, praised not Millet's hard work, but Cherbourg itself, and in a distinctly conservative manner:

[Millet] ne doit pas le talent qu'il acquiert seulement à ce qu'on appelle la vocation, à l'éducation qu'il a reçue de la nature et des maîtres; il en doit une grande part, la meilleure, peut-être, au sol où il est né, lequel, si j'ose ainsi dire, s'incarne en lui; c'est là qu'il a pris cette qualité maîtresse dans l'art: la personnalité. (C. S. 1892: 2)

(Millet does not owe the talent he acquired only to what is called vocation, to the education that he received from nature and from masters. He owes a great part, the greater part, perhaps, to the soil where he was born: the soil, if I dare say so, which is embodied in him. It is from there that he derives that quality which is paramount in art: personality.)

Immediately thereafter, a monsieur Danneville addressed the crowd in similar terms. Referring to the erection of the monument as 'une œuvre de réparation et de justice envers un enfant du peuple' (an act of reparation and justice to a child of the people), Danneville ascribed fine, robust qualities to Millet, attributing them to his Norman birth: 'Il appartenait à cette vigoureuse et forte race de la Hague, si intelligente, si pleine de bon sens et d'esprit gaulois' (C. S. 1892: 2) (He belongs to the strong, vigorous race of la Hague, so intelligent, so full of good sense and the Gallic spirit). Whereas the Mayor spoke against the notion of noble birth to praise Millet's example of Republican virtue, Véel and Danneville assigned to birth

an importance of the first order, albeit in different terms. They spoke of the power of the Norman soil and the 'race' of people born there, claiming that it played 'perhaps the greater part' in shaping the artist's personality. Evoking the soil as a birthright indicates an alternative context for Millet's persona – the conservative, nostalgic and populist notion of racial purity propounded by Clericals and Legitimists.

These observations suggest that the hermetically sealed theoretical model proposed for French public statuary – a model that posits a direct and exclusive relationship between patronage and the thematic content of a given monument – fails to account for the multitude of readings attributable to Chapu's monument to Millet, and perhaps to others as well. The Republican cocoon wrapped around Chapu's Cherbourg monument during its planning did not survive even the first hour of its public (post-inaugural) life. The speeches by Véel and Danneville demonstrate that a single monument could, in fact, accommodate opposed political readings. Here, conservatives appear literally to have been invited to graft their own meanings onto the piece. Chapu's monument demonstrates the need to explore discursive contexts beyond officially intended ones to illuminate fully the range of meanings a given work can generate.

Tourism offers just such a discursive context. By 1884, Barbizon had long since learned to reap economic benefits from the artists' colony established there. Guidebooks for the nearby town of Fontainebleau included descriptions of Barbizon's rustic, even homely charms, at least as early as 1853, designating the village 'd'aspect laid, situé à une extrémité occidentale de la forêt' ('of unsightly guise, situated at the eastern edge of the forest') a picturesque, rustic day trip, and an 1867 guidebook already listed Millet as a local attraction (Joanne 1867: 202–3). The forest of Fontainebleau had been the king's hunting grounds, and those monarchical connotations attached themselves to the painters, 'les véritables rois de la forêt de Fontainebleau' (the true kings of the forest of Fontainebleau) (Bernard 1853: 119). Cherbourg, too, offered itself and Millet to tourists. Guidebooks suggested visits not only to Chapu's monument but also to the rugged surrounding countryside and to Gruchy (Cherbourg 1903: 53–4). Of particular importance in illuminating Chapu's works is the relationship between tourism and the centuries-old practice of pilgrimage. In their sociological study of pilgrimage, Victor and Edith Turner asserted that 'a tourist is half a pilgrim if a pilgrim is half a tourist' (Turner and Turner 1978: 20). Their model suggests that tourism, like pilgrimage, involves participants in 'rites of passage', temporarily removing them from their daily lives and situating them in liminal times and spaces during which psychic or spiritual transformation may occur. Tourists' excursions take them to 'centres out there,' realms of proffered authenticity that return meaning and truth to lives lived in the artificial, alienating spheres of the modern world. Return to quotidian

life finds tourists rejuvenated by their experiences and raised in status (Turner 1973).

The structural and theoretical similarities linking tourism and pilgrimage are coupled here with historically contingent factors that further align the two practices and give those correspondences political relevance. France witnessed a marked increase and change in pilgrimage activity during the last decades of the nineteenth century. Against the typically held notion of arduous journeys to distant religious shrines, pilgrimage had persisted after the Medieval period in localized forms that fostered community cohesion as much as spiritual cleansing (Marrus 1997). The traumas of 1870–1, however, led to a massive, national pilgrimage movement conducted primarily in the name of religious devotion. Modern French pilgrimage was based on the pilgrimages of the Middle Ages, spurred by a penitent, reactionary impulse to return piety to a decadent society. For urbanites, leaving crowded, international population centres such as Paris for rural pilgrimages offered opportunities to reconnect with the provinces and its people, the alleged heart of the nation. In 1872, the Assumptionist Order established *Le Pèlerin,* a month-long period of penance focused originally on La Salette, a town in the French Alps, but later redirected at Lourdes. Attended by 1,400 people, including 100 Legitimist members of the National Assembly, the conservative underpinnings of the pilgrimage in 1872 were unmistakable. Lourdes quickly gained international renown: 400,000 pilgrims were arriving annually by 1900, and excepting Rome and Jerusalem, it remains the most visited Catholic pilgrimage destination in the world (Kaufmann 1996; Harris 1999).

The popularity of Lourdes owed much to the traumas of the Franco-Prussian War and the Commune, making it one of the most tangible elements of the return to *l'ordre morale.* The pilgrimage grew around reports that an illiterate, 14-year-old peasant girl, Bernadette Soubirous, witnessed 18 visions of the Virgin Mary near a grotto on the banks of the Gave River, beginning on 11 February 1858. Soubirous unearthed a spring whose waters were reported to have healing powers. News of the miracles at Lourdes spread and the site's renown increased rapidly. Fearing that Lourdes would become a haven for right-wing consolidation, the fledgling Republican government closely monitored activities there after the commencement of the organized, national pilgrimages began. Although based in a retrogressive impulse to return to France's Catholic glory, the success of Lourdes as a modern pilgrimage site depended on modern technology. Rail service reached Lourdes in 1866, and hotels and souvenir merchants profited from the faithful who flocked there. A basilica designed as a pastiche of the Gothic style rose over the grotto where Soubirous had had her vision, as did a bathhouse through which the spring's miraculous waters flowed.

At least two contemporary journalists called touristic visits to Barbizon pilgrimages, a reference that could not have been unintentional. The writer for *Le Monde*

Illustré described the monument as admirably situated, 'pour ceux qui aiment à se souvenir et qui voudront en passant faire halte auprès de ce lieu de pèlerinage artistique consacré à la mémoire de deux hommes dont le talent a toujours suivi de nobles voies . . .' (Anonymous 1884b: 246) (for those who love to remember and who, in passing through, would like to make a stop near this place of artistic pilgrimage consecrated to the memory of two men whose talent always followed noble paths). Similarly, the piece in *Le Figaro* referred to the visit as 'le pèlerinage à la maison de Rousseau et à l'atelier de Millet . . .' (Valter 1884: 1–2) ('the pilgrimage to the house of Rousseau and the studio of Millet . . .').

Comparing Chapu's two monuments to the shrine at Lourdes demonstrates that all three blur the distinction between nature tourism and pilgrimage, and thus between the conservative and liberal versions of the Third Republic's *ordre morale*. Right and left, God and country, tourist attraction and religious shrine, when placed in the context of reactionary nationalism, occupied more common ground than either liberals or conservatives acknowledged, and more than subsequent scholarship has identified. These blurred distinctions explain the transformation of Millet's persona from that of a politically volatile painter to an untouchable icon of modern France.

A native of a village within walking distance of Barbizon, Chapu no doubt harboured a particular fondness for the two artists commemorated in the bronze relief just outside the village wall (Fidière 1894: 3–22). He donated his time and materials to the project, allowing the subscription committee to spend its 10,000 francs on preparing the site (Valter 1884: 2). The relief depicts Millet and Rousseau bust-length and in three-quarter profile, and is embedded in one of the large, moss-covered boulders typical of the forest. Already outside the village, the monument is further isolated within an enclave of other boulders and a canopy of trees that articulate a natural chamber. Set well above eye level, the work dictates a hierarchical relationship that subjects visitors to the gaze of these 'kings of the forest' as much as vice versa. Similar relationships are established in the Cherbourg monument (Figure 3.1), which stands at the back of the city's public park, an enclosed garden a short walk from the train station beyond the bustling port city. Removed from the centre of everyday life, guidebooks emphasized the monument's natural setting, 'se dresse dans une cadre d'ormes verdoyants' (Cherbourg 1905: 517) (standing in a frame of verdant elm trees). Atop a pedestal approximately 12 feet tall, Millet's image presides over its audience as it does at Barbizon. Isolation and hierarchy situate both monuments within the context of 'romantic tourism', that is to say, tourism designed to evoke personal, romanticized responses from its audience (Urry 1990: 45–6, 97–8; Walter 1982).

The site specificity of Chapu's works further enhances their romantic aspect. At the inauguration of the Cherbourg monument, Danneville stressed the scenic beauty of the Normandy coast in shaping Millet's artistic sensibilities:

L'enfant de la Hague ne se sentait nullement dans son milieu à Paris, où l'air lui manquait; sa pensée était au milieu de la Hague, au bord de l'Océan où si souvent il avait suivi angoisse la marche d'une barque de pécheurs battue par la tempête. (C. S. 1892: 2)

(The child of la Hague did not feel at all in his element in Paris, which he found stifling. His thoughts were at la Hague, at the edge of the ocean where so often he had followed in distress the progress of a boat of fishermen battered by the storm.)

Likewise, one commentator remarked on the importance of the Barbizon relief's exact location as one where Rousseau often painted, lending the bronze a talismanic quality:

En pénétrant dans le village on voit la roche s'élever du milieu des branches dominant un peu les roches voisines. C'est à cet endroit'là même que Rousseau venait souvent s'installer devant son chevalet, à l'aube, et c'est là qu'il peint bon nombre de tableaux qui l'ont fait si justement glorieux. (Anonymous 1884a: 251)

(Entering the village one sees the rock rising among some branches that slightly overpower the neighbouring boulders. It is to this exact spot that Rousseau came often, installing himself before his canvas, at dawn, and it is there that he painted a fair number of the canvases that have so justifiably made him glorious.)

The journey to the sites where Millet and Rousseau had their 'visions' recalls that taken to the grotto where Soubirous witnessed her apparitions, or to any other sacred site.

Worship of God and nature proceed hand in hand at Lourdes, Barbizon and Cherbourg, infusing pantheistic spirituality into Chapu's monuments and the rejuvenating qualities of the natural world into the experience of the Divine at Lourdes. 'Nature is curative, performs magical re-creations and other miracles otherwise assigned to Lourdes, God or *gurus,* [and] the medicine is weakened by the presence of other humans' (Graburn 1989: 31). By embedding his bronze relief into a boulder, Chapu fused his tribute to Millet and Rousseau with nature, the tourists' ultimate desire. The Cherbourg monument, too, formally blends rustic nature with high art. The pedestal upon which the bust of Millet rests rises from a base resembling a natural rock outcropping backed by a fictive tree trunk. Chapu repeated his combination of bronze and stone at Cherbourg by including a life-size, cast figure of a peasant woman lifting a small child to lay wildflowers near the bust. The shift in materials implies two levels of fictive, sculptural space and thus perforates the boundary between viewer and sculpture. Although faceless and generalized, like Millet's painted peasants, Chapu's figure is only semi-allegorical. Stepping onto the carved, rocky base, she and the little girl invite passers-by to participate in analogous acts of homage.

Through tourism, visitors to Chapu's monuments assume the role of pilgrims in search of communion with nature: Millet serves as their intercessor. His peasant roots lent his memory the power to bridge the gap between alienated urbanites and the natural world for which they yearned. To claim that nature replaced God at these sites, however, would oversimplify the case. Soubirous may serve as an intercessor between the Catholic pilgrim and the Divine, as Millet links the tourist with the natural world, but through their peasant identities, each figure seamlessly blends these objects of worship: God and Nature commingle as the focus of adulation at each site. Belief in Soubirous' vision came not despite her uneducated peasant background, but because of it. When she told local priests that the vision had identified herself as 'the Immaculate Conception', a widely held Catholic belief declared dogma by Pope Pius IX in 1854, they were convinced that Bernadette could not have known the term other than through a miraculous vision. Her rural isolation thus proved the veracity of her claim (Kselman 1983: 159–60). Sensier's biography of Millet, too, elided nature and religion, claiming that Millet's peasant upbringing, and not official training, had the greatest impact on his talent:

Revenant un jour de la messe, [Millet] rencontra un vieillard, le dos voûté et retournant péniblement chez lui; il fut surpris de la perspective et du mouvement de cette figure courbée et vivante. Ce fut pour le jeune paysan la découverte du raccourci; d'un coup d'œil, il comprit le mystère des plans qui s'avancent, reculent, s'abaissent ou se relèvent. (Sensier 1881a: 33)

(Coming home one day from mass, he met an old man, his back bowed, and going wearily home. He was surprised at the perspective and movement of the bent figure. This was for the young peasant the discovery of foreshortening. With one glance he understood the mysteries of planes advancing, retreating, rising and falling.) (Sensier 1881b: 39)

Crediting Millet's grandmother Louise Jumelin with the greatest influence on the artist, Sensier described the family matriarch as a woman in whom 'religion se mêlait à l'amour de la nature' (Sensier 1881a: 12) (religion was mixed with her love of nature) (Sensier 1881b: 25). Chosen in honour of St Francis of Assisi, Millet's name associated him with 'l'infatigable contemplateur des choses de la nature . . . un patron bien choisi pour l'homme qui, plus tard, devait être l'amant plus passionné de l'œuvre de Dieu' (Sensier 1881a: 11) (the faithful observer of the things of nature . . . the happy choice of a saint for the man who, later, would become the passionate lover of the works of God) (Sensier 1881b: 22). Commingling faith and nature transforms Sensier's book into an extended metaphor for love of God.

'[For nineteenth-century public statuary,] the inherent contradiction between immortalising the unique and glorifying the communal generated a conflict that was both philosophical and aesthetic' (Hargrove 1980: 22). Hargrove's statement may be true, but when it came to commemorating Jean-François Millet, this contradiction proved advantageous. Millet's manufactured persona as a peasant-painter made possible the confusion of the communal and the unique. For Republicans, the artist represented a simple man of humble origins whose accomplishments glorified the power of the individual. For conservatives, his connection with the natural world opened a portal to the Divine and transformed him into a visionary painter whose artistic canonization mimicked that of Catholic saints. Chapu's two provincial monuments transcended the deep political schism between right and left in the late nineteenth century. Instead of miring his works in heavy symbolism that would have situated his tributes in either liberal or conservative rhetoric, Chapu maintained a sense of ambiguity that appealed to tastes broader than those of a particular political faction. He spoke to deeper impulses of French nationalism that ran beneath the surface of both programmes. In doing so, he found the common ground that had originally spurred both versions of the *ordre morale*. Art, nature and religion merge in Henri Chapu's janus-faced, provincial monuments to Jean-François Millet, which loosely identify Millet as a French national hero and thus offer something for everyone to appreciate.

Note

1. All translations are my own unless otherwise indicated.

References

Anonymous (1884a), 'Le monument de Millet et de Rousseau,' *L'Illustration,* 2147, 19 April: 251.

Anonymous (1884b), 'Monument de Rousseau et Millet, à Barbizon,' *Le Monde Illustré,* 1412, 19 April: 246.

Anonymous (1887), 'Concours et expositions', *La Chronique des arts et de la curiosité*, 36, 19 November: 283.

Bernard, F. (1853), *Fontainebleau et ses environs,* Paris: Librairie Hachette.

Bouillon, J.-P, Dubreuil-Blondin, N., Ehrard, A. and Naubert-Riser, C. (eds) (1990), *La Promenade du critique influent: Anthologie de la critique d'art en France, 1850–1900,* Paris: Hazan.

C. S. (1892), 'Centenaire de la République à Cherbourg et inauguration du Monument Millet', *La Vigie de Cherbourg et de la Manche,* 77, 25 September: 1–2.

Cherbourg, (1903), *Cherbourg et ses environs,* Cherbourg: Librairie Henry.

Cherbourg (1905), *Cherbourg et le Cotentin,* Cherbourg: Imprimerie E. Le Maout.

Clark, T. J. (1973), *The Absolute Bourgeois: Artists and Politics in France 1848–1851,* London: Thames & Hudson.

Cohen, W. (1989), 'Symbols of Power: Statues in Nineteenth-Century Provincial France', *Comparative Studies in Society and History,* 31, 3: 509–20.

Fidière, O. (1894), *Chapu: sa vie et son œuvre,* Paris: E. Plon, Nourrit & Cie.

Graburn, N. H. H. (1989), 'Tourism: The Sacred Journey', in V. L. Smith (ed.), *Hosts and Guests: The Anthropology of Tourism*, Philadelphia: University of Pennsylvania Press.

Hargrove, J. (1980), 'The Public Monument', in P. Fusco and H. W. Janson (eds), *The Romantics to Rodin: French Nineteenth-Century Sculpture from North American Collections*, Los Angeles: Los Angeles County Museum of Art.

Hargrove, J (1991), 'Shaping the National Image: The Cult of Statues to Famous Men in the Third Republic', in R. A. Etlin (ed.), *Nationalism in the Visual Arts*, *Studies in the History of Art*, 29: 49–64.

Harris, R. (1999), *Lourdes: Body and Spirit in the Secular Age,* New York: Viking.

Herbert, R. L. (1876), *Jean-François Millet,* London: Hayward Gallery.

Joanne, A. L. (1867), *Fontainebleau: son palais, ses jardins, sa forêt et ses environs,* Paris: Librairie Hachette.

Kaufmann, S. K. (1996), 'Medicine, Miracles and the Spectacle of Lourdes: Popular Religion and Modernity in Fin-de-siècle France', PhD dissertation, State University of New Jersey.

Kselman, T. (1983), *Miracles and Prophecies in Nineteenth-Century France,* New Brunswick, NJ: Rutgers University Press.

Longfellow, E. W. (1883), 'Reminiscences of Thomas Couture', *Atlantic Monthly,* 52: 233.

MacCannell, D. (1976), *The Tourist: A New Theory of the Leisure Class,* New York: Schocken Books.

Mainardi, P. (1993), *The End of the Salon: Art and the State in the Early Third Republic,* Cambridge: Cambridge University Press.

Mantz, P. (1887), *Catalogue descriptif des Peintures, aquarelles, pastels, dessins rehaussés croquis et eaux-fortes de J.-F. Millet*, Paris: École des beaux-arts.

Marrus, M. R. (1997), 'Cultures on the Move: Pilgrims and Pilgrimages in Nineteenth-Century France,' *Stanford French Review,* 1, Fall: 205–20.

McMillan, J. F. (1995), 'La France Profonde, Modernity and National Identity,' in J. House (ed.), *Landscapes of France: Impressionism and its Rivals*, London: Hayward Gallery.

McWilliam, N. (1996), 'Race, Remembrance and *Revanche:* Commemorating the Franco-Prussian War in the Third Republic', *Art History,* 19, 4: 473–98.

McWilliam, N. (1999), 'Mythologizing Millet', in A. Burmeister, C. Heilmann, M. F. Zimmerman (eds), *Barbizon: Malerei der Natur, Natur der Malerei,* Munich: Klinkhardt & Biermann.

Meixner, L. (1995), *French Realist Painting and the Critique of American Society, 1865–1900,* Cambridge: Cambridge University Press.

Moreau-Nélaton, E. (1921), *Millet raconté par lui-même,* 3 vols, Paris: H. Laurens.

Salé, M.-P (1998), 'L'image de Millet en France dans les années 1880,' in *Millet/ Van Gogh,* Paris: Musée d'Orsay.

Sensier, A. (1881a), *La vie et l'œuvre de Jean-François Millet,* Paris: A. Quantin.

Sensier, A. (1881b), *Jean-François Millet: Peasant and Painter*, trans. H. de Kay, Boston: James R. Osgood & Company.

Thomson, R. (1994), *Monet to Matisse: Landscape Painting in France, 1874– 1914*, Edinburgh: National Gallery of Scotland.

Turner, V. (1973), 'The Center Out There: Pilgrim's Goal', *History of Religions*, 12, 3: 191–230.

Turner, V. and Turner, E. (1978), *Image and Pilgrimage in Christian Culture: Anthropological Perspectives,* New York: Columbia University Press.

Urry, J. (1990), *The Tourist Gaze: Leisure and Travel in Contemporary Societies,* London: Sage.

Valter, J. (1884), 'Le Monument Rousseau-Millet à Barbizon', *Le Figaro,* 105, 14 April: 2.

Walter, J. A. (1982), 'Social Limits to Tourism', *Leisure Studies,* 1: 295–304.

–4–

Open-Air Museums and the Tourist Gaze
Stephen F. Mills

Open-air museums present one of the modern world's most accessible images of the past, providing virtual landscapes of a more detailed kind than any electronic equivalent yet available. Visitors can see the displayed buildings, relocated originals or full-scale replicas, from all sides, individually and collectively, and in all weathers merely by following a marked trail through the site. Although visitors cannot live or work within these buildings, such reconstructions provide a state-of-the-art glimpse of the world as it used to look, with great care being taken to ensure that modern intrusions, such as emergency exits and anti-theft devices, are kept out of sight wherever feasible, and that the buildings are as authentic in their visible dimensions as currently possible. Even while explicitly catering to the perceived expectations of their visitors, open-air museums stoutly maintain that they remain an integral part of academia. My study of those venues, mostly open-air sites that present the Ulster and Virginia past, suggests that although they believe they are presenting history, their concern for the visual dimensions of experience means they are in effect engaged in the creation of heritage sites, particularly those most appropriate for enhancing local tourist potential. In their attempt to escape from the cabinet-of-curiosities tradition, curators have sought to extend the contextual grasp of the visitor, initially within the museum's own interior space, for example, in the presentation of furniture within mock-up or, increasingly, relocated rooms (Horne 1984; Hudson 1987). Curators working mostly outdoors[1] were then able to present such rooms within a house, and finally houses (or forges, apothecaries or post offices) within the context of other buildings, roads, and fields. Parallel representational strategies emerged from within world fairs, epitomized by the 1893 Chicago Columbiad (Greenhalgh 1988). Here, the great powers presented their various, usually subject, peoples, civilized and prosperous now that the light of Western civilization had been forcibly shone into their eyes (Rydell 1984, 1993). But in Chicago, so popular were the downmarket amusement park attractions that a parade, Pied Piper-like, had to be devised to encourage visitors to enter the main exhibition area (Mills 1996a). Large exhibition halls were never as popular as painted ladies and candy, and the issue of 'dumbing down' is not a recently devised one. Subsequent attempts to narrow the divide between mass attractions and

serious exhibits have always seemed to follow in the footsteps of B. T. Barnum, who transformed Scudder's American Museum, essentially a cabinet of curiosities, into a freak show (Harris 1973). In museums and heritage sites, the balance between high and mass culture has to be continually renegotiated, for it is here that scholarship meets mass society.

Charles Dickens's Mr Gradgrind caught his own children trying to glimpse a travelling circus (Dickens 1969: 53–58). They wanted a spectacle: as a teacher he wanted a thesis on equine physiognomy. Real life scholars, such as Matthew Arnold, F. R. Leavis and J. B. Priestley, have been equally repelled by mass culture. Even Walt Disney portrayed visitors to Pleasure Island in *Pinocchio* (1940) as having all the good taste and decorum of the Joker in Tim Burton's *Batman* (1989). Recognizing the potential of such venues, Disney sought to reinvent the amusement park as a tourist attraction where wholesome family values could be promoted within commercially sound, visually stimulating, but historically inauthentic, surroundings (Mills 1992: 78–96). Given that Disneyland promoted all-American values, using particular images of technology (positive), other countries (cute and backward), and particularly American history (patriotic), theme parks became associated in the public eye with a very particular slant on the American past, expansionist and essentially unproblematic, all within spectacular surroundings (Mills 1990: 66–79). Museum curators, however, realized that this association of Disney with such fantastic and unrealistic views of the past (Main Street, Indian encampments, and even Cinderella's castle) provided museums with a magnificent opportunity to use the authenticity of their own exhibited artefacts to distinguish themselves from the misuse of such historical images within a growing number of themed attractions. In Virginia, Anheuser-Busch developed the 'Old Country' theme park adjacent to its Tidewater brewery. Here, visitors from the nearby historic sites of Jamestown, Williamsburg and Yorktown could 'chill out' amidst rides and ersatz old world areas, representing Germany, Britain and France. The example of such venues cause heritage sites, particularly those nearby, to insist that however accessible they make their presentations they are in no way comparable with those of the theme park promoter. Even Williamsburg, with its view of the 1770s as if Mary Poppins had been in charge, is in a different league. It is researched, *in situ*, carefully and lovingly restored, everything that the theme park is not. The recreation has been documented, justified, debated, and rejigged to suit changing tastes and changing scholarship (Handler and Gable 1997). But for all its researched pedigree it remains essentially a visual experience for the majority of those passing through, from the visitor centre's welcoming video via the presence of the British flag over the Governor's residence to the drilling of the militia in front of the Armoury (Bryson 1990: 107–10). Text is kept to an absolute minimum. Even the student worksheets mostly involve looking for items to check off or comment upon, a strategy many will recognize from the heritage trails developed

in churches and cathedrals around Britain. The use of such 'Hunt the Artefact' lists may well engage young visitors more than a boring guided tour, but the experience is essentially visual, with minimal further engagement, being little more than magpie collecting.

Authenticity and the Tourist Gaze

Why are open-air museums so besotted with visual dimensions at the expense of other aspects of the past? Partly, this reflects their curious position at the juncture of the performing arts, scholarship and tourism. All museums have to justify their now rather old-fashioned role of preserving and extending collections, both to the general public, by making their wares more available to the public gaze, and to the rest of academia, by emphasizing the research-based nature of their activities.[2] This circle is squared by presenting an essentially visual experience ('look, don't touch'), based upon artefacts validated by in-house scholarship, implying significance beyond mere surface appearances, and distancing themselves from what detractors consider to be little more than history theme parks, a criticism to which park-based venues, such as open-air folk museums, are particularly prone (Angotti 1982: 179–88; Relph 1987: 187–8; Norman 1990). No wonder museums seek to re-establish the boundaries by emphasizing authenticity and professionalism.

The authenticated artefact still lies at the heart of the modern museum experience, though today collected artefacts are used to demonstrate particular research-based themes. In the case of open-air museums, this generally reflects their interest in the evolution of a particular area or people, in terms of settlement or emigration, both indicated through the resulting buildings. Translating such academically valid themes into visually comprehensible displays is no easy job, especially when particular artefacts necessary to display desired narratives may not be available, or may need considerable prior understanding by the visitor. Many open-air venues have attempted to address this dilemma through the provision of indoor display areas that show aspects that cannot easily be presented in landscape terms. Re-created or restored landscapes are therefore supplemented by what is effectively a more traditional museum, as at the Ulster Folk and Transport Museum outside Belfast or the Jamestown Settlement in south-eastern Virginia, so comprehensively developed that the displays do not depend upon the visitor having experienced the surrounding site. Others, as at Williamsburg, provide films and slide shows to provide the minimal historical context necessary to make any sense of the recreation, the better to enhance the visitor experience. This of course has the effect of further prioritizing the visual aspect of the main outdoor displays, which, paradoxically, moves Williamsburg towards the history theme-park end of the spectrum.

Furthermore, the growing trend to have an initial visitor reception centre reflects an awareness that the essentially visual nature of the experience alone is insufficient to address the full potential of the issues within which such artefacts are located.[3] The visual dimension, that is the layout, the physical dimensions, the scale and the colour, may be of marginal interest to the scholar but it is essential for the tourist. Indeed, the visual displays are central to the visitor experience. Most people do not visit the research centres unless corralled to do so, and pass on as quickly as possible. For most visitors, particularly for children, the museum experience is provided via the pathway through the outdoor exhibits, with scant concern for the more analytical displays of the visitor research centre, to which they only return afterwards for liquid refreshment and the toilets.

Landscape Recreation and the Visually Incongruous

For most visitors, however, the ultimate validation of open-air museums' standing remains the quality of their landscape recreations. Each building has been scrupulously rebuilt, or if one of the structures remains *in situ*, has been carefully restored, using the finest scholarship and craftsmanship available, outlined in the guidebook and on adjacent display boards. Buildings' pedigrees are more valid than individual structures and confirm the academic worth of the whole enterprise. An Irish crofter's cottage at the Museum of American Frontier Culture in Virginia has not only been carefully reconstructed but there on view is the history of the building's careful demolition, storage, and recreation in Virginia. It is almost not necessary to read the display boards, their presence alone being sufficient imprimatur. The removal of a Worcestershire farm from Norchard near Stourbridge is similarly documented. That such various buildings re-emerge in the Virginia countryside is entirely incongruous but is justified not only in terms of rescuing buildings, to illustrate people's ethnic heritage, but also in terms of enabling visitors to walk through the past, the 'unique selling point' of such venues. Indeed, the authenticity of such exhibits, despite their discrepant location, is the very reason visitors come when they could easily go to a less scrupulous, entirely tourist site, such as Busch Gardens Old Country theme park. This deliberate presentation of genuine buildings within incongruous surroundings by the museum seems strangely similar to those equally authentic Tudor mansions transferred from England to the banks of the James River by wealthy Virginia owners for reasons of conspicuous consumption, such as Agecroft Hall now in Richmond, a fifteenth-century, half-timbered manor house brought over from Lancashire to be assembled in the late 1920s by T. C. Williams Jr., heir to a tobacco fortune, within 23 acres presented in full period style.

Unfortunately, a willingness to identify with academia when necessary, to distinguish the folk museum from such wealthy vulgarities on the one hand and

from history theme parks on the other, remains coupled with a refusal to accept the full implications of the norms of scholarship. We know that Disney's views of small-town America in movies and theme parks are fanciful, and that his images of the Wild West are more dime novel than what actually happened. Indeed, when Disney tried to launch a new form of history park in northern Virginia that would adhere to scholarly norms, hardly anyone believed the corporation, and the project faltered (Wallace 1996: 159–74). But with folk parks loudly proclaiming their 'we-are-not-theme-parks' pedigree, we are entitled to ask if such sites have fully realized what this self-imposed distinction from the ephemeral and spectacular involves, or if they remain fatally committed to getting their landscapes merely to 'look right'.

History, as an academic enterprise, rather than as a synonym for the past, is a self-conscious debate about the past. It is not a monologue, but a debate about traces of the past, what we can learn from them, and how best to present our findings. As museums maintain that they adhere to mainstream scholarly norms they surely need to go beyond relying upon the supposedly self-evident nature of the landscapes they create and exhibit. If open-air folk museums are not prepared to accept that debate is central to claiming an academic imprimatur, then what they are surely engaged in is little more than the production of visually pleasing tableaux, heritage dioramas rather than history. This is not to denigrate heritage, but what is deemed appropriate for tourist display in heritage venues is less rigorously defined than in those institutions claiming adherence to the full norms of scholarship. History is a debate not just with other scholars, but also with the viewer or the reader, and such debate is not readily reduced to outdoor tableaux through which the visitor wanders as through a zoo.

Visualizing the Ulster Experience

The Ulster Folk and Transport Museum at Cultra on the eastern shores of Belfast Lough is the most established open-air museum in Northern Ireland, developed by a generation of geographers, such as E. Estyn Evans (Evans 1973) who assumed that landscapes could be deciphered for the cultures that created them, and that once recreated could demonstrate which aspects distinguish a particular heritage from those elsewhere. Though difficult, such analyses and syntheses are nevertheless deemed essentially unproblematic, establishing and sustaining a now familiar set of heritage images via a representational strategy based upon an unsophisticated empiricist view of history. Like most open-air museums, Cultra presents a synthetic, pastiche display of a cultural heritage, much like the Swedish-ness of the first folk park, Skansen. Buildings deemed typical have been brought together from across Ulster and reconstructed as cultural bastions, preserving,

sharing and creating landscapes worth seeing, experiencing, and thus worth memorialising (Hudson 1987: 113–43). The landscapes are outward and visible signs of less tangible ways of life. Evans sought to preserve and promote rural elements vanishing from Ulster. If he could not impose these rural elements upon Ulster, as De Valera tried to do in Eire, he could at least impose them upon our collective consciousness through a specifically visual genre based on the tableau. Across Europe, other enthusiasts of similarly marginalized ways of life collected ageing and often decaying buildings and brought into being folk parks that help to give visual form to images of collective pasts (Ehrentraunt 1996), but through their associations with archaeology and anthropology, areas of scholarship deemed increasingly scientific and thus supposedly value-free, such tableaux are deemed essentially unmediated, telling us 'how it is'. Now the industrial past is becoming as distant as the rural past, it too is present in the form of a relocated Belfast terrace.

Without such supposedly scientific rationales, such arrays would be but the magpie collections of antiquarians, but this was a distinctly pre-postmodern view of science, concerned with the removal of ignorance rather than with debate. Facts could be fixed, and then the debate would move on, particularly when these facts were buildings that could be seen first-hand by the visitor, as if the selective hand of the curator were not involved. There is thus no debate evident within either the created landscapes of the folk museum or in the writings of E. Estyn Evans. *Genre de vie*, *milieu*, and *personnalité* were the terms used and made visible in landscape form, terms familiar to anyone who has visited open-air folk museums anywhere. Lest such terms imply prescientific romanticism, they are sustained empirically with regional identities being indicated by artefacts created within particular milieux. This places a considerable burden of evidence upon the choice of artefacts, for the artefacts are deemed indicative of wider themes, visual metaphors for otherwise inaccessible processes. To this end, it is essential that buildings are authenticated, making the visual metaphor 'real' at the very moment the exhibit is most a product of the imagination.

Assemblages of buildings deemed to typify a nation or a province have often been criticized for being little more than historical theme parks, so an increasing number have gone beyond world-in-miniature landscapes to (re)create settings that tell a story (Norman 1990). The Ulster-American Folk Park near Omagh in County Tyrone presents Ulster's links with the New World. Its clearly recognizable narrative of explicitly authenticated, visually interesting and historically represent-ative buildings is further validated by the presence of the *in situ* Mellon family farm, the ancestral homestead of those rural Protestants who paradoxically made America industrially great. Diverse buildings brought together suggest a common-ality based in regional synthesis, a sense of place expressed visually. However, setting relocated buildings around the *in situ* Mellon farmstead confirms the

'seeing-is-believing' intuitive belief that seeing an artefact in its original location is not an interpretative process, but unmediated, unproblematic and straight-forward, a perspective that extends to the surrounding assemblage.

This folk park's basic narrative is easy to grasp: what we were, how we changed, what we became, complex processes we can immediately experience visually. Passing through this array compresses a long and complex historical process into the visual gaze of the visitor. An otherwise complex line of reasoning has been simplified enough to be represented visually and thus unproblematically. Under-standing is created through a series of visual elements to create a total framework of meaning. Across the river, the neighbouring Ulster History Museum establishes itself within the space between fact and illusion through the presentation of simulated realities, plausible, full-size replica buildings. It is the coherence of the visual narrative that is vital, for the more coherent it is, the less likely will it appear to be problematic and worth questioning. Both venues provide grand tours in miniature, confirming Ulster's own long development and its crucial engagement with first Britain and then America, relationships that are presented as self-evident rather than problematic. The visceral impact of the visual is enhanced when authenticated and three-dimensional, with each element confirming the unprob-lematic nature of its neighbour, and in turn confirmed by such familiar icons as covered wagons and country cottages, such that visitors can experience these venues as little more than a pleasant ramble around a safely accessible array of historical buildings (Merriman 1989). At the very entrance to the Ulster History Museum, the visitor centre stands like a distillery, whereas inside other equally familiar sights are immediately apparent, such as a classic Irish round tower, and a Norman motte and bailey, all incongruously standing together. More incongruity is apparent outside the main entrance where visitors encounter what the park calls a 'Portal Dolmen' which, though its detractors believe it to be misplaced, is nevertheless an image with two vital roles. It encourages an immediate identif-ication between the venue and the past, even while precluding modern forms of sectarian identification, all evident in the twinkling of even an untrained eye, on what was always seen as primarily an eye-catching tourist venue on the road from Dublin to the Donegal coast.

Even in the far west of Ulster, the Glencolumbcille Folk Museum uses local vernacular replicas to present a view of the Irish past that seems bent upon attract-ing the holidaying diaspora rather than exploring what is problematic about such seemingly authentically Gaelic, truly Irish communities. The Museum presents a seemingly timeless tableau whose presence in the contemporary landscape tells us more about the intertwining of heritage tourism with cultural politics than about the past *per se*. Scholars may debate whether Europe's periphery was ever authent-ically Celtic, but with the provision of thatched cottages, seeing is believing. The visual trumps the analytical yet again.

Across the Atlantic, there is competition for the tourist dollar from promiscuously yet explicitly exploited images from the past, or at least from the movies. In response, the Museum of American Frontier Culture in the Shenandoah Valley, in Staunton, Virginia, presents the museum world's equivalent of the 'Old Country' theme park's concern for those traditions that moved into Virginia during the colonial period, providing instead an array of authenticated buildings from Germany, Ulster and England, leading to the final exhibit, an American farm (Mills 1997). In this, the museum prides itself in following the International Committee for Archaeological Heritage Management (ICAHM) requirement that 'presentation and information should be conceived as a popular interpretation of the current state of knowledge, and . . . be revised frequently' (ICAHM 1993). However, although newly arrived buildings are brought to life using the latest reconstruction and presentation techniques, the museum has no interest in challenging visitors' preconceptions about frontier life through exposure to *new* historical scholarship (Mills 1996b). Artefacts are offered to trigger folk memories, with no recognition of inevitable deformations (Kennedy 1993; Sollors 1989). Replicas and reconstructions invite visitors to conflate artefacts with the events they represent, even while they transmit not the event itself but one particular representation of it.

Although critiques of such conflations are commonplace among literary scholars, museums pride themselves on the professional codes of those historians for whom the notion that 'every decoding is another encoding' is but philosophical whimsy. Problems of representation cannot be sidestepped so easily. If we say that historical processes generated particular buildings, which we then use to represent emigration or the Western frontier, we are asking such relics to act as traces rather than as metaphors. But physical fragments, large or small, remain signs, representations of some larger whole, wherever and however displayed: how much more so when relocated, repositioned, or amalgamated with other buildings and contents in arrangements never previously extant. Such assembled fragments of the past are given a privileged status, confirming an empirical connection between a past situation (colonial days) and a present experience (being an Ulsterman/Irishman/American), even when discontinuities between artefacts are elided, and when the amalgam created is totally synthetic. The use of authenticated buildings in particular enables curators to act as if representational problems should be of no concern to them, despite exercising a display aesthetic where their full-scale dioramas must not just be right, but look right too. Are their artefacts not real, rather than metaphorical, representational, or virtual? Even where they are replicas, the high level of authenticated skill and research used to create them makes them appear real, looking 'as good as new'. The high value we place on sight over the other senses, even common sense, again means that the visual is given priority over other aspects of experience, however useful extras such as the smell of peat fires

or the sound of the furrier's hammer on the anvil may be. This means that the tourist gaze is far more crucial in validating these sites than scholars sympathetic to challenging the authentic images derived from popular culture may want to admit. Such modern open-air sites are to be commended for developing presentational strategies that value accessibility. In harnessing the goals of public education, however, such venues are concerned more with the norms of heritage, rather than with the requirements of history. Such venues provide an essentially aesthetic experience rather than a taste of either life as lived in the past or any appreciation of the way in which such displayed items are far from unproblematic.

The lauded authenticity of the buildings at such sites suggests not a present-day collection of images, but a penetration through to the past. The exhibits are not of this age but of another, revealing the past unmediated, unadulterated by the misconceptions and the mythologizing of popular culture (Anderson 1984). The clutter of the past is presented in an orderly and hence comprehensible manner, the only issue being the most efficacious presentational strategy. The open-air museum is no place for postmodernist angst. Such venues do not seek to challenge visitors' preconceptions through exposure to the unfamiliar fruits of new scholarship about the past (Lowenthal 1989: 115–27). Instead, such venues offer a direct visceral engagement with the past itself, an opportunity to look at how buildings actually were, rather than how the movies or advertising might otherwise present them. In challenging the misconceptions of an almost totally visual medium, the movies, such museums thus provide not a debate about the past but a pathway taking the visitor around a series of structures that are experienced to the extent that they are seen, rather than built, lived in, or even merely touched. Of all the senses, it is sight that is most engaged.

History, Heritage and the Tourist Gaze

These various open-air folk museums clearly illustrate both the promise and the limitations of professing to be part of academia while presenting a genre-specific form of historical narrative. The documented authenticity of individual artefacts is used to confirm the worth of the assemblage, which together forms a landscape that is greater than the sum of its parts. Landscape remains an essentially visual construct even when no longer restricted to the familiar two-dimensional representation of three-dimensional space (Cosgrove 1984). In museums' synthetic landscapes, the flood of authenticated details appears to confirm that what is being experienced is unmediated historical research of the first order, even while there is no trace of debate. As with most television documentaries, museum narratives are essentially engaged in something else. Artefacts are self-evidently more vital

than scholarly debate. Such venues both encourage and then sustain an over-reliance upon the visitors' concern for surface description, even while presenting the past as a sophisticated series of outdoor dioramas. The unwillingness to provide alternative scenarios with an over-reliance upon an essentially visual construct, landscape, means that such museums essentially engage in heritage tourism.

Reasons for folk museums' conservative presentational strategies are varied. Following the French Revolution, galleries increasingly presented former aristocratic collections for public view. Although the royal collection of paintings by Rubens and Breughel in Brussels has become subject to the public gaze, the canvases remain essentially within the traditional mode of presentation, items left to hang on the wall and speak for themselves. As public galleries increasingly presented artefacts as well as paintings, three-dimensional items were presented in much the same kind of way, with information necessary only to confirm the authenticity of the item on display, and never such as to rival the artefact for the attention of the visitor. Any scholarly debate about artefacts was thus kept away from the artefacts themselves, as if they were little more than three-dimensional paintings. Part of the horrified response to the 1991 Smithsonian Institution's presentation of paintings about the American West was due not just to the deconstructionist material provided on accompanying boards, but to the fact that *any* text had been provided, for to historicize such exhibits was to threaten the idea that works of art were merely for aesthetic appreciation. Those who do challenge the purely aestheticist approach and wish to historicize their exhibits tend to do so by stealth, mainly by providing alternative links from the objects to wider debate over their significance. Many galleries, such as the Sainsbury wing of the National Gallery in London or the newly redeveloped Gemäldegalerie in Berlin-Tiergarten, offer both the inquisitive scholar and the neophyte access to computerized images of important pictures, which are then historicized and deconstructed, within metres of the original items, but safely removed into another room, so as to avoid interfering with the aesthetic contemplation of the authenticated original artefact.

The French Revolution's centralism also helped to stimulate local anti-metropolitan nationalisms, which have often come to be expressed within the various attempts across Europe and beyond to preserve, if only in cultural zoos, the folk traditions threatened by globalizing modernity. So in their folk museums, the Danes laud their refusal to be subsumed within a German *Volk* despite military defeats, the annexation of southern Jutland, and finally, occupation. Their museum landscapes were deliberately constructed as outward and visible signs of their resistance, architectural norms Danes can emulate in their everyday environments. Likewise, the Norwegians celebrate their separation from Denmark, while the Swiss celebrate their independence from everyone. Such rationales have harnessed the study of folk cultures to very specific political agendas, seeing folk parks more

as centres of national celebration than as centres for the critical analysis of cultural change. As centres promoting particular cultural agendas, such sites encourage their national publics to visit more in the spirit of national exuberance and pilgrimage than that of dispassionate scholarship.

So, although open-air folk museums might initially appear quite different from art galleries, in that they seem to provide a totally contextualizing array within which any one artefact is displayed, on closer investigation, most folk museums operate like outdoor galleries, letting the artefacts individually and together speak for themselves, so that the visitor has an almost totally aesthetic experience of each item and of each assemblage, rather than a historically contingent experience.

Beyond the Merely Visual: Open-Air Museums and Beyond

It has long been argued that to be concerned with the visual is to be overconcerned with the literally superficial, merely the gloss upon reality. Whether such surfaces are indeed merely ephemeral or alternatively the 'outward and visible sign' of deeper truths, remains problematic. There is a widely held presumption that by its very nature the tourist venue provides little more than a superficial experience, catering to what can be photographed, but little more. Even restaging, although seemingly based upon what seems to be historically authentic, is, in practice, judged upon aesthetic grounds, so much being omitted. The visiting tourists, on the other hand, see only what they want to see, expectations overwhelming all other facets. Museums claim to stand against such a promiscuous gaze, being committed to other more substantial and worthy concerns, even while seeking to be included on the grand tour. For the curator who can spend a lifetime contemplating and studying the museum's artefacts, the visible surfaces may well be merely clues to more fundamental processes, but to the passing visitor the overall impression of a venue is what remains most valid (Merriman 1989), and in open-air museums what remains are authenticated buildings combined to recreate a landscape from the past, something that cannot be discerned elsewhere for all the 'noise' created by the present.

Standing on the uneasy ground where academia and mass society meet, the modern open-air folk parks, given their visible similarities with history theme parks, understandably seek to develop a distinctive stance by identifying with most, if not all, aspects of academia. For all their archival facilities and authenticated buildings, such sites are, in the landscapes for which they are most known, inherently unable to demonstrate scholarship's most fundamental expectation: debate openly acknowledged, invited and addressed. They thus sidestep scholarship's central axiom: that knowledge is always contingent and subject to revision. Instead, folk parks have concentrated upon visual tableaux of authenticated

buildings,[4] maintaining that in so doing they are scholarship's public face, synthetic landscapes emerging from first-class, modern scholarship. While this is consistently so in terms of practical rescue, preservation and display aesthetics, open-air (and most indoor) museums singularly fail to present our knowledge of the past as contingent. Furthermore, the use of authenticated artefacts implies an unmediated visitor experience. This is both theoretically and practically impossible. In addition, concern for the authenticity of their display artefacts leads curators into a form of vulgar empiricism whereby, in seeking to side-step ideological or at least theoretical issues they believe would confuse or alienate their visitors, they fall prey to promoting older discredited paradigms, rural-agrarian fantasies and, in effect, heritage rather than history.

Heritage venues are almost entirely focused upon the provision of a sense of identity in terms of an essentially visual experience. Where that visual experience does not fully exist, or does not exist in such a fashion as to be quickly assimilated by the uninitiated visitor, subtle visual traces may have to be made more explicit. This can be done in at least two ways: by providing an enhanced experience, as with restoration, so that what had been evident is now readily available for modern scrutiny, or by supplementing what remains with a suitable replica. Archaeological remains are notoriously difficult to make accessible. The general public would flee from any venue that resembled an archaeological journal. The remains unearthed at Coppergate in York (now the Yorvik heritage site) illustrate the problem, one possible solution and the problematic nature of such responses. The site was immensely popular even while excavation was being undertaken, visitors flocking to the viewing stand. Subsequently, patrons have been able to visit an adjacent recreation of the site, and to leave via a mock-up of the original dig, all recently much enhanced. The contrast between the three-dimensional tourist site and the almost two-dimensional dig is striking and deliberate. Once the passage of time has squashed remains into almost indecipherable layers, the skills to envisage what they represent are difficult and time-consuming to develop, far beyond what can reasonably be asked of any tourist. The three-dimensional recreation, being visual, auditory and even olfactory (including added smells to remind people of the omnipresent cesspit), essentially reanimates the flattened past, even while being presented as a replica. Yorvik thus contains most of the elements seen and critiqued in open-air museums, the definitive narrative, the visual experience, and the tourist shop, but it seeks to show how this image has had to be created by the archaeologist from what little has survived. It thus suggests that the reconstruction is not definitive, but partly imaginative.

Indoors, the York exhibition has developed strategies that could equally be used in open-air museums and that help critics to respond to the inevitable frustration expressed by open-air museum curators. Insisting that a commitment to academic

norms requires exhibits to be forever open and contingent could become a recipe for never doing anything. But the recognition that all artefacts are contingent, all interpretations are partial, and what is visually available is not necessarily the most vital, is no merely philosophical whimsy. Such postmodern awareness requires that museums publicly question their assumptions about the innocence of what specific representational genres can and cannot do. The representational dimension of artefacts needs to be addressed rather than sidestepped. Exhibits and displays could suggest a dialectical rather than a finite relationship with museums' central concerns.

Alternatively, this might mean having to challenge the belief that such museums are best located within academia rather than within tourism. It might mean that the instability of meaning is addressed by moving the central focus of the visitor experience away from the outdoor exhibits, with more concern for seeing such displays as merely one more form of representation. The Nottingham tourist attraction 'The Tales of Robin Hood' presents a fascinating look at the many and varied ways in which tales of outlaws and Sherwood Forest have emerged from movies, chansons, tall tales, folk stories and songs. In its section, 'Case for Robin Hood', it even has academics talking about their spin on Robin Hood. Rooted in a recognition that even in Nottingham people today will most likely arrive at an interest in Robin Hood through television and the movies rather than through folk tales or university courses, it invites visitors to choose whose Robin Hood they find most interesting. With a variety of visual images, ranging from mediaeval manuscripts to Hollywood posters, such venues suggest that the visual is not necessarily static, a given or even superficial, for contrasting images demonstrate the need for the visitor to be more than a voyeur, to become engaged with the competing concerns behind the various images. The instability of meaning is thus used to good effect, not sidestepped.

This chapter has argued that, as centres of scholarly research, open-air museums are particularly vulnerable to an overconcern for what is easily made visible, to the exclusion of the most important feature of scholarship, that is, debate over the very nature of evidence and the contingency of any findings. Fortunately, there are some indications that a concern for the visual within modern heritage sites, such as Yorvik, does not have to mean either dumbing down or a retreat from modern scholarship. However, it remains remarkable to what extent folk museums seem unwilling to address the symbolic use to which their essentially visual displays are inevitably put. So long as open-air museums remain wedded to the visual delights of their synthetic landscapes as required by their roles as heritage (and thus tourist) sites, they will never be able to address the contingent nature of their exhibits, preferring to present definitive narratives that ignore modern scholarship, becoming, paradoxically what they so earnestly seek to avoid: history theme parks.

Notes

1. There are, however, increasingly prestige venues such as the new National Museum of Scotland in Edinburgh or the Smithsonian Institution in Washington, DC, that have display areas large enough to present buildings indoors, whether a Highland croft or a southern shack, a small-town post office or a mine pump house. Outdoor folk museums remain, however, the usual venue for displays based around buildings, and remain the only venue for any display necessitating an array of such structures.
2. Even within popular culture, the museum's reliance on academics rather than on business executives is recognized, as in Thomas Harris's film *Silence of the Lambs* (1984) where the Smithsonian expert on Sumatran moths disparages a co-worker for not having a PhD and thus self-evidently not being a fully fledged member of the museum's research team.
3. Navan Fort in County Armagh had a spectacular 'Iron Age' visitor centre to attract the site-bound visitor precisely because there was actually so little to see of the fort unless the visitor had been suitably prepared to interpret what did survive underfoot.
4. Even venues such as Ulster-American Folk Park are not averse to confusing the two occasionally. Amidst the genuine buildings of the Ulster display, the chapel is actually a replica that combines elements from a variety of sites, although it is doubtful whether visitors actually notice amid the plethora of genuine structures. All the American structures are replicas.

References

Anderson, J. (1984), *Time Machines: The World of Living History*, Nashville, TN: American Association for State and Local History.

Angotti, T. (1982), 'Planning the Open-Air Museum and Teaching Urban History: The United States in A World Context', *Museum*, 34: 179–88.

Bryson, B. (1990), *The Lost Continent*, London: Abacus.

Cosgrove, D. (1984), *Social Formation and Symbolic Landscape*, London: Croom Helm.

Dickens, C. (1969), *Hard Times*, Harmondsworth: Penguin.

Ehrentraunt, A. (1996), 'Globalization and the Representation of Rurality: Alpine Open-Air Museums in Advanced Industrial Societies', *Sociologia Ruralis*, 36, 1: 4–26.

Evans, E. E. (1973), *The Personality of Ireland: Habitat, Heritage and History*, Cambridge: Cambridge University Press.

Greenhalgh, P. (1988), *Ephemeral Vistas: The Expositions Universelles, Great Exhibitions and World Fairs, 1851–1939*, Manchester: Manchester University Press.

Handler, R. and Gable, G. (1997), *The New History in an Old Museum*, Durham: Duke University Press.

Harris, N. (1973), *Humbug: The Art of P. T. Barnum*, Chicago: University of Chicago Press.

Horne, D. (1984), *The Great Museum: The Re-Presentation of History*, London: Pluto.

Hudson, K. (1987), 'The History and Customs of the Homeland', in K. Hudson, *Museums of Influence*, Cambridge: Cambridge University Press.

ICAHM (International Committee for Archaeological Heritage Management) (1993), 'Article 7: Presentation, Information, Reconstruction', *Antiquity*, 67: 402–5.

Kennedy, L. (1993), 'Ethnic Memory and American History', *Borderlines*, 1, 2: 130–41.

Lawson, M. (1999), 'Building a Metaphor for the Future: Berlin has a new Reichstag and Jewish Museum. Only One is a Hit', *Guardian* (European edition), 13 November: 8.

Lowenthal, D. (1989), 'Pioneer Museums', in W. Leon and R. Rosenzweig (eds), *History Museums in the United States*, Urbana: University of Illinois Press.

Merriman, Nick (1989), 'Museum Visiting as a Cultural Phenomenon', in P. Vergo (ed.), *The New Museology*, London: Reaktion Books.

Mills, S. F. (1990), 'Disney and the Promotion of Synthetic Worlds', *American Studies International*, 28, 2: 66–79.

Mills, S. F. (1992), 'The Contemporary Theme Park and its Victorian Pedigree', in S. Ickringill and S. F. Mills (eds), *Victorianism in the United States: Its Era and Legacy*, Amsterdam: VUP.

Mills, S. F. (1996a), 'The Presentation of Foreigners in the Land of Immigrants: Paradox and Stereotype at the Chicago World Exposition', in M. Materassi and M. Santos (eds), *The American Columbiad: 'Discovering' America, Inventing the United States*, Amsterdam: Free University Press.

Mills, S. F. (1996b), 'Imagining the Frontier', in P. J. Davies (ed.), *Representing and Imagining America*, Keele: Keele University Press.

Mills, S. F. (1997), *The American Landscape*, Edinburgh: Keele University Press.

Norman, P. (1990), *The Eighties, the Age of Parody*, London: Hamish Hamilton.

Relph, E. (1987), *The Modern Urban Landscape: 1880 to the Present*, Beckenham Kent: Croom Helm.

Rydell, R. W. (1984*), All the World's A Fair*, Chicago: University of Chicago Press.

Rydell, R. W. (1993), *World of Fairs: The Century-of-Progress Expositions*, Chicago: University of Chicago Press.

Sollors, W. (1989), 'The Invention of Ethnicity' in W. Sollors (ed.), *The Invention of Ethnicity*, New York and Oxford: Oxford University Press.

Wallace, M. (1996), *Mickey Mouse History and Other Essays on American Memory*, Philadelphia: Temple University Press.

–5–

British Photographers and Tourism in the Nineteenth Century: Three Case Studies
Robin Lenman

This essay examines the work of a number of commercial photographers in relation to three British 'landscapes of leisure' between the 1850s and 1914. The selected regions are Scotland, parts of which were already among Europe's most popular tourist destinations by the mid-nineteenth century; the River Thames from its upper reaches above Oxford down to Staines, which by the 1870s was changing from a commercial waterway into a pleasure zone for urban excursionists; and England's south-western tip: the Isles of Scilly and Cornwall between the Lizard Peninsula and Land's End, where tourism was gradually developing by about the 1880s. The photographers are the famous Aberdonian George Washington Wilson (1823–93), who turned from painting to photography in 1852 and founded a business of international scope and importance; Henry Taunt (1842–1922) of Oxford, a figure of regional significance whose heyday spanned the last three decades of the century; and the first two generations of the Gibson family of Scilly and Penzance: John Gibson (1827–1920) and his sons Alexander (1857–1944) and Herbert (1861–1937), who created a local firm that still exists today. The regions offer interesting contrasts, not only in size, character and rhythm of economic development, but also in the 'place-myths' associated with them. The photographers can thus also be compared in illuminating ways, both in the scope of their operations and the expectations they had to satisfy – and helped to create – and the business strategies they employed in a highly competitive market.

If the sources on nineteenth-century tourism are patchy and often difficult to interpret (see Benson 1994: Chapter 4), the same is true for commercial photographers, including those discussed here. Substantial numbers of pictures survive for all of them, but Wilson and Taunt are otherwise only thinly documented; although the former's friend and sometime collaborator, the Aberdeen bookseller George Walker, vividly recorded their early photographic tours together in his journal[1] and Taunt's picture registers ('number books') and the manuscripts of some of his lectures and publications also still exist.[2] The Gibsons seem to have left no business records at all but a major and hitherto virtually untapped source for these and many other photographers is the mass of photographs registered between

1862 and 1912 under the 1862 Copyright Act and held in the Public Record Office (PRO) at Kew.[3] This collection raises some puzzling questions: in particular, why certain photographers, including Wilson, registered pictures regularly and copiously while others – not only medium- and small-sized firms like Taunt, Gibson, and Sutcliffe of Whitby, but also big names such as J. Valentine and F. Frith – did so much more sparingly or not at all. However, the PRO files contain thousands of remarkable images, provide valuable chronological data, and offer fascinating glimpses of competition in action: between Cornish photographers for dramatic shipwreck images, between Wilson and Valentine for views of remote St Kilda, and among practically everyone, amateurs included, for sellable pictures of royalty.

Since the appearance of Roger Taylor's pioneering monograph (1981), G. W. Wilson's importance as a landscape photographer has been widely recognized, and in recent years more has been written about him, relating his activities in detail to both photography and tourism in Scotland (Durie 1992, 1997; Withers 1994; McKenzie 1997). Here, therefore, it is only necessary to make a few key points about him, mainly for comparison with Taunt and the Cornish photographers. From a humble rural background in Banffshire, Wilson nevertheless managed to train as an artist and in 1849 set up in Aberdeen as a portrait miniaturist. In 1852, he moved into portrait photography, and two years later was commissioned by Queen Victoria to photograph the new castle of Balmoral under construction. He also met Walker, who encouraged him to experiment with stereoscopic views of places around Aberdeen, and became one of his first distributors. The popularity of these early pictures and royal requests for more views led Wilson to specialize in landscape photography, while continuing the portrait business as a source of regular income. Within a few years, competition encouraged him to expand his operations and, in 1861, an invasion of England took him as far south as Cornwall. By the mid-1860s, the firm was turning out more than half a million prints a year and by 1876, when Wilson opened a large new production plant on the outskirts of Aberdeen, it had probably reached its peak, with a considerable labour-force, sophisticated equipment and a distribution network extending throughout Britain and abroad. Its thousands of views were available as paper 'view scraps' in various formats and as stereo cards, lantern slides and tipped-in illustrations for books published in association with the London firm of Marion. By 1887, however, when Wilson handed over management to three of his sons, decline was setting in and continued despite various reorganizations after Wilson's death in 1893. In 1908, the firm's assets, including some 65,000 negatives, were auctioned off at knock-down prices.[4] As Durie remarks (1992: 96–9), it is hard to explain this failure precisely; other large firms like Frith and Valentine kept going, but competition, some commercial misjudgments and the replacement of stereo- and lantern-slide-

viewing by new forms of commercial entertainment were clearly part of the answer.

As Taylor points out, Wilson turned to landscape photography at an ideal moment (1981: Chapter 5). Scott Archer's recently perfected wet collodion process made it possible, with relatively short exposure times, to capture masses of fine 'Pre-Raphaelite' detail, to which albumenized printing paper could do full justice. Brewster's hand-held stereoscope, introduced in 1849 and soon an indispensable drawing-room item, was generating stupendous demand for photographic images, especially views. By the 1850s, too, Scottish tourism was booming (Durie 1994; Gold and Gold 1995). Even before 1800, a combination of Ossian-mania and Continental war was encouraging travellers to go north. But it was the extraordinary Walter Scott phenomenon in all its manifestations – including George IV's visit to Edinburgh in 1822, stage-managed by Scott – that laid the foundations for a whole industry. The publication of Scott's *The Lady of the Lake* in 1810 started an immediate rush to the Trossachs, and the Scott mystique persisted, also for increasing numbers of Americans, well into the second half of the century. The visit of Queen Victoria (also a Scott enthusiast) in 1842 and her later purchase of the Balmoral estate – which was vital for Wilson, as we have seen – gave another big boost to tourism. There was also the impact of steamers, railways and entrepreneurs like Thomas Cook, who conducted his first 'Tartan Tour' in 1846 and 20 years later was reported as having brought 3,000 visitors from the English Midlands in a single week (Durie 1994: 496; Gold and Gold 1995: Chapter 5).

As well as creating a visual taxonomy of emerging 'Royal Deeside', Wilson in the early part of his career also exhaustively covered the established sites of Scottish tourism: Abbotsford, Melrose and other places along the Tweed; Loch Lomond, Loch Katrine and the Trossachs; and Glencoe, Oban and the inner Hebridean islands of Mull, Staffa (with Fingal's Cave), and Iona. Although he and his assistants also roamed much further afield, north and south of the Border, interest in these locations remained so intense that they were often rephotographed as continual contact-printing wore out the original plates, or to match new viewpoints captured by competitors. Today, Aberdeen University's computerized Wilson catalogue lists no fewer than 88 images of Abbotsford, 139 of Balmoral, 198 of Loch Katrine and 252 of Braemar. Like others who created literary or visual representations of nineteenth-century Scotland, Wilson must be regarded as both a beneficiary and a promoter of tourism. Contemporaries certainly regarded him in this way; the free travel passes, hospitality and other favours pressed on him during his picture-making tours by steamer companies and the like suggest that Walker's claim, in his 1893 obituary, that his friend by mid-career 'had done more for opening up Scotland generally, than Sir Walter Scott had done for the Trosachs [sic]' was not just funereal rhetoric.[5]

Doubtless, Wilson's photographs succeeded with the public to the extent they did because, in important ways, they replicated the tourist experience. Even before, for example, Staffa hove into view around the Western tip of Mull the average visitor, guidebook in hand, would have absorbed pages of historical, geological and botanical information, plus lines from Wordsworth, lines from Scott and purple-prose descriptions by previous travellers (for example, *Black's Guide* 1854: 9–12). As with the sight, so with the photograph: 'reading' it was a dynamic process to which the intentions of the photographer and the cultural equipment of the viewer both contributed. So, no doubt, Roger Fenton's sombre photograph *Shadow of the Valley of Death* of 1855 derived much of its impact from Alfred Lord Tennyson's *Charge of the Light Brigade*, published the previous year. Sometimes, the photographer supplied the allusions himself: Wilson's 1868 Trossachs album, for instance, juxtaposed 12 tipped-in images with lengthy quotations from *The Lady of the Lake*. Inevitably, however, and even when viewed stereoscopically, a photograph left much to imagination and memory. This was certainly true by comparison with paintings, especially with the intensely coloured, illusionistic works of artists like John William Inchbold, John Brett and John Everett Millais in the orbit of Pre-Raphaelitism (Bartram 1985: Chapter 3). The sensory gulf between even the finest albumen print and an actual landscape (or, indeed, human body) was far greater. Walker, in the Hebrides with Wilson in July 1860, was at first reluctant to make the boat-trip from Iona to Staffa, having already seen so many pictures of the latter, including stereographs (Figure 5.1). His subsequent description reveals how *un*like a photograph it really was:

> When about a mile distant I began to perceive that [Staffa] was not pure black and white, but that bands and patches of colour came gleaming out, where I did not expect any, and my wonder and admiration increased with every stroke of the oars, and now I grew more and more delighted and astonished with its vastness, and also with the beautiful and harmonious tints of the lichens, which covered the basaltic pillars, and their blending into the green herbage on the top and the purple tint of the sea beneath, arising from the tangle [of seaweed]. (Walker 1884–c. 1910: 290)

In this way, the viewer's task of adding the necessary historical, literary and scientific associations was augmented by that of 'correcting in', from actual experience, all the sense-impressions of a real scene.

But if some of the discrepancies between image and reality derived from the medium's limitations, others were there by design. Like many view-photographers then and since, Wilson 'gardened' his foregrounds for pictorial effect and sometimes manipulated the negative to add or suppress detail (Durie 1992: 99). More significantly, however, his photographs of the classic sights tended to abstract them from the flux of time and change, presenting them to the viewer in an isolated,

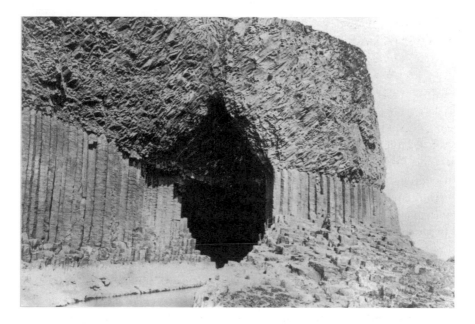

Figure 5.1 G.W. Wilson, *Fingal's Cave, Staffa*, c. 1865. (Photo: author.)

denatured form rather like botanical specimens (see Edwards 1996). Not only rural poverty but also signs of modernity and industrialization were eliminated as far as possible. As his pictures of, for example, the Forth Bridge under construction demonstrate, Wilson was as interested in technological progress as anyone else, but in Scotland's tourist fantasy-landscapes it was out of place. Thus, as McKenzie (1989) has noted, Wilson's coverage of Loch Katrine ignored the huge engineering project, carried out in stages between the mid-1850s and 1877, to pump pure Trossachs water from the lake to Glasgow which in due course was photographed by Thomas Annan and T. A. and J. M. Gale. Cook, by contrast, in his 1861 Scottish guide hailed it as 'a great work of noble enterprise and scientific skill . . . to quench the thirst, clean the outer man, and supply the culinary and sanitary necessities of Glasgow' (*Cook's Scottish Tourist Official Directory* 1861: 51). Another unwelcome reminder of the workaday urban world from which most tourists came was, of course, the presence of other tourists. Even if, objectively, tourism was often a collective experience, the subjective illusion of contemplating the hallowed monument or sublime landscape alone – John Urry's 'Romantic-exclusive' gaze (1990: Chapter 3) – was potent. Although the conceit of simultaneously being a tourist and despising other tourists recurs throughout modern travel literature, it was nicely articulated in a book exactly contemporaneous with Wilson's early views: *In the Wild Hebrides,* by the surgeon Walter Dendy. Before describing the

stupendous scenery of the Sound of Mull, Dendy (1859: 3) devoted two whole pages of his slim volume to denigrating various types of English tourist on the steamer, from (supposed) drunks and vandals to 'the *petit-maître* from London town, the mere routine excursionist, the slave of the guidebook, decked out in all the exuberant fashion of Regent Street'. Then, on Staffa: 'It is almost profanation to herd with a group of idlers or sightseers, "each the other's blight", who follow slavishly in the wake of the conceited guide, and return quite content at having walked along the causeway of Fingal's Cave' (Dendy 1859: 34). At sunset, finally, en route from Canna back to Arisaig, with dolphins, whales and myriad seabirds disporting themselves all around, he doubly enjoys the marvellous sight because the other passengers are at supper ('feeding') below decks (Dendy 1859: 62). Although Wilson's townscapes and sporting scenes are necessarily full of people, his set-piece souvenir views are often either empty or contain only one or two diminutive figures to indicate scale, thus speaking to the viewer as a solitary presence. Since the tourist and photographic seasons in Scotland precisely coincided, such a *mise-en-scène* required a deliberate plan either to work at first light or to dodge tourist groups. So, on the Staffa expedition already mentioned, as Walker recalled, 'The day passed busily, and quickly, and while the passengers from the steamer streamed over the place we had a hearty mid-day meal, resuming our work when they left' (1884–c. 1910: 290).

Henry Taunt's career was similar to Wilson's in many respects (Graham 1973; Brown 1973; Read 1989). It began, after he set up independently in 1868, with an heroic pioneering phase during which he both created a portfolio of Oxford pictures and spent the summers, with one or two assistants, camping out in a specially adapted skiff and prospecting for views along the Thames and Avon. He also created an effective distribution network and eventually, in 1889, set up a factory-like production centre between Oxford and Cowley. By this time, his writing and publishing activities meant that much day-to-day picture making was being done by assistants, and in the years before the First World War (which terminally weakened the business) the firm extended its geographical reach by acquiring picture stocks from other companies. Compared with Wilson & Co., however, which by 1900 had photographers working for it as far afield as South Africa and Australia, Taunt's scope was far narrower, with some coverage of the country between the Thames and the South Coast but most of his efforts concentrated on the Thames Valley itself and adjacent areas.

As we shall see, Taunt eventually had to face increasingly fierce competition, but this followed a long period of prosperity during which he was the Thames's premier photographer. Taunt's success was based on expanding tourism in Oxford, Windsor and along the river, and this was itself made possible by other changes. When Taunt, still a photographer's apprentice, made a first, rather hair-raising boat

trip upstream from Oxford to Cricklade in the winter of 1859, barge traffic was being killed by railway competition and the waterway was neglected and weed-grown, with dilapidated locks and weirs, uncontained flooding and little life apart from the occasional eel fishery or rustic ale house.[6] A decade later, a new era had begun, largely because the jurisdiction of the Thames Conservancy, created by Parliament in 1857 to manage the river below Staines, had been extended in 1866 to cover the entire 'Upper Navigation' to the source. Despite limited resources, the Conservancy was eventually to succeed, by efficient management and systematic renewal of the infrastructure, in transforming the Thames from a watery wilderness into a safer, cleaner and much more accessible resource. Recreational activity expanded accordingly, further boosted by improved rail links to London. Whereas in the early 1860s, when Lewis Carroll was rowing his little friends on picnic expeditions up and down from Oxford, pleasure boating was rare and localized, by 1889, when Jerome K. Jerome's bestselling novel *Three Men in a Boat* appeared, there were thousands of craft in use (and registered by the Conservancy), ranging from steam launches to houseboats, skiffs and scullers. At peak periods, popular spots like Boulter's Lock near Maidenhead – like similar places on the Seine – presented a spectacle, often depicted by painters and illustrators, of mass leisure on an unprecedented scale. 'In these days of brain fag and nerve strain', commented one guidebook, 'who does not turn lovingly to the broad bosom of good old Father Thames, there to rest and recreate at will? There is no restorative in the pharmacopeia like an up-river holiday' (*The Royal Thames Guide* 1900: ii). (The book also noted the growing numbers of Americans, a sure sign of a maturing leisure zone.) Boat racing, too, at Oxford and Marlow, attracted increasing crowds and publicity, and the July regatta at Henley, held annually since 1839, developed into an international fashionable sporting occasion.

Taunt's response to all this was to turn himself into a kind of one-man tourist industry. Meanwhile, cashflow was maintained by portraiture, and other commissioned work – 'Oriel Wine Club', 'Pony, chaise and 5 ladies & gents [at Wycombe Abbey]', 'Mr Comin's sailing boat sail hoisted', etc.[7] – for a wide variety of clients; and Taunt, a staunch Tory, also became photographer-in-attendance at Disraeli's house-parties at Hughenden in Buckinghamshire. For a time, he even ran a bicycle-hire business. In 1871, he gave the first version of an illustrated lecture that was to be repeated many times, in and around Oxford and at the London Polytechnic, in which he deployed his talent as an entertainer, using sophisticated projection equipment – also available for hire – and a sequence of hand-coloured slides to create a beguiling picture of boating on the Thames.[8] The following year saw the publication of Taunt's book-format *New Map of the Thames*, based on a survey done by himself, illustrated with tiny tipped-in photographic views, and full of information for oarsmen, anglers and campers (Read 1989). This work, which went through six editions by 1897 and became popular on both sides of the

Atlantic, inaugurated a long series of publications, including maps, regatta plans, and guidebooks relating to Oxford, the Thames, the Cotswolds and places even further afield. Illustrations were drawn from Taunt's stock of landscapes, which numbered about 3,000 by 1874 and grew by another 50,000 over the next 30 years. In addition to its Oxford 'core', the collection came to include early-1860s shots of the 'old' river with its antediluvian characters and archaic tackle; vistas of the great reaches at Henley and Cliveden; slices of *paysage intime* ('bits'); and views of quiet corners of Windsor or Eton; and the new pubs, hotels and boatyards springing up in response to tourism. Although many serene images were taken from Taunt's boat or secluded camping spots when no one was about, fun was as central to the experience of the modern Thames as solitude to that of the Trossachs or the Hebrides: hence the numerous images of 'the crush' at Henley or Boulter's Lock, not only for their pictorial interest but, as Jerome K. Jerome indicated, because the dolled-up Sunday crowds, squashed into boats or parading along the towpath, offered rich pickings for the enterprising photographer (1957: 170–2).

As with Wilson's photographs, however, a good deal of sensory information was missing from Taunt's pictures, especially smells. In the 1850s, Oxford, Reading and other towns discharged their sewage straight into the river, so that locks became solid with effluent; with putrid animal-carcasses adding to the stench, the nastiness must often have been indescribable (Luckin 1986, especially Chapters 1, 4, 7; *Parliamentary Papers* 1866). Although the Conservancy worked hard at the problem, threatening offenders with legal action and extending its powers along tributaries up to ten miles from the Thames, it was a slow process, and in 1866, the year of a serious cholera outbreak in London, its engineer alarmed a Parliamentary Select Committee by producing a bottle of noxious fluid from Teddington Lock (*Parliamentary Papers* 1866: 64, §§1263–6). A scene in Jerome's *Three Men in a Boat*, in which a dead dog floats by as river water is being brewed for tea, suggests continuing concern a quarter of a century later (1957: 130), but there is no hint of this either in Taunt's images or, more surprisingly, in his tips for prospective holidaymakers.

There was no sign, either, of other conflicts of interest being fought out along the Thames: between municipalities, industrialists, water companies, 'riparian' landowners and the growing numbers of town dwellers coming to fish, boat, ramble and generally disport themselves. In legal terms, the Thames was a minefield, as public-access litigants like the Commons Preservation Society and the Thames Rights Defence Association found in cases to do with use of backwaters and towpaths and, above all, angling rights. Underlying these often arcane matters, however, were larger questions about the redefinition of a natural resource, with an emerging mass society in the background. Riparians, understandably, resented encroachment on their space and protested about noise, trespass, drunkenness, indecency, vandalism and the bad examples set to local villagers. The perpetrators,

claimed Sir Gilbert East, bart., landowner, magistrate and Old Etonian, in 1884, belonged to 'a class of savages born on purpose' (*Parliamentary Papers* 1884b: 205, §2790). Inevitably, the borderline between holiday exuberance, low-level criminality and irregular class warfare was and is hard to define. The Conservancy, although it increasingly regarded itself as representing the public, had few funds for litigation and tended to treat riparians with exaggerated respect, 'for', commented its Vice-Chairman, Admiral Sir Frederick Nicolson, 'they are very thorny customers, are riparian owners' (*Parliamentary Papers* 1884a: 20, §217). All in all, the issues here were probably not very different from those relating to regions like the Lake District or the Norfolk Broads. But London's proximity made them much more pressing: hence the appointment of another Select Committee in 1884, and the passage of the 1885 Thames Preservation Act, to create a framework for the river as 'a place of regulated public recreation' (Woodgate 1888: 324). In fact, the new legislation sidestepped most of the arguments about private rights, although it addressed some public-order matters and improved protection for fish and other wildlife. In any case, as already indicated, Taunt's images of carefree anglers and picnickers revealed no more about current conflicts than the proverbial twentieth-century holiday brochure. Nor did his portraits of lock-keepers, many of them his friends, show the tensions within the Conservancy, which was run on authoritarian lines by ex-naval officers whose men worked long and unsocial hours, often in primitive and isolated locations, for extremely low pay (Berkshire County Record Office 1910–11).

By 1906, when he left his city-centre premises and began to trade exclusively from Cowley, Taunt was facing much greater competition than he had 30 years earlier. There were now many more maps and guides on the market, as well as publicity material produced by steamer and railway companies, and many new photographers to illustrate them. New methods of photomechanical reproduction, mass-produced picture postcards produced by proliferating British and foreign firms, and practices of amateur photography (guidebooks now routinely noted hotels with darkrooms) were rapidly eroding the position of the classic landscape print. This intensified Taunt's longstanding rivalry with the big national companies, each of which had a sizeable foothold on his home turf. He had to compete with them head on in terms of price and quality, and his picture registers ('number books') indicate that in the 1900s he, or more probably his assistants, spent much time 'scent-marking' core territory with new views of familiar subjects rather than venturing further afield. Yet being an established local figure had important advantages. If Wilson's or Valentine's men could easily descend, for example, on Oxford and photograph it end to end, it was harder for them to locate the choice 'bits' of river landscape that constituted much of Taunt's output. Local events had always been good earners, especially the big Oxford regattas, Torpids and Eights, that Taunt photographed from his own barge on the Isis. These were large-group

sporting and social occasions involving some of the wealthiest young people in the land – 'the noblest of England's sons and the fairest of her daughters', as Taunt sentimentally described them[9] – and guaranteed to generate plenty of direct and indirect business: hence his bulldog-like determination to defend his copyright in the courts.[10] Fairs, militia parades, druidic gatherings, and political rallies at Blenheim Palace were further examples of the kinds of happening that kept a reputable, well-connected local tradesman (as Taunt always regarded himself) going.

Like Scotland, West Cornwall was discovered as a tourist destination before 1800, but the growth of a serious tourist industry was slow, even after the completion of the Tamar railway bridge (and an immediate visit by Cook) in 1859 (Thornton 1997; Payton 1992: Chapter 5). An important late nineteenth-century stimulus was the Great Western Railway, which introduced an overnight service from London to Penzance in 1877, opened the Tregenna Castle Hotel in St Ives the following year, and in 1904 launched the Cornish Riviera Paddington-to-Penzance express. This cut journey time to seven hours, and over the next decade, boosted by imaginative publicity, helped to increase passenger revenues by over 70 per cent (Thornton 1997: 67). By the turn of the century a lively debate was going on about tourism's role in Britain's first postindustrial region, given the catastrophic decline of Cornish mining. Cornwall's late start encouraged the airing of such modern questions as the drawbacks of a seasonal service sector and the dangers of over-development. In 1898, for instance, a Scottish correspondent of the *Cornish Magazine* pointed a warning finger northwards, where 'once the whole land smiled, [but] now you see nothing but rows of villas backed by railway embankments' (Findlater 1898: 235). Before the 1920s, however, tourism's impact was probably small. For reasons of cost and distance, visitors tended to belong to a social elite: Leslie Stephen and his family, for example, at St Ives, and the headmaster of Cheltenham College and assorted senior clergy at Sennen. There were also well off vacationers from other parts of Cornwall, such as the Spurway family, outfitters of Liskeard, whose photograph album records holidays in Scotland and the Lake District as well.[11] Such 'summer people' often stayed for weeks or months, perhaps bought pictures from the St Ives and Newlyn painters, and possibly ventured on a trip to Scilly. But their numbers were hardly such as to transform the region's culture and economy.

From at least as early as the mid-1840s, photography was quite widely known and practised in Cornwall, thanks to regional art schools, the Art Union of Cornwall and, especially, the Royal Cornish Polytechnic Society at Falmouth (see Thomas 1988: 12–23). But business conditions were different from those in more populous and heavily frequented parts of Britain, and photographic firms in Hugh Town, Isles of Scilly, Penzance, Helston or even Falmouth were local or subregional in

scope. They also faced early competition from the big up-country companies, Valentine – whose 1886 catalogue contained a set of West Cornwall and Scilly slides (*Catalogue of Photographic Publications* 1886: 50) – Frith and Wilson; and even Taunt descended on Falmouth and the Lizard in the mid-1870s.[12] Some locals found it worthwhile to retail pictures by the 'nationals', among them the capable Scillonian landscape and bird photographer Charles King, who represented Frith (*Kelly's Directory* 1996: 1271). King was also a flower dealer and chemist; his rivals, the Gibsons on Scilly and the mainland, were telegraph agents and purveyors of fancy goods, and an earlier Penzance photographer, Annie Allsop, not only sold Frith views but traded as a book- and music-seller, stationer and proprietor of a circulating library (*Harrod's* 1878: 901). As with small operators elsewhere, diversification was essential for survival.

Nevertheless, like Taunt with his Eights Week pictures, alert locals could tap sources of income denied to outsiders. Some of these derived from bread-and-butter tasks: studio portraiture, works photographs for prize-winning local boot factories and, probably in the Gibsons' case, recording Newlyn paintings before their despatch to exhibitions in London or Birmingham. (An attractive studio image of two old fishwives posed against a painted seaside background suggests an interesting relationship between photographers and artists.)[13] Arguably, however, some individuals used their local knowledge to exploit one of a range of perceptions of 'the West' – others related to a healthful subtropical paradise, or a Tennysonian Lyonesse – that were establishing the region as a 'peripheral' destination dramatically different from the urban and suburban 'centre'. This was the image of Cornwall/Scilly as a region of untamed nature, barely containable by progress and civilization. One manifestation of it was the ubiquitous painting, stereograph or postcard of spectacular Atlantic weather.[14] Another was an event-picture of a particular kind, the shipwreck photograph.

Images of shipwreck were guaranteed to have a strong impact. At the most prosaic level, maritime accidents were a matter of ongoing public concern, fuelled by alarming statistics: nearly 25,000 deaths, for example, occurred in British-registered vessels worldwide between 1875 and 1883 alone (*Reports from Commissioners* 1885: 1). At the same time, mass-circulation illustrated papers vividly conveyed the drama of individual events by means of wood-engravings and, eventually, also photographs. In the half-real, half-mythical background were retellings of Grace Darling's heroic exploit of 1838 and the shipwreck scenes in popular classics like Charles Kingsley's *Westward Ho!* (1855), with their didactic undertones of Providence and divine retribution. As far as the West was concerned, although it hardly had a monopoly on disaster, the waters around Scilly, Land's End and the Lizard had a particularly grim reputation, thanks to the proximity of major shipping lanes, the prevalence of storm and fog, and a 'weather kitchen' created by gales and currents. Guidebooks supplied names, dates, casualty figures,

dramatic narratives of wreck and rescue, and spine-chilling evocations of the fatal sites. Murray's 1872 *Handbook for Travellers in Devon and Cornwall*, for example, described the rocks off Annet Head, Scilly, as 'objects picturesque and pleasing to tourists wafted round them by a summer breeze, but as terrible when beheld white with foam and cataracts of raging water from the deck of some luckless vessel driving towards the land' (Murray 1872: 475).

Also significant was the Cornish variant of the semi-allegorical shipwreck painting associated with mid-Victorian celebrities like Clarkson Stanfield, whose melancholy image of a derelict ship, *The Abandoned*, first shown in 1856, had been acclaimed by both Ruskin and the public (*Great Victorian Pictures* 1978: 93). At the turn of the century, in his Cornish phase, the Northumbrian artist Charles Napier Hemy produced three equally desolate post-wreck paintings, *Lost*, *Wreckage*, and *Birds of Prey* (*Charles Napier Hemy* 1984: 49, 54). Before this, many comparable pictures had been painted by the Newlyn artists, whose influence on Cornwall's image was all the greater because they exhibited at mainstream venues like the Royal Academy and the Royal Institute of Painters in Watercolour (see Cross 1994). In the decade between 1883 and 1894, Walter Langley, one of the Newlyn colony's first members, did a series of harrowing large-format watercolours with depressing literary titles like *But Men Must Work and Women Must Weep* (Kingsley) and *Never Morning Wore to Evening, but Some Heart did Break* (Tennyson) (Langley 1997). However, the most celebrated Newlyn picture, shown at the Royal Academy in 1888 with a lacrimose Ruskin text, was Frank Bramley's *A Hopeless Dawn*, which reworked the familiar theme of a young fisherman's wife being comforted by an older woman so effectively that it was bought for the Tate Gallery (*Frank Bramley* n.d.: 32–3). The impact of this and similar images was greatly increased by reproduction, not only in art journals but also in mass-circulation papers like *The Graphic* and *The Penny Magazine*.

If these pictures mostly evoked the tribulations of poor seamen and fisherfolk, real events often involved people with whom affluent potential tourists could identify. On 8 May 1875, for example, the German liner *Schiller*, inbound from the US, struck the Retarrier Ledges off Scilly and sank with the loss of some 300 lives. The event attracted enormous attention on both sides of the Atlantic and continued to generate stories for months as bodies drifted ashore, monuments were erected and boards of inquiry convened. Other incidents involving large passenger ships included the stranding of the American liner *Paris* on the south-eastern Lizard in May 1899 and of White Star's *Suevic*, at the peninsula's very tip, in March 1907. In these cases, fortunately, no lives were lost. However, over 100 had drowned when the liner *Mohegan*, miles off course, had struck another of the Lizard's deadly reefs, the Manacles, on 14 October 1898.

For much of the period covered by the PRO copyright files, local photographers depicted the aftermath of these and other episodes, plus related subjects such as

lifeboat launches and the new Wolf and Bishop lighthouses. Given local conditions, many of their photographs were not only difficult but dangerous to obtain, demanding technical skill, nerve, agility and considerable local knowledge (Figure 5.2). As wrecks usually occurred in inaccessible places and broke up rapidly, only locals had much chance to record them. (The exception was the *Paris*, which remained beached for six weeks, enabling professionals and amateurs from as far afield as Birmingham to photograph her).[15] The main players were the Gibsons, William Harrison of Falmouth and A. H. Hawke of Helston, although Hawke seems not to have registered his pictures. John Gibson's photograph of the *Schiller* victims' mass grave – the ship had vanished – was one of the earliest of a long line of shipwreck-related images that continued up to the *Suevic* and beyond. The PRO files suggest that 1898/9 was particularly rewarding. Both Harrison and Herbert Gibson registered pictures of the *Paris*, the former catching several magnificent shots of the vessel being towed off to Falmouth for repair.[16] Harrison also took two photographs from seaward of what remained of the *Mohegan*: one probably soon after the wreck, and the other the following May, also showing the *Paris* a short distance further inshore.[17] In the meantime, Alexander Gibson had taken to the water to record the steamer *Blue Jacket* wedged beside the Longships lighthouse off Land's End.[18]

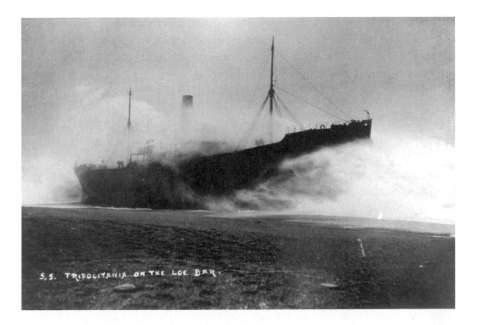

Figure 5.2 A.H. Hawke, *S.S. Tripolitania ashore near Porthleven* (Photo: author.)

A poignant and much-publicized detail of the *Mohegan* disaster was the fact that the ship had hit the rocks after passing the Manacles bell-buoy, and Harrison manipulated the negative to 'move' it into both his pictures. The symbolism of doom thus evoked was more explicitly conveyed in an article in the *Cornish Magazine* soon after the wreck:

> And when the sounds of that bell came in the landward breeze to where I stood looking across the reef they seemed, not a message of warning to those who cross the deep, but as the death-knell of the hundreds of men, women and children who have breathed their last in the sea around the Manacles . . . In wintry days, when the grey-backed sea roars amongst the rocks; through the peaceful hours of starry nights; and in the summer when the sapphire sea reveals the masts of lost vessels deep down, it will toll on and express something of the desolation of homes in England and America and of the sorrow of a thousand broken hearts. (Bluett 1989: 416)

Two of Alexander Gibson's pictures appeared as illustrations (with one by Harrison and another by Burrow of Camborne), showing battered lifeboats and wreckage from the *Mohegan* strewn along the shore. Not included, however, were at least six other Gibson photographs registered in the same month that captured macabre scenes of tragedy and death: corpses loaded onto carts and laid out, unshrouded, in St Keverne church, a crowd peering into the mass grave, and the funeral ceremony in heavy autumn rain, half-hidden behind a cluster of umbrellas.[19] Though hardly suitable for the average album, these images, as Michael Hiley has pointed out, were on sale in Penzance soon after the events (Hiley 1983: 44). It is almost as though Gibson – not only with these but with other photographs he made between the mid-1880s and 1914 (see Cowan 1997: plates 32, 37) – wanted to represent Cornwall's perilous coast as a landscape of terror.

Several conclusions emerge from this study. In the first place, as other writers have argued, commercial-view photographers played a significant role in the promotion of nineteenth-century tourism. Broadly speaking, success entailed anticipating the public's taste and, by extension, adhering to visual conventions already established by painters and illustrators. This in turn involved a succession of complex, if largely automatic, choices relating to composition, viewpoint and lighting, occasionally followed by 'post-production' manipulations, in order to eliminate social and environmental eyesores, perspiring tourists and other unpoetic realities. Many of the resulting pictures clearly match the modern conceptualization of tourism as a journey 'from world to world', from the safe, familiar and prosaic to the perilous, exotic or even sacred (for example, Graburn 1977). Although more and more travellers could count on hot and cold water and a *table d'hôte* at their chosen destinations, some of these seemed, nevertheless, to be on the very rim of workaday reality, borderlands between garden and wilderness. Photographers' task was to communicate the lure of these places, and sometimes to discover them. Gibson

clambering over the Lizard, Wilson on the beetling cliffs of Skye or Orkney and, in a more minor key, Taunt capturing the 'fairyland' of hoar-frost along Port Meadow, were in the business of making spines tingle in Hampstead or Edgbaston, in anticipation or recollection. (Popular literature doubtless had comparable effects, Sir Arthur Conan Doyle's 1912 novel *Hound of the Baskervilles*, for example, in relation to Dartmoor.) Business, undoubtedly, was paramount. Although many wet-plate views are remarkably beautiful – especially by comparison with the mass-produced postcards of the 1900s – and Wilson for one deserves the description 'artist', they were essentially commercial products: something as obvious to a photographer embarking on a strenuous field trip as to any professional fisherman or prospector. (Walker was apt to tot up the over-the-counter yield of a day's shoot in hard cash.)[20] Finally, it is particularly important to emphasize the effect of competition on commercial photography, above all between large and small enterprises. This, of course, is part of a broader theme, emerging since the mid-nineteenth century: the rise of big, heavily capitalized firms, national or international in scope, and the ability – or not – of smaller, more localized operators to survive alongside them. From this perspective, a Taunt picture of skaters on the Cherwell, or a Gibson wreck-photograph, may be regarded, like a hand-built sports-car, as a niche product dependent on unusual qualities for its survival in the marketplace. In places like West Cornwall, where all the businesses were small, such imperatives helped to shape the image of an entire region.

Notes

1. Manuscript volumes in Aberdeen Central Library (ACL), together with a range of Wilson's albums of views. Although Walker only began to write up his journal after his wife's death in 1884, it was based on detailed earlier notes and probably also letters. (See Walker 1884–c. 1910: 3135A-B.)
2. Available at the Centre for Oxfordshire Studies, Oxford (COS), with a large collection of Taunt pictures.
3. See PRO, Copy 1 series (registers) and Copy 3 series (boxes of loose registration forms with attached prints). Michael Hiley used this collection for his study (1983).
4. See sale catalogue, 9–11 July 1908, in Aberdeen University Library, Department of Special Collections and Archives: MS 3125/12/1-2. Lot 463 was a folding camera designed for tropical use.
5. ACL: [George Walker], 'In Memoriam. George Washington Wilson 1822 [sic]-1893', *Brown's Aberdeen Book-Stall*, 16 (12 April 1893), pasted into Walker 1884–c. 1910: 3137A; obituary: 3220B.

6. COS: Taunt 18, 'Up the Thames in the Christmas holidays' [c. 1910]. On the Victorian Thames, see Walker 1957; Bolland 1974.
7. COS: Taunt 195, number book.
8. COS: Taunt 178, lecture notes.
9. COS: Taunt 178: 36–7.
10. COS: Taunt 168: Opinions of the press 1868-78: *Times* cutting, 11 April 1871.
11. Centre for Cornish Studies, Redruth (CCS): Spurway album.
12. COS: Taunt numbers book 190-2, nrs. 3,400-3,500.
13. CCS: unnumbered horizontal album.
14. It would be interesting to know whether Frith's *Rough sea: Hell Bay [Bryher], Scilly*, registered in 1894 (PRO: Copy 3/215/1), which appeared in guidebooks for decades, was taken by King, who marketed similar subjects under his own name.
15. E.g. PRO: Copy 1/441: 4 stereographs by John Place of Birmingham, registered 6 July 1899.
16. PRO: Copy 1/440, Box 1, pictures registered 22 and 26 May 1899; Copy 1/441 (14 July 1899).
17. PRO: Copy 1/440, Box 1 (29 June 1899).
18. PRO: Copy 1/438, Box 1 (11 and 14 Nov. 1898).
19. PRO: Copy 1/438, Box 2 (21 and 24 Oct. 1898).
20. ACL: Walker, *Journal*, pp. 272, 291.

References

Bartram, M. (1985), *The Pre-Raphaelite Camera: Aspects of Victorian Photography*, London: Weidenfeld & Nicolson.

Benson, J. (1994), *The Rise of Consumer Society in Britain 1880–1980*, London and New York: Longman.

Berkshire County Record Office, Reading (1910–11), D/TC 132: Lock-Keepers' Sub-Committee: Précis of Visits to Keepers of Locks and Weirs and Ferrymen.

Black's Guide to Staffa, Iona, Glencoe and the Caledonian Canal, &c. (1854), Edinburgh: Black.

Bluett, A. (1898), 'Around the Manacles', *Cornish Magazine*, I: 403–16.

Bolland, R. R. (1974), *Victorians on the Thames*, Tunbridge Wells: Midas.

Brown, B. (ed.) (1973), *The England of Henry Taunt, Victorian Photographer*, London: Routledge.

Catalogue of Photographic Publications Comprising 14,000 Views of the Finest Scenery in Scotland and England, by Valentine & Sons, Photographers, Dundee (1886), Dundee: J. Valentine.

Charles Napier Hemy R. A. 1841–1917 (1984), Newcastle on Tyne: Tyne and Wear County Council Museums.

Cook's Scottish Tourist Official Directory (1861), Leicester: Cook.

Cowan, R. (1997), *A Century of Images: Photographs by the Gibson Family*, London: A. Deutsch.

Cross, T. (1994), *The Shining Sands. Artists in Newlyn and St Ives 1880–1930*, Tiverton: Westcountry Books.

Dendy, W. (1859), *In the Wild Hebrides*, London: Longman.

Durie, A. (1992), 'Tourism and Commercial Photography in Victorian Scotland: The Rise and Fall of G. W. Wilson & Co., 1853–1908', *Northern Scotland*, 12: 89–104.

Durie, A. (1994), 'The Development of Scotland as a Tourist Destination', in A. V. Seaton (ed.), *Tourism: The State of the Art*, Chichester and New York: Wiley.

Durie, A. (1997), 'Tourism and photography in Victorian Scotland: The Contribution of George Washington Wilson', in *By Royal Appointment: Aberdeen's Pioneer Photographer George Washington Wilson 1823–93*, Aberdeen: University of Aberdeen.

Edwards, E. (1996), 'Postcards – Greetings from Another World', in T. Selwyn (ed.), *The Tourist Image: Myths and Myth-Making in Tourism*, Chichester: Wiley.

Findlater, Miss J. H. (1898), in 'How to Develop Cornwall as a Holiday Resort. Opinions of eminent Cornishmen and Others', *Cornish Magazine*, 1: 235.

Frank Bramley R. A., 1857–1915 (n.d.), Lincoln: Usher Gallery and Lincolnshire County Council.

Gold, J. R. and Gold, M. M. (1995), *Imagining Scotland: Tradition, Representation and Promotion in Scottish Tourism since 1750*, Aldershot: Scolar.

Graburn, N. H. H. (1977), 'Tourism: The Sacred Journey', in V. L. Smith (ed.), *Hosts and Guests: The Anthropology of Tourism*, Philadelphia: University of Pennslyvania Press.

Graham, M. (1973), *Henry Taunt of Oxford: A Victorian Photographer*, Oxford: Illustrated Press.

Great Victorian Pictures: Their Paths to Fame (1978), London: Arts Council.

Harrod's Devon and Cornwall 1878 (1878), Norwich: n. p.

Hiley, M. (1983), *Seeing Through Photographs*, London: Gordon Fraser.

Jerome, J. K. (1957), *Three Men in a Boat*, London: Penguin.

Kelly's Directory of Cornwall 1893 (1996), Redruth: Cornwall Business Systems (available as CD-ROM).

Langley, R. (1997), *Walter Langley, Pioneer of the Newlyn Art Colony*, ed. E. Knowles, Bristol and Penzance: Sansom & Co. and Penlee Gallery.

McKenzie, R. (1989), 'Problems of Representation in Early Scottish Landscape Photography', in M. Hallett (ed.), *Rewriting Photographic History*, Birmingham: Birmingham Polytechnic.

McKenzie, R. (1997), 'George Washington Wilson and the Victorian Landscape Aesthetic', in *By Royal Appointment: Aberdeen's Pioneer Photographer George Washington Wilson 1823–93*, Aberdeen: University of Aberdeen.

Murray, J. (1872), *Murray's Handbook for Travellers in Devon and Cornwall*, 8th edn, London: John Murray.

Luckin, B. (1986), *Pollution and Control. A Social History of the Thames in the Nineteenth Century*, Bristol and Boston: Hilger.

Parliamentary Papers: Reports from Committees 1866/12: Minutes of Evidence Taken Before the Select Committee on the Thames Navigation Bill (1866), 6 June (S. W. Leach).

Parliamentary Papers: Reports from Committees 1884/16: Minutes of Evidence Taken Before the Select Committee on the Thames River Preservation (1884a), 2 May.

Parliamentary Papers: Reports from Committees 1884/16: Minutes of Evidence Taken Before the Select Committee on the Thames River Preservation (1884b), 13 June.

Payton, P. (1992), *The Making of Modern Cornwall: Historical Experience and the Persistence of 'Difference'*, Truro: Dyllansow Truran.

Read, S. (1989), *The Thames of Henry Taunt*, Gloucester: Sutton.

Reports from Commissioners, Inspectors and Others 1884/5, vol. 35: First Report of the Royal Commission on Loss of Life at Sea (1885), 20 Feb.

Taylor, R. (1981), *George Washington Wilson, Artist and Photographer 1823–93*, Aberdeen: Aberdeen University Press.

The Royal Thames Guide Illustrated (1900), 3rd edn, London: Simpkin.

Thomas, C. (1988), *Views and Likenesses: Photographers and Their Work in Cornwall and Scilly 1839–70*, Truro: Royal Institution of Cornwall.

Thornton, P. (1997), 'Coastal tourism in Cornwall since 1900', in S. Fisher (ed.), *Recreation and the Sea*, Exeter: Exeter University Press.

Urry, J. (1990), *The Tourist Gaze: Leisure and Travel in Contemporary Societies*, London: Sage.

Walker, G., (1884–c.1910), *Journal*, manuscript volumes in Aberdeen Central Library.

Walker, G. E. (1957), *The Thames Conservancy 1857–1957*, London: Thames Conservancy.

Withers, C. (1994), 'Picturing Highland Landscapes: George Washington Wilson and the Photography of the Scottish Highlands', *Landscape Research*, 19: 68–79.

Woodgate, W. B. (1888), *Boating*, London: Longmans.

–6–

Artists as Drivers of the Tour Bus: Landscape Painting as a Spur to Tourism
Peter Howard

The academic interest of geographers in the visual arts has been very considerable in recent years, although this builds on a tradition that dates back at least to the 1930s with the work of Vaughan Cornish in Britain (Cornish 1935). The visual nature of geography has been heavily underlined by geographer artists such as Ewart Johns (1955) and by the work of Jay Appleton (1975) largely in the 1970s. Since then the work has been caught up in the broader sweep of cultural geography (Cosgrove 1984; Cosgrove and Daniels 1988; Daniels 1993; Matless 1998). Indeed, the distinction between this geographical work and that coming from the 'new art history' is sometimes not immediately obvious. This chapter comes from a different tradition, and a fundamentally geographical one, for it is primarily a cartographic exercise, based in a tradition that involves the location of pictures in both time and space, through graphs and maps, and of analysing the results (Howard 1991, 1999).

Such an approach has the advantage of avoiding the bias wrought by art-historical canons of quality. Whatever the criteria used by art connoisseurs and historians to decide what art survives and what does not, the relationship between the work and place is not foremost among them. This can lead to serious distortions. For example, the qualitative significance of Thomas Gainsborough and John Constable, as well as of the Norwich school, could easily lead to a presumption of the popularity of East Anglian landscapes in the eighteenth and nineteenth centuries, but this would be completely false, for those places only achieve some, quite modest, popularity after the First World War (Howard 1991: 152).

To investigate the subtle relationships of artistic perceptions to touristic pre-dilections, this chapter examines the landscape paintings exhibited at the Royal Academy of Art's Summer Exhibition in London. First, some of the historical trends of artists depicting various places are examined, showing that artists' preferences have indeed shifted dramatically over time, and concluding that artists have pioneered landscape preferences, which later became more widely popular. This part is followed by a discussion of landscape painting in the 1990s, and some tentative forecasts as to future, evolving landscape tastes are offered.

This chapter looks at the English artist working abroad and especially on the European continent (for English artists working in the British Isles, see Howard 1983, 1991). One of the enormous advantages of landscape paintings, prints or photographs is that they are produced and exhibited in great numbers, and that most of them are place-specific, so that quantitative evidence is at least a possibility. Many pictures are either imaginary or a collage of many places but a large number are intended to represent the artist's experience of a particular place at a particular time.

Most countries have exhibitions such as that of the Royal Academy (RA) which have been running for many years (in this case since 1759) with few changes of rules, accompanied by published catalogues throughout that period. So it is fairly easy, if time consuming, to map all the places mentioned in the titles of works, and a one-fifth sample of these names forms the source of the maps in this chapter.

However, these maps and graphs are constructed from written catalogue entries, (Graves 1907; Royal Academy of Arts 1981) and that brings with it a reliance on the artist's choice of title and on the cataloguer's correct transcription. Titles such as *Landscape* are of little help, and some place names defied all attempts to find them. Also, both the size of the exhibition and the very popularity of landscape itself as a subject matter have varied considerably over time, so the statistics relate to proportions of total landscapes. The prestige and significance of the Royal Academy itself has fluctuated (Howard 1991: 4). Art historians might blanch at the idea of treating all work exhibited at the RA as of equal quality. Nevertheless, one might conclude that most of the landscape works exhibited are depictions of named places that were judged sufficiently attractive to merit depiction by an artist of sufficient merit to be worthy of hanging by the committee. If this were a small numerical source with subtle variations over time, the dangers of relying on this evidence would be considerable, but there are about 75,000 titles of landscape work in this study, and the variations in places and subjects depicted are so dramatic that there can be little doubt as to their general validity. The analysis of this material was a major function of a research project that forms the basis of many of the assertions in this chapter (Howard 1983).

In what follows, I offer snapshots of selected quarter-century periods to highlight continuities and changes in artistic (and touristic) preferences over a timespan of almost 200 years. I will consider the years 1800–24, 1850–74, 1900–24 and 1950–80 as representative case studies of larger trends.

1800–24

The first map (Figure 6.1) shows a one-fifth sample of all the locatable landscape pictures exhibited at the Summer Exhibition between 1800 and 1824. This was a

period when some of the artistic tours in Britain had become very well worn (Andrews 1989). In fact, most of these pictures from the continent were from the last decade of that period, as the Napoleonic Wars had restricted foreign travel. Almost all the pictures from northern Europe were post-Waterloo, most depicting the built environment, typically port scenes from Antwerp to Calais, and town-scapes along the Seine, especially Rouen and Paris (including paintings by Richard Parkes Bonington and J. M. W. Turner). What is remarkable is the tight con-centration on two areas of the rest of Europe: Italy and Switzerland (except for a few pictures of Greek classical sites at the time of their war of independence). An earlier map would show the overwhelming dominance of pictures from the Italian Grand Tour, but during this period, interest in Italy was largely restricted to Latium and the Campania, with few works even from Florence or Venice. The focus of artistic activity was Rome, with visits out to Subiaco, Lakes Albano and Nemi, Tivoli and other local sites, of classical rather than Renaissance significance. Artists then often added a short stay in Naples, though in some fear of disease, to depict Vesuvius, Pompeii and other classical sites.

The other destination was Switzerland, which had not figured significantly on an eighteenth-century map. Artists, such as Francis Towne or John Robert

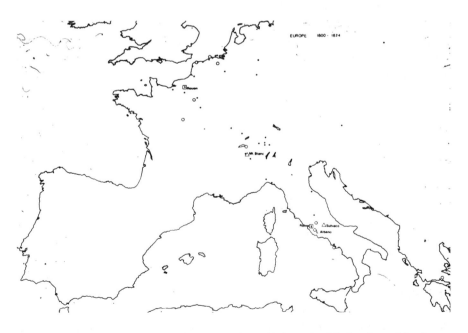

Figure 6.1 Royal Academy Pictures 1800–1824. Map. A 20% sample of the locations of the pictures of continental European landscapes hung at the RA Summer Exhibition.

Cozens became, almost for the first time, interested in mountains (Nicholson and Nicholson 1959), and also loved to depict Chillon Castle on Lake Geneva, famous for its spine-chilling qualities, which itself formed the archetype of many pictures done back at home. Turner depicted the site in 1809 (Wilton 1982: pl.13). There are many castles overlooking lakes in North Wales (Dolbadarn is a particular example) that acted as surrogate Chillons back at home. In Devon, Walmesley painted Okehampton Castle and gave it an entirely imaginary lake of its own (Howard 1991: 73; Somers-Cocks 1977).

This artistic legitimation, which arose out of the singling out of certain places as attractive and measuring other sites against these privileged places, is one of the principal effects of the artist-tourist. When Turner visited the Tamar, he declared the New Bridge at Gunnislake to be the most Italian he had ever seen (Thornbury 1877: 143) and his *Crossing the Brook* (1812, National Gallery, London) includes a splendidly Italian tree. Not only were buildings in the style of Greece and Rome to be built back at home, but the genres and landscape features found elsewhere were transferred to a home situation. The Devonshire clergyman and amateur artist John Swete found that a certain bridge reminded him of Claude, whereas the coast near Torquay was a Salvator Rosa (Swete 1790–1804, v.2: 82; v.9: 152). The whole town of Torquay was later to be built in the likeness of Italy, palms and all. Indeed, so many bays in southern England were likened to the Bay of Naples (including Mount's Bay, Torbay, Minehead Bay and Weymouth Bay), that it would be interesting to discover what was wrong with those that were not. Areas of steep roads and hills became linked with Switzerland, as did parts of Exmoor near Lynton, as well as Suisse Normande in Orne, and the Sächsische Schweiz on the Saxon-Bohemian border. Today, many of our coastal caravan sites ape the architecture of the Costa del Sol so this process of legitimation continues.

1850–74

During this period, larger exhibitions contained a greater proportion of landscape work than before, with more being of named places. During the eighteenth century, almost half the landscape pictures had not been identified by location. A half-century on, there were also many additions to the map (Figure 6.2). Indeed, the entire pattern of changing taste seems to be an additive process. New places are added to the lexicon, new landscape features become fashionable, but only rarely are places or features discarded: they merely become *passé*. We keep discovering new things and places to like, without discarding old favourites. No one really finds Clovelly, to take an obvious English example, actually ugly, merely that its charms become overblown, overvisited and belong to another era (Bradshaw 1954: 45). So destinations, and even subject matter, become linked to a particular time.

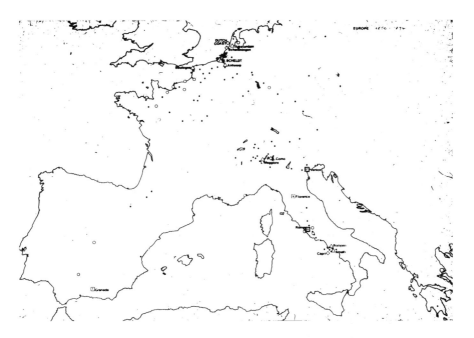

Figure 6.2 Royal Academy Pictures 1850–1874. Map. A 20% sample of the locations of the pictures of continental European landscapes hung at the RA Summer Exhibition.

The interest in northern France (there still being scarcely any interest in the southern half of France) has, in this period, spread westwards, but it was still largely concerned with great buildings, the chateaux on the Loire, Mont St Michel, or the cathedrals of Bayeux or Rouen. On the coast, this interest merged with the attraction of port scenes. Similar scenes were found in a long belt stretching through Belgium to their greatest centre in the Netherlands, with pictures of fishermen and coasts at Scheveningen being reminders of the Dutch seventeenth-century school as well as of the Romantic importance of the sea at this time.

Two great inventions made a profound impact on the artist tourist. One was the photograph, which after 1850 was frequently employed as a sketch, if not as a finished product. The comparative speed of the camera matched the new speeds available via the steam engine, both in marine and railway use. The start of railway-based tourism produced a reaction against it (Blaikie 1885). Artists themselves by this time would probably get to the continent by steamship, often via Dieppe, but predominantly to Antwerp and off down the Rhine, a trip that was traced by William Thackeray in his 1850 novella *The Kickleburys on the Rhine* (Thackeray 1903). Indeed, the Rhine Gorge became one of the great sites of mid-century, and artists found themselves working in picturesque small towns such as Boppard or throughout newly fashionable Bavaria. Tourists who had visited the

RA or other exhibitions might be indignant upon reaching the Ehrenbreitstein that the 'lying painters paint it just three times as high as it is', as Charles Kingsley wrote in a letter (Massingham and Massingham 1967: 78). The amusements of travel in Germany were by now greater than the frustrations, if Richard Doyle is to be believed (Doyle 1904). Further south still, Alpinism remained important, although artists were now as likely to travel a little further, across into the Italian Alps and Lakes as well as the to Swiss ones, as did John Ruskin.

Mention of Ruskin brings us to Venice, which became part of a newly independent Italy during this period, and was at last an artistic hot spot of enormous importance. The Italian Tour, perhaps no longer so grand, had developed to include four major centres, though it remained firmly urban. The Venetian interest was clearly focused on the Grand Canal and St Mark's, whereas there were more vernacular scenes in Florence. Interest in Rome and its countryside had expanded to include Renaissance buildings and especially gardens, as well as classical sites, and a new interest was developing in Naples Bay. This comprised pictures from Capri and Amalfi, where the interest was not archaeological, be it classical (as at Pompeii) or Renaissance, but more of an entirely nineteenth-century Romantic interest in the Italian way of life in these villages. Pictures typically include local vernacular housing, the sea, fishing boats and rural staffage. We have here the beginning of the Mediterranean Coast View, a genre that was to become dramatically important to the arts in the twentieth century and thence to the tourism industry. Elsewhere, the interest remained largely of great buildings or architectural ensembles (for example, Moorish views from Granada, Seville and Toledo). Egypt and the Holy Land became popular, although the interest was still confined to the depiction of great monuments, such as the Sphinx, and to religious subjects, such as those by William Holman Hunt; it did not extend to genre scenes, although Edward Lear was beginning to develop this field.

1900–24

Fifty years later, the geographical pattern is similar but there are also some highly significant changes. The greatest shift of perception of home landscapes, the discovery of the dreary landscapes of fen, marsh and bog (Rodee 1977) seems not to have had a great impact on foreign scenes. This is odd, as that new taste had been learned largely from the French painters working around Barbizon in the Forest of Fontainebleau to begin with (Howard 1991: 107). Abroad, the English artist still sought the Sublime, the Picturesque and the Romantic. Before the First World War, there was quite a vogue for visiting the romantic towns of southern Germany, most notably Rothenburg-ob-der-Tauber and the villages of the Black Forest, as recorded by Jerome K. Jerome in his novel *Three Men on the Bummel*

(1900). The long-established fascination with townscape (especially port and canal scenes) in the Low Countries declined dramatically after the First World War, but the emphasis on many such views in northern France dates precisely from those years, with the addresses of the artists including military ranks. Some seem to have been working when in reserve or back from the line at such towns as Equihen and Montreuil, but much of Normandy was also popular, following on from travel practices of late nineteenth-century French artists, at such art colonies as Honfleur. One is tempted to infer that the professional artists had now largely abandoned that kind of townscape, but that the genre lingered with the gentlemanly amateurs of the officers on leave.

The new preference for fishing harbours, usually at small ports on rocky and rough coasts, is significantly different from earlier interests in harbours. In Brittany, as at home in Cornwall, fishing villages seem to provide the dignity of labour, which was such a feature of the time (Watson 1882). Almost any fishing hamlet on the Western seaboard now had its artistic devotees. In the south of France, the Mediterranean coast scene arrived from its original home in the Bay of Naples, whence it had spread to the Riviera di Levante in Liguria and to Taormina in Sicily, as well as to Provence, but this coastal interest is significantly different in mood from its northern counterparts. If the Breton fishing scene praises the dignity of the hard-working fishing community in the face of danger, the Mediterranean offers a glimpse of a hedonistic lotus land (see also Lübbren in this volume). During the succeeding decade, this was to become the most frequented haunt of English artists overseas as well as of many of the artistic elites of Europe and America, and as much a focus as Rome had once been. However, there is only a slight hint of such scenes being found across the Spanish border in the Costa Brava. The interest in the inland parts of Provence, beloved of the painters Vincent van Gogh and Paul Cézanne, was as yet rather minor.

While Rome, Florence and Venice remained great foci of Italian interest, there is evidence of dispersal from these centres, and such dispersal, both geographically in terms of location, and towards a widening range of landscape features or genres, seems to be a common feature. An area is first visited for its already well known 'lions', the Colosseum or Tivoli, usually in the great cities. Gradually, artists are tempted to explore further afield, and interest spreads into other smaller towns. Perhaps Tuscany is the type of area for such dispersal, out from Florence and Siena, and into smaller Tuscan and Umbrian towns, to San Gimignano, Monte-pulciano, Perugia, Assisi and Urbino. Later still, in the last 20 years of the twentieth century, this will extend yet again, especially into the Tuscan countryside so much now a symbol, in England, of Italianness. This dispersal can also be seen very clearly in Spain (outwards from Seville, Granada, Toledo), in southern France and a great deal outside Europe. In Egypt, for example, early interest in the Sphinx and the pyramids was succeeded not only by visits to other towns with other famous

sites, such as Luxor, but especially to an expanded interest into local scenes, and especially genre scenes in the *souks* and inner towns. Indeed, this fascination for oriental, urban *genres-de-vie* is the core value of pictures from Algiers, Tunis and Tangier.

The impact of the First World War seems limited in this period, except for the very simple decline in the output from Germany. Although this may be due in part to my choice of quarter-centuries as periods, the failure of artists to be depicting the war is quite marked. Whatever the importance and fame of war artists on the Western Front, the weight of numbers seems to be in providing pictures of a desperate normality (with remarkably few changes in style since 1900) or a hedonistic paradise (on the Riviera).

1950–80

The final period is marked by an enormous increase in the size of the RA Summer Exhibition since the Second World War, and the concentration on landscape of the artists who exhibited there, who were not, at this period, generally the avant-garde, nor even professional. We witness the continuation of the process of dispersal in much of Italy (even in the Veneto), in inland Provence and in Spain, although the artistic interest in south-west France has tended to be a well dispersed interest in small-town life and rural scenery since it first became apparent earlier in the century. The pattern, too, is more generally very scattered, a feature even more obvious in the distribution within England and Wales (Howard 1985: 147; Brace 1999). This partly relates to the preference for rural scenery over urban, noticeable for much of the twentieth century, and which itself may be the effect of the change of the main mode of transport from rail to road.

There is little doubt that common forms of transport greatly affect the pattern, but they do not seem to be the cause of new vogues. The role of turnpikes, steamships and aircraft in opening new areas is clear, but artists have certainly not gone everywhere it was possible to go and have visited some places against the odds. The train enabled many smaller towns to be easily visited, but only the car encouraged the beauties of the next little hamlet to be discovered, so the car allowed artists (and no doubt other tourists) to find their own place without the aid of the guidebook. This resulted in a large number of titles bearing farm and village names that proved untraceable. In general, new transport provision permits an existing preference for a landscape genre to be explored in new areas, but it does not usually cause a new genre to appear. An obvious case is air travel, enabling the well established Mediterranean coast scene to jump from the French Riviera, where it had been dominant long before World War Two, to the Balearic Islands, and the discovery of the Algarve and the Costa del Sol. By the 1980s, air travel led to a discovery of similar scenes on the Greek Islands. An examination of the dates of

the pictures from the Balearic Islands shows that the boom of artistic activity on Majorca and Ibiza was at its height in the 1950s (and was literary as well as artistic, with the best-known resident being the novelist Robert Graves). By the 1970s, artists had largely moved on to find their favoured scenes elsewhere. Mediterranean views became very standardized. One of the consequences of extreme popularity seems to be greater conformity – the more paintings there are, the more they are all the same! Buildings were white with red-tiled roofs, but arranged in a higgledy-piggledy fashion rather than along a street. There would be a glimpse of the sea and of mountains. Certain plants acted as guarantors of location. Just as the Italian pine had done for Turner, so the bougainvillea and the palm have been more recent signifiers. Inland, the Tuscan countryside and interior Provence came into vogue, especially the scenes beloved by the post-Impressionists, with Cézanne's Mont St Victoire at last becoming a firm favourite.

In most of northern Europe, rural dispersal is the most obvious feature, but the withdrawal from central Europe is also striking. That Germany and the Rhineland should be less attractive after the Nazi war is understandable, but there was also a very considerable drop in the attractiveness of the Low Countries, Switzerland and Austria. Indeed, Austria has never been an artistic favourite. Paris, which established dominance as an urban artistic focus during the 1930s, may have been supplanted shortly after the war by New York as the world focus for avant-garde art, but clearly the French city's attractions lingered for the exhibitor at the RA. The Paris of Montmartre, the Île de Seine and the Rive Gauche set the standard.

Features of Change

Changes in fashion in tourism are not a new phenomenon, and the sheer speed of decline in interest in Italy in the 1780s or the increases in French popularity in the 1920s are dramatic demonstrations that these are real changes. Indeed, French landscapes, which represented only 6 per cent of those exhibited at the RA in the decade to 1900, had increased more than threefold to 20 per cent in the decade to 1930. By comparison, Germany, including all of the Rhineland, never reached 4 per cent, and not even 2 per cent in the twentieth century. The dominance of images of Italy, later France, and only very recently Spain, in the English conception of continental Europe, is very marked.

Such patterns of output reveal some significant features about the way in which interest in places evolves. The additive nature of change has already been mentioned, as have the processes of dispersal and the importance of legitimated landscapes, which litter the map of England and the rest of Europe. Apart from the numerous 'Switzerlands', there are several rivals to the title of Venice of the North. In one demonstrable case, the lower course of the River Dart (between Totnes and the sea) changes its identity throughout the nineteenth century. What was at first 'just like

a string of lakes' (Swete 1790–1804, v. 2: 179) and carefully depicted at full tide, with no glimpse of the sea beyond but with the castle to the side, just like Chillon, became by mid-century 'the English Rhine', complete with Lorelei, only for it to be discovered, by 1892, that 'the Rhine analogy is quite unjust, it's more like some Scotch sea-loch' (Page 1893). The poor Dart could never be itself. There must be many such perceptual histories waiting to be uncovered.

Such legitimation may bring discovery to places that would otherwise be in a kind of 'aesthetic shadow'. The Southern Uplands of Scotland never really achieved the popularity their relief and scenery might lead one to expect, either for artists or for tourists, but they are too close to the more dramatic Highlands, just as Bodmin Moor is in the shadow of Dartmoor. Further afield, the Massif Central of France clearly lies in the aesthetic shadow of both the Alps and of the Mediterranean coast, for English visitors, though probably not for French. Both the Jura and Austria also are shaded by the Swiss and Italian Alps, and Italy south of Naples does not seem to offer anything more interesting than the north, other than a further distance to travel.

Associated landscapes are another feature – places visited either to depict the residence, birthplace or grave of someone famous, or to depict 'their' landscapes in the case of major landscape artists or writers. Thus the works of Sir Walter Scott were vital in tempting English artists north of the border to Scotland, not only to visit Abbotsford but also the Trossachs (Withers 1994; Howard 1991: 97; see also the chapter by Lenman in this volume). On the continent, Raphael was a major attraction at Varallo (Cartwright 1880), Rembrandt in Amsterdam and Rubens in Antwerp. The popularity of Breton villages, of the Forest of Fontainebleau, of Etretat on the Norman coast or of inland Provence is also clearly attributable to various French painters, though the effect is often delayed. Only after 1950 did the places painted by Cézanne and van Gogh become major centres of artistic pilgrimage.

New media or techniques also lead to new ideas, new features and locations. The water colourist traditionally paints water, though often in the form of mist and atmosphere rather than in liquid form. The engraver prefers the straight lines of the built environment, and the ability of the photograph to depict surface texture has produced a love of walls, cobbles, even haystacks, especially in the wet. Many lovers of the traditional pattern of the English hedgerow-countryside might be surprised to learn that such attraction is a fashion that arose from avant-garde cubism. If current ideas of landscape attractiveness are largely determined by the need to make still colour photographs (Taylor 1994), the impact of the video will presumably lead to quite different preferences, where landscapes have movement, and may well be populated.

The time lag between artists and general tourists needs some urgent research, as does the mechanism by which preferences are passed through the system. If artists, especially of the avant-garde, and supported by writers and other opinion

formers, are responsible for the discovery of new landscape preferences, then how long does this change take to filter down to artists other than the front rank, and eventually to other kinds of tourist of various aesthetic levels? What are the intermediaries? Certainly even the Royal Academy Summer Exhibition, popular though it is, does not direct huge numbers to a new location, although there is some evidence that a book might do so, as was widely claimed of Peter Mayle's *A Year in Provence* (1991). The discovery of attractiveness in things previously uncon-sidered seems to require an aesthetically trained eye, actively seeking new and original concepts of attractiveness. How long does it take for the discovery that rusty corrugated iron can be a very effective addition to a green countryside to percolate down to the level of the postcard sale?

Recent Change

One problem with the historical account above is that it is based largely on the titles of exhibited works in catalogues, most of which suggest a location but many fewer of which suggest an actual subject. These titles can, however, be supplemented by studying selected illustrations (for example, Royal Academy 1999). In recent years, I have viewed actual pictures or their reproductions at the exhibition to examine changes taking place currently. The evidence does seem to indicate that if we were able to define the kind of landscapes currently preferred by artists, we would have a tool for making prognostications about future tastes of the public and perhaps some ability to discover the places where these tastes might be given substance.

A glance at most exhibitions of current work, or even a visit to a postcard or poster shop or gallery, will show that there is a lot of landscape around. But what is it about? There are various threads in this new postmodern landscape prefer-ence, but perhaps the most obvious is an ecological concern. The word 'ecology' is used here in its loosest possible sense – as generally used in artistic circles, a very indeterminate shade of green, a preference for rough-hewn nature. In trying to explain it, the words of Gerard Manley Hopkins not only are beautifully accurate but remind us that this new preference has quite deep roots in the past – 'when weeds in wheels shoot long and lovely and lush' (Hopkins 1953). Indeed, the outstanding feature of this preference is that it is unmanaged, or appears to be. Buddleias bloom in a bomb site, and there are accidental beauties, or where not accidental, planted in a casual, undesigned, vernacular way. This unmanaged element largely signifies 'unmanaged by authority'. Vegetable and back gardens are usually very carefully designed by their owners but, provided they are suffic-iently overgrown and untidy, have become major visual material, with vegetable growing being as acceptable as flower cultivation, and both more so than the sweeping parkland of the great country house. This preference for ordinary

landscape will select the cottage rather than the mansion, but extends also into the cities and to the suburbs, which were first seen in pictures by the Camden Town Group early in the twentieth century – but while Camden Town artists depicted the elegant suburbia of St John's Wood, the modern suburbia is more likely to be municipal estates on the outskirts of northern towns (Barron 1979).

Recent shows at the Royal Academy include such titles as Denis Lucas's *House Opposite* and Catherine Goodman's *Wash House, Entrecasteaux* (both 1990) or Michael Davis's *Abandoned Goose Shed* and William Bowyer's *Snowstorm over Winter Garden* (both 1991). A view of Versailles is now as likely to be of the potting shed or the bonfire heap, 'the unpleasaunce', as it is of the great vista. Modern landscapes are a bit scruffy, and often strictly functional. They frequently lack the structure of the traditional landscape picture, having no depth from foreground to distance.

Above all, new landscapes are undesignated. Agricultural landscapes are not in the forefront, and certainly not the landscape of agribusiness. Where depicted at all, working the land is likely to be in a market garden or an unused headland with a collapsing old pigsty and some rusting farm machinery. The mood is beautifully captured in a postcard from New Zealand captioned *Stayed Here for a Bit* and depicting a roofless wooden house, with a tree growing out of it, and outside a doorless car bursting with shrubbery. Perhaps the appropriate management response would be to scatter scrap iron around the farm or in the corners of the national park. Farms have been acceptable pictorial material since the 1930s, but today's painted or photographed farmsteads are neither formally picturesque nor efficient factories, just scruffy. These buildings are not listed. While probably open to the elements, they are not open to the public – at least not for payment. They are not National Trust gardens; the landscapes are not within Areas of Outstanding Natural Beauty or in National Parks. If they are, they are like those of Robert Clement who works on Dartmoor but whose landscapes are full of barbed wire rolls, pigs in corrugated iron sties, and granite walls in need of repair. The town scenes are not Conservation Areas. Heritage seems to be going out of fashion (but see the chapter by Evans and Spaul in this volume).

The desirable landscape is not really going out of favour, however, it is merely changing its spots. Artists are finding the pleasures of the insider's landscape – the places made by local people (Relph 1976). The self-conscious place is shunned. As soon as a particular place becomes designated, official, spruced-up and above all visited, the artist potters off elsewhere. But there lies the rub, of course. The artist's very activity, and especially the oxygen of publicity in a public exhibition, is a critical part of the process of providing self-consciousness on the site.

So the landscape to suit tomorrow's tastes will be small-scale, unself-conscious, scruffy, very much a land of human effort, but often being defeated by Nature, and by Human Nature – including weeds and scrap iron. This is as true of the town as

of the countryside, and it is not only confined to painting in art galleries. The postcard rack now shows these trends very clearly. The image of the city of Amsterdam may now be portrayed as a couple of wrecked and vandalized bicycles locked to a post. One postcard of Prague is of a group of overflowing dustbins. These new places are very private, and will lose their attractiveness as soon as the first waymark goes up. Apparently artists, among others, turn round and go the other way whenever they see a brown roadsign giving directions to a visitor attraction. The new landscape is unself-conscious and to an extent often unlocatable. Often the place is of little consequence. The collapsing, corrugated-iron farm building might be anywhere; so might the Prague dustbins. Perhaps the new taste in landscape defies the tourist industry because travel is denied. The new taste suggests that the things we may really want to see probably exist at the bottom of our own garden rather than on the other side of the world.

Landscape art was long considered an activity of little consequence. Gainsborough is famously attributed as 'going off to some sweet village to paint landskips' (Clark 1949: 34) whenever he was tired of the social whirl in Bath. Landscape, and indeed the countryside, was often considered politically neutral, and its representation an innocent activity that had no impact on the land depicted (Inglis 1987). However much we may now recognize that the very concept of landscape itself is loaded, and that every manifestation of it has overtones of political and social discourse (Gröning 1992; Daniels 1993), the innocence of landscape painting still seems to be widely believed, at least by its practitioners. However, the history of artistic landscape preference suggests that tourism might be regarded as the slime trail of the artistic molluscs. Artists may like to think they tread lightly on the land. Regrettably, the truth is that their trade is an extractive industry. Indeed, landscape artists have quite successfully made us regard some industrial landscapes as attractive, especially after the industry has died. Former coal mines are conserved, and shipyard scenes, perhaps by William Lowry, abound on house walls. John Pfahl makes beautiful photographs from the pollution of power stations (*Aperture* 1990). Aesthetics may, in a strange inversion of the language, be used as an anaesthetic to make us unaware of the meanings behind appearances. It may be too fanciful to blame directly the hotel landscapes of Benidorm on artists making the Mediterranean coast such a preferred destination, but equally artists cannot be entirely exonerated.

There is one great consolation. The evidence seems also to suggest that almost all landscapes are capable of being loved; nothing is irredeemably ugly. Just as artists have shown us the beauty of the tin shack, so there may now be artists working to show us the beauties of the Costa del Sol, or even the fascination of an airline terminal in August. Whatever region or city wants to make itself a favoured tourism destination might be well advised to begin with a substantial prize for an art competition.

References

Andrews, M. (1989), *The Search for the Picturesque: Landscape Aesthetics and Tourism in Britain 1760–1800*, London: Scolar.

Aperture (1990), 'Beyond Wilderness, themed issue, 120.

Appleton, J. (1975), *The Experience of Landscape*, London: John Wiley.

Barron, W. (1979), *The Camden Town Group*, London: Scolar.

Blaikie, J. A. (1885), 'The Dart: Totnes to Buckfastleigh', *Magazine of Art*, 398.

Brace, C. (1999), 'Looking Back: The Cotswolds and English National Identity, c. 1890–1950', *Journal of Historical Geography*, 25, 4: 502.

Bradshaw, V. (1954), 'My Favourite Sketching Grounds, II. Clovelly', *The Artist*, 48: 45.

Cartwright. J. (1880), 'Varallo and her Painter', *Portfolio*, 50.

Clark, K. (1949), *Landscape into Art*, London: John Murray.

Cornish, V. (1935), *Scenery and the Sense of Sight*, Cambridge: Cambridge University Press.

Cosgrove, D. (1984), *Social Formation and Symbolic Landscape*, London: Croom Helm.

Cosgrove, D. and Daniels, S. (eds) (1988*), The Iconography of Landscape*, Cambridge: Cambridge University Press.

Daniels, S. (1993), *Fields of Vision: Landscape Imagery and National Identity in England and the United States*, Oxford: Polity.

Doyle, R. (1904), *The Foreign Tour of Brown, Jones and Robinson*, 2nd edn, London: Routledge.

Graves, A. (1907), *Royal Academy of Arts: A Complete Dictionary from its Foundation in 1769 to 1904*, London: George Bell.

Gröning, G. (1992), 'The Feeling for Landscape: A German Example'*, Landscape Research*, 17, 3: 108–15.

Hopkins, G. M. (1953), 'Spring', in G. M. Hopkins, *A Selection of His Poems and Prose*, ed. W.H. Gardner, Harmondsworth: Penguin.

Howard, P. (1983), 'Changing Taste in Landscape Art', unpublished PhD thesis, Exeter: University of Exeter.

Howard, P. (1985), 'Painters' Preferred Places', *Journal of Historical Geography*, 11, 2: 138–54.

Howard, P. (1991), *Landscapes: The Artists' Vision*, London: Routledge.

Howard, P. (1999), 'Early Tourist Destinations: The Influence of Artists' Changing Landscape Preferences', in R. Kain and W. Ravenhill (eds), *Historical Atlas of South-West England*, Exeter: Exeter University Press.

Inglis, F. (1987), 'Landscape as Popular Culture', *Landscape Research*, 12, 3: 20–5.

Johns, E. (1955), 'The Artist and the Scientific Study of Scenery' *Studio*, 149: 42–49.

Massingham, H. and Massingham, P. (1967), *The Englishman Abroad*, London: Phoenix House.

Matless, D. (1998), *Landscape and Englishness,* London: Reaktion.

Nicholson, M.H. and Nicholson, N. (1959), *Mountain Gloom and Mountain Glory: The Development of the Aesthetics of the Infinite*, New York: Cornell University Press.

Page, J. L. W. (1893), 'The Rivers of Devon: Dartmouth and the Dart', *Portfolio*: 30–2.

Relph, E. (1976), *Place and Placelessness*, London: Pion.

Rodee, H. D. (1977), 'The "Dreary Landscape" as a Background for Scenes of Rural Poverty in Victorian Paintings', *Art Journal*, 36, 4: 307–13.

Royal Academy of Arts (1981), *RA Exhibitors 1905–1970*, London: EP Publishing.

Royal Academy of Arts (1999), *Royal Academy Illustrated*, London: Royal Academy of Arts.

Somers-Cocks, J. V. (1977), *Devon Topographical Prints 1660–1870: A Catalogue and Guide*, Exeter: Devon Library Services.

Swete, J. (1790–1804), 'Picturesque Sketches of Devon', unpublished MSS in 17 volumes, Exeter: Devon Record Office.

Taylor, J. (1994), *A Dream of England: Landscape, Photography and the Tourist's Imagination*, Manchester: Manchester University Press.

Thackeray, W. M. (1903), *The Kickleburys on the Rhine*, in W. M. Thackeray, *Christmas Books etc.*, ed. W. Jerrold, London: Dent.

Thornbury, W. (1877), *The Life of J. M. W. Turner R.A.*, London: Chatto & Windus.

Watson, A. (1882), 'After the Herring', *Magazine of Art*: 405–11.

Wilton, A. (1982), *Turner Abroad: France, Italy, Germany, Switzerland*, London: BCA.

Withers, C. W. J. (1994), 'Picturing Highland Landscapes: George Washington Wilson and the Photography of the Scottish Highlands', *Landscape Research*, 19, 2: 68–79.

North to South: Paradigm Shifts in European Art and Tourism, 1880–1920

Nina Lübbren

In this chapter, I wish to extract from the tangle of historical complexity one strand of painterly practice that has so far gone little remarked. This is the widespread partiality among European and American artists from the late 1870s to the mid-1890s for overcast days and the subsequent and almost complete shift to a preference for sunny skies around the turn of the century. I will argue that this turnabout in plein-air practice adumbrates and parallels a shift in the leisure habits of tourists, focusing in particular on the seaside holiday. As we shall see, painters' stylistic choices were predicated upon the connotations associated with particular places, and these places were, in turn, linked to the geographies of modern tourism.

During the 1870s and 1880s, most artists in Europe did not like painting out of doors during sunny weather. Isobel Field, sometime artist and wife-to-be of Robert Louis Stevenson, remembered that the painters in Grèz (France) in the summer of 1877 'scorned sunlight, and endless time was wasted waiting for a grey day' (quoted in Campbell 1984: 44). The American painter Julian Alden Weir, working in Brittany in 1874, lamented, 'I took my large study out today, but could do very little as the sun came out' (quoted in Young 1960: 49). The Dutch artist Anton Mauve dutifully 'sat in the sun and turned brown' in July 1883 but found that 'inspiration stayed away' and confirmed that he was 'not too keen on all that wonderful summer heat' (quoted in Engel 1967: 66). Blue skies were rarely seen on English exhibition walls, noted one critic in 1882 (quoted in Rodee 1977: 308). And in the Bavarian artists' village of Dachau, painters even donned dark eye glasses on fine days to soften the impact of 'glaring sunlight' (Ludwig Dill, quoted in Boser 1998: 209).

Painters' predilection for overcast skies went hand in hand with a preference for particular motifs, locations and landscape types. The German painter Max Liebermann's canvas *Netmenders* (1887–9; Figure 7.1) may serve as a representative example. The palette is limited to tonal variations of black, white, grey and a matt green, with only a few muted accents in other hues. Diffuse daylight eliminates almost all cast shadows and hence strong contrasts. Storm clouds, windy weather and sombre light are typically conjoined to a scene of preindustrial activity,

showing Dutch fisherwomen in regional costume set in a bare terrain. Modernity seems to have bypassed this community; we see no urban fashions, no steam-powered machinery, and certainly no tourists. Liebermann and thousands of his artist-colleagues sought out destinations in the north of Europe that were off the tourist track, and they painted landscapes that held little interest for those seeking picturesque attractions. The solemn weather conditions reinforced the effect of a scene of a harsh environment, ill suited to leisure seekers.

However, by the beginning of the twentieth century, the artistic taste for over-cast northern sites had undergone a distinctive change, noticeable both on a stylistic as well as on an iconographic level. The palette lightened and the erstwhile staples of peasants and fisherfolk increasingly gave way to modern subjects of leisure and recreation. Again, Liebermann's work may stand for that of numerous other artists; his *Bathing Boys*, painted around ten years after the *Netmenders* (1896–8; Figure 7.2), shows a sunny day. Streaks of white and reddish-pink on the nude boys' bodies evoke the effect of bright light reflected off skin, and the white

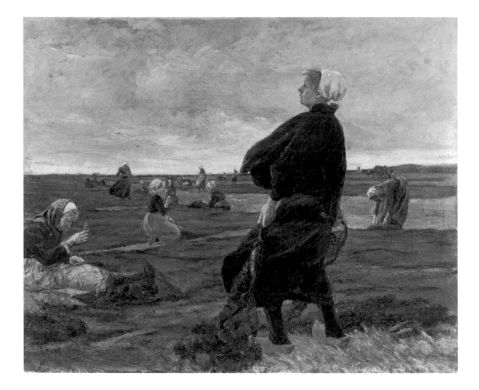

Figure 7.1 Max Liebermann, *Netmenders*, 1887–9, 180.5 × 226 cm, Kunsthalle, Hamburg.

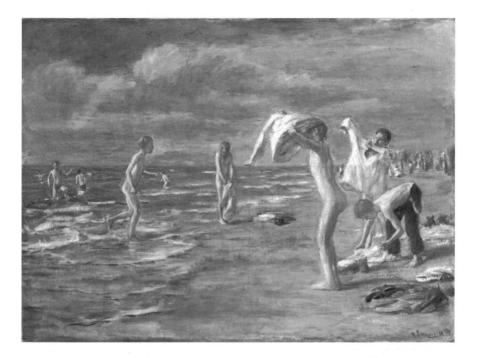

Figure 7.2 Max Liebermann, *Bathing Boys*, 1896–8, 121.9 × 151.1 cm, Bayerische Staatsgemälde-sammlungen, Neue Pinakothek, Munich.

shirts accentuate this brightness. The figures cast shadows and although the day remains slightly cloudy, the relatively heightened palette and wider variety of colours and contrasts (note the red garments) make this a very different scene from the *Netmenders*. Moreover, the earlier focus on native work and contemplation (the standing netmender) has shifted to an emphasis on playful activity and recreation. The coast has been transformed from a fishing region into a leisure beach (note the fashionably dressed vacationers and wicker beach chairs in the background on the right of *Bathing Boys*).

Similar shifts in subject matter and palette can be discerned in the oeuvres of large numbers of artists across Europe and of all stylistic persuasions, ranging from Laura Knight and George Clausen in England, Peder Severin Krøyer in Brittany and Denmark, and Ottilie Reylaender in Germany and Italy, to Vincent van Gogh in the Netherlands and France, Henri Matisse in Brittany and Provence, and Edvard Munch in Norway and Germany.[1] Indeed, in the heyday of overcast painting, even the arch-Impressionist Claude Monet became temporarily infected by the fashion for the sunless north. In 1886, he spent the autumn on the Breton island of Belle-Île, aware that he was trying something new:

I'm having a great deal of trouble in rendering its [the island's] sombre and awesome appearance. There's no point in my being the man of the sunlight, as you call it, one mustn't specialise in a single theme. (Letter to the art dealer Paul Durand-Ruel, quoted in House 1986: 25)

Around 1900, after the shift to a sunnier mode, landscape artists not only varied the way they painted familiar sites; they also began to seek out new locations in the south, especially on the Mediterranean coast. As the French poet Guillaume Apollinaire noted in 1914, 'Artists today are being drawn to the Midi. Instead of spending their vacations in Brittany or in the area around Paris . . . painters are now heading for Provence' (quoted in Thomson 1994: 65). This move from overcast to sunny, from native to leisure subjects, and from north to south constituted a significant shift in artistic practice. This shift, although widespread, has not been much noticed within the discipline of art history. Indeed, it may be precisely *because* it is so widespread that the phenomenon has slipped through the net of art-historical inquiry. Despite attempts since the early 1980s to dislodge the modernist artistic canon and to open out the field to critical issues beyond traditional formal analysis, the history of late nineteenth- and early twentieth-century art remains partitioned into disconnected arenas, with the French Isms (Impressionism, Symbolism, Post-Impressionism, Symbolism, Fauvism) occupying centre stage and other national 'schools' neatly slotted into their separate trajectories.

As a result, the change from overcast to sunny has been critically discussed mainly in terms of the impact of the Fauves in France or of the dissemination of Impressionism throughout the non-French world (for example, Broude 1990; McConkey and Robins 1995). I should point out that the sun I am discussing in this chapter is not the Impressionist sun and, crucially, the places associated with the new paradigm were not those places favoured by Impressionists in the 1870s. The Fauves, on the other hand, do fit into the new sunny paradigm; however, it needs to be stressed that they did not inaugurate the new mode. The Mediterranean landscapes of around 1904 to 1908 by Henri Matisse, Henri Manguin, Henri-Edmond Cross and other artists associated with the Fauves were predated by a number of earlier paintings in 'sunny' mode, for example, Liebermann's *Bathing Boys* (Figure 7.2) and George Clausen's *Mowers* (1892, Usher Gallery, Lincoln; reproduced in Broude: 84). More importantly, the Fauves were themselves participants in a much wider European moment.

The difficulty of tackling the developments I have outlined with the traditional tools of art history is compounded by the fact that the shift does not really constitute a style. Knight, Matisse and Munch, after all, share few stylistic commonalities but they did all switch from an 'overcast' to a 'sunny' mode of painting. It is therefore a shift in mode or a paradigm shift rather than a stylistic development that I am investigating here.[2]

In this chapter, I wish to propose tourism as one key aspect for the understanding of this wider European paradigm shift. Examining the phenomenon through the lens of tourism may open the way for a pan-European perspective that goes beyond the analysis of individual styles or movements. It may also provide a useful corrective to art history's insistent bias for chronology by counterbalancing an attention to changes over time with an attention to geography and changes in place. Landscape painting throughout the nineteenth and into the twentieth century was closely bound up with particular places and regions, and these places and regions became increasingly bound up with the geographies of European leisure travel. Fewer and fewer locations, no matter how supposedly remote or uncorrupted by modernity, remained outside the purview of the tourist matrix, and the places painted by artists were especially susceptible to touristic exploitation (see Herbert 1990, 1998; Lübbren 1999, 2001: 144–61; Howard's chapter in this volume). All open-air artists, whether they liked it or not, had to come to some sort of terms with the expanding tourist industry and its attendant myths and rituals. This chapter maps open-air easel painting of natural scenery, produced between 1880 and 1920, onto the geographies of an incipient mass tourism in Europe.[3]

The Rise and Fall of the Grey Paradigm

This section examines the landscape aesthetic of the 1880s and 1890s in greater detail, and traces the shift from 'grey' to 'sunny' around 1900. I begin with what I propose to call the 'grey' paradigm. We have already seen how dependent this generation of plein-air painters was on a particular type of overcast day. Artists' and critics' writings most frequently apostrophize this kind of day as 'grey'. Charles Fromuth described the outdoor work of Salon artists as 'months of labour . . . under a grey day with even light' (quoted in Sellin 1983: 59). Arthur Hoeber (1895: 78) extolled the virtues of 'that Breton grey, the like of which is seen nowhere else in the world, – a soft, pearly, luminous colour'. In the North German village of Worpswede, Otto Modersohn waxed rapturous about the 'infinitely subtle grey everywere' (diary 1889, quoted in *Worpswede* 1986: 15). In the Netherlands, the painters of the so-called Hague School based their entire reputation on their ability to reveal 'the poetry of "grey"' (the critic Jan van Santen Kolff, quoted in Leeuw et al. 1983: 83). Indeed, Gerard Bilders, one of the artists who came to be associated with the Hague School, praised grey as early as 1860 and strove to assimilate every conceivable colour to this one tone:

> I am looking for a tone which we call coloured-grey (*gekleurd-grijs*), that is a combination of all colours, however strong, harmonized in such a way that they give the impression of a warm and fragrant grey . . . to preserve the sense of grey even in the most

powerful green is amazingly difficult and whosoever discovers it will be a happy mortal. (Quoted in Marius 1973: 103–4)

Bilders' impassioned paean reveals the powerful affective charge with which the colour grey could be invested. The artist described grey as 'warm and fragrant', using words that conjure up the kind of outdoor conditions needed to obtain this effect, like an overcast summer's day among aromatic plants. What is particularly striking, however, is the twofold function of the term 'grey': it refers both to the mixing of pigment on a painter's palette and to actual meteorological conditions in real places.

In their writings, artists frequently conflated these two functions of 'grey'. Archibald Hartrick came to the Breton village of Pont-Aven in the autumn of 1886, and remembered the place as 'vivid with colour; no longer grey in the Lepage manner' (1939: 39; on Lepage, see below, note 2). It is interesting to note that Hartrick mentions the colour of an actual place (Pont-Aven) practically in the same breath as the colour found in painting (Lepage).

One explanation for the eager wait for overcast days may lie in the working habits of the landscape painters who perpetuated the grey mode. Overcast days with even, diffuse and shadowless lighting conditions mimicked most closely those obtaining in a studio. On such days, shadows and clouds move very little, and such a situation could suit artists who were not in pursuit of the effect of a spontaneously dashed-off impression but were more methodical, more 'academic', in their working routines. The American Dennis Miller Bunker, working in Connecticut after a season spent in Brittany, summed up the attitude of many:

> The days are distressingly bright for me and I long for a solemn sky and gray world. In France it is just the other way, and the sunless days are in the majority. I like them so much better to paint, because they don't change and one can paint calmly. That's a great thing, to know that you have time and your subject is to be just the same for hours. In sunlight it is never the same . . . (Quoted in Sellin 1982: 133)

However, this practical reason is not quite sufficient to illuminate the widespread and passionately held preference for the grey over the sunny. In the last few decades of the nineteenth century, the colour grey had accrued a range of ideological and cultural meanings beyond the merely meteorological. 'Grey' was a marker for certain plein-air painting practices but it was also associated with particular geographical places and particular social attitudes. These attitudes, I would argue, were of an adversarial nature and may best be summed up under the rubric of 'anti-tourism'.

Landscape painters of the 1880s and 1890s were generally averse to being identified with tourists. They treated tourists with disdain and were dismayed by

the presence in their villages of 'riffraff' (Modersohn-Becker 1979: 168, letter of 1899) or the 'aimless bustle of summer tourists' (Clement Nye Swift, quoted in Sellin 1983: 90). Nevertheless, artists were caught up in the rhetoric of a particular type of tourism, that of anti-tourism. The literary historian James Buzard, who coined this term, argues that modern tourism has, from its beginnings, consisted of two interdependent strands, tourism and anti-tourism (1993: 1–4). Anti-tourism is adversarial in character; that is, anti-touristic rhetoric needs tourism as a negative foil. Anti-tourists set up their own supposedly authentic travels as the antithesis of the triviality and mass consumerism ascribed by them to tourists.

To artists in the late nineteenth century, 'sunny' weather signified modernity in the forms of tourism and leisure whereas 'grey' weather signified the premodern in the guise of 'timeless' nature and locals in regional costume. Those locations most often visited and painted by landscapists and most frequently mentioned in conjunction with the grey paradigm were coastal and rural regions in the Netherlands, in Brittany, in Cornwall and in the north of Germany. They were situated in geographic regions that were more likely to experience evenly lit, grey days than others, and they were set in flat, unprepossessing and often marshy terrain that was the opposite of the hilly, picturesque regions associated with mainstream tourism. The grey mode also signified not only the labour performed by locals (in opposition to touristic idleness) but also the serious labour of the painters themselves (they were in the countryside to work, not to go on holiday). In sum, landscape painting in the grey mode staked its claim to 'authenticity', in opposition to what anti-tourists derided as the superficial *ersatz* experience of tourists.

Painters rarely stated their anti-touristic impulses directly. However, a trace of touristic surprise may be discerned in the reaction of one newcomer to the scene. The American Howard Russell Butler, newly arrived in Brittany in 1885, was struck by 'a tendency among young artists to avoid sunlight effects, preferring the most uncomfortable, chilly, somber days to those which certainly give one the most pleasure out of doors' (quoted in Sellin 1983: 48). It is clear that the choice of 'grey' arose out of an oppositional stance to contemporary middle-class leisure tastes.

The commitment to the grey paradigm becomes especially revealing when artists find themselves having to rethink their assumptions. This happened, for example, when they travelled south or, as in the case of Paula Modersohn-Becker, when they negotiated Impressionism. Modersohn-Becker and her fellow painters working in the North German artists' colony of Worpswede valued the place for its moorland atmosphere, its rich colours and its light – which was not, however, the glaring sunlight of the south. In 1901, Modersohn-Becker scorned the kind of 'sun that divides everything and inserts shadows everywhere' but extolled the 'sun that broods and makes things grey and heavy' (Modersohn-Becker 1979: 299; compare

a similar remark by Liebermann in 1894, quoted in Bunge 1990: 55). The sun that 'divides' may be taken as a reference to the sun of Impressionism, another instance of the way artists tended to collapse pictorial style and a particular kind of weather. However, Modersohn-Becker did not only associate colour with style but also with place. In 1905, after having seen an exhibition of paintings by Charles-François Cottet in Paris, she expressed her preference for Cottet's pictures of Brittany over his more recent ones painted in Spain, Turkey and Africa: 'One doesn't understand the southern colours because one doesn't know them' (Modersohn-Becker 1979: 400). (It is interesting to note that by 1907, in line with the shift to 'sunny', Modersohn-Becker had become reconciled with Impressionism: 'I wanted to conquer Impressionism by forgetting it . . . We have to work with a processed and digested Impressionism' [Modersohn-Becker 1979: 473]).

A more common impetus for artists to rethink their preconceptions was actual travel to the south. Many artists used to working in the grey mode had initial difficulties when encountering Mediterranean weather conditions. Antoine Guillemet who visited Provence in the summer of 1876 lamented: 'The true Midi is really not made for painting . . . There is too much sunlight, too much light everywhere . . .' (quoted in House 1998: 17). When Monet first tried to paint in Bordighera on the Italian Riviera in the spring of 1884, he complained, 'as for the blue of sea and sky, it's impossible' (quoted in Thomson 1994: 66). The journey from north to south, it seems, was not simply a geographical transposition but also an aesthetic journey into a different artistic realm. The Danish painter Jens Ferdinand Willumsen, habituated to Scandinavian and Breton locations, visited the south for the first time in 1889 and wrote from Granada (Andalusia) that he had to screw up his eyes and grimace against the light, and that he needed time to make sense of the 'chaos of cold and warm colours' (quoted in Krogh 1996: 53).

Around 1900, 'grey' increasingly started to disappear from painters' palettes and critics' words of praise. The painter Paul Signac condemned the tone outright in 1898, adopting Delacroix's diary note 'The enemy of all painting is grey!' as his battle cry (Signac 1992: 208). Five years later, the German art critic and champion of modernism, Julius Meier-Graefe, disparaged Georges Seurat as 'grey and motionless', compared with the 'luminosity of Signac's atmospheric pictures' (quoted in Franz 1996: 37). The tide had definitely turned. After 1900, the grey paradigm increasingly made way for the new sunny paradigm, which exemplified the generic south.

Beach Life North and South

It is important to remember that the allegiance to grey or to sunny was not only a matter of personal stylistic development but was also closely bound up with

particular places, or, more precisely, with particular place-myths. The term 'place-myth' was coined by the sociologist Rob Shields to denote the cluster of stereo-typical clichés and images associated with a specific location. These stereotypes need not have any direct relation to the actual topographical and social realities of that place but they form peoples' expectations and ideas of that site (Shields 1991: 46–7, 60–1). Place-myths do not accrue only around exact locations, such as towns or villages, but also around wider regions, such as 'Brittany' or 'the Midi', and even around more vaguely defined 'virtual' locations, like 'north' and 'south'. The concept of place-myth provides a useful way into issues both of art and of tourism, allowing us to construct a framework within which these two cultural formations may be discussed together. Tourists draw on place-myths for the choice and the subsequent experience of a holiday destination (Urry 1990, 1995). Landscape painters likewise rely on place-myths to structure their selection of paintable sites. It should be noted that while painters responded to pre-existing representations they also participated actively in the construction and, through their pictures, the dissemination of place-myths. Artists' painted place-myths could be instrumental in enticing further visitors to a particular destination, and this influx of outsiders could, in turn, generate enough entrepreneurial activity at the local level to trans-form a village into a tourist site (Lübbren 2001: 115–43, 2002).

Tourism is not a monolithic entity. Not only were there different types of tourism (and place-myths) associated with different kinds of places but touristic practices were themselves changing. One of the most striking changes took place within the culture of the seaside holiday, and it is this change that I wish to link to the pictorial shift from grey to sunny. The change in touristic beach culture that culminated in the surf 'n'sand holidays still familiar to us today began to take shape around 1900 and finally emerged as the dominant mode after the First World War. Painters were among the first to have sensed the new mood, and their practices and works of the early 1900s anticipate, in many respects, the full-fledged beach culture of the 1920s (see Möller 1992: 70). The remainder of this chapter will focus on representations and place-myths of the coast from 1880 to around 1920.

In the mid-nineteenth century, the European coast was a very different kind of place to what it became in our time. Seaside holidays initially took place under the banner of 'health and hygiene'. Medical journals and guidebooks up to the late nineteenth century praised particular coastal locations for their therapeutic properties, especially their bracing air and equally bracing water. Bathing was not for pleasure; the sea was a cold expanse in which patients had to immerse them-selves as prescribed by physicians (Corbin 1995). When visitors were not being dipped into chilly water, they strolled along beach promenades, gambled in casinos, or sat fully clothed on beach chairs, gazing at the waves, reading or chatting. The shift to the more active, sun-seeking and pleasure-oriented beach holiday of the twentieth century began slowly to take shape around the turn of the

century (Walton 1983: 42). These were also the very years when artists shifted from the grey to the sunny paradigm.

Earlier generations of vacationers had favoured the mild climate of northern summers or southern winters. They had also protected their bodies from the risks of acquiring a brown skin (associated with menial labour and, hence, low social status) by means of parasols, hats, veils and other paraphernalia (see Tavenrath 2000: 9–15). The new taste of the early twentieth century was, by contrast, for maximum exposure to sun and air. By 1920, acquiring a tan had become one of the primary raisons d'êtres for a seaside holiday (Blume 1992: 73–4; Walton 1997: 49, 52; Levenstein 1998: 250–1). One aristocratic tourist, Prince Jean-Louis de Faucigny-Lucinge, remembered a summer in the 1920s spent on the French Riviera: 'We immediately started sunbathing, which was something new at the time. A lot of sunbathing, exaggerated sunbathing . . . hours and hours of sunbathing' (quoted in Blume 1992: 74). Sunbathing may have been new to the aristocracy but it had been enjoyed by others for several decades (Tavenrath 2000). One of Munch's models for his sundrenched canvas *Bathing Men* (1904, Munch Museum, Oslo) remembers sessions in the sun as early as 1904:

> The sun had been scorching all day, and we just enjoyed it. Munch painted for a short while on his bathing scene; but most of the day we were lying down, overwhelmed by the sun, in deep sandpits at the edge of the water, between the stones, absorbing all the sun we possibly could. Nobody asked for a bathing suit. (Quoted in Berman 1993: 77)

This description of a modelling session is strikingly reminiscent of Prince Jean-Louis's 'hours and hours of sunbathing' 20 years later. The 1920s mark the culmination of a gradual development from 'beach as remedy' to 'beach as fun'. As Jean-Didier Urbain argues, after the First World War, the body was no longer 'exposed' to the threats of solar radiation but 'offered up' to the elements with a view to physical and psychic regeneration (Urbain 1996: 143–4).

The discovery of the sun and the tan as principal ingredients in holidaymaking was closely linked to particular place-myths. Indeed, under the pressure of the paradigm shift from grey/cure to sunny/hedonism, many sites and regions re-made themselves entirely and came to be associated with realigned new place-images. Most obviously, this entailed the discovery of southern locations and the opening up of the Mediterranean summer season. It may be argued, of course, that the southern seaside had attracted tourists (especially those of the wealthy upper classes and the aristocracy) for decades. Nice on the French Côte d'Azur, for example, had been one of the most popular seaside resorts since at least 1860 and the first European city to develop an entirely tourist-based economy (Haug 1982: xiv–xvii; Möller 1992: 65–9; Soane 1993: 42–55). However, with the exception of a handful of exclusive society resorts, the Mediterranean coast

remained touristically undeveloped throughout the nineteenth century. Most of the Provençal seaside resorts are relative newcomers in comparison to their precursors on the English, Channel and Baltic coasts (Walton 1997: 38, 42). More significantly for pictorial representation, the Mediterranean was of little interest to mid- and late-nineteenth century painters, besides regional artists and scattered visitors.[4]

For a start, the image of the south was not yet primarily linked to the sun. Although occasional commentators did note the unusual brilliance of the southern sun, visitors on the whole shunned the solar intensity of the summer months (the railway services between Paris and Marseilles ceased with the start of the summer timetable until 1900; Möller 1992: 69). Moves to establish Juan-les-Pins, Hyères, Cannes and others as bathing resorts failed because of the assumption that the Mediterranean summer heat was unbearable and posed a health risk (Möller 1992). The changing texts of Cook's *Traveller's Handbook for the Riviera* may serve to illustrate the shift in perspective that occurred in the early twentieth century.

The 1912 edition of Cook's *Handbook* opens with a sober description of the climate as 'not perfect' but 'one of the best in the south of Europe', and warns prospective vacationers of 'the troublesome mistral or north-west wind'; February to April are identified as the best months for a visit (that is, not the summer season); and the introductory section concludes with medical advice to 'invalids', noting that the sunshine is 'especially cheering for phthisis patients' and that the sea contains 40 per cent of common salt (Cook & Son 1912: 1–2). This is still the rhetoric of the seaside as medical cure. Fifteen years later, the tone of the *Traveller's Handbook* is rather different. The section on climate is retained but moved to a later page, preceded by an introduction replete in rapturous elegies on the glories of the Mediterranean, the 'most romantic spot on earth': 'The name Riviera at once connotes a vision of warmth and splendour . . . the warmth and brilliance and colour of the day, with the deep blue of the sea running softly to the shore; the full green of southern trees and the perfume of fantastic blooms . . .' (Cook & Son and Elston 1927: 1). Significantly, the language is highly pictorial, evoking the region in terms of colour and light, the very terms that had been used by painters around the turn of the century. There is even a direct reference to art: the 'Raphaelesque blue of the sky' (ibid.). Cook's *Handbooks* demonstrate how the specific geographical region of the Mediterranean coast acquired its own place-myth, that of the 'south'. From having been a somewhat exotic location whose climate offered challenges for (non-local) painters and tourists, the Riviera had by the 1920s taken its firm place in a network of place-myths and tourist routes.

The move from north to south is perhaps especially apparent within the practice of French painters, facilitated by the circumstances of geography: France happens to have both a northern and a southern seaside. However, the shift is by no means confined to France, and painters (and tourist entrepreneurs) in other nations developed different strategies that did not involve actual travel to the south. Two

processes may be outlined: that of importing the south into the north, and that of asserting northern difference in the face of an encroaching 'southernization'.

The South in the North

The most interesting adaptation made by early twentieth-century artists involved the 'Mediterranization' of images representing northern locations. Paul Gauguin's *Seaweed Gatherers in Brittany* (1889; Figure 7.3), set on the beach at Le Pouldu, conforms to the key place-myth of Brittany as a sombre, grey, melancholy region, peopled by poor but exotically costumed fisherfolk and peasants, living a traditional lifestyle. By contrast, Robert Henry Logan's *Crowded Beach, Le Pouldu* (c. 1900; Figure 7.4), painted around eleven years later in the same location, shows a beach given over almost entirely to pleasure pursuits, bathed in bright sunlight, stretched out under a brilliant blue sky and dotted with beach tents, parasols and holidaymakers in urban leisure gear. Similar strategies of 'southernizing' northern beaches can be detected in the representations of most of the formerly 'grey' artists' haunts (see, for example, Katwijks Museum 1995: 40, 104).

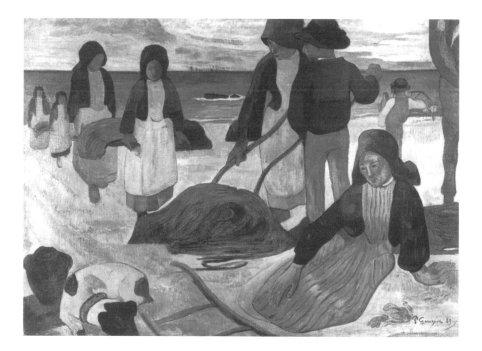

Figure 7.3 Paul Gauguin, *Seaweed Gatherers in Brittany*, 1889, 87 × 123.1 cm, Museum Folkwang, Essen.

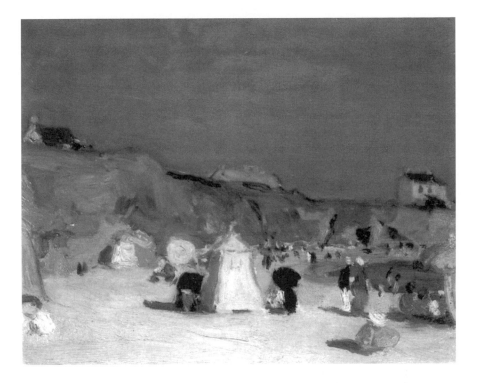

Figure 7.4 Robert Henry Logan, *Crowded Beach, Le Pouldu*, c. 1900, Sheppard Family Trust.

Throughout the second half of the nineteenth century, the Netherlands had been identified by painters as the 'grey' country par excellence. The American artist Henry Ward Ranger who had worked in Holland in the 1890s, wrote ruefully upon his return to the US:

> The air [in Holland] is full of moisture, giving the delightful haze which artists love in a picture. You very seldom see the hard, sharp outlines which you get here, under our brilliant sun . . . (Ranger 1893: 132)

By 1916, however, the curators of an exhibition of Dutch art actually commended the painter Gari Melchers for having opened the eyes of artists to the revelation that 'Holland was not always enveloped in a drab forbidding grey mist' (quoted in Lesko and Persson 1990: 63). The retrospective rehabilitation of Melchers (who worked in the Netherlands from 1884 to 1915) as a painter of sunshine is part of the curious realignment of place-myths and colour paradigms that took place in the wake of the shift to the sunny: the sunny, 'southern' leisure mode was co-opted for northern locations (see also Figures 7.1 and 7.2).

Cornwall had, in the 1880s, been a prime site for 'grey' painting in Britain. By the 1890s, however, British beach locations wanted to be 'southernized' in order to attract the new type of sun-loving visitor. Coastal stretches were re-marketed to accord with the 'southern' ideal: the Great Western Railway promoted the 'Cornish Riviera' as early as the 1890s; the Great North of Scotland Railway came up with the 'Scottish Riviera' for the Moray Firth coast (Towner 1996: 215); and a real-estate agency dubbed Bournemouth the 'English Riviera' in the 1890s (Soane 1993: 7). Guidebooks and travel posters reinforced the changed place-myths (Thornton 1997: 67–8; see also Wilson 1987). As John Towner observes, the Edwardian terms 'breezy' and 'bracing' were replaced by the 1930s with 'sunshine' and 'warmth' as desirable attributes of an English seaside resort (1996: 215).

The English artist Laura Knight performed the 'southernization' of style within her own oeuvre: her canvas *The Fishing Fleet* (undated, Bolton Museum and Art Gallery; reproduced in Phillips 1993: 26), painted in Staithes on the East Yorkshire coast around 1900, fully embodies the grey northern paradigm: we see fisherfolk in non-urban working clothes, going about their traditional pre-industrial trade, all under a leaden sky. The contrast to pictures produced by Knight in Lamorna Cove in Cornwall one-and-a-half decades later is striking. Works such as *Two Girls on a Cliff* (c. 1917, Sotheby's; reproduced in Fox 1988: plate 30) have transformed the overcast sky and grey sea of *Fishing Fleet* into an aquamarine, turquoise and neon-blue expanse. The even, diffuse light of a grey day has turned into the brilliant glare of a sunny day in which objects and figures cast strongly-contoured shadows. In the Lamorna picture, there is not a fishing boat in sight, and the women shown lounging idly on the cliff tops are stand-ins for the urban viewers. Their gaze from an elevated lookout point onto a sea panorama replicates a tourists' gaze onto the proverbial view.

All of the later, 'southernized' paintings share a significantly lightened palette and a treatment of light and shadow that suggests bright sunshine; they also include middle-class urban tourists instead of the exclusive focus on locals. The point is not that paintings of sunny beaches and tourists at leisure did not exist at all before 1900; they did (see, for example, Herbert 1988: Chapter 7), but after that date, they became the dominant mode that pervaded nearly all plein-air practice. Most paintings of the seaside (and many of landlocked areas, as well) now looked like the sorts of images conducive to the touristic imagination: they represent nice days with beautiful views and fun or relaxing activities.

The strategy of 'southernizing' the north can be perceived throughout Europe; however, an alternative strategy of adjusting to the dichotomy north versus south also existed. This involved valorizing the characteristic attributes of northern place-myths as superior to the south. The process of affirming the distinctiveness of the north is especially noticeable in Scandinavian, Finnish and Icelandic art and has been linked to contemporary discourses of national identity (Nasgaard 1984;

Varnedoe 1988; Facos 1998). However, the rugged, unpeopled, undeveloped and resolutely un-sunny wilderness representations of the north, exemplified by Gustaf Fjæstad, Harald Sohlberg, Albert Edelfelt, Thórannin B. Thorláksson and others, may also be seen in the context of a revival of the anti-touristic mode of earlier landscape painting. Anti-tourism did not go away. I would suggest that by the turn of the century, as villages were increasingly turning into tourist destinations, the contradictions of representing preindustrial rural or fishing lifestyles had become so blatant that anti-tourist artists found themselves having to look further afield. They left Europe altogether in search of the ultimate souths of the Pacific and Indian oceans (for example, Paul Gauguin in Tahiti and the Marquesas, Ottilie Reylaender in Mexico, Emil Nolde in Papua New Guinea, Heinrich Vogeler in Sri Lanka), or they ventured forth into the 'wildernesses' of northern Europe. In the early 1900s, such adventures began to be reported regularly in the art press. Among those discussed were the German artist Richard Friese who painted polar life (reproduced in *Studio* 1902: 63) and the Swedish painter Anna Boberg who discovered the Lofoten Islands in the Arctic circle as pictorial subject matter (*Studio* 1905: 160–1).

The works of the northern wilderness painters could not be further from the touristic idylls of southern sunny beaches but that was precisely their point: they were statements of anti-tourism that are only intelligible as such if read against the predominant grain of southernization. The Swede Richard Bergh decried the 'wild and everchanging landscape of the north [which] does not welcome the painter as does the homogenous landscape' of the south (quoted in Nasgaard 1984: 38). However, as Roald Nasgaard points out, this lament is rhetorical and Bergh was, in fact, asserting the north's superiority over the facile pleasures to be gained in the south. Finally, Helmer Osslund's rejection of places popular with painters also resonates with hostility towards places popular with holidaymakers: 'I have noticed that the more the easel, sun shade and strange chairs preside, the worse the [painterly] result is' (Nasgaard 1984: 88).

In conclusion, I would like to stress that the paradigm shift from grey to sunny mode should not be viewed as a shift from retrograde to modern. Such an assumption is easily made, on an iconographic as well as on a stylistic level. The iconography of 1880s seaside and agrarian painting privileges pre-modern natives over the contemporary middle-class tourists who begin to appear in pictures around 1900; the earlier images are also often painted in a more academic idiom than many of the sketchier studies and Fauve pictures of the early 1900s; and, finally, the sheer teleological bias of art history continues to exert its pressure on chronology. What comes later is too often seen to be somehow more progressive and modern than what came earlier. However, such assumptions are misleading. Firstly, the fisher-folk and rustic costumes of 1880s paintings express touristic nostalgia for a

lifestyle outside of tourism as much as the later celebrations of beach life cater to touristic hedonism. Both attitudes are inextricably locked into modernity and into changes *within* (not beyond) tourism. Secondly, the stylistic 'progress' from Liebermann's *Netmenders* (Figure 7.1) to, for example, Henri Manguin's *Bather at Cavalière* (1905, Musée de l'Annonciade, Saint-Tropez; reproduced in *Peintres de la couleur* 1995: 295) is also a chimera. On the one hand, it is logically fallacious to posit the use of pure bright hues, abbreviated execution and distortion of form seen in Manguin's work as inherently more 'progressive' than the grey tonality and naturalistic rendering of figures seen in Liebermann's picture. Each idiom has to be situated within its own historical context. On the other hand, we have seen that works that are widely hailed as 'modernist', such as Gauguin's *Seaweed Gatherers in Brittany* (Figure 7.3), partake of the grey mode as much as do less overtly avant-garde images. Assumptions based on an opposition of modern versus retrograde are historically dubious, and are nearly all reducible to the focus on a limited canon in circulation within the history of nineteenth-century art. This canon excludes nearly all of the painters discussed in this chapter, except for Monet, Gauguin and the Fauves. The resulting limited view of the art of the period impoverishes our understanding both of non-canonical practitioners and of the canonical 'masters'. Revisiting plein-air painting in the light of tourism and its attendant place-myths alerts us to the way in which art production is locked into much broader dependencies and cycles of cultural consumption than those confined to one particular art world or one particular region.

Acknowledgements

I would like to thank David Crouch and Christopher Clark for their discerning and critical comments on earlier drafts of this chapter.

Notes

1. Compare, for example, Knight's *Fishing Fleet* (c. 1900, Bolton Museum and Art Gallery) and her *Beach* (1908, Laing Art Gallery, Newcastle-upon-Tyne); Clausen's *Stone Pickers* (1887, Laing Art Gallery, Newcastle-upon-Tyne) and his *Mowers* (1892, Usher Gallery, Lincoln); Krøyer's *Sardine Factory at Concarneau (Brittany)* (1879, Statens Museum for Kunst, Copenhagen) and his *Summer Evening on Skagen's South Beach* (1893, Skagens Museum, Skagen); Reylaender's *Moor Hut* (c.1900, artist's estate, Worpswede) and her *Under the*

Orange Tree, Italy (1908, artist's estate, Worpswede); van Gogh's *Drawbridge in Nieuw-Amsterdam* (1883, Groninger Museum, Groningen) and his *Langlois Bridge at Arles* (1888, Wallraf-Richartz-Museum, Cologne); Matisse's *Large Grey Seascape* (1896, private collection) and his study for *Luxe, Calme et Volupté* (1904, Museum of Modern Art, New York); and Munch's *Evening (The Yellow Boat)* (1891–3, National Gallery, Oslo) and his *Bathing Men* (1907–8, Munch Museum, Oslo). (For reproductions of these works, see Fox and Green-acre 1979; Fox 1988; McConkey 1980; Hornung 1987; Doppagne 1994; Elderfield 1992; Hodin 1972.)

2. Some commentators have noted that the preference for grey days may be due to the stylistic influence of Jules Bastien-Lepage, the French painter of rural subjects who enjoyed great popular success in the early 1880s (for example, McConkey 1978; Jacobs 1985). Without wishing to diminish the importance of Lepage, I would suggest, however, that his art had the impact it did because it fed into widely held attitudes that made others especially receptive to his kind of painting. Bastien-Lepage was not only an 'influence' but himself part of wider trends.

3. It should be noted that the development I am describing in this chapter concerns only the end of the nineteenth and early twentieth century. An investigation into the relationship of the paradigm shift north to south during this period to earlier permutations of the north-south axis and their link to travel and the Grand Tour is, unfortunately, beyond the limits of this study. However, there is no doubt that many of the developments discussed here are subtended by positionings *vis-à-vis* Romanticism and representations of the south, especially Italy (Turner, Nazarenes and others) and the north (Scandinavian Romanticists, British painters of Scotland). It would seem that the *fin-de-siècle* shift from north to south was predated by a shift from south to north in the first half of the nineteenth century. This shift, as played out in the career of Corot, is brilliantly analysed by Galassi (1991). See also Conisbee et al. (1996).

4. The exception are local painters whose productions, however, made few dents on practices outside their native region. Regional painters of the Mediterranean would make a fascinating study in their own right that exceeds the limits of this chapter. Briefly, it seems that they either tried to assimilate their southern province to northern paradigms (for example, Luc Raphaël Ponson's *Morning at Sausset*, Marseille, Musée des beaux-arts, reproduced in *Peintres de la couleur* 1995: 134) or experimented with creating an alternative vision (for example, André Gouiran's *Cannes, View from La Napoule*, 1890, Musée de Cannes, reproduced in *Peintres de la couleur* 1995.: 51, 110, or Paul Saïn's *September Morning on the Road to Villeneuve-lès-Avignon, near Avignon*, c. 1889, Musée de Carpentras, reproduced in House 1995: 175). However, these remain isolated examples that don't cohere into an overall place-myth. Still,

future research may differentiate this picture. For a comprehensive documentation on Provence, see Soubiran (1992) and *Peintres de la couleur* (1995). See also Silver 1998a, 1998b; Wayne 1998.

References

Berman, P. G. (1993), 'Body and Body Politic in Edvard Munch's *Bathing Men*', in K. Adler and M. Pointon (eds), *The Body Imaged: The Human Form and Visual Culture since the Renaissance*, Cambridge: Cambridge University Press.

Blume, M. (1992), *Côte d'Azur: Inventing the French Riviera*, London: Thames & Hudson.

Boser, E. (1998), 'Von München nach "Neu-Dachau": Eine Künstlerkolonie und ihre Voraussetzungen', in *Deutsche Künstlerkolonien 1890–1910: Worpswede, Dachau, Willingshausen, Grötzingen, Die "Brücke", Murnau*, Karlsruhe: Städtische Galerie Karlsruhe.

Broude, N. (ed.) (1990), *World Impressionism: The International Movement, 1860–1920*, New York: Abradale Press/Harry N. Abrams.

Bunge, M. (1990), *Max Liebermann als Künstler der Farbe: Eine Untersuchung zum Wesen seiner Kunst*, Berlin: Gebr. Mann Verlag.

Buzard, J. (1993), *The Beaten Track: European Tourism, Literature, and the Ways to Culture, 1800–1918*, Oxford: Clarendon Press.

Campbell, J. (1984), *The Irish Impressionists: Irish Artists in France and Belgium, 1850–1914*, Dublin: National Gallery of Ireland.

Conisbee, P., Faunce, S. and Strick, J. (1996), *In the Light of Italy: Corot and Early Open-Air Painting*, New Haven and London: Yale University Press.

Cook, T. & Son (1912), *The Traveller's Handbook for the Riviera (Marseilles to Leghorn) and the Pyrenees (Biarritz to Marseilles)*, London: Thomas Cook & Son and Simpkin, Marshall, Hamilton, Kent & Co.

Cook, T. & Son and Elston, R. (1927), *The Traveller's Handbook to the Rivieras of France and Italy, incl. Rhone Valley, Basses and Maritime Alpes, and Corsica*, London: Simpkin, Marshall, Hamilton, Kent & Co. and Thomas Cook & Son.

Corbin, A. (1995), *The Lure of the Sea: The Discovery of the Seaside 1750–1840*, trans. J. Phelps, Harmondsworth: Penguin.

Cowart, J. and Fourcade, D. (1986), *Henri Matisse: The Early Years in Nice, 1916–1930*, Washington and New York: National Gallery of Art and Harry N. Abrams.

Doppagne, B. (1994), *Ottilie Reylaender: Stationen einer Malerin*, ed. Worpsweder Kunsthalle Friedrich Netzel, [Lilienthal]: Worpsweder Verlag.

Elderfield, J. (1992), *Henri Matisse: A Retrospective*, New York: Museum of Modern Art.

Engel, E. P. (1967), *Anton Mauve (1838–1888)*, Utrecht: Academische Uitgeverij Haentjens Dekker & Gumbert.

Facos, M. (1998), *Nationalism and the Nordic Imagination: Swedish Art of the 1890s*, Berkeley: University of California Press.

Fox, C. (1988), *Dame Laura Knight*, Oxford: Phaidon.

Fox, C. and Greenacre, F. (1979), *Artists of the Newlyn School (1880–1900)*, Newlyn: Newlyn Orion Galleries.

Franz, E. (ed.) (1996), *Farben des Lichts: Paul Signac und der Beginn der Moderne von Matisse bis Mondrian*, Münster and Ostfildern: Westfälisches Landesmuseum für Kunst und Kulturgeschichte and edition tertium.

Galassi, P. (1991), *Corot in Italy: Open-Air Painting and the Classical-Landscape Tradition*, New Haven and London: Yale University Press.

Hartrick, A. S. (1939), *A Painter's Pilgrimage through Fifty Years*, Cambridge: Cambridge University Press.

Haug, C. J. (1982), *Leisure and Urbanism in Nineteenth-Century Nice*, Lawrence: The Regents Press of Kansas.

Herbert, J. D. (1990), 'Painters and Tourists: Matisse and Derain on the Mediterranean Shore', in J. Freeman (ed.), *The Fauve Landscape*, Los Angeles: Los Angeles County Museum of Art.

Herbert, J. D. (1998), 'Reconsiderations of Matisse and Derain in the Classical Landscape', in R. Thomson (ed.), *Framing France: The Representation of Landscape in France, 1870–1914*, Manchester and New York: Manchester University Press.

Herbert, R. L. (1988), *Impressionism: Art, Leisure, and Parisian Society*, New Haven and London: Yale University Press.

Hodin, J. P. (1972), *Edvard Munch*, London: Thames & Hudson.

Hoeber, A. (1895), 'A Summer in Brittany', *Monthly Illustrator*, 4, 12: 74–80.

Hornung, P. M. (1987), *P. S. Krøyer*, Copenhagen: Stokholm.

House, J. (1986), *Monet: Nature into Art*, New Haven and London: Yale University Press.

House, J. (1995), *Landscapes of France: Impressionism and Its Rivals*, London: Hayward Gallery.

House, J. (1998), 'That Magical Light: Impressionists and Post-Impressionists on the Riviera', in K. Wayne with essays by J. House and K. E. Silver, *Impressions of the Riviera: Monet, Renoir, Matisse and their Contemporaries*, Portland, Maine: Portland Museum of Art.

Jacobs, M. (1985), *The Good and Simple Life: Artist Colonies in Europe and America*, Oxford: Phaidon.

Katwijks Museum (1995), *Katwijk in de schilderkunst*, Katwijk: Katwijks Museum and Genootschap 'Oud Katwijk'.

Krogh, L. (1996), *Catalogue Book: The J.F. Willumsen Museum*, trans. J. Kendal, Frederikssund, Denmark: The J. F. Willumsen Museum.

Leeuw, R. de, Sillevis, J. and Dumas, C. (eds) (1983), *The Hague School: Dutch Masters of the Nineteenth Century*, London: Royal Academy of Arts in association with Weidenfeld & Nicolson.

Lesko, D. and Persson, E. (eds) (1990), *Gari Melchers: A Retrospective Exhibition*, St Petersburg, Florida: Museum of Fine Arts.

Levenstein, H. (1998), *Seductive Journey: American Tourists in France from Jefferson to the Jazz Age*, Chicago and London: University of Chicago Press.

Lübbren, N. (1999), 'Touristenlandschaften: Die Moderne auf dem Lande', *Anzeiger des Germanischen Nationalmuseums*, Nuremberg, 63–9.

Lübbren, N. (2001), *Rural Artists' Colonies in Europe, 1870–1910*, Manchester: Manchester University Press.

Lübbren, N. (2002), '"Toilers of the Sea": Fisherfolk and the Geographies of Tourism in England, 1880–1900', in D. P. Corbett, Y. Holt and F. Russell (eds), *The Geographies of Englishness: Landscape and the National Past 1880–1940*, New Haven and London: Yale University Press.

Marius, [G. H.] (1973), *Dutch Painters of the Nineteenth Century*, ed. G. Norman, [Woodbridge]: Antique Collectors' Club.

McConkey, K. (1978), 'The Bouguereau of the Naturalists: Bastien Lepage and British Art', *Art History* 1, 3: 371–82.

McConkey, K. (1980), *Sir George Clausen, R.A. 1852–1944*, Bradford and Newcastle upon Tyne: City of Bradford Metropolitan District Council and Tyne and Wear County Council.

McConkey, K. (1995), *Impressionism in Britain*, with an essay by A. G. Robins, New Haven and London: Yale University Press in association with Barbican Art Gallery.

Modersohn-Becker, P. (1979), *In Briefen und Tagebüchern*, eds G. Busch and L. von Reinken, Frankfurt am Main: S. Fischer Verlag; trans. as *Paula Modersohn-Becker: The Letters and Journals* (1983), trans. A.S. Wensinger and C.C. Hoey, New York: Taplinger.

Möller, H.-G. (1992), *Tourismus und Regionalentwicklung im mediterranen Südfrankreich: Sektorale und regionale Entwicklungseffekte des Tourismus. Ihre Möglichkeiten und Grenzen am Beispiel von Côte d'Azur, Provence und Languedoc-Roussillon*, Stuttgart: Franz Steiner Verlag.

Nasgaard, R. (1984), *The Mystic North: Symbolist Landscape Painting in Northern Europe and North America, 1890–1940*, Toronto, Buffalo and London: University of Toronto Press in association with the Art Gallery of Ontario.

Peintres de la couleur en Provence, 1875–1920 (1995), Marseilles and Paris: Office Régional de la Culture Provence-Alpes-Côte d'Azur and Réunion des musées nationaux.

Phillips, P. (1993), *The Staithes Group*, [Cookham]: Phillips & Sons.

Ranger, H. W. (1893), 'Artist Life by the North Sea', *Century Magazine*, 45/99, 5: 753–9.

Rewald, J. (1978), *Post-Impressionism: From Van Gogh to Gauguin*, 3rd rev. edn, London: Secker & Warburg.

Rodee, H. D. (1977), 'The "Dreary Landscape" as a Background for Scenes of Rural Poverty in Victorian Paintings', *Art Journal*, 36, 4: 307–13.

Sellin, D. (1983), *Americans in Brittany and Normandy*, Phoenix, Arizona: Phoenix Art Museum.

Shields, R. (1991), *Places on the Margin: Alternative Geographies of Modernity*, London: Routledge.

Signac, P. (1992), *From Eugène Delacroix to Neo-Impressionism*, trans. W. Silverman, in F. Ratliff, *Paul Signac and Color in Neo-Impressionism*, New York: Rockefeller University Press.

Silver, K. E. (1998a), 'An Invented Paradise', *Art in America*, 86, March: 78–87.

Silver, K. E. (1998b), 'The Mediterranean Muse: Artists on the Riviera between the Wars', in K. Wayne with essays by J. House and K.E. Silver, *Impressions of the Riviera: Monet, Renoir, Matisse and their Contemporaries*, Portland, ME: Portland Museum of Art.

Soane, J. V. N. (1993), *Fashionable Resort Regions: Their Evolution and Transformation, With Particular Reference to Bournemouth, Nice, Los Angeles and Wiesbaden*, Wallingford: CAB International.

Soubiran, J.-R. (1992), *Le Paysage provençal et l'école de Marseille avant l'impressionnisme, 1845–1874*, Paris and Toulon: Réunion des musées nationaux and Musée de Toulon.

Studio (1902), 27, 115: 63 (reproduction of Richard Friese, *Family of Bears [Polar Life]*).

Studio (1905), 35, 147: 159, 160–1 (discussion and reproductions of Anna Boberg).

Tavenrath, S. (2000), *So wundervoll sonnengebräunt: Kleine Kulturgeschichte des Sonnenbadens*, Marburg: Jonas Verlag.

Thomson, R. (1994), *Monet to Matisse: Landscape Painting in France 1874–1914*, with an essay by M. Clarke, Edinburgh: National Gallery of Scotland.

Thornton, P. (1997), 'Coastal Tourism in Cornwall Since 1900', in S. Fisher (ed.), *Recreation and the Sea*, Exeter: Exeter University Press.

Towner, J. (1996), *An Historical Geography of Recreation and Tourism in the Western World 1540–1940*, Chichester: John Wiley & Sons.

Urbain, J.-D. (1996), *Sur la plage: Mœurs et coutumes balnéaires (XIXe-XXe siècles)*, Paris: Éditions Payot & Rivages.

Urry, J. (1990), *The Tourist Gaze: Leisure and Travel in Contemporary Societies*, London, Newbury Park, New Delhi: Sage.

Urry, J. (1995), *Consuming Places*, London and New York: Routledge.

Varnedoe, K. (1988), *Northern Light: Nordic Art at the Turn of the Century*, New Haven and London: Yale University Press.

Walton, J.K. (1983), *The English Seaside Resort: A Social History 1750–1914*, Leicester and New York: Leicester University Press and St Martin's Press.

Walton, J.K. (1997), 'The Seaside Resorts of Western Europe, 1750–1939', in S. Fisher (ed.), *Recreation and the Sea*, Exeter: University of Exeter Press.

Wayne, K. (1998), *Impressions of the Riviera: Monet, Renoir, Matisse and their Contemporaries*, with essays by J. House and K. E. Silver, Portland, Maine and Seattle, Washington: Portland Museum of Art and University of Washington Press.

Wilson, R. B. (1987), *Go Great Western: A History of GWR Publicity*, Newton Abbot, Devon: David St John Thomas/David & Charles.

Worpswede: Eine deutsche Künstlerkolonie um 1900 (1986), Ottersberg-Fischerhude: Galerie Verlag Fischerhude.

Young, D.W. (1960), *The Life and Letters of J. Alden Weir*, ed. L. W. Chisolm, New Haven: Yale University Press.

–8–

Picture Essay: Souvenir Bangkok
Holiday Snapshots from a City on the Move
Davide Deriu

The distinguishing principle between that which is photographable and that which is not cannot become independent of the individual imagination: it remains the case that the ordinary photograph, a private product for private use, has no meaning, value or charm except for a finite group of subjects . . . If certain public exhibitions of photographs, and particularly colour photographs, are felt to be improper, this is because they are claiming for private objects the privilege of the art object, the right to universal attachment.

<div align="right">Bourdieu: Photography: A Middle-brow Art</div>

Like the vagabond, the tourist is on the move. Like the vagabond, he is everywhere he goes *in*, but nowhere *of* the place he is in. But there are also differences, and they are seminal . . . The tourist moves *on purpose* (or so he thinks) . . . The purpose is new experience; the tourist is a conscious and systematic seeker of experience, of a new and different experience, of the experience of difference and novelty.

<div align="right">Bauman: 'From Pilgrim to Tourist'</div>

Orientations: A Project on the Move

The routes of international mass tourism have long beaten the tracks of South-East Asia. In recent years, some of the largest urban areas of this part of the world have also been consolidating their own status as tourist attractions – not only as transit places en route to rural and coastal resorts. In the imagery of Western visitors, the traditional values of peaceful and unhurried life embedded in the popular myth of the Far East have blended with a metropolitan culture characterized by high-tech sectors and high-speed vectors. Often regarded as examples of creative congestion, the sprawling cities of South-East Asia have promptly been remapped within the strategies of global tourism.

The case of Bangkok is significant, if not emblematic, of this ongoing phen-omenon. Thailand, as many guidebooks proudly remind you, has exceptionally escaped European colonization throughout its history – a record in independence

that contrasts today with its prominence as a thriving centre of sex tourism. However, the growing attraction of its capital city exceeds the cocktail of erotic and exotic lures. Amidst the urban explosion that marked the Asian Pacific Region, significantly over the 1990s, Bangkok was often regarded as a sort of laboratory of metropolitan change, its growing image being fuelled by the Western fascination with an oriental version of 'urban chaos'.

In the wake of the post-1997 financial crisis, which abruptly reduced the rate of construction in Bangkok, a new excitement emerged among Western observers, as architects, planners, and artists found a stimulating example in the city's ability to reinvent itself. The City of Angels was, in the rhetoric of late 1990s post-urbanism, above all a City on the Move. This slogan was also chosen as the title of an itinerant exhibition that, starting in 1997, brought together artists and architects who engaged through different media with the current urban trends emerging across the Asian continent. This initiative, which was described by its organizers as 'a project on the move', evolved from one stage to another into ever-different displays, following a curatorial strategy that sought to mirror the ephemeral nature of the subject matter. An open framework allowed it to include new ideas and contributors along the way.

When it was first presented in Vienna in 1997, *Cities on the Move* was boasted as 'the first comprehensive show of contemporary Asian art in Europe'. After four shows in various European cities and a brief appearance in New York, the exhibition was eventually brought to Asia. The blueprint of this exhibition, which was staged in Bangkok in 1999, celebrated the recent explosion of Asian megalopolises as a 'period of chaotic but exciting transition', in which 'everything is in a permanent transformation' while 'nothing is established, harmonious and "normal"'. Urban growth and social change were enthusiastically described as symptoms of 'the complex, stimulating and theatrical process of mutation of Asian cities'. Appealing as this dynamic condition may seem to a Western viewpoint, the intoxication with 'urban chaos' has also been criticized for its somewhat romanticized vision of spectacular, and yet often dramatically conflictual, processes. With all its charge of ambitions and ambiguities, *Cities on the Move 6* unfolded as a festival of shows, performances and events throughout Bangkok, generating much enthusiasm and polemics alike.

Intervention: *Souvenir Bangkok*

Bangkok, October 1999. Hundreds of snapshot photographs are on display. They have been collected from tourists and turned into picture postcards 'free for all'. This intervention, called *Souvenir Bangkok*, is part of a group project realized for *Cities on the Move 6*. The pictures are all works of foreign travellers who have

been visiting the city during the first week of the show. These non-professional photographers have consented to a public display of their snapshots, which were acquired, processed and disseminated through several venues of the exhibition, thus infiltrating various spaces of the host city. The result is a cacophony of instant images portraying a week in the life of the metropolis seen through the tourists' eyes. These home-made postcards quickly vanish as they pass into the hands of curious visitors.

Souvenir Bangkok aimed at questioning the omnipresent encounter between the tourist and the city as it is mediated through the camera eye. The primary aim of this operation of *image hijacking* was to question what kind of authoritative credence a holiday snapshot might assume upon entering a public discourse, particularly when the pictures are exposed to those who live in the so-called tourist honey pot. The provocative gesture of claiming for ordinary snapshots 'the privilege of the art object' was also a comment on the concept underlying the exhibition itself. Hundreds of still images reproducing individual trajectories in and around the city *on the move* began their own travels as they were watched and appropriated by the exhibition goers – be they locals, visitors, or artists themselves. These multiple fragments of 'collage tourism' were temporarily deprived of their main function as souvenir images destined for private viewing. They became instead readymade objects exposed to the public gaze, open to multiple meanings, memories, and narratives of explanation.

This short picture essay juxtaposes two series of fragments. The illustrations are among the few remains of the project *Souvenir Bangkok*; the accompanying texts consist of quotes extracted from contemporary writings situated at the crossroad between tourism studies and photographic practices. As each photograph may be regarded as a citation of reality, the selected passages might be read as snapshots of academic theory. There is no attempt to suggest hidden meanings behind this montage. The short-circuit between theory and praxis rather intends to raise further questions about the troubled encounter between contemporary tourism and visual culture.

Figure 8.1 D-Project. Snapshot n. 241: Bangkok, 8.10.99.

'Sightseeing is the main activity of tourism because, with seeing, reality remains external and in its place, leaving the spectator equally free from transformation by the encounter . . . Just as shopping offers the tourist the reassurances of financial transaction and possession, so photography offers an equivalent in the realm of perception . . . As Kodak points out, photographs are a way of preserving memories and are powerful and pleasurable stimuli for reawakening forgotten experiences. But over and above this innocent desire to secure ephemeral experience for retrieval in an uncertain future, there is the act of photographing as a form of behaviour in itself. Taking photographs can be a way of maintaining a relationship of controlled proximity and distance to a lived environment.' (Curtis and Pajaczkowska 1994: 209–10)

Figure 8.2 D-Project. Snapshot n. 174: Bangkok, 8.10.99.

'[P]hotography is a socially constructed way of seeing and recording . . . To photograph is in some way to appropriate the object being photographed. It is a power/knowledge relationship. To have visual knowledge of an object is in part to have power, even if only momentarily, over it. Photography tames the object of the gaze, the most striking examples being of exotic cultures . . . Photography gives shape to travel. It is the reason for stopping, to take (snap) a photograph, and then to move on. Photography involves obligations. People feel that they must not miss seeing particular scenes since otherwise the photo-opportunity will be missed . . . Indeed, much tourism becomes in effect a search for the photogenic; travel is a strategy for the accumulation of photographs.' (Urry 1990: 138–9)

Figure 8.3 D-Project. Snapshot n. 53: Bangkok, 6.10.99.

'The camera is *the* international signifier of tourism . . . Holiday photography is the record which shows, no matter how rushed the visit, that what was seen was what was there; and it is always realist, things as they appear to the mechanism.' (Hutnyk 1996: 145–6)

'Cameras point at culture everywhere, poking into the darkest flashlit nooks and crannies, capturing anything and everything in a million rolls, a massive campaign . . . The co-ordinates of cultural identity and comparison are fixed in small, easy-to-carry squares. It is as if a great reduction machine were at work turning life into a billion miniatures . . . Nothing is ever seen just as it is; all angles, especially camera angles, are positioned and determined by factors of context and contingency. Even pointing the camera without thinking invokes a complex set of figuring preconditions.' (Hutnyk 1996: 147–8)

Figure 8.4 D-Project. Snapshot n. 448: Bangkok, 7.10.99.

'Pictures do not simply record events; the practices of photography are part of them. The events become mortgaged to the future, where self-presentation is not simply about current companions or audiences but future ones removed in space and time. Photography provides a technology through which space and time bound events can be made spatially and temporally portable.' (Crang 1999: 248)

'The possibility of the photograph as a souvenir converts a journey into an excursion . . . where experience is allowed to be accumulated rather than lost, or, rather the acknowledged loss of the experience is what produces aesthetic charge in the picture – perhaps explaining why other people's holiday snaps can be so tedious.' (Crang 1999: 251)

Acknowledgements

The exhibition *Cities on the Move 6: Art, Architecture and Film in South East Asia* was held in Bangkok between 9–30 October 1999. The first part of *D-Project* illustrated here (*Souvenir Bangkok*), was realized by Davide Deriu and Francesca Violi, with the collaboration of Kyoji Nozaki. Theo Michell and Apiradee Kasemsook subsequently carried out the second phase (*My Bangkok*). For an account of the whole project, see Deriu, Kasemsook and Michell (1999).

I wish to thank all those who have contributed to the realization of *D-Project*, and in particular the staff at the *About Studio* in Bangkok for invaluable support during the show and assistance with the photographic material.

References

Bauman, Z. (1996), 'From Pilgrim to Tourist, or a Short History of Identity', in P. du Gay and S. Hall (eds), *Questions of Cultural Identity*, London: Sage.

Bourdieu, P. (1990), 'The Social Definition of Photography', in P. Bourdieu (ed.), *Photography: A Middle-brow Art*, Cambridge: Polity Press.

Crang, M. (1999), 'Knowing, Tourism and Practices of Vision', in D. Crouch (ed.), *Leisure/Tourism Geographies: Practices and Geographical Knowledge*, London: Routledge.

Curtis, B. and Pajaczkowska, C. (1994), '"Getting There": Travel, Time and Narrative', in J. Bird, B. Curtis, M. Mash, T. Putnam, G. Robertson and L. Tickner (eds), *Travellers' Tales: Narratives of Home and Displacement*, London: Routledge.

Deriu, D., Kasemsook, A. and Michell, T. (1999), 'Story of D: A Project and Some Reflections', *Art4d*, 55: 42–3.

Hutnyk, J. (1996), *The Rumour of Calcutta: Tourism, Charity and the Poverty of Representation*, London: Zed Books.

Urry, J. (1990), *The Tourist Gaze: Leisure and Travel in Contemporary Society*, London: Sage.

Part II
Practices and Encounters

–9–

Unlosing Lost Places: Image Making, Tourism and the Return to Terra Cognita

Roger Balm and *Briavel Holcomb*

Introduction

The domain of imagery has long been under 'house arrest' within the broad economy of signs. The rules of engagement with that economy are based on linguistics, so the semiotics of imagery has all too often been subsumed under 'text' and the power of visuality has been underappreciated as witnessings, observations, memory and experience have been transformed into the written word (Moxey 1986; Ball and Smith 1992; Evans 1999). The social functions of imagery and word do indeed co-exist in a broad economy (with all that word's connotations of order and management) but that should not imply that imagery is text in another guise. Imagery is a pictorial system of information that can be, and increasingly is, taken uncut by the written and spoken word. Images have, as W. J. T. Mitchell (1980: 3) suggests, their own shamanic presence and 'semantic, syntactic, communicative power to encode messages, tell stories, express ideas and emotions and pose questions'.

There are strong indications that imagery's intellectual incarceration is ending as the flow of work on visual culture quickens and deepens. Investigations into the role of sight and imaging since the early 1980s (Rorty 1980; Bryson et al. 1991, 1994; Jenks 1995; Mirzoeff 1999 *inter alia*) have had important implications for tourism studies and have opened up rich veins of enquiry (Urry 1990; Selwyn 1996; Crawshaw and Urry 1997; Crang 1999). Tourism involves appropriation of the memories of others (Crawshaw and Urry 1997) but the means of appropriation of that memory is essentially visual; the memory of others is perpetuated and renewed through visual encounters in the past and through the social work that visual records can achieve (Moxey 1986; Fyfe and Law 1988; see also Benjamin 1992).

We consider here the return to terra cognita of lost places from an iconological perspective to demonstrate the remarkable durability of pioneer images from rediscovered lost places. These images are carried forward from past to present, adapted through involvement in a complex process of commodification, but they

remain recognizable and potent. In discussing this potency, we acknowledge the shared economy of word and picture noted above by citing freely from narratives of those who have rediscovered lost places. These narratives run along a different cognitive, expressive and informational path from that of images but they are clearly valuable sources of supplemental evidence in support of judgements about images. There is a predictable process by which lost places become unlost, and we examine this process using two case studies: Machu Picchu (Peru) and the Valley of the Kings (Egypt). For purposes of examination, it is the images of these places that are of concern to us, not the places per se.

Lost space is a malleable medium that may be fashioned into a variety of forms and conditions with imagery as a catalyst. The relationship with lost places, mediated through imagery, plays a powerful role in tourism that goes far beyond influencing choice of destination, extending to a cognitive level where tourists as individuals become creative place builders on a tabula rasa by marking and positioning personal aspirations and imaginings in a cognitive space that stands in contrast to the familiarities of place and space of the known world and daily existence. Through return to the site of the lost, the tourist (and that means any one of us) may purge intervening spans of time, dominated as they are by the grind of daily life. In being returned to a past age (or in the suggestion of being so), we may enjoy the *frisson* of agelessness as we encounter deceased experience. It has been argued by David Lowenthal and others (Lowenthal 1985) that metaphors of unlosing, in the form of disinterment and resuscitation, have pervaded humanist thought from the time of the Renaissance. What we unlose has probably always been an exercise in selectivity. It is certainly so in contemporary Western culture, as Edward Said notes in *Culture and Imperialism*: 'Today's anxieties and agendas influence the images we construct of a privileged, genealogically useful past, a past in which we exclude unwanted elements, vestiges, narratives' (1994: 16–17).

Iconology and Iconic Predecessors

The words 'icon' and 'iconic' are now used with little discrimination as the tide of imagery encountered in daily life continues to rise. Iconic status is an earned characteristic that relatively few images acquire, however. There is not necessarily any equality of significance among visual signs. Iconic images are survivors, displaying longevity within the extended family of images. As Norman Bryson (1991) observes, some images, as signs, project themselves historically, throwing themselves forward in space and time, with their interpretation governed by the two historical horizons of 'then' and 'now.' Whether they are effectively passed forward depends upon whether they continue to work socially as agents of identification, information and understanding (Moxey 1986). To consider simultaneously

both historical source (an image's past life) and cultural work (an image's present and future life) implies that an image has the potential power to transcend the time and place of its creation but also that an image may be examined relative to that original time and place. In other words, an image as an artefact is both fluid and fixed.

Following the trailing threads of a particular image back to source is an historiographical exercise in which we are concerned with the canon of values and pictorial rhetoric embodied in that image (Mitchell 1986), and with situating and explaining those values with reference to the cultural setting of their creation. Such trailfinding was pioneered by Erwin Panofsky in 1939 in his Studies in Iconology as applied to humanist themes in Renaissance art (Panofsky 1972). There are distinctions to be drawn between iconology and its first cousin, iconography, and these distinctions were addressed in Panofsky's later discussions of meaning in the visual arts: 'I conceive of iconology as iconography turned interpretive, and thus becoming an integral part of the study of art a method of interpretation which arises from synthesis rather than analysis' (Panofsky 1955: 32).[1] The more ambitious iconological objective requires relating a work of art to the cultural context in which it was produced, going a step beyond the standard analysis of pictorial tradition (Moxey 1986).

As we are here discussing pioneer photographs produced for documentary purposes rather than art objects, is it valid to examine them by borrowing from arthistorical theory? Without doubt it is. This present stage in late modernism in which we find ourselves allows not only the incorporation of new forms into art but also the capacity to interrogate a broader range of images once considered beyond the pale of art history (Danto 1995). As James Elkins (1999: 4) argues:

> The variety of informational images, and their universal dispersion as opposed to the limited range of art, should give us pause . . . visual expressiveness, eloquence, and complexity are not the proprietary traits of fine art, and in the end it may mean that there are reasons to consider the history of art as a branch of the history of images, whether those images are nominally in science, art, archaeology, or other disciplines.

Initial pictures of a lost site by first locators (those who first rediscover the location) establish a model for the imagery that follows and provide support for the commodification that ultimately occurs. We may term these pictures 'pioneer images'. They function as iconic predecessors to the extent that they influence subsequent imagery and, through that imagery, the way sites become identifiable and understood by tourists and other consumers. In the context of unlosing, the way these places are offered up to be known today is strongly linked to the way in which they first became re-known. In other words, the form and scope of initial publication matter since they largely determine possibilities for wider knowing, for

the building and expansion of lay knowledge. The images associated with both the cases discussed here were published and widely disseminated within a short time of the original discoveries. Imagery associated with lost place and space is not hard to find across the spectrum of visual media and may, at first evaluation, seem throwaway or trivial: from new age pop archaeology (lost civilizations), through historico-tragic imagery of the lost (the *Titanic*) and searches for lost expeditions (Mallory and Irvine on Mount Everest), to searches for mythical lost land masses (Atlantis) and lost skills and techniques (stone carvers of Easter Island and Inca masons). Although it seems that pioneer imagery would be swamped by later tides of merchandising and place-promotion it is in fact those same tides that elevate the status of the pioneer image to that of the iconic predecessor. Indeed, this flood tide of commodification may be seen as an indicator of a culture in rude health if the energetic diffusion of images is anything to go by. As Giulio Argan (1980: 17) contends:

> The image which is worn out, consumed, recited for the thousandth time, or deformed by the careless habit by which it has been adapted to the most varied occasions is often much more eloquent for the historian of the image than the scholarly, purified, controlled version which is established by the lucid structure of a formal system. The image which is discredited or sometimes contaminated by ingenuous associations, combinations, or even by banal confusions (through assonance) with their latent images in the memory is the document of a culture of the diffused image.

Argan sees the loosening of the 'knot of relationships' as central to iconological enquiry in the arts. An effective way of loosening the knot is to identify key parties in the unlosing process and to construct a conceptual model of that process.

The Process of Unlosing

There are four key parties in the unlosing process, beginning with the lost site itself. Our focus here is on archaeological sites and settings that have accrued high charisma. Obviously we include in this group such sites as the Valley of the Kings in Egypt and Machu Picchu in the Central Andes of Peru because we use these sites as our case studies. Second, there are the investigators who bring lost places back to public view (referred to here as 'first locators') and set them on the path to terra cognita, such as Howard Carter et al. in the case of Tutankhamun's tomb, and Hiram Bingham in the case of Machu Picchu. Third, there are actual tourists and virtual tourists, the latter group being consumers of goods, services and media in some way 'branded' with the lost site. The fourth party is imagery, most importantly the pioneer imagery obtained by first locators.[2] Imagery is of central importance because it animates the other three parties in profound ways. The

power of imagery is evident with all sites but in the case of relative inaccessibility it is implicated in using product linkage, displays of artefacts, media promotion and Web travel as a substitute for direct encounter. Imagery is thus a key facilitator of virtual tourism. The imagery of the first locators is aggressively appropriated by marketers. First locators use pictures as documents and as recording devices and their results are often hard earned under difficult conditions. By contrast, appropriation of those images and their translation into retail use is relatively easy, rapid and thorough. To those who have never visited the sites, the image may represent the totality of experience, expectation and lay knowledge. To those who have visited, the image is an aide-memoire, which may eventually efface personal memories.

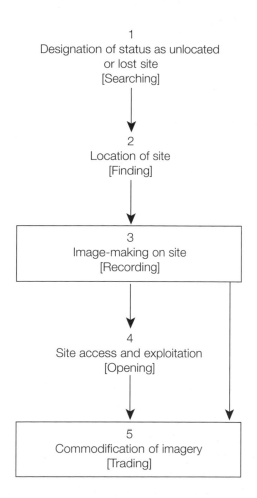

Figure 9.1 Stages in the unlosing process.

Identifying key parties helps us to construct a processional model based on the interlinked roles of the parties. Five stages in this model can be identified (see Figure 9.1), beginning with 'searching' and then proceeding in turn to 'finding', 'recording', 'opening' and, finally, 'trading.' Stages three and five are boxed for emphasis as these are the two we will be examining in some detail. Note that there is a functional connection between them (indicated by the right-hand arrow) because there always remains a discernible link between the commodified image (no matter how attenuated) and the pioneer image. The starting point of the model is the goal of rediscovery, including the journey out from the known world and into the unknown by an expedition or search party, usually under the guidance of specialist researchers. Designation of the site as 'lost' is a conferral of special status and is implicit in this stage. In the narrative of expeditions, this stage is often dramatized by recounting handicaps overcome, thus accentuating the success marked by stage two, the location of the designated site. This is a 'eureka' stage as the previously untested notions about the lost place are re-examined in the light of reality. Failure to locate means the progression back to terra cognita is halted before stage two is reached. Stage three is of critical importance and usually coincides with stage two: the production of pioneer images by first locators. With these images, the return of the lost to terra cognita commences in earnest, assuming that the pioneer images have a means of broad dissemination through media. Stage four is the opening of the site. This involves establishment of physical access by means of roads or other infrastructure so that it is no longer a place to which only specialists may make their way. This stage is marked by exploitation and the planned incorporation of the site into the orbit of tourism marketing and may be actively aided by government to the extent it is seen to yield advantages in economic development. It is a stage of domestication because the provision of access has a subduing or taming effect on the site. The final stage is the commodification of imagery. This stage is open-ended and describes the ongoing process of reproducing or adapting for reuse the pioneer images of first locators.

Central to our argument is the contention that despite adaptation of the pioneer images and the complexities of commodification over time, reference to the original pictures can still be traced. To provide evidence for this assertion about iconic predecessors, we will now turn to our case studies and discuss how the early images have been reused, particularly in tourism marketing.

Machu Picchu

The first locator of Machu Picchu in Peru, Hiram Bingham, was well connected to the great and the good of academe and public life as an alumnus of Yale University in the US. The Yale Peruvian Expedition of 1911 was formed after a speech by

Bingham to the Yale Club in New York City in 1910, the proposed venture attracting wide support, both financial and logistical, from the assembled diners. The stated goal was to 'climb the highest mountain in America, collect a lot of geological and biological data, and above all to find the last capital of the Incas' (Bingham 1951: 102). Bingham (1951: 100) spoke of his geographical goals in the twentieth century but in the Romantic voice more associated with the century preceding:

> These snow-capped peaks in an unknown and unexplored part of Peru fascinated me greatly. They tempted me to go to see what lay beyond. In the ever famous words of Rudyard Kipling there was 'Something hidden! Go and find it! Go and look behind the ranges – Something lost behind the Ranges. Lost and waiting for you. Go!'

Bingham eventually came upon the ruins of Machu Picchu on 24 July 1911. In a later book, he describes his recollections of the events of that day, though almost certainly in a form embellished for self-promotion and adjusted for the status that the ruins had acquired since first discovery: 'Would anyone believe what I had found? Fortunately in this land where accuracy of reporting is not a prevailing characteristic of travelers, I had a good camera and the sun was shining' (1979: 153–4). This account, together with some other aspects of his narrative, was rehearsed in later years through several publications and carefully crafted for popular consumption.

The majority of the expedition's photographs of Machu Picchu were taken by Bingham himself during the 1912 expedition, rather than during the year of initial discovery (1911). It is probable that Bingham's interest in Machu Picchu was overshadowed during the first expedition by his search for the last Inca capital (Bingham 1989).[3] The most interesting photograph from the 1911 expedition was taken by Herman Tucker, an arresting image of the site shrouded in vegetation (see Bingham 1913: 499). Bingham was to use Tucker's vantage point in 1912 for an overview of the site after clearance of vegetation: 'We were anxious to secure photographs which would give some idea of the remarkable art and architecture of the white granite structures, even though this meant an enormous amount of painstaking labour' (Bingham 1951: 149). Overall, the visual archive of the 1911–15 explorations totals 12,000 images. The most important vehicle of dissemination for the expedition's photographs was *National Geographic Magazine* but a series was also published in 1913 in *Harper's*. The *National Geographic Society* underwrote the 1912 expedition with a grant of $10,000, and an article on the Peruvian discoveries dominates the edition for April 1913. A preface asserts that Bingham's account together with the 250 'marvelous pictures . . . forms one of the most remarkable stories of exploration in South America in the past 50 years.'

The characteristic view of Machu Picchu, the view that has become the iconic predecessor and has been widely appropriated, is Bingham's panoramic view from

above (Figure 9.2). The lack of visible foreground or footing in the frame gives free range to the swooping diagonals of the Andean topography. The image suggests levitation above the site, a condor's eye view. Bingham (1951: 152) provides the rationale for this viewpoint:

> The sanctuary was lost for centuries because this ridge is in the most inaccessible corner of the most inaccessible section of the central Andes. No part of the highlands of Peru is better defended by natural bulwarks – a stupendous canyon whose rock is granite, and whose precipices are frequently 1,000 feet sheer, presenting difficulties which daunt the most ambitious modern mountain climbers.

As items of visual information, no other images in the 1911–15 archive match the content of the condor-view photographs. The visual choice is clear: to show the totality of a location in an all-embracing view within a scopic regime hinging upon Cartesian perspectivalism and fitting with the codes of visual knowledge valorized by the scientific world view (Jay 1988). Such views are traceable back to Renaissance times and the production of town views from elevated vantage points (Nuti 1999). In the context of Machu Picchu, the visual message of loss to the passage of time is implicit in Bingham's overview photograph of 1912: the ruined dwellings, the abandoned plazas and terraces, and the temple structures open to the wind. The scene is replete with signs of human skills and a sense of order but the bringers of those signs and that sense of order have disappeared utterly, it seems. The complete absence of people in the photograph, their negative space, is an important part of the picture's rhetoric for we the observers, the witnesses, are able to enter into that negative space of the lost and fill it with our own sense of order.[4]

Binghamesque panoramic imagery is today replicated in countless brochures, advertisements and Web sites, and the iconic predecessor has been appropriated for marketing applications ranging from outdoor clothing to instant coffee. It is also popular with some charity appeals that link fundraising with travel to remote and/ or exotic locations. The most common and effective application is, unsurprisingly, in tourism. The 'Lost City of the Incas' has become the most important revenue-producing park in Peru with accelerating numbers of arrivals: from 180,000 in the mid-1980s to approximately 700,000 in the late 1990s; currently 98 per cent of international tourists to Peru incorporate a visit to Machu Picchu (Desforges 2000; UNESCO 2000). Although it is possible to reach Machu Picchu today on air-conditioned buses via the hairpin bends of the Hiram Bingham Highway, marketing materials often emphasize that the visitor to Machu Picchu is an adventurous type, following in the footsteps of the first explorers although, in reality, fewer than 5 per cent of visitors to Machu Picchu choose to reach the site via the Inca Trail (UNESCO 2000). The Inca Trail is sold as adventure tourism even though local

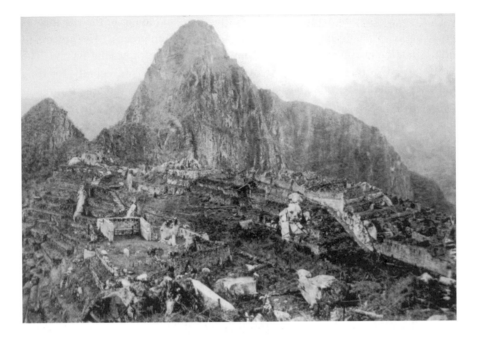

Figure 9.2 Iconic predecessor: Machu Picchu, 1912. Photograph by Hiram Bingham. National Geographic Society.

porters carry one's kit and cook meals at camps set up en route. The recent brochure for Abercrombie and Kent (2000: 26) describes the experience:

> The Lost City of the Inca's [sic], rediscovered at the beginning of the 20th century, is one of the world's architectural wonders, set in the sheer mountainous heart of the Andes. There is . . . the sense of walking in the past, climbing the peaks for different views of the city, sharing an experience that transcends the ages in a journey back in time. The easiest way to get there is by train from Cuzco, however, the best way, for the fit, is a four-day hike: treading ancient Inca trails across the mountains through forest and swamp, passing long abandoned villages atmospheric in the clouds.

Current visitor numbers notwithstanding, the issue of access to the site has always loomed large not only for the first locators but, latterly, for tourism management. In opening the site to mass tourism, the vertiginous terrain has been a principal obstacle, precluding access by fixed-wing aircraft (though there is a nearby landing pad for helicopters). The valley bottom is occupied by the Urubamba River, and the only land link out, with the exception of the remaining Inca footpaths, is a narrow-gauge railway between Cuzco and Aguas Calientes. The opening and exploitation of a site constitutes stage four of our schema (Figure

9.1). Providing access represents a domestication and taming of the site that, as noted earlier, is an essential part of the commodification process. The process of domestication and taming is still continuing in the case of Machu Picchu. The Peruvian government has, for example, shown enthusiasm recently for road building along the Urubamba Valley to bring tourists into the area in greater numbers and to spur a form of ribbon development in the process. In mid-2000, plans for an aerial tramway up from the valley floor were officially endorsed by the government. The role of such schemes as these in the unlosing of Machu Picchu is clear: the pace of unlosing moves in step with increasing access. The ordered progression of the unlosing process (Figure 9.1) is not fundamentally altered by enhancing access but progression is quickened. As evidence for this we can turn to the case of Tutankhamun and the Valley of the Kings, a very different site with easier access but where the basic steps in the unlosing process are the same as for Machu Picchu.

The Valley of the Kings

The Valley of the Kings lies on the Western side of the Nile, adjacent to modern-day Luxor in Egypt. The charisma that this location has acquired can be largely attributed to the location and unsealing of the tomb of the 'boy king' Tutankhamun by Howard Carter, beginning in November 1922. The background to the discovery is well known and need not be related here. Suffice it to say that the tomb site had been explicitly designated as their archaeological goal by Carter and his benefactor and partner Lord Carnarvon since first obtaining the concession to dig from the Egyptian government in 1914. The concession was accompanied by a caution that the valley was probably exhausted of valuable finds. Carter persevered nonetheless:

> We remembered . . . that nearly a hundred years earlier Belzoni had made a similar claim, and refused to be convinced. We had made a thorough investigation of the site and were quite sure there were areas, covered by the dumps of previous excavators, which had never been properly examined. (Carter 1972: 25)

Belzonian doggedness[5] rewarded Carter handsomely, but only just in time since the discovery came just as the search was about to be abandoned as fruitless. With the Valley of the Kings, as with Machu Picchu, we are the beneficiaries of first-hand written accounts by the first locators to accompany the pioneer imagery. The commentary of Howard Carter plays to the popular understanding of lost place in the Egyptian context that had been formed and nurtured through imagery since the early nineteenth century, a deeply sensual lay knowledge of the tombs as sub-terranean caches of treasure embedded in a matrix of suspended time. Carter's

account also plays to common orientalist metaphors regarding Egyptian treasure trove (MacKenzie 1995), concerning its retrieval from burial under the desert sands and the simultaneous retrieval from lost memory and knowledge. As Carter relates it:

> You feel it might have been yesterday. The very air you breathe, unchanged through the centuries, you share with those who laid the mummy to rest. Time is annihilated by little intimate details . . . and you feel an intruder. That is perhaps the first and dominant sensation, but others follow thick and fast: The exhilaration of discovery, the fever of suspense, the almost overmastering impulse, born of curiosity, to break down seals, and lift the lids of boxes, the thought – pure joy to the investigator – that you are about to add a page to history, or solve some problem of research, the strained expectancy – why not confess it? – of the treasure seeker. (Carter and Mace 1927, v.1: 145–6)

Whereas Bingham had a penchant for condors' perch viewpoints, looking down and across the site, Carter and his excavation photographer favoured views in and through passageways, doors and chambers. In examining the pictures today, we are given a grave-robbers' eye view. On first shining his torch into the outer chamber of Tutankhamun's tomb, Carter was struck by the abundance of gold; 'everywhere,' he said, 'there was the glint of gold' (1927, v.1: 141). The pioneer imagery from the excavation is a near-perfect fit with Walter Benjamin's characterization of documentary photography as a forensic procedure that treats a site as a crime scene, disturbing as little as possible while the evidence is collected (Benjamin 1992). Carter's photographer was Harry Burton of the Metropolitan Museum in New York. Burton fastidiously recorded each stage of the excavation process and every sequence in opening the nested sarcophagi of Tutankhamun (towards the ultimate inner chamber containing the funerary shroud itself). The lid of the last coffin was finally raised during the 1925–6 excavation season. The contents were a study in gilded androgyny, youthful ripeness and sensuality (Figure 9.3).

'At such moments,' declares Carter, 'the emotions evade verbal expression, complex and stirring as they are. Three thousand years and more had elapsed since men's eyes had gazed into that golden coffin . . . Here at last lay all that was left of the youthful Pharaoh' (1927, v.1: 141). As an artefact, the remains belong to that particular class of objects that stare back at the observer (see Elkins 1996). Certainly, part of the explanation for the potency of the original image, and the enduring interest in the mask particularly, is that stare directed into the middle distance beyond the observer's eyes. The object of that stare is the visual equivalent of the negative space of missing figures in the iconic image of Machu Picchu. We are able to reoccupy the space and provide an object, any object we feel is appropriate.

In one important sense, the opening of the site to the public and its subsequent exploitation as a tourist attraction was already occurring when the tomb was first

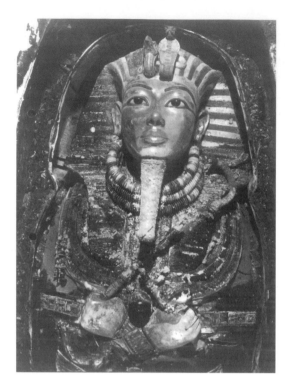

Figure 9.3 Iconic predecessor: Tutankhamun, 1925. Photograph by Harry Burton. Griffith Institute, Ashmolean Museum, Oxford.

entered. Not only had a prior agreement been reached, giving the *Times* of London exclusive rights to the photographic images and their subsequent syndication but Carter tailored the excavations to fit the tourist tide:

> Past experience had taught us that it would be well to resume our work on the tomb . . . as soon as the decline of the great heat rendered it practical, our aim being to carry it out with due scientific procedure and to be able to open the tomb to the public as early as possible during the tourist season. Our anticipations were fully justified, for, between January 1 and March 15, 1926, there were over 12,000 visitors to the tomb. (Carter and Mace 1927, v.2: 121)

Travel to Egypt by Europeans, if not tourism, had been frequent in the century preceding Carter's discoveries, of course. The nineteenth century witnessed what the Starkeys (1998: 6) call a 'vast number of European travellers to Egypt', including artists, photographers and writers (such as David Roberts, Frederick Catherwood, Francis Frith, Gustave Flaubert and Amelia Edwards). More ordinary

travellers increasingly visited some of the Egyptian sites along the Nile, perhaps as a detour from the journey to India. In 1864, a guidebook rhapsodized that 'life on a Nile barque has a charm which seldom fails to operate on the most inert mind. The traveller is perfect king on his own boat' (quoted in Warner 1994: 1). By 1890, young English ladies were climbing the pyramids, following breakfast at Shepheard's Hotel, and Luxor had become a fashionable winter resort. Such travels formed part of populist celebrations of Egyptiana but also connected in some cases to something more profound where the pulses of enthusiasm for everything Egyptian during the nineteenth and early twentieth century took the form of what art historians have termed the 'Egyptian revival' and were sustained by a substratum of classical scholarship. As with the case of Machu Picchu, today's visitors to Egypt are encouraged to identify with the travellers of the past if not submit entirely to the concept of time travel. The brochure for Longwood Travel (Longwood Travel 2000: 1) proclaims that 'to explore Upper Egypt is to take a journey back in time to age of the Pharaohs', and Egypt's Ministry of Tourism sees Luxor as 'a living museum with a vast number of ancient monuments. It is also highly oriented to tourists, and might be thought of in the same regard as a theme park, where the attractions just happen to be real monuments' (Egypt Ministry of Tourism 2000). No matter that much Nile travel today is on multi-decked cruise ships following a truncated shuttle itinerary between Luxor and Aswan. In a recent catalogue, Cox and Kings (2000: 30) describes the vessel *Philae* thus:

> Built in the style of the paddle wheeler, this deluxe ship was completed in 1995 and offers the elegance and sophistication of travel in the Edwardian era. Beautifully decorated in the style of the turn of the century, the *Philae* offers luxurious facilities, with only 58 cabins and 4 suites, a swimming pool and a sun deck. Cabins have en-suite facilities with television, telephone, air-conditioning and a private balcony.

Nineteenth- and early twentieth-century Egypt lacked the gilded presence of the boy king. Today, yearly tourist arrivals to Egypt total close to four million. The Valley of the Kings and the tomb of Tutankhamun are major attractions, though scarcely containing now much of note since the funerary mask and anything else moveable and of value has been transferred to the Egyptian Museum in Cairo. The gilded mask, although long since separated from its wearer, for all intents and purposes has become Tutankhamun. The original association between Tutankhamun and the Valley of the Kings has been replaced with a contrived, attenuated and fluid association linked to marketing and commodification, at the centre of which is the mask. Based on examination of typical itineraries, described in brochures such as those published by Cox and Kings and Voyages Jules Verne, Luxor and the adjacent Valley of the Kings has become twinned with Giza and the Pyramids. In an important sense, that of place-marketing, the Valley of the Kings

remains the gilded locale it was in Carter and Carnarvon's day. Many travel brochures featuring Egyptian destinations are branded with Tutankhamun's mask, based on the iconic predecessor of Harry Burton's photograph of 1925.

As an image, the mask itself was prepared for its journey from the Underworld and into commodification as soon as it was separated from the mummy and had its lustre restored and reincased for public viewing. Re-presented thus, it was recognizably the same artefact but wholly different in complexion from that recorded via Burton's lens. Two near-contemporary events have fueled and been fueled by Tutankhamun imagery: the *Treasures of Tutankhamun* exhibition that toured Europe and the United States in the late 1970s, and the *Egyptomania* exhibition, held in Paris, Ottawa and Vienna in 1994-5. This latter exhibition attracted over 3,000 visitors a day in Paris. Brian Curran (1996: 739) describes the force of commodification at flood tide:

> *Treasures of Tutankhamun* traveled across the country on a whirlwind of publicity that inspired an 'Egyptian' craze in movies, television shows, mystery novels, and trinkets of every kind and description. During this period of 'Tut-mania', the Egypt-oriented consumer could conceivably wake up in the morning to the strains of Steve Martin's 'King Tut' song, apply 'King Tut' cologne after shaving, go downstairs for a cup of 'King Tut' tea, and proceed downtown to the shopping district (and the local museum shop) where still more Tutankhamun products (books, catalogues, T-shirts, posters, jewelry, stationery, whiskey, decanters etc.) could be purchased.

And let's not forget architecture. Although the days of shipping out wholesale the standing monuments of Egypt to be re-erected in places such as London ('Cleopatra's Needle' on the Thames Embankment) or Paris (an obelisk from Luxor on the Place de la Concorde) are over, replication is still common. Take, for example, the Luxor hotel in Las Vegas that incorporates the image of Tutankhamun morphed with the rump of the Sphinx, the gilded image of the boy king brought to the casino.

Conclusion

A form of pictorial genealogy can be applied to present-day images found in the marketing of lost places. Traced back, they return us to pioneer images that over time have taken on the role of iconic predecessors. This exercise in pictorial genealogy involves backstepping through the five-stage model we have described. We have paid particular attention to the images produced by first locators and their subsequent commodification, using the two case studies of Machu Picchu and Valley of the Kings. Materially, the pioneer images of Bingham and Burton have grown old: 85 years in the case of the former and 75 in the latter. So how do we

account for their durability and continued potency? It is unlikely to be attributable to their technical or aesthetic perfection as pictures, for they were workaday recordings in many ways. Nor can it be due to the scarcity of images for the camera was a tireless worker both at Machu Picchu and the Valley of the Kings. The most likely explanation is that these images, in addition to being the first to be produced and disseminated, best fitted conceptions about these lost sites specifically, or some notion of what lost sites generally should mean. Thus, their potency and their continuing utility (their social work) will continue until something of a better conceptual fit comes along. This is unlikely in either the Peruvian or the Egyptian case, for it is in the nature of iconic predecessors to be self-perpetuating. They work catalytically, continuously informing conceptions of the lost for which they then serve as pictorial exemplars.

We suggested at the outset that personal reunion with lost places can fill an emotional and cognitive need in people. Yet the actual rediscovery of lost places is rare, particularly those of high charisma. How can this mismatch between need and supply be squared? Why do we not run out of lost places and spaces? The explanation lies in the effectiveness of marketing that uses imagery to exploit the charisma of lost places, thereby apparently recreating them. In his discussion of sacred landscapes, Richard Tressider (1999) suggests that the tourism industry can provide unlimited access to places of escape through constructed representations fashioned largely through landscape imagery. Representations of the lost are, we argue, powerful examples of this unlimited access. The charisma of the lost and the advantages to be gained from retailing an encounter with it is clear to the tourism industry and other commercial interests, but borrowing from the imagery of the past is required to realize those advantages.

In considering the return of the lost to terra cognita, a paradox is embedded in that borrowing; however, if the commodification of imagery returns lost places to terra cognita it also effectively reloses important aspects of those places as they become accessible, endlessly reproduced and stripped of characteristic details and genius loci. A site's return to terra cognita thus has a curving trajectory with a rising limb associated with the pioneer imagery of first locators eventually giving way to a downward curve as the site becomes lost again in the commercial deeps.

Notes

1. In his 1939 text, Panofsky favours the word 'iconography' over 'iconology.' The implication is clear, however, that he equates iconology with the discovery and interpretation of 'symbolical values' and 'iconography in a deeper sense';

he identifies iconology as the third of three 'strata' of meaning, access to which lies in interpretation rather than description (Panofsky 1939: 8).

2. The focus in this chapter is on first locators, but in a small number of cases it is the imagery of last rememberers that is dominant. A good example, in context of lost place and space, is the iconic image of the upended *Titanic* as seen from the lifeboats.

3. In addition to surveying the site of Machu Picchu, the Yale-Peruvian expeditions of 1911–15 located the last Inca strongholds of Vitcos and Vilcabamba La Vieja. Current consensus of opinion is that Machu Picchu was constructed in the later fifteenth century as a country estate for Pachacutec, the ninth Inca. If this is the case, Bingham overstated both the antiquity and importance of the site in concluding that it was Tampu-tocco, the 'country place with windows', the burial place of Pachacuti VI and an early capital city prior to the acquisition of Cuzco and the eventual expansion of the Inca Empire. Machu Picchu was, he concluded, 'the capital of the little kingdom where . . . during the centuries – possibly eight or ten – between the Amautas and the Incas, there were kept alive the wisdom, skill and best traditions of the ancient folk . . . When they once got control of Cuzco . . . there was no longer any necessity for them to maintain Tampu-tocco. Consequently, Machu Picchu may have been practically deserted for three hundred years while the Inca Empire flourished' (Bingham 1951: 210).

4. In reality, the location of Machu Picchu was well known to local inhabitants. Bingham was led to the ruins by a guide and, for the final ascent to the site, by a local boy. Three families were living in the buildings, and some of the land was under cultivation.

5. Giovanni Belzoni worked in Egypt in the early nineteenth century and displayed a flair for locating concealed entrances into tombs. He was the first to open the Great Temple at Abu Simbel and the pyramid of Khafre at Giza. His combination of intuition and ingenuity translated into a profitable line of work, locating and removing artefacts for shipment to European museums.

References

Abercrombie and Kent (2000), *South America and Costa Rica: Tailor-made Journeys for the Discerning Traveller. Edition 2000*, London: Abercrombie and Kent.

Argan, G. C. (1980), 'Ideology and Iconology', in W. J. T. Mitchell (ed.), *The Language of Images*, Chicago: University of Chicago Press.

Ball, M. S. and Smith, G. W. H. (1992), *Analyzing Visual Data*, Newbury Park: Sage.

Benjamin, W. (1992), *Illuminations*, London: Fontana.

Bingham, A. M. (1989), *Portrait of an Explorer*, Ames: Iowa State University.

Bingham, H. (1913), 'In the Wonderland of Peru. The Work Accomplished by the Peruvian Expedition of 1912, under the Auspices of Yale University and the National Geographic Society', *National Geographic Magazine*, 14: 387–574.

Bingham, H. (1951), *Lost City of the Incas. The Story of Machu Picchu and its Builders*, London: Phoenix House.

Bingham, H. (1979), *Lost City of the Incas,* New York: Atheneum.

Bryson, N. (1991), 'Semiology and Visual Interpretation', in N. Bryson, M.A. Holly and K. Moxey (eds),*Visual Theory*, Cambridge: Polity.

Bryson, N., Holly, M. A., and Moxey, K. (eds) (1994), *Visual Culture: Images and Interpretations*, London: Wesleyan University.

Carter, H. (1972), *The Tomb of Tutankhamen*, London: Barrie & Jenkins.

Carter, H. and Mace, A. C. (1927), *The Tomb of Tut-ankh-Amen*, 2 vols, New York: George H. Doran & Company.

Cox and Kings (2000), *Middle East 2000 and Central Asia,* London: Cox & Kings.

Crang, M. (1999), 'Knowing, Tourism and Practices of Vision', in D. Crouch (ed.), *Leisure/Tourism Geographies: Practices and Geographical Knowledge*, London: Routledge.

Crawshaw, C. and Urry, J. (1997), *Tourism and the Photographic Eye*, in C. Rojek and J. Urry (eds), *Touring Cultures*, London: Routledge.

Curran, B. A. (1996) 'Egyptomania: Egypt in Western Art, 1730–1930', *Art Bulletin*, 78: 739–52.

Danto, A. C. (1997), *After the End of Art: Contemporary Art and the Pale of History*, Princeton: Princeton University Press.

Desforges, L. (2000), 'State Tourism Institutions and Neo-liberal Development: A Case Study of Peru', *Tourism Geographies,* 2: 177–92.

Egypt Ministry of Tourism (2000), www.touregypt.net.

Fyfe, G. and Law, J. 'Introduction: On the Invisibility of the Visual', in G. Fyfe and J. Law (eds), *Picturing Power*, New York: Routledge.

Elkins, J. (1996), *The Object Stares Back*, New York: Simon & Schuster.

Elkins, J. (1999), *The Domain of Images*, Ithaca: Cornell University Press.

Evans, J. (1999), 'Introduction', in J. Evans and S. Hall (eds), *Visual Culture: The Reader,* London: Sage.

Jay, M. (1988), 'Scopic Regimes of Modernity', in H. Foster (ed.), *Vision and Visuality*, New York: The New Press.

Jenks, C. (1995), *Visual Culture*, London: Routledge.

Longwood Holidays (1999), *Egypt and Jordan*, Woodford Green: Longwood Holidays.

Lowenthal, D. (1985), *The Past is a Foreign Country*, Cambridge: Cambridge University Press.

MacKenzie, J. M. (1995), *Orientalism: History, Theory and the Arts*, Manchester: Manchester University Press.

Mirzoeff, N. (1999), *An Introduction to Visual Culture*, London: Routledge.

Mitchell, W. J. T. (1980), 'Introduction' in W. J. T. Mitchell (ed.), *The Language of Images,* Chicago: University of Chicago Press.

Mitchell, W. J. T. (1986), *Iconology: Images, Text, Ideology*, Chicago: University of Chicago Press.

Moxey, K. (1986), 'Panofsky's Concept of Iconology and the Problem of Interpretation in the History of Art', *New Literary History*, 17: 265–74.

Nuti, L. (1999), 'Mapping Places: Chorography and Vision in the Renaissance', in D. Cosgrove (ed.), *Mappings*, London: Reaktion Books.

Panofsky, E. (1955), *Meaning in the Visual Arts: Papers in and on Art History,* Garden City: Doubleday.

Panofsky, E. (1972), *Studies in Iconology: Humanistic Themes in the Art of the Renaissance*, New York: Harper & Row, Icon Editions.

Rorty, R. (1980), *Sensuous Geographies*, London: Routledge.

Said, E. (1994), *Culture and Imperialism,* London: Vintage.

Selwyn, T. (ed.) (1996), *The Tourist Image: Myths and Mythmaking in Modern Tourism*, Chichester: Wiley.

Starkey, J. and Starkey, P. (1998), *Travellers in Egypt*, London: I. B. Taurus.

Tressider, R. (1999), 'Tourism and Sacred Landscapes', in D. Crouch (ed.), *Leisure/Tourism Geographies: Practices and Geographical Knowledge*, London: Routledge.

UNESCO (2000), www.unesco.org.

Urry, J. (1990), *The Tourist Gaze: Leisure and Travel in Contemporary Societies*, London: Sage.

Warner, N. (ed.) (1994), *An Egyptian Panorama: Reports from the 19th Century British Press*, Cairo: Zeitouna.

−10−

Holocaust Tourism: Being There, Looking Back and the Ethics of Spatial Memory
Griselda Pollock

There are two key experiences that prompted me to propose this ghastly subject for a collection of essays on tourism and visual culture.

One evening in September 1999, I was phoned to be invited, at short notice, to join a group leaving Manchester in two days' time for a 'Day Trip to Auschwitz.' As part of an educational initiative within and for the Jewish community, these day trips to Poland have been available over the last few years. They form part of a growing phenomenon in which over 700,000 people annually visit the complex and dreadful site. Leaving Manchester airport at about 4 a.m. and arriving in Kraków for about 10 a.m., the group, accompanied by its own 'facilitators' and educational guides, would do a walking trip around the old Jewish quarter of Kazimierz in Kraków. A 40-minute bus journey would then take the visitors to the border town of Oświęcim in order to visit the memorial site and museum of the concentration and death camp known to history as Auschwitz, the Germans' colonial renaming of the Polish site of a former military barracks next to a medieval town with its own considerable Jewish population, now nil. The group would then return to Kraków and fly back to Britain arriving at midnight at Manchester airport. Needless to say, I did not feel able to go.

Many considerations constrained me: The short notice, the responsibility for 'education' for such a group of British Jewish visitors to these sites, the conditions of travel at such unearthly hours.[1] Most of all, there was a conviction that I should never go to Auschwitz.

I am certainly too scared. At a personal level, the terror of being that close to that danger threatens me too unbearably. At a less unpredictable level, I am perplexed at the ethics of going to, visiting, touring a place whose all too real and still powerfully symbolic function was to be a horrific terminus, the end of a line, the factory of death, a place from which none was intended to return. Moreover, although about 70,000 people were found still barely alive when the Russians liberated the camps on 23 January 1945, the 'survivors' have never 'come back' from the hell they still live, irrespective of where in the world they now live. As one of the survivors whose testimony is incorporated into the Holocaust exhibition at

the Imperial War Museum in London, bleakly reminds us: 'Once you have been tortured, you remain tortured forever.' The time of trauma is an eternal present.

Auschwitz is thus not simply a site, a place, a town, a topography. It signifies an encounter with death, and as such signifies a stupefying absence, the destroyed millions who signified furthermore, the destruction of one of the civilizations of Europe. Indeed, for Theodor Adorno, that manufactured, administered dying changed death for the rest of us. To go, to tour *and to leave*, is to defy that demonic logic, to put 'Auschwitz' back in a place with an entrance *and an exit*, to see its impoverished remains as the closed containers of a history that is past and fading.

Behind my decision not to go on the day trip lay the second incident, pertinent to my title. It concerns the problematic of tourism of any sort. In 1994, I was listening idly to a radio programme while driving. It was about vacationing in Poland, a beautiful country of mountains and lakes, little explored by Western Europeans since the formation of the 'wall' that divided Eastern from Western Europe during the Cold War. While discussing the touristic attractions of Poland's medieval cities, the presenter identified a growing phenomenon he named 'Schindler Tourism'. This referred to the enormous international impact of Steven Spielberg's 1992 film, *Schindler's List*, as a result of which Kraków had re-emerged as a tourist spot. As the broadcaster described it, a visit to the sites used in the film overlaid the seeking out of the actual sites *referred to* by the film, though not used in the film for purely cinematic reasons. The social geographer Andrew Charlesworth has demonstrated in his scrupulous research into what he names Holocaust geography, that the house of the sadistic camp commandant, Amon Goeth at Plazow, was lower down the hill than the rest of the camp. This historical fact did not make for the desired cinematic effect – no little reminiscent of the Bates house in Hitchcock's *Psycho* (1962) – of Goeth living in a villa overlooking the enslaved Jewish prisoners whom he would arbitrarily shoot as his morning exercise from his elevated balcony (Charlesworth 1994, 1996). The actual site of the ghetto was also not used in the film; instead, the parts of the town from which Jewish families and communities had been evacuated were substituted, thus actually reversing the movements of history for the sake of the cinematic picturesque. These anomalies in the historical geography of the representation underscored the extraneous factors that frame the tourist's experience of seeing something worth seeing and remembering, rather than encountering the opacity of any place vis-à-vis the history that has taken place there, a history that often as not cannot be simply seen, cannot be turned into an intelligible site and be known through the fact of seeing the location.

Discussing the dangers of a mythicization of Auschwitz in his book, *Images of the Holocaust: The Myth of Shoah Business*, the historian Tim Cole (1999) makes a distinction between 'pilgrims' and 'tourists' amongst the throng who visit Auschwitz. Pilgrims are those who return to a place that they once knew, or come

to visit the 'cemetery' of murdered relatives and friends. Tourists are constituted as those for whom this place is a 'sight' rather than a memorial site. What the pilgrims come to experience is not visible; they do not come to be informed. What the place of the visit signifies is already 'overknown', often unbearably so as both recuperable memory and as the etched lining of memory that is trauma. The pilgrims do not come awaiting a packaged, planned, itinerized experience, preshaped by the new canons of the museum educators and the heritage industry. They bring another kind of knowledge, against which the present emptiness and hollow shells of pavilions, displays and visitors' centres seem irrelevant.

What do people who visit those camps that have been preserved as museums, monuments, memorials, 'see'? Tourism is predicated on the journey to the other, out of time, preserved as a past, a promise of difference. Tim Cole argues that Holocaust tourism belongs in a new kind of tourism, a tourism of death: Graceland, the Book Depository in Dallas, the street where John Lennon was shot and so forth. Each could be called a place of history. Each could instruct. If people did not register these sites through such visits their place in history might be lost. But this is the knife-edge we walk.

The tourist, therefore, knows only of the place name as somewhere made remarkable by the enormity of the deaths that occurred there. The named becomes a part of what I sense is forming a Holocaust iconography, itself a *musée imaginaire*, composed of atrocity images in archive footage and documentary photographs of the sights that greeted the liberating Russians and Allies when they opened up the camps. On the other hand, there is also another strand in this visual imaginary: the kitsch clichés of Nazi insignia, SS uniforms and so forth, reproduced in both popular culture and neo-nationalist self-fashioning. Auschwitz, a German name on no contemporary map of the 1940s, is certainly a 'heavy' thing to see on an itinerary that will encompass other kinds of sites of historical or visual interest, dispersed between travel, eating and shopping. The tourist is, therefore, at the mercy of the way the encounter is stage managed as a memorable visit, rather than a visit of memory.

The architect Robert van Pelt and his collaborator Deborah Dwork have undertaken a rigorous historical analysis of the Auschwitz sites using documents, blueprints, contracts, specifications and other site plans, many of which came to light only after Glasnost revealed materials taken to the Soviet Union by the Russian armies that liberated Auschwitz. These documentary materials that detail the calculated building and specification for an industrial machinery of mass murder are vital in the current historical controversy, the crisis of truth, that is now being contested in the academy as in the law court, in the wake of Holocaust denial. They form another necessary level of knowing, complementing the testimonial and archive evidence with forms of analytical and interpretative reconstruction that allow the larger, systematic picture to be formed so that the

function of Auschwitz can incontestably be established in all its enormity and complexity. It concerns providing another kind of knowledge for a site whose name functions metaphorically for the whole of the Holocaust.

Using these archives dispassionately to reconstruct the massive constellation of three main camps and their 20-odd satellites, van Pelt and Dwork conclude that the unknowing tourist risks gaining an experience that bears virtually no relation to the historical actuality that these records, combined with survivor testimony, allow us to reconstruct (Pelt and Dwork 1996). Indeed, Tim Cole (1999) concludes that as a result of the postwar Polish rebuilding in ignorance of the original plans and buildings, and indifferent to the necessity of respect for those forms, the 'reconstructions' that now stand in for the Auschwitz experience mean that the tourist is encountering a simulacrum, a fiction, that he names, perhaps too flippantly, 'Auschwitz-land'. This fiction involves postwar reconstructions that are not labelled as such, combinations of materials and histories from different sites. There is almost no clear indication of the different histories, populations and usages of each of the three main complexes that constituted the totality of Auschwitz's concentrationary universe. Any visitor must grasp the difference between Auschwitz I, II and III. Auschwitz I, the original brick-built barracks that constituted the administrative centre for the complex and housed Polish political prisoners as well as Soviet prisoners of war. Here are sited the displays. Then, several kilometres away, there is the vaster, unrestored Auschwitz II (Birkenau) which is approached down the railway lines and the post-1943 gate, while, more distant, lies Auschwitz III (Monowitz) which was the slave labour camp attached to the I. G. Farben works. In the industrialized extermination at these three sites, it is estimated that 70,000–75,000 Polish men and women, 15,000 Soviet prisoners of war, 21,000 gypsies, 10,000–15,000 other nationals and between 960,000 and 1.1 million Jewish men, women and children were murdered. It was in Birkenau that the Jewish, Romany and Sinti peoples were put to death by gassing, starvation and forced labour.

National histories, shaped by post-war political and ideological narratives, have further overdetermined what is and is not marked at Auschwitz. For the newly established Communist Polish government, Auschwitz I would become the symbolic representative space of a national tragedy at the hands of Fascism, thus subsuming the specificities of diverse, racially determined routes to death under a monolithic image of national suffering at the hands of Fascist Germany. Tim Cole concludes:

> A large part of the war-time camp of Auschwitz I was used after the liberation as housing to alleviate the post-war shortage. When the museum was established, these sections were excluded from 'Auschwitz-land.' Moreover, the landscape at tourist 'Auschwitz-land' is ambiguous as soon as you walk into the visitor centre. This building combines all of those tourist essentials – cafeteria, toilets, souvenir shop, cinema – and, as Dwork

and Van Pelt note, is assumed by visitors to have been built after the decision to turn the camp into a museum. In reality, it was constructed between 1942–1944 as the place where prisoners were 'tattooed, robbed, disinfected, shaved.' Auschwitz I's place of prisoner initiation has silently become the place of Auschwitz-land's tourist initiation. In a very real sense, the contemporary tourist enters Auschwitz unawares before she or he enters tourist 'Auschwitz,': the two are far from synonymous. (Cole 1999: 110; citing Pelt and Dwork 1996: 374)

In order, therefore, for Jewish, Romany or Sinti pilgrims to return to the site of memory and commemoration, they have to walk some miles down the road to Birkenau, a place not identified or indicated but equally not reshaped by musealization and documentary (re)information.

Recently, as part of a planned educational tour of formerly Jewish Eastern European sites, organized for teenagers, my son visited Poland: Kraków and Auschwitz were both on the itinerary. The group were firstly deeply prepared for this encounter by their visits to other parts of the former Jewish worlds of Eastern Europe, notably its once thriving urban centres in Prague, Budapest and Kraków. Despite further dialogue about the proposed trip to the death camp, many of the young people appeared prey to fearful anticipation about encountering so horrific a symbol of Jewish suffering as a real place they might find themselves in, even if, in a quirk of history, they would also be allowed to leave it alive. As grandchildren of survivors or refugees, some of these visitors might be counted as pilgrims, painfully visiting the horrific unmarked and airy graves of forebears they never knew. Others from families less directly affected by this European disaster, were not, however, tourists. For the educational tour forms a part of a long-term youth programme undertaken in many countries and in many forms, in which the question of cultural identity is explored through a progressive series of encounters with histories of the twentieth century as they have redefined the possibilities and limits of Jewish experience within modernity. Can I, therefore, shade the tourist/pilgrim opposition with the intermediary subject position of 'student of a missing history'?

I would now like to add yet a further layer to this somewhat crude classification of types of visitor to the sites of former death camps. Vicarious tourism is created through representation, and especially through film. As critical thinkers have made abundantly clear since Adorno's philosophical reflections in the early 1960s, the Shoah – so often recently metaphorized in its complex entirety simply by the word 'Auschwitz' – has raised challenging questions in every field: on the nature of history and historiography, ethics, philosophy and above all, on the possibility of representing an event that within all the available logics of these domains of human knowledge, self-knowledge and moral consciousness could not have and should not have happened. In happening, it defied all the known terms of human historical self-understanding. To represent it at all is to risk bringing it within the terms of

known possibility. Thus the notion of the unspeakable, or the unrepresentable, is not semi-religious awe before the ineffable, but a serious ethical position that can only hold open the dilemma, each side of which is sharp as any razor's blade. Not to represent is not to remember and thus not to learn never to repeat; to represent is to render the event an event within the limits of human conception and thought, thus to run the risk of normalising it. In the end, the ethics is worked through at the level of the forms and politics of representation.

Notably in the tradition of documentary, film is both tempted to offer itself as part of the need to record and register the scene of this event while raising the fundamental modernist dilemma that tourism as a paradigm of modern experience and consciousness confuses: is seeing knowing? Can being shown in representation/ reconstruction constitute an authentic encounter?

My argument here will not in the end be based on the problems of genre: documentary versus fiction film, for instance. It is based in history, and on an historical understanding of the struggle precipitated by the event itself, a struggle over the ethics of representation and hence, the relation any others have to what they did not experience. Are we all tourists in history now that there is a culture industry to bring it 'alive' for us in a myriad of representations, practices and discourses? Here, the repetition that is at the heart of successful tourist experience is in tension with the power of a representation or event that is done for the first and thus definitive time. Tourism replicates; art introduces the singularity that nonetheless has an effect. The question is then how to avoid making a genre out of this event, this time and its places, a troping of Holocaust experience while creating ways of encountering some hitherto unrevealed dimension of what I can only, advisedly, call its unknowable truth.

In 1999, James Moll, a young American director working under the influence and patronage of Steven Spielberg, won an Oscar for his documentary, *The Last Journey*. The film maker had traced five survivors of the Holocaust from Hungary. The Hungarian Jewish community was significant in that it was not directly part of the German-controlled territories until 1944. A very large Jewish community certainly was persecuted by anti-Jewish laws and harassed by Fascist thugs under Admiral Horty's right-wing, pro-German government from the mid 1930s, but it was secured against the horrors of transportation and execution until the spring and summer of 1944. One of the major points of debate amongst certain historians concerns the notion of 'a war against the Jews' and revolves around how to explain the ferocity, the intensity, the frenzy even, of the belated assault on this large Jewish community of over 750,000 people, most of whom were murdered in the course of two months by being shipped to Auschwitz for immediate massacre in May and June of 1944.

The Last Journey follows a model for the recording of Holocaust testimony. In turn and interwoven, each survivor begins by telling of a family background, lived

either in small rural towns and villages or in the modern metropolis of Budapest. Happy memories of warm families, friends, rituals, festivals and degrees of cultural particularity or assimilation are recounted. Each person evokes the fullness of family life, sunny childhoods, easy interfaith and intercommunal relations with other children at school, on the streets, at play. Then comes the beginning of the Jewish laws when despite new hardship and restrictions, life goes on. Then, the focus turns to the events of 1944, the sudden and traumatising roundups, incarceration in makeshift ghettoes, agonizing train journeys, the shocking arrival at night, separation, loss, survival. Up to this point, the film powerfully adds to the growing body of testimonial literature, video archive, and documentary film, recording for posterity the lived memories of these five survivors, each remarkable for their histories and their present lives: one is an artist, another a US Senator. In its final section, however, the film takes its turn into the terrain of Holocaust tourism. For these five survivors and their families are invited to be filmed on their first return to the camp, or to Germany to confront a Nazi doctor, who performed experiments on Jewish prisoners at Auschwitz, or to find the record of the death of a sister and to visit graves of those who died after liberation.

This seems so simple and so obvious a conclusion, prepared as we are by the conventions of how to make a good television story: find the characters, build up background and then initiate the unscripted before the living eye of the camera. Moving from the recall of the past, the film promises the unmediated emotion of the moment that individuals and their now American families encounter once again in the present, the place that holds a seeing of the memories of horrors. The problem is that we, the viewers, are going along for the ride, watching these moments vicariously through the apparently invisible but necessary camera crew, director, producer, producer's assistant, best boy, grip, sound engineer, catering assistant and so forth. The film makes a spectacle of a potentially personal pilgrimage, intruding a sentimentalizing voyeurism that, at its worst, becomes a kind of Jerry Springer experience of vicariously viewing the rawness of human feelings in an unpredictable staging of a human drama. Emotions experienced by the individuals involved become sentimentality when watched by others for whom the film incites their affectivity as a misrecognition of the inadequacy of human emotions to deal with what the survivors are encountering through this extraordinary concept of a return to Auschwitz.

Tourism, as I have argued elsewhere, involves the spectacularization of the work, or experience of the other (Pollock 1993). Holocaust tourism takes this to a newly terrifying level; what is made into spectacle is the death and torture of others, no longer present. Or, in this case, the vicarious viewing of the re-encounter with that death and torture in a place now rendered unimaginable as a death camp by the warmth of a Polish sun and the quiet, shaded alleys of leaf-laden trees down which a man and his son, a mother and her family can wander.

I want to contrast this seemingly inoffensive piece of documentary testimony that I suggest is in fact deeply troubling with three other films that involve the journey back to these sites. *The Last Journey* was made in the tradition of the video archives of the Shoah Foundation run by Spielberg to record all testimonies of all survivors. The testimonies for the most part frame the speaking heads in their own environments, here and now. Words are what take the speaker back and make us witnesses, addressed head to head, in the here-and-now. They involve no travel, no tourism. These other three films do. They have, however, I shall argue, posed the ethical question of how that obligation to return, to see and remember might be executed without the danger and immorality that I found in *The Last Journey*.

Kitty Returns to Auschwitz, 1980 (Yorkshire Thomson Media)

In 1980, Yorkshire Television made an extraordinary film, the first of its kind. Based on the story of Kitty Hart (née Felix), a radiographer now living in Birmingham who spent her teenage years in Auschwitz, the unpretentious film was the first film made in Britain to invite a survivor, firstly, to tell her story, and then to consider accompanying a film crew to the site where that story had taken place. On camera in Birmingham, Kitty Hart discussed the proposal and indicated her own ambivalence. What would it, could it be like? Why do it? In the end, she proposes that she will go, but only if her son, a doctor in Canada, accompanies her in the hope that he may understand what she carries as a memory, so that he will continue to act as a historical witness to generations that she may not know.

The film cuts quickly to a late autumn scene outside Auschwitz II (Birkenau) and there is no solemn procession up disused railway tracks. A modern Polish taxi draws swiftly up before the waiting camera and there are Kitty Hart and her son, in coats and gloves, warm clothes that underline the season and the temperature, the need for warm clothing against Poland's vicious climate. It is unclear what she will do and the indecision itself becomes a potent signifier of what is at stake in the utter perversity of arriving at Auschwitz by cab, as if the place belonged in the realm of ordinary travel, of arrival and departure.

'This was not here when I came', is the first thing Kitty Hart says. 'It was dark; it was the middle of the night. There were lights.' Thus the first memories evoked in the pale autumn daylight emphasize the very opposite of the touristic, or the filmic project: to orient and situate the visitor. What Kitty Hart stresses is precisely the disorientation of the incoming prisoners, who do not know where they have arrived, at what kind of place they have arrived, who were calculatedly dispossessed by night, by noise, by confusion, by brutality, of the information necessary to 'get one's bearings'. This time, for other reasons, for several minutes, Kitty Hart looks around, struggling with the newly unfamiliar in order 'to get her bearings.'

'Where is B.1?,' she repeatedly asks . She makes clear that the site itself changed; indeed, one of her work details was the actual construction of the railway lines that are still visible, entering the now too famous gate, and running all the length of the camp to the gas chambers at the farthest end.

Although what follows is happening on camera, and we are following the mother and son, overhearing her rapid, angry, distressed, detailed, factual, terrifying descriptions, we are in fact positioned by the camera as witnesses to a conversation, identifying in his helplessness with her son David, whose prompts and questions constantly incite Kitty Hart to incredulous sarcasm. What is thus recorded is not sentiment, emotion, pious memory, but rather the utter gap between language and the experiences that these places witnessed. Kitty Hart repeatedly enjoins her son to picture this, 'you must imagine . . .', and what he must imagine is the mass of people, the thousands, the hundreds of thousands of women, stacked in their bunks, stampeding into latrines, standing or dying at endless roll calls, the cold, the smell, the dirt, the loss of all human dignity inflicted on people living amongst the dead, in a landscape of mud, mud, and more mud. These are absent, yet it is Kitty's overwhelming desire to recreate the pulsating, muddy morass of desolated humanity that the camera cannot find, that the camera cannot resuscitate. The moments of rupture in the outpouring of her desire to tell, to make visible to the belated witness what she can so vividly still see in her mind's eye, occur exactly when the narrative brings Kitty Hart to memories of death: such as the occasion when her entire block, all her friends, were taken to be killed. Then she re-experiences the loss, and the emptiness of the landscape echoes with that sudden and terrible finality of absence. On another occasion, telling of how her mother saved her life, Kitty Hart recalls her work in the Canada Kommando, at the time of the uprising and the blowing up of the crematoria.[2] But for her mother's daring in directly requesting of the Camp Kommandant that her daughter be brought back to camp B.1b, Kitty would not have survived. She mentions that she has never met anyone else from that Kommando. She thinks she is the only survivor. At that point, the way in which the single figure stands in the vast landscape revealed by the camera, takes on a deep meaning of the emptiness that surrounds her, the silence of the abandoned place, the absence of the once desperate hands that pierced the grilles of Block 25.

Moving across the vast landscape that the camera can only follow from a distance or above, Kitty and her son reassemble the shards of her remembered places within a vastness that dwarfs these lonely figures. Entering the beautiful plantations of birch trees that gave the place its name, Birkenau, Kitty digs in the watery pools, picking up a shard of bone that remains from the great pits in which bodies too numerous for the ovens were incinerated. This gesture echoes several other occasions on which Kitty bends to touch the ground, to assert the physical reality of this earth that forms a link from a present – in which Kitty and her son

walk it again – and a past that cannot be seen, that cannot be imagined, but on which she insists, with a manic intensity of images that are suddenly unleashed in her mind by her actual presence once again in this real place.

It is this exchange between a past and a present, in which the land itself seems the only concrete link, that makes this film constantly swerve away from the mundane, artless documentary it might seem. At the point at which the documentary trope of returning to the original site of whatever trauma is being reinvestigated breaks down, because two temporalities collide, this unpretentious film becomes a major document. What it did, cannot be repeated. The film becomes an event in visual culture, not the initiation of a repeatable genre. What happened on film happened both because it was a first, and because of the singular character of Kitty Hart, her son and what the filming of her return released into words. These are words at war with the emptiness, the indifference, the silence of images that charge the viewing of this film, propelling the viewer beyond voyeurism into a searing experience of the unbridgeable gap between what she sees and knows and what we cannot share. The film refuses the lie of sentimentality by unconsciously enacting what Charlotte Delbo, a French political prisoner in Auschwitz, repeatedly asserts in her Auschwitz trilogy: You can never know if you were never there.[3]

Chantal Akerman, *D'Est (From the East)*, 1996

In 1996, the Belgian film maker Chantal Akerman exhibited an installation at the Walker Art Centre, Minneapolis, and at the Jewish Museum in New York. It was titled simply *D'Est*. This comprised a room in which her film of that title was screened in conventional cinematic format. The next room contained 49 television monitors, grouped in various numbers across which sequences from the film were fed through a computer-generated and controlled timing so that movement seemed to flow horizontally from one screen to another in parallel with the movements of the camera itself. In a third room, a single monitor sat on the floor of an otherwise empty room, and while its grainy and often indecipherable image flickered the film maker read a statement about the biblical prohibition on iconic representation, about her experience of making the film and discovering in that process what it was really about. The film tracks a post-Glasnost journey from Berlin to Moscow, a journey through Eastern Europe. Chantal Akerman deploys her distinctive use of fixed cameras with long takes as well as a travelling camera, that pans along the city street. The film spends its time at bus stops, train stations and roadsides. The sound of walking feet recur as people promenade or walk their city streets at night.

This is a film about a journey into the East that is titled 'of, or from, the East'. It is a journey of discovery, and recovery. Customs strangely reiterated without explanation or cultural resonance in her family's home in Belgium now find their

context as part of the hybrid cultures of Eastern Europe from which the film maker's family originally came. Going back cannot be part of the project's founding intention. Yet finding an unanticipated familiarity with foods, habits and elements of ways of life rendered the film a journey of discovery.

For the viewer, or this one at least, it did not take long to find the film almost unbearable to watch. The long slow takes, the resting camera before which the viewer is allowed time to absorb the casual scene before which the camera situates its 'eye', lead the viewer to look, to see and then to reflect. The landscape of rural Poland, for instance, is little changed. The technologies, the trucks, the ways of farming, bear the hallmark of prewar economies, or economies held to their prewar conditions. What we see, therefore, is the landscape the way it was, except that there is a howling absence. A major section of that prewar population of small towns and semi-agricultural villages is absent. There is no rhetoric for saying this: there is no text. There is the accumulation of time spent in the viewing process, in accompanying the dead-pan, open-eyed camera on its designated trajectory into the East. From this filmic time, emerges a picturing of place as absence.

This film is, therefore, the antidote to tourism. It makes no spectacle of these places whose depopulation cannot be represented; it can only be accumulated by repetition of a similar, uneventful attention to place as a survivor of an absenting. The film offers one set of images for the viewer to see; the images are haunted by what is no longer there. An extended and understated visuality incites the viewer's recognition of what is invisible and the meaning of this double seeing.

Claude Lanzmann, *Shoah*, 1986

How can I have introduced this problematic of cinema and the journey back without invoking what is the definitive intervention, *Shoah*, a nine-hour film, made over eleven years earlier by the French film maker Claude Lanzmann? I do not intend to offer a further analysis of a film so massively important and widely debated. Like the film of Kitty Hart, it initially involves taking a survivor back to a death camp and exposing the utter mismatch between history and place. Like *D'Est*, *Shoah* established its own inventory of visual signs, camera movements and these also rested on the question of the invisible meanings of place. Long takes of landscapes reclaimed by grass and trees, searched by tired, dead eyes for what was once there but cannot be 'seen' again, also mark the disjuncture of image and memory. Throughout the nine hours, the viewer is taken again and again down rail tracks, on endless train journeys, that mime the movement of the film itself ever deeper into the horror of the event, until it rests with Filip Müller, a survivor of a Sonderkommando at Auschwitz, and Abraham Bomba, the barber, both of whom finally tell of the inside of the gas chamber, the only place where the journey can

end, and from which Lanzmann diverts his camera. It cannot be seen; it can be told as it remains in this or that man's mind's eye. For this viewer, *Shoah* is the definitive film of this problematic of the journey and the sites that needs to be taken on board before the debate can even begin.

I want to introduce it here in order to stress the power of the aesthetic event, the film not as the initiator of a genre that can then be reproduced, but as the shocking singularity of artistic intervention that thereafter defines a way of seeing and an ethics of representation. *Shoah* conjugates faces to places, installing the passion of subjects, passion being used here in its original sense of suffering. Lanzmann worked to refind the two survivors of the first extermination camps established in December 1941. Thus he begins with historic precision at that moment at which the event took place that changed all previous terms of persecution. He starts with the use of the gas vans at Chełmno to mass murder the Jewish populations of Poland.

Lanzmann traced the one young boy, Simon Srebniza, who survived the bullet in the head that should have killed him along with the last remnant of the Sonderkommando at Chełmno.[4] The film opens with the process of taking this one man, this unique historical figure, back to the wooded meadows where once had been what cannot now be imagined. Throughout the film, the invisibility of the event is stressed, as what can be recovered depends entirely upon searching out through words, through pressing questions, the details of what happened that no one can bear to tell. The traumatic effect of the film on its audiences involves creating long and slow established familiarities with key witnesses, seen at home, seen in public, and some, a few, seen at the original sites. For the most part, they are not taken back. The film builds by montage, linked by the recurring trope of the train. Faces thus become the landscape of memory to which the viewer's eyes become attached. These faces talk in a variety of languages and accents, registering their geographies of home and dispersion.

Trauma dismays the film at the points when words fail, when the camera remains witness to that disruption through emotion or silence. Thus the past, to which the film refuses to take us through the musealized use of archive footage, of photographs, of frozen fetishes of what once was, remains itself, while the present also exists. In that present are the witnesses: the survivors, the bystanders and the perpetrators.

These three films, belittled by a necessarily abbreviated treatment here, ironically reverse the terms in which I opened this section. I wrote of vicarious tourism by film. What marks all these films as critical events, as artistic texts, is their use of the relations of production and viewing film, the modes of spectatorship, the forms of the gaze, specific to the cinematic, in order to refuse and even refute the dominant terms of cinema: the erasure of its own rhetoric in favour of spectacle

and unreflexive identification offered to the viewer. The ethics of the return, the visit to the space or site at which the horror we collectively label the Holocaust took place, involves an insistence on two factors: the present in which the re-encounter takes place, and the acknowledgement of the untraversable gap between the two subjects: the survivor and the belated witness that the viewer is called upon to become. Without these refusals of the fiction of history and the reduction of the other to object of the voyeuristic gaze, no film maker or artist can be adequately sure of the politics of their representation. Stimulating the viewer's affectivity to swamp the site or the survivor, or exposing viewers to such horror that they turn away at the abjection of the human other they cannot bear to confront, are both equally distracting, if inevitable.

Postscript

My postscript takes up an installation that avoids both problems in its minimalist literalism. *Bus Stop II* (1999) was exhibited at the Royal Academy in London as part of its controversial exhibition, *Apocalypse: Horror and Beauty in Contemporary Art* (2000). Darren Almond has worked repeatedly with and at Auschwitz, but never enters the camps. He uses the Polish town's signposts, the bus timetables and bus stops outside the camp in which the name of Oświęcim signals the continuity of a Polish place and its movements, that include the index of the touristic visitor, by indicating also times of travel to and from Auschwitz. There is, in one sense, a link with Chantal Akerman's evocative use of the train station, the bus stop, the walking feet as associative signs for deportation and the 'transports.' For Akerman, the ordinary things of town life are haunted by the other time when they were appropriated as means of transport to mass destruction. As she and her camera move east, they catch both a perpetual going and a staying put: not a return.

It would appear that for Darren Almond, too, the bus shelters outside Auschwitz are part of the life of Oświęcim. People come and go, for he has chosen to focus on two bus shelters. In *Oświęcim March 1997* (1997), two films were projected side by side to the musical score of Arvo Pärt. The films in grainy black and white dispassionately register the people at two bus stops outside the former concentration camp, one for people having visited the camp about to make the return journey to the town, the other a stop for people planning a further journey elsewhere. As a metaphor, it does not work, for it is precisely about tourism and not about the nature of the one-way travel that we must confront in the site and term Auschwitz.

In 1999, Almond was permitted to remove these bus shelters and to transplant them to Berlin, to the Max Hetzler Gallery, as part of his exhibition. Michael Archer comments that in such an environment, these stark and simple 1960s

structures 'connect with sculptural history: the Duchampian ready-made, the found object (cigarette butts remain in waste bins), the engineered look of minimal sculpture, and so on' (Archer 2000: 182–3). Indeed. Yet there might also be a powerful, even political charge created by bringing these objects from that place back to Berlin. As signifiers of that place in the East, disguised by either its Polish name for German viewers, or incised into present consciousness by the fact of that name being listed on so mundane a piece of modern bureaucracy as a bus-shelter list of departures, the bus shelters of Oświęcim/Auschwitz could indeed take on an uncanny quality of the return of the repressed within the doubled geography of Poland/Germany in 1999.

Having removed the originals, Darren Almond was required to design and build new bus shelters for the original spot from which he had appropriated the used bus shelters. These gleaming new objects stood nakedly on the polished wooden floors of the Royal Academy in London as minimalist sculptures denuded of affect, conceptually but hardly acutely encouraging some comment that they were in some unfathomably literal way, 'about the Holocaust'. These shelters will 'return' to Oświęcim, to take up their post outside the camp when the exhibition is over. What can that mean? What do these glass and metal structures signify in London and what will they carry back? Can anything that they indexically held, even as discovered objects of Communist Polish manufacture, standing at a certain point on a contemporary itinerary, be 'represented' in their recreation by a young British artist, and does anything of that concern Auschwitz in any sense other than the touristic: where the name marks the spot on a map, to be visited and left? Lanzmann's trains are about a terrible movement, the use of the mighty engines of modern industrial transport to take millions from 13 nations to one end point: genocide. They link all of Europe with the passage of that freight, and repeatedly, the film insists on the perplexity of the bystanders that so many arrived and none left. The one-way traffic is the key issue to be confronted. That is our access to the void of death that was made by the event.

The question of visiting Auschwitz has been addressed by major historians and cultural analysts in terms of issues of commemoration, museum theory, memory and historical authentication. I have aimed to address the deeply ethical questions posed to and by contemporary visual culture in its relation to the representation of the Holocaust. The touristic is both actual, in the hundreds of thousands of visitors to 'Auschwitz-land', and also vicarious through films. Finally, I am arguing, it is structural, the default condition to which representation will recur unless a crucial distinction is made between the place that can be visited and left, and the problematic burned into Western European culture by what Paul Celan simply called 'that which happened', the event.

Notes

1. Jewish groups visiting Auschwitz are usually taken around by Polish guides, with little special attention or sensitivity to the meaning the site has for visitors who are Jewish. See below for a discussion of the Polish national reading of the camps. For further discussion of differing national narratives of the Holocaust, see Young (1993).
2. Canada Kommando was the fanciful name given to the stores of the murdered people's possessions, Canada signfying to middle Europeans an exotic far-off land. The Kommando was a work group designated to sort and recycle these vast stores of clothes and other possessions. It was the custom to annihilate these work groups regularly so that no one would survive to tell the story of what such stores evidenced.
3. See Charlotte Delbo's *Auschwitz and After* (1995). This book is a trilogy composed of *None of Us Will Return* (written 1946, published 1965), *Useless Knowledge* (written 1946–7, published 1970), and *The Measure of Our Days* (1970). Her last work, *Days and Memories*, was published in 1985, the year of Delbo's death.
4. Sonderkommando was the special workgroup that was forced to take bodies out of the gas chambers and cremate them in the ovens. Its workers were regularly killed. Their successors' first task was to cremate the workers they succeeded.

References

Archer, M. (2000), 'The Ticking of the Clock,' in *Apocalypse: Horror and Beauty in Contemporary Art,* London: Royal Academy of Arts.

Charlesworth, A. (1994), 'Contesting Places of Memory: The Case of Auschwitz', *Environment and Planning D; Society and Space,* 12.

Charlesworth, A. (1996), paper given at the conference *Speaking the Unspeakable,* London, University College.

Cole, T. (1999), *Images of the Holocaust: The Myth of Shoah Business*, London: Gerald Duckworth & Co.

Delbo, C. (1995), *Auschwitz and After*, trans. R. C. Lamont, New Haven: Yale University Press.

Pelt, R. van and Dwork, D. (1996), *Auschwitz 1270 to the Present*, New Haven: Yale University Press.

Pollock, G. (1993), *Avant-Garde Gambits: Gender and the Colour of Art History*, London: Thames & Hudson.

Young, J. (1993), *The Texture of Memory: Holocaust Memorials and Meaning*, New Haven: Yale University Press.

Joe's Bar, Douglas, Isle of Man: Photographic Representations of Holidaymakers in the 1950s[1]

Doug Sandle

In the visual culture of tourism, photography has a significant and central role both in the representation of the tourist gaze and in providing objects for its consumption. In 1910 and through several following decades, the Kodak girl exhorted us to 'save [our] happy memories with Kodak'; this was an advertising campaign in which the seaside and other tourist locations were often featured.[2] Although relevant to many applications of photography, it is perhaps with regard to tourism that the characteristic of photography to compress time into a single image is particularly apposite. The tourist photograph is a representation of the present for the future consumption of the past. At the moment of its conception, the tourist photograph has already become both a memory, and a reconstruction, of the tourist gaze. As such it provides for a nostalgic reminiscence and a private and public testimony to the holiday other, that self-remembered that both disrupts and confirms the mundane self of the everyday.

As the tourist gaze is later remembered and secondarily elaborated, the tourist photograph is also part of a dynamic of social and cultural exchange, used to negotiate and confirm status and social values through representations of the holiday other as a successful tourist. If, as Burgin (1982: 144) asserts, 'the intelligibility of the photograph is no simple thing' and 'is the site of a complex intertexuality', and as Edwards (1996: 200) notes in her study of the tourist postcard image, the photograph 'can make the invisible visible, the unnoticed noticed, the complex simple and the simple complex', then the holiday photograph belies its apparent casualness.

The seminal role of the visual artefact and in particular, the photograph, in the construction of tourist sites is well demonstrated by the development of the Isle of Man as a holiday resort.[3] Situated in the Irish Sea between the North West coast of England and Northern Ireland, the island is 572 square kilometres in area with a current population of just over 71,700.[4] Although a dependency of the British Crown, the Isle of Man is not part of the UK and has no elected representatives in

the British parliament. It is self-governing in domestic and fiscal affairs through *Tynwald*, which is reputed to be one of the oldest parliaments in the world.

Remnants of the Manx Gaelic language remain in many of the island's place, institutional and family names, which along with its particular blend of Celtic and Viking history, its folklore and the promotion of its 'Manxness', all contribute to a sense of the island as being a separate country. Visually, this is reinforced by its national flag and its unique forms of sterling currency and postage stamps that all feature the ubiquitous insignia of the Three Legs of Mann. The provision of spectacle, such as the famous TT motorcycle races, and the promotion of the island's varied and unspoilt scenic environment, provide further powerful opportunities for the Isle of Man both to construct and to serve the needs of the tourist gaze.

However, in this respect its main asset is undoubtedly its island character, for as Ryan (see 1997: 156) in his particular study of islands and tourism has noted, 'islands', as he connoted islands, are 'lands of the immediate present freed from concerns of future mortgages and pensions; locations of beaches that skirt and contain land safely from an appealing but uncertain sea'. The consumer perception of what he refers to as 'is-lands' of geographical confined space and historical/ cultural strangeness' has been well served by the Isle of Man, which has been adept in constructing its image, not just as a tourist destination, but in particular, as a holiday is-land. This sense of the Isle of Man being separate and different, of being a land elsewhere, was the basis of its advertising slogan of the late 1950s: 'Go abroad to the Isle of Man'.[5]

In this particular construction, however, not only the island, but the surrounding sea itself has had to be transformed as an object of the tourist gaze. As the English seaside holiday developed with the notion that sea water was good for you and the seashore a recreational site, for the Isle of Man transportation across the sea was an impediment that needed to be transformed into a commercial opportunity. The Irish Sea can be one of the roughest and most inclement in the world, and one of the tasks of those with an economic interest in the promotion of the Isle of Man as a tourist destination was the construction of the romantic sea journey as an element of the holiday experience. Within this transformation, the visual was to play a major role, and the visual representation of the sea as a romantic holiday gateway was vigorously promoted. Interestingly, it was not just the sea, but the means of travel, the ships, that became integrated as both sign and referent within such representations. The romantic portrayal of the ships of the Isle of Man Steam Packet Company became a common subject of Manx postcards, posters, stamps and general visual memorabilia.[6]

The island's capital, Douglas, with its sweeping bay and sandy beach, developed as a major resort from the late nineteenth century up to the First World War, and

continued thereafter with fluctuating numbers of tourists until its stagnation and then decline from the 1950s to the present day.[7] However, while no longer the island's major industry, tourism nonetheless continues to play a role. As Urry (1990: 102) has noted, the 1988 Isle of Man advertising slogan, 'You'll look forward to going back', heralded a shift towards the representation of heritage as a tourist attraction that has continued to the present day.

The Isle of Man with its vintage transport systems, its vernacular farming and fishing industry, its sites of prehistory, of a Celtic and Viking past and of industrial archaeology, its smuggling and piracy, and, ironically, its Victorian and Edwardian tourism, all provide it with a plethora of heritage sights and opportunities for spectacle. Accordingly, the Isle of Man has vigorously embraced heritage, and currently, the whole island has been transformed and construed as a heritage site with the calculated promotion of the *Story of Mann*. To this end, the tourist gaze is carefully directed, by way of signposts, brochures and maps, to explore and consume an allusive Manxness and its various histories in reconstructed populist format. Thus, according to one of its publicity leaflets, specifically aimed at short-break tourists: 'The *Story of Mann* is full of fascinating stories to tell and brings our unique past alive for you with an island wide presentation' and '. . . is a tale of 10,000 years of sometimes turbulent Manx history told at nine international award winning themed presentations'. Allied to the *Story of Mann*, as a themed spectacle, is a souvenir industry promoted through *Story of Mann* heritage shops.

Recently, the Isle of Man government has established a film foundation both to promote the island as a venue for the making of screen and television films, and to invest in the film industry. This strategy has had some success, most spectacularly in 1999 with the film *Waking Ned* (directed by Kirk Jones), which was a particular hit in the US as *Ned Divine*. In this film, the Isle of Man is used as a location for Ireland, and the Manx village of Cregneish is reconstructed as the fictional Irish village of Tollymore. In fact, Cregneish is a heritage village, preserved as a working museum and a representation of a past rural Manx life. Thus the narrative unfolds about an Irish village that is not Irish but Manx, and which, moreover, is not an ordinary village but largely a heritage representation. All is coalesced within a fictional film to be consumed as representations of representations of representations, a prime example of complex intertextuality and of Baudrillard's notion of the consumption of representations as symptomatic of the postmodern cultural condition.[8]

While the visual has played a major role in the construction of the Isle of Man as a tourist resort and as an object for the tourist gaze, our main concern is with the use of photography as a further construction of the holiday reminiscence and the positioning of the holidaymaker within that construction. In this sense, the term 'holidaymaker' is more apposite than 'tourist' (or 'visitor', as commonly termed

by the Manx), for the 'holidaymaker', particularly through photography and its potential for restructuring reminiscence, both makes the holiday and makes the self as the holiday other.

In this process, while the selection of people, places and objects to be photographed are important indirect signifiers of the holiday other, the inclusion of the self within the holiday is obviously of special significance, whether contextualized within a particular place or with other people. Regarding the latter, apart from the use of photographic timing mechanisms, a common convention in representing the self with significant others is to approach a nearby stranger with a request to take the photograph of the couple or group. It is a unique feature of the socially defined holiday space that complete strangers can be so approached and entrusted with another's possessions.

One convention, common in the Isle of Man during the 1940s and 1950s, was the group photograph, taken outside the boarding house or hotel, by one of the group, a passer-by, or by professional photographers who touted their business around the bigger hotels. Often these pictures included the landlady and/or landlord if they had been particularly sociable with the visitors. This was part of the construction of the holiday to be reminisced. It was a sign of having had a wonderful time and signified that the self as the holiday other had had a friendly relationship with the landlady and had not experienced the more authoritarian and bullying landlady of popular myth. Such visual rhetoric was part of the self-congratulatory social currency of the tourists' reminiscence, even when it had been achieved purely by chance.

Another opportunity for the photographic portrayal of the self as the holiday other was provided by the photographic backdrop. For example, with rudimentary constructed props, models and a painted background, the holidaymaker could pose in front of a rustic cottage, row a boat in Douglas Bay or seemingly take the wheel of a fast sports car. In such 'staged' constructions, the holidaymaker is signified as romantic in the countryside, daring in rowing out to sea, or sporty at the wheel of a fast car, and so on, within a process that was both serious and ironically playful. In such photographs, there is a curious juxtaposition of the informal and the formal, a posed relaxation in which photographer and photographed collude to manipulate the touristic self-gaze as a representation within a representation. These aspects of collusion, the interplay of representations and their different subtexts as components of the structured tourist gaze were later to develop a particular complexity and richness with the emergence of Joe's Bar. Joe's Bar, in Douglas, was not a real bar, but a simulated tableau that in the 1950s and 1960s was chosen by thousands of visitors as a photographic site to construct and represent their holiday others. We will suggest that this was done within a dynamic whose complexity reveals such photography as an early precursory manifestation of the postmodern.

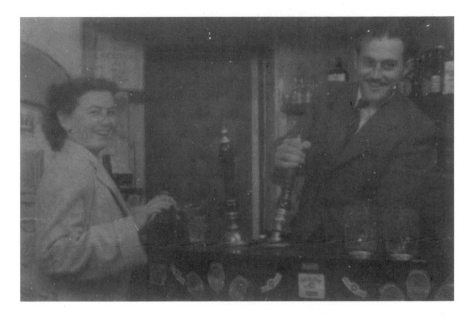

Figure 11.1 Mock bar at O'Connor's studio, Douglas Isle of Man (copyright Manx National Heritage).

In 1948, Alf Grey, a photographer who had been working for several seasons in Blackpool, taking and selling photographs of tourists, arrived in the Isle of Man to work for a season at the photographic studio of one Harold O'Connor. At O'Connor's, there were a few backdrop sets and models such as a mock TT bike, a sports car and a backdrop of a country cottage. There was also a rather small, crude backdrop of a bar scene, which proved to be quite popular. On Grey's suggestion, a more three-dimensional bar scene was constructed (Figure 11.1).

When Grey with his wife Hetty and their eight-year old son Howard next returned to the Isle of Man in 1950, he opened up his own studio and darkroom at 82 Strand Street in Douglas, premises he shared with the rock shop and factory of Benny Fingerhut, a local entrepreneur. On the ground floor was an open shop-front studio into which the passing public could be encouraged to step and be photographed. Remembering the growing popularity of the bar scene at O'Connor's, Grey employed some set designers from the local theatre to build a replica bar complete with counter, shelves of bottles of various drinks, china beer pumps, bar stools and so on. With help from his family, Joe's Bar, named after a friend Joe Godfrey, became hugely popular. In 1964, after a dispute with Fingerhut, a new Joe's Bar was opened at 76 Strand Street which continued until September 1971, when the Greys finally returned to the mainland to live in London.[9]

On average, about 60 Joe's-Bar photographs would be taken every day throughout a three-month holiday season over a period of 20 years. With several prints of each one, many thousands of such photographs must have found their way onto the mantelpieces or into the photo albums of hundreds of tourists, not only from the north of England, Wales, Scotland and Ireland but, as letters to the Greys often testified, from many other parts of the world as well. Unfortunately, following both the dispute with Fingerhut and the Greys' final departure from the Isle of Man, there were few samples of the Joe's-Bar photos retained by the family. However, in 1996, a stock of negatives and prints, mostly from the mid 1950s, was traced to a rather damp garage in Ramsey, a northern town in the island, and subsequently obtained by Howard Grey. The process of examining and documenting this unique record has only just begun, commencing with the prints, many of which had become damaged due to poor storage and damp. Nonetheless, the images still demonstrate a photographic intensity and retain their cultural and historical significance.

During the mid-1950s, Douglas was still primarily a resort that catered on average for 310,000 staying visitors and from 60,000 to 100,000 day trippers every summer season (Craine 1966: 63). With Joe's Bar a popular tourist attraction, the prints from this period reveal a range of subjects and groupings, including the holiday group or family of mixed gender and generations (Figure 11.2), young

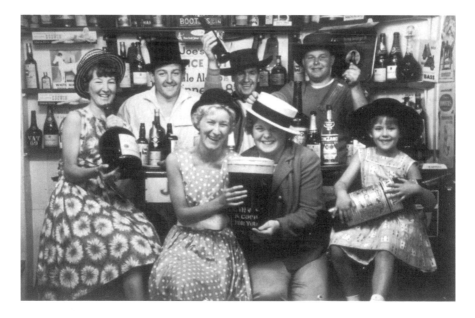

Figure 11.2 Holiday group photograph of mixed generations, Joe's Bar (copyright Howard Grey).

single-gender groups, and both single-gender and mixed couples. There is also a contrast between day-time photographs of holidaymakers in casual or even beach wear, and evening photographs where the holidaymakers are dressed more formally, particularly prior to going dancing or to a show, both popular holiday entertainments of the 1950s.

There is a predominance of photographs of younger holidaymakers, which reflects the change in the tourist profile from families to young people that began to take place in the mid-1950s. Douglas, and the Isle of Man in general, were not able to respond successfully to this shift, a failure that was to contribute to the further decline of the Manx tourist industry in the 1960s.

Joe's Bar offered a photo opportunity where the quality of portrayal was more sophisticated than could have been achieved by the tourist's own camera. Grey had developed his skills as a portrait photographer working in London during the 1920s and 1930s for the studio practice of Mindal and Faraday. Both Grey and Mindal were immigrants from Eastern Europe, and Grey's employer demanded a portrait style of the kind that had been developed by Josef Karsch, another Eastern European photographer who had considerable influence in Hollywood, particularly regarding the lighting of sets. Also, Grey had developed substantial skills in retouching negatives. Initially done to correct the lack of sensitivity of the then orthochromatic film to the long waves of the spectrum, retouching could be used to enhance the appearance of the subject by toning out blemishes, spots, uneven sun tan tones and so on.[10]

Grey's experience and expertise in set lighting and negative retouching provided a salient opportunity for a particular construction of the holiday other: the glamorizing of the ordinary, in which the photographed subject would often collude with the photographer to maximize glamour and surface style (Figures 11.3 and 11.4).

This invitation to glamorize the ordinary was advertised by examples pinned to the entrance of Joe's Bar, which included showcase photographs of popular and glamorous celebrities from show business. The Greys were well connected in this respect, since the popular singer and entertainer of the time, Alma Cogan, was a niece; photographs of Cogan and other celebrities taken in Joe's Bar were often featured in the publicity.

A subtext of glamour is sexuality, and one of the characteristics of the holiday other is the pursuit of sexual opportunity and behaviour. A feature of the extraordinariness of the tourist gaze is its foregrounding of sexual desire. Young couples being photographed together in Joe's Bar were encouraged to put their arms around each other. Often they had only recently met, and Joe's Bar became an opportunity for a precursory confirmation of physical interest, the couple often being photographed in a spot that the Greys jokingly referred to as the 'honeymoon corner'. Generally, for both males and females, Joe's Bar provided the opportunity

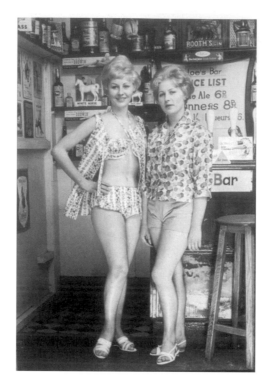

Figure 11.3 A glamour pose, Joe's Bar (copyright Howard Grey).

for the kind of pose that enabled the construction of glamour, style, swagger and the momentary appearance of a physical and sexual confidence.

A particular feature of the Joe's Bar site was the use of props such as giant cardboard bottles and glasses, a range of hats, and theatrical props such as dancing canes. Although the appearance of the bar is a realistic one, these props and their use remind the viewer that Joe's Bar was not totally real; and there is a tension between the veridical and the staged, providing shifting and sometimes ambiguous thresholds of representation. That this provides a space for symbolic enactment is perhaps confirmed by the particular use of the giant bottles and glasses in their phallic guise, signifying the presence of a sexual dynamic. However, such enactment is often ambiguous with regard to its unconscious nature, as the photographed holidaymakers seem to be aware of and to enjoy the sexual inference with a degree of playfulness that provides both opportunity and permission jokingly to acknowledge, and in part to construct, the sexuality of the holiday other. The wearing of fancy-dress hats and the lascivious use of props, such as the giant bottles, permitted the playful and ironic acting out of a symbolic sexuality.

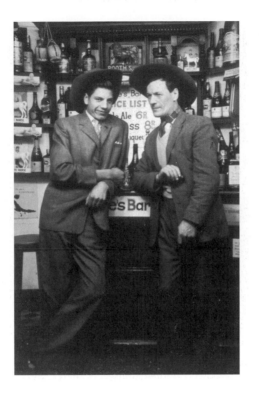

Figure 11.4 Stylish males, Joe's Bar (copyright Howard Grey).

The play with the giant bottles, the show business props of hats and canes, and the often extravagant poses and gestures that are also a feature of many of the photographs, are remnants of the burlesque, and as such are signifiers of carnival and ludic involvement, considered particularly characteristic of the traditional seaside holiday (Shields 1991: 83–101; Ryan 1997: 161–3). Indeed, this aspect of carnival is reinforced by the very fact that central to the simulacrum that is Joe's Bar is the underlying symbolic presence of alcohol (Figure 11.5). Alcohol is the fuel for carnival behaviour and, within Joe's Bar, such carnival is enacted as part of the holidaymaker's making of the image of the holiday other.

As behaviour in the actual bars and dance halls of Douglas in the 1950s, especially among young holidaymakers, was considerably more decorous, such play acting perhaps anticipates the more extravagant drunkenness of the young British tourist, especially the male, which was to be a feature in the later decades of the twentieth century in locations such as Lloret and Ibiza .

It is also significant that pubs and bars at that time were still predominantly masculine spaces, where young men tested and acted out their manhood in symbolic rites of passage. In Joe's Bar, it is the young males who more often than not

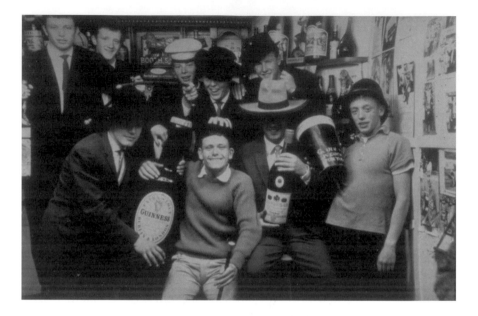

Figure 11.5 A laddish group pose with symbolic alcohol, Joe's Bar (copyright Howard Grey).

assertively dominate the space with spatially expansive poses. During this period, women, especially younger ones, would rarely visit a bar alone. Even in the company of men, it was usually the lounge they chose rather than the tap room or saloon, of which Joe's is more reminiscent. But in Joe's Bar there is the opportunity for a symbolic female presence in a male-dominated territory, supported, it must be said, by the women sometimes taking on masculine representations in the form of the hats and canes. Nonetheless, as many of the photographs show, there is the suggestion of an acting out of a claim on the male territory, made with varying degrees of confidence and satisfaction.

This particular use of the Joe's Bar space by the younger male and female holidaymakers in the mid-1950s, we would suggest, both anticipates and is part of a changing cultural dynamic around alcohol and pub behaviour. It is also important to note that behind the photographer there was a public audience, as Joe's Bar was open to the passing throng of tourists who often gazed into the scenes being enacted. This would have added to the social dynamic of the poses adopted.

In his study of the seaside resort, Ryan (1997: 161) writes about 'a turning of the back upon the beach', when the need of the tourist gaze for carnival becomes catered for by other, less beach-oriented, attractions. This turning of the back on the beach heralds the decline of the British beach as a venue for mass tourism. In the 1960s, the Isle of Man could not provide for the younger tourist, and in spite

of increasing young people's entertainment, it lacked the infrastructure to sustain the new tourist gaze that was increasingly being satisfied by sunnier and more distant locations. Joe's Bar, situated in Strand Street, running parallel with the promenade, is on the edge of this transition. In a sense, the photographs testify to the beginning of a turning away from the beach, a move away from the shore towards new venues of constructed spectacle and entertainment. Strand Street used to be called Sand Street, and Joe's Bar is liminal, on the edge both physically and culturally, of changing patterns of both individual and social behaviour.

It is within this duality and its contradictions that the richness of Joe's Bar resides. Joe's Bar was a bar but not a bar, a means to document the tourist gaze that became in itself a sought-out object of that gaze, a private and yet a public space, and a means to highlight surface style and glamour. In some ways, it was a highly manipulated formal photographic studio yet the rapid 35 mm Leica camera used was informal and journalistic, anticipating a new era of more spontaneous photographic documentation. Its human tableaux were both posed and spontaneous, seemingly natural yet highly constructed. Joe's Bar was a place in which photographer and photographed colluded to make the holiday other by representations within representations, all providing a rich intertextuality of signification. It is such characteristics that suggest that Joe's Bar and its photographs, taken half a century ago, were precursors of the postmodern.

Notes

1. This chapter has developed from the paper submitted to the original conference by Sandle and Grey (2000) with the support of a travel research grant by the Isle of Man Heritage Foundation.
2. For example, in one poster, the Kodak girl, camera at the ready, is sitting on rocks beside the sea in a scene complete with idyllic children, picnic basket and flocking seagulls (Ford 1989: 37). See also Urry (1990: 138–40, 1995: 176–77) regarding the role of photography in the tourist gaze.
3. The Douglas Advertising Committee (DAC), a voluntary group from local businesses founded in 1893, included Thomas Keig, a prominent local commercial photographer. The DAC became the Advertising Board in 1894, the Isle of Man Publicity Board in 1931, and then the Isle of Man Tourist Board in 1952. Keig worked as a photographer for the Advertising Board for many years producing views for handbooks etc. (Beckerson 1966).
4. Economic Affairs Division, Isle of Man Treasury (2000).
5. A poster campaign in the mid-1950s featuring this slogan was promoted by British Railways (Kniveton 1992: 44).

6. Several advertising posters featuring ships of the Isle of Man Steam Packet are featured in Kniveton (1992). Established in the 1830s, the Isle of Man Steam Packet Company still has an aura of romanticism attached to it. Part of its former working apparel, the crew sweater, has been appropriated as a sought-after fashion item. The interweaving of constructed myth with the more arduous experiences of sea travel is illustrated by the joke, particularly enjoyed by the Manx themselves, that the initials of that sweater read not the 'Isle Of Man Steam Packet Company', but the 'I Often Make Sick People Company'.

7. For an account of the growth and decline of the Isle of Man tourist industry, see Cooper and Jackson (1989).

8. This fluidity of reality, geography and representation becomes more bizarre with regard to a leaflet contained in the commercial video of the film. Advertising the Irish shipping company, the Stena Line, with an offer to save '£40 on your next trip to Ireland', the leaflet states, 'You've seen the film now . . . see the stunning scenery for yourself on a trip to Ireland with Stena Line'. There is also the daunting prospect that, particularly for American tourists, the Isle of Man might become Waking Ned Country in the same way as a number of locations in England have appropriated literary or popular television characters to become geographical identities, for examples, Robin Hood Country, James Herriot Country, and Last of the Summer Wine Country (Williams 1998: 177). Isle of Man director of tourism, Geoff Le Page, was quoted in the *Sun* newspaper, 24 March 1999, claiming that American tour operators had received tens of thousands of inquiries from people eager to find out how to get to the real Tollymore, in spite of it being a fictional village.

 Urry (1990: 85), with reference to tourism, suggests that 'postmodernism problematises the distinction between representations and reality' and that 'an increasing proportion of the referents of signification, the "reality" are themselves representations'. See also Baudrillard (1994).

9. The author gratefully acknowledges the help and advice provided by Howard Grey in the preparation of the original conference paper and in making the photographs from Joe's Bar available.

10. Some dust spots and blemishes have occurred in the found prints as a result of the poor storage and also in their further reproduction, and some prints appear to have been initial rejects.

References

Baudrillard, J. (1994), *Simulacra and Simulation,* trans. S. F. Glaser, Michigan: University of Michigan Press.

Beckerson, J. G. (1996), 'The Isle of Man Official Board of Advertising 1894–1914', MA dissertation, University of East Anglia; deposited at Manx Museum Library, Douglas, Isle of Man.

Burgin, V. (1982), 'Looking at Photographs', in V. Burgin (ed.), *Thinking Photography*, Basingstoke: Macmillan.

Cooper, C. and Jackson, S. (1989), 'Destination Life Cycle – The Isle of Man Case Study', *Annals of Tourism Research*, 16, 377–98.

Craine, R. P. (1966), ' Douglas (Isle of Man): A Town's Specialisation in Tourism', BA Hons dissertation, Durham University; deposited at Manx Museum Library, Douglas, Isle of Man.

Economic Affairs Division, Isle of Man Treasury (2000), 'Isle of Man Government', http://www.gov.im/ (accessed 31 July 2000).

Edwards, E. (1996), 'Postcards – Greetings from Another World', in T. Selwyn (ed.), *The Tourist Image: Myths and Myth Making in Tourism*, Chichester: John Wiley & Sons.

Ford, C. (1989), *The Story of Popular Photography*, London: Century.

Kniveton, G. (1992), *Happy Holidays in the Isle of Man*, Douglas: The Manx Experience.

Ryan, C. (1997), 'Memories of the Beach', in C. Ryan (ed.), *The Tourist Experience: A New Introduction*, London and New York: Cassell.

Sandle, D. and Grey, H. (2000), 'Joe's Bar, Douglas, Isle of Man: Visitor Representations in the 1950s', paper given at the conference *Visual Culture and Tourism*, Anglia Polytechnic University, Cambridge.

Shields, R. (1991), *Places on the Margin: Alternative Geographies of Modernity*, London and New York: Routledge.

Urry, J. (1990), *The Tourist Gaze: Leisure and Travel in Contemporary Societies*, London: Sage.

Urry, J. (1995), *Consuming Places,* London and New York: Routledge.

Williams, S. (1998), *Tourism Geography*, London: Routledge.

−12−

Straight Ways and Loss: The Tourist Encounter with Woodlands and Forests

Simon Evans and *Martin Spaul*

Prologue

In his survey of the place of forests in the Western imagination, R. P. Harrison (1992) offers a distinctive account of their symbolic role in Dante's *Divine Comedy*. 'Inferno' famously opens with an encounter with a dark forest – *selva oscura*, the wildwood – an encounter which appears to represent a fall into a state of sin or moral confusion:

> In the middle of our life's path
> I found myself in a dark forest
> Where the straight way was lost. (Dante, as trans. in Harrison 1992: 81)

Such an interpretation is licensed by a Renaissance commonplace, that the uncultivated world is a harsh wilderness as a direct result of Adam's fall (Thomas 1983: 18), a perpetual earthly reminder of sin. Harrison suggests, however, that these lines have a more complex meaning, that the dark forest is encountered 'precisely because Dante is moving in a straight line'. It is rather the linear path of unreflective existence, the following of an obvious secular logic, which constitutes a moral error; and the encounter with the dark forest – traditionally a site in which the settled assumptions of civilization are inverted – is the beginning of a process of redemption.

Redemption begins at a point at which the 'straight way', which Dante attempts to continue within the dark forest, becomes impassable. His way is blocked by a series of encounters with the beasts of the wilderness; wild nature has checked secular logic. However, Virgil is on hand to lead Dante, against all apparent logic, down through the circles of Hell. After this descent, and the subsequent ascent up the mountain of Purgatory, Dante has a fresh encounter with a forest; but now he finds himself in the 'ancient forest of earthly paradise' – *selva antica* – a forest cleansed of dangers where Dante is 'free to wander aimlessly'. In Harrison's trenchant phrase, this ancient forest is a 'municipal park under the jurisdiction of

the City of God'; the terrors of wild nature have been expunged and Dante in his redeemed state has become a 'forester', unable to put a foot wrong in tamed nature (Harrison 1992: 81–3).

Harrison's reading of Dante has an interest that extends beyond the niceties of literary interpretation, for it is far from innocent: it brings to Dante's work a contemporary ecological consciousness that wishes to find a positive role for the wilderness. The dark forest becomes a source of tutelage, the demonstration of a prior error: the following of a linear rationality that cannot find meaning or place in wild nature. From this perspective, it is the disappearance of the dark forest that constitutes the principal loss, for which a tidied, anodyne simulation of nature cannot compensate. As Harrison (1992: 85) says, with all we know about the fate of the world's forests, we can read Dante's poem as an allegory of mastery over nature, and its forest symbolism becomes supremely ironic, because Western civilization has executed a secular, historical and material transposition of this allegory. The contemporary ecological consciousness is left to mourn the fact that it is no longer possible to experience the disorientation that took Dante from the straight way to that of redemption. In an ordered world, the economic rationality of forestry and the imposition of tourism has largely displaced terrors, myths, outlaws and aristocratic display.

The reversal of valuations in this reading of Dante, seeing the path from wild-wood to earthly paradise as loss rather than gain – as the loss of a sensuous, dense relationship with nature, and its replacement with the anodyne experience of the tourist, wandering inconsequentially in a landscape made for the eyes – can be made to yield another layer of meaning. At this temporal distance, we can see Dante's background as the product of a historically specific formation, but it is less easy to do so for our own interpretative categories. The sense of loss that the contemporary ecological consciousness feels at the sight of a natural space tamed, forests turned into 'municipal parks' or 'standing reserves' (Heidegger 1993: 322), seems to be rooted in an incontestable reality rather than in just another historically specific image; but recognizing this picture as a picture, and finding the means ironically to bracket its terms, is a constant challenge in any theorization of the contemporary relationship with 'nature'.

Introduction

This chapter uses the vehicle of the tourist encounter with historic woodlands to explore a disquiet with the theoretical terms in which such encounters are often framed: that of the 'tourist gaze' and its associated ideas (see, for example, Urry 1990, 1992, 1995). This disquiet is not based on the idea that such a framing is 'wrong' – it is difficult to see how such a thesis could be maintained – but rather

on the notion that the negative valuation of vision implicit in concepts of the gaze that are derived from an anti-ocularcentric critique (Jay 1993) skews analysis in a direction that already has a prior appeal in contemporary intellectual culture, and specifically in portrayals of mass tourism (for a related disquiet over radical critiques of the gaze in media analysis, see Burnett 1995: 218–77). Such analyses become a lament for lost authenticity (Maleuvre 1999: 20) and marginalize the progressive aspects of modern scopic regimes (Jay 1992). The depiction of encounters with heritage woodlands sought here is more ambivalent: the intention is that tourist landscapes should be seen not only as suspended between a mode of encounter that is multisensory and authentic, and one that is depthless and com-modified, but also between a further mode derived from a Hegelian account of the modern relationship with the relics of the past. This Hegelian account gives a central role to vision, with memory as an infinite gallery of images interiorized and consciously held (Wyschogrod 1998: 114), but with a regretful knowledge of the gains and losses that such a relationship entails. From this perspective, the tourist encounter with historic landscapes is 'museal' in Adorno's (1967) double-edged sense, in which the loss of a living relationship is balanced by reflective clarity.

This chapter is programmatic and seeks only to establish a few points of the complex field that opens up when alternative valuations of vision are sought. Following the Dantean motif of the prologue, the same landscapes are visited twice, with a theoretical reorientation separating these visits. Firstly, a reading of woodland tourist sites is offered, based on Macnaghten and Urry's (1998: 172–211) analysis of the disciplinary practices associated with the framing and control of mass access to the 'English countryside'. A theoretical bridge then sketches selected fragments of a tradition against which a visual, touristic relationship with landscape need not be seen as an object of suspicion. This sketch moves over the terrain of Western Marxism from which critiques of the gaze have been drawn, but with more emphasis given to the elements of Hegelian rationalism to be found in this tradition – in particular that which finds its most explicit expression in the later work of Habermas (1981, 1987). Finally, a reading of a woodland heritage site is offered in which the process of its 'visual consumption' is disorientating, contra-dictory and provocative – arguably an exemplar of Baroque vision (Jay 1992: 186–93; Macnaghten and Urry 1998: 124) in a popular tourist setting.

The sites that provide the empirical setting for this study are small leisure and tourist venues in East Anglia, sites encountered, typically, on 'country holidays' and local leisure visits. The sites studied range from high-profile National Trust properties (for example, Hatfield Forest, Essex; Felbrigg Hall, Norfolk) through to small Forest Enterprise sites (for example, Chalkney Woods, Essex) and RSPB reserves (Royal Society for the Protection of Birds, for example, Strumpshaw Fen, Norfolk). The detailed reading is of a single site (Marks Hall, Essex). The selection is not arbitrary: the sites all offer substantial interpretative materials for visitors and

are heavily, and visibly, managed as both historically and environmentally import-
ant sites. The special nature of these sites limits any general conclusions that may
be drawn from this study, but this was regarded as a 'price worth paying' for
specificity.

Woodlands as Disciplinary Landscapes

In their account of the evolution of the English countryside as a 'landscape of
discipline', Macnaghten and Urry identify a diverse set of processes that interlock
in the production of tourist spectacles: the development of conceptions of the
countryside by elite planning groups, the availability of a set of near universally
understood markers and codes to police the minutiae of rural leisure activities, and
the historical evolution of cultural conceptions of the countryside that restrict
visions of what its uses might be. Planning initiatives have sought to diversify rural
economies and to enhance the 'quality of the environment' – both in the sense of
tourist amenity and in terms of international agreements that set environmental
benchmarks for progress towards sustainability. The disciplinary nature of these
frameworks is apparent when they are brought under the Lefebvrian category
of 'representations of space' (1991: 40–6), theoretical conceptions developed by
elite groups (albeit within a democratically ratified framework) and ready for
imposition on 'lived' spaces as a set of disciplinary spatial practices – instruments
of land management that aim to constrict responses to the countryside to those
considered desirable. These instruments function against the background of a
set of shared cultural tendencies in contemporary Britain – the attitudes, practices
and material culture which make up the fabric of everyday life and provide the
anchoring mechanisms for specific forms of discipline. These are the supports that
sustain an encounter with countryside as an orderly, passive, visual experience: a
population used to viewing the world at a remove from a moving platform (a mode
of experience rooted in mass transport, see Thrift 1996: 256–310); the absorption
of countryside as a cinematic experience, as a screen and soundtrack from which
one is insulated spatially on footpaths, walkways and viewpoints; the maintenance
of personal physical boundaries by such devices as all-terrain transport and high-
tech 'protective' clothing; and occupational insulation, as an urban population
encounters countryside spaces of which it has little prior understanding. Also
crucial is the status of the English countryside, constructed as an object of rever-
ence and respect, held at a visual distance, whose enchanting qualities may be
unobtrusively acquired.

This general framework has a specific application to the tourist woodlands of
this study. Firstly, these woodlands exist as tourist attractions in a space created by
both environmental-scientific and economic initiatives, which interact symbiotically.

On the one hand, ancient woodland habitats are rare, and seen as 'heritage in danger' (see Wright 1985), the area of 'ancient woodlands' (longstanding coppice and woodland pasture) having dwindled to the point at which preservation and restoration became an important national crusade (see Samuel 1994: 144–6). Such woodlands form a link with periods of English history that have a substantial cultural cachet; as Williams (1975: 48) observed, nostalgic evocations of vanished English ways of life settle on a hazy image of a set of 'feudal and immediately post-feudal' values. The fact that woodland pasture and coppice provide such a link permits them to be constituted as heritage objects. However, a contemporary scientific perspective raises some difficulties in translating this potential attraction into a reality and inculcating 'appropriate' attitudes and ways of seeing into the tourist encounter. International biodiversity agreements have meant that these habitats, which provide unique support for rare species, have become a focus for scientific concern, attracting the status (and support funding) of SSSIs (Sites of Special Scientific Interest) and ESAs (Environmentally Sensitive Areas). The maintenance of these habitats requires intensive and specialized management; however, managed woodland – especially dense, coppiced woodland, which provides the most varied habitats – may lack the picturesque and awe-inspiring properties associated with 'sacred groves' and 'great trees' (Schama 1995). Seeing 'ancient woodlands' as ancient is, in the phrase of Tsouvalis-Gerber (1998), a matter of 'making the invisible visible'. Whilst woodlands can afford 'picture postcard' experiences, historic woodlands trade authenticity and environmental value for visual amenity, and their management can provoke public hostility; alarm-management regimes are commonly accompanied by explanations of why trees are being felled.

The wooded landscapes that exist in this space of environmental and heritage opportunity are constructed, from the tourist's point of view, with a set of disciplinary devices that serve both to define what is being seen and its proper mode of use. A landscape established at the level of a Lefebvrian 'conceived space' (1991: 38–41) is anchored in spatial practices that can mesh, unobtrusively, with the behaviour and cultural dispositions of the tourist. A woodland is a bounded entity, bounded historically by deer banks and fences and in contemporary terms marked off from the spaces of intensive agriculture by 'traditional' management practices geared to the preservation of an ecosystem rather than to the demands of modern production. The functional boundary for the urban visitor is that of the car park, a boundary defined by tourist practices and well-aired limitations of rural travel, and the processes of charging and channelling visitors can depend largely on these contingencies. A modestly attended entrance and a modest parking fee, coupled with interpretation boards and perhaps a visitor centre, begin the framing of the tourist experience. This experience is made distinctive by a combination of conventional signifiers that give the landscape an identity and meaning: a memorable

name, facilitated by the traditional practice of naming woodlands and coppice areas as a functional element of the business of woodland management; the embellishment of a name with a modern logo, an equally functional part of the business of modern marketing; a defining map, that establishes both the identity and historicity of the landscape (by marking traditional boundaries and features) and serves the modern purpose of orientation, defining the space of the attraction; and further trappings of modern corporatism, the legally constituted body in whose custody the landscape now finds itself, and a list of supporting agencies or commercial sponsors (connecting the woodlands with wider social processes). These layered signifiers endow the landscape with an undeniable social existence, and establish it as a focal point for historical and environmental care and concern.

The passage from open countryside and access road to trees is made meaningful as interpretation boards and visitor centres impart stylized lessons in history and natural history. These enable tourists to recognize that the landscape is being managed 'in a traditional way', to recognize some types of tree, to realize that this is a 'native woodland' unsullied by recent and foreign interlopers, and – whether they can see it or not – that the woodland shelters wildlife that depends on its continued care. The means by which this experience is established trades on common cultural competences. A heritage gloss is established by a language of description situated between the resonantly poetic and marketing hyperbole: 'ancient and magnificent oaks', 'a natural patchwork of colours', 'nature perfected'. Diagrams and visual explanations are drawn from the efficient repertoire of modern instructional texts and guidebooks: line drawings of wild flowers, characteristic leaf and tree profiles, a child's guide to animal tracks in moulded plastic – all serving to give the tourist experience a legible structure. This instruction draws the particular landscape into general concerns: the abstractions of history, biodiversity or conservation become anchored in the particularity of the tourist's visit, which thereby acquires a broader significance. Importantly, the only acts that the sites support as meaningful are those that embody reverence and care; as far as the interpretative materials are concerned, any transgression borders on the meaningless or nihilistic.

The tourist encounter with woodland has a further dimension linked to the ethic of environmental care or historical reverence: sites are framed as 'polite landscapes' (to borrow Williamson's [1995] characterization of eighteenth-century parklands), supporting a comfortable, genteel experience, governed by codes of restrained enjoyment and modest display. An interlocking set of codes serves to shape the appropriate responses to the landscape; the construction of an object of care and study, noted above, defines the landscape as a shared extension to the well-tended garden – to be enjoyed with binoculars and guidebook in hand. The form of the interpretation centres says as much as their content, echoing summer houses and garden furnishings, models of tasteful, middle-class restraint: few

colours that are more obtrusive than soft greens and browns; a preference for natural wood structures and surfaces; textual elements in sober, upright fonts – the garish tourist attraction is miles away. The visitor is entering Dante's 'ancient forest'; there will be no disorientating or uncomfortable experiences here ('good boots are advisable in wet weather') and there will be no wild beasts – especially in the form of uncontrolled dogs, trail bikes, motor vehicles, guns or sources of loud music. There are explicit edicts which insist that this will be so: where to park, what to pay, the quiet activities which the visitor is welcome to pursue, what is strictly forbidden – 'please picnic in the area provided', 'leave the wild flowers for others to enjoy'. However, the boundary between acceptable and unacceptable behaviour, despite its graphic expression, is not the subject of explicit policing. Rather, disciplinary signs are reminders of and supports for, a moral geography that has been drawn elsewhere. All that is left is for the visitors to relax in and affirm that moral geography: by clothing codes, in particular by the 'outdoor wear' of the serious enthusiast, supported by an industry and a battery of specialist publications – but capable of encompassing jogging wear and other displays of relaxed vitality; by enacting tableaux of shared enjoyment – the walking companions, the happy nuclear family, the cheery greeting of strangers on the woodland path.

The mechanisms of control integrated into a disciplinary landscape may appear as obvious signifiers; the signage discussed above finds echoes within the woodlands as waymarked paths: posts carrying the coloured bands of metered walks (their distance and time meshing with contemporary concerns for scheduling, timekeeping, and the perception of walking as something to be administered in healthy 'doses'); terse arrows that 'remind' the visitor to follow an 'appropriate' and already well-trodden path; or some specific piece of interpretation. Less intrusive mechanisms of control are available as side effects of woodland management. Whilst it is easy to wander freely through a woodland of mature standard trees, with the dense shade of high branches keeping the ground clear of undergrowth, coppice woodland creates a dense barrier to the walker throughout most of its cycle, channelling visitors along managed paths. Newly cleared coppice was traditionally protected by 'dead hedging' (cut branches, loosely woven together) to protect young shoots from foraging deer; a revival of the practice forms both a heritage experience and a disincentive to roaming visitors. The tourist is effectively separated from a woodland landscape that becomes simultaneously a historical exhibit, a play of light and shade, and an enclosure for momentarily glimpsed wildlife, through which the tourist passes in a perambulation that frames a cinematic experience. Physical impact is kept to a minimum, and a bodily involvement with the landscape can largely only be enjoyed if you are a 'conservation volunteer', working within a predecided management scheme.

An interpretation that focuses on a tourist site as an object of the gaze, and that decodes the means by which this gaze is framed, clearly finds a congenial

application in the tourist woodlands of this study; and it also gives a plausible characterization of an 'aesthetic environmentalism' engendered by these landscapes. However, the ease with which such an interpretation is constructed may also prompt doubts, if we remember the lesson of the *Divine Comedy*. It involves an image of a relationship with nature – alienation, a loss of intimate involvement, distanced aestheticized framing – which chimes with contemporary discontents. Perhaps other, submerged images might depict this relationship in a different way.

Theoretical Interlude

The tourist gaze is a specific manifestation of what has been characterized as a key facet of modern consciousness: the predominance of vision over the other senses. It is almost implicit in the use of the term 'gaze', rooted in French critical philosophy (Jay 1993), that the historical rise of vision is to be portrayed negatively, that the separation of subject and object implied by visual experience is seen as a crucial loss, and that in this separation some sort of (near-unspecifiable) authentic experience or union has slipped beyond reach. Thus Guy Debord speaks of the spectacle – the visual experience constructed for mass consumption – as the essence of all ideological deceptions and manipulations; it can be so because the world 'is no longer directly perceptible', and 'real life' is negated (Debord 1994: 17, 151). The same conviction is present in Lefebvre, who develops a historical anthropology portraying a kind of fall in which the 'optical and visual world' comes to impose abstraction on the natural rhythms of life, on 'lived time . . . everyday time . . . bodies with their opacity and solidity' (Lefebvre 1991: 97). This is the end-point of a historical process in which 'the visual gains the upper hand over the other senses' and 'all social life becomes the mere decipherment of messages by the eyes' (Lefebvre 1991: 286). Separation from the world by visual spectacle intersects with Marxist critiques of the dominance of exchange value over use value, because spectacle becomes the means by which objects are placed beyond sensual, natural enjoyment; objects are 'offered up to the gaze yet barred from any possible use, whether this occurs in a museum or a shop window' (Lefebvre 1991: 319). The designation and promotion of tourist sites constitutes a special case of this general pattern: as mapped for the tourist, 'beauty spots and historical sites and monuments' designate places where 'a ravenous consumption picks over the last remnants of nature and of the past in search of whatever may be obtained from the signs of anything historical and original' (Lefebvre 1991: 84).

These observations stand in a long tradition; they occupy much the same space as Heidegger's broad attacks on industrial modernity (Zimmerman 1990); and as observations on the touristic aspects of modern experience they are predated by the complaints of Quatremère (Sherman 1994) and Valéry (Adorno 1967). However, the senses of 'naturalness', 'real life', 'separation' and 'debarral from use' on

which such critiques trade are difficult to pin down (Wyschogrod 1998: 72), especially since they attempt to point to modes of being that have supposedly slipped from contemporary grasp, and acquire a sense largely by a vague opposition to modernity. A contrastive space in which these problems may be explored has been opened up by Maleuvre (1999), specifically in the context of the museum and its attempts to present an image of the past. He poses the question of the status of the museum, in a manner that invites immediate parallels with landscape, as to whether history is to be 'conceived as historical living . . . as immanence within a tradition' or as an 'objectified spectacle, a way of holding tradition as a thing'. In the former case, 'historical being' lies in 'embeddedness within the social, economic and material forces of evolution', in the latter it is 'preservation against the tide of those very forces' (Maleuvre 1999: 13). As a representative spokesman for immanence, Maleuvre cites Quatremère, whose complaints against the museum were prompted by the opening of the Louvre. He railed against the estrangement of works of art from the contexts of their creation or traditional reception, arguing that to do so was to separate them from the 'network of ideas and relations that made the works alive with interest' – a process of deadening that merely serves to enshrine the 'material hull' of the work in the museum (Quatremère, cited in Maleuvre 1991: 15).

This regret for the lost authenticity of the art work is paralleled in contemporary attitudes to place and tradition, and serves to colour critiques of mass tourism and the heritage industry. In the case of landscapes preserved or restored as heritage objects, an extension of Quatremère's argument applies: although the 'material hull' of these landscapes has not been carried off anywhere, these landscapes have in most aspects been lifted from the life of the community which created them. Heritage and tourism landscapes are no longer 'in place' in the sense that they once were – living embodiments of rooted communities – but have drifted into the 'space' of tourist attractions: alienable parcels of countryside integrated into a social and economic network, created by mobile populations in search of leisure activity. However, preserved landscapes are 'museal' in both senses explored by Adorno (1967); they have been removed from the living tradition of their original use, but this removal can be construed as an enhancement of their meaning. The holding of the past as an objectified spectacle, through the artificial preservation of landscapes and land management practices, need not solely be seen as an obsession with 'surface' (Walsh 1992: 70).

Jay (1993: 594), in closing his account of the anti-ocularcentric tradition in French thought, concludes that the case against vision, as a foreclosure of critical thought and experience, is far from proven. This doubt is expanded by Maleuvre (1999: 21–39), who gives a positive characterization of 'holding tradition as a thing' through a passage in Hegel's *Phenomenology of Spirit* (§753). Hegel had explored the kinds of loss that Quatremère and Lefebvre lament. Looking back at

the Hellenic 'golden age' – a commonplace exemplar of lost authenticity in the Romantic era – Hegel remarks on its relics that the 'statues are now only stones from which the living soul has flown'. The knowledge of this loss constitutes the 'unhappy consciousness', an alienated consciousness aware of itself and incapable of forgetful immersion in a traditional world or belief system (for a more precise account see Taylor 1975: 206; Inwood 1992: 37). The artefacts in the museum, or the museal landscape, are no longer capable of reanimation: 'They have become what they are for us now – beautiful fruit already picked from the tree, which a friendly fate has offered us . . . it cannot give us the life in which they existed.' This is a repetition of Quatremère's point, but in a mode of resignation rather than of polemic; however, this resigned recognition does not imply that the modern consciousness cannot achieve some form of connection with these objects. Although 'our active enjoyment of them is . . . not an act of divine worship', we have a surrogate that makes sense for us: 'an external activity – the wiping off of some drops of rain or specks of dust from these fruits, so to speak – one which erects an intricate scaffolding of the dead elements of their outward existence.' These 'dead elements' of historical detail cannot allow us to enter into the life of historical objects, but they do allow us to 'possess an idea of them in our imagination'. For Hegel, this is not a matter of consumption, self-aggrandisement or cultural capital, but a highly specific achievement which distinguishes us from those who unreflect-ively inhabited that lost world: 'It is the inwardising in us, in the form of conscious memory, of the Spirit which in them was still only outwardly manifested.'

Hegel's argument produces an abrupt change in perspective. It reverses valua-tions of the gaze, and vision becomes a mode of active, engaged recollection – a means of holding, and giving value to, lost social formations. This programmatic argument may be brought closer to concerns over landscape through Raymond Williams' discussion of Thomas Hardy, and his representation of the vanishing traditions of the countryside, a body of literature that continues to colour inter-pretations of rural heritage. Williams characterizes 'the real Hardy country' as 'border country' (Williams 1975: 239), his work occupying a border between the unreflective inhabiting of tradition and educated reflection on, and record of, that tradition (a recurring personal motif for Williams). It is a difficult enterprise because the stance of the 'educated observer' and a deep involvement in the world observed are at odds with one another, because 'without the insights of consciously learned history and of the educated understanding of nature and behaviour he cannot really observe at all' (Williams 1975: 249). The dilemma that Williams finds confronting Hardy at a personal level may be projected onto the preservation of museal landscapes at an institutional level, because they occupy the same unstable ground: fixing a tradition in a framework of bureaucratic support and the apparatus of interpretation, but at the same time affirming the continuance of that tradition. Williams (1975: 249) cuts through this dilemma with the Hegelian judgement that

'the real perception of tradition is available only to the man who has read about it'. The objectification of a relic from the past, and its rational interpretation, is not, from this perspective, seen as a pale shadow of past experience or a missed opportunity to reactivate some full-bodied engagement with it – it rather brings the past to a particular kind of reality for the first time.

A focus on the representation of the past in memory, in a Hegelian stance of active recollection, addresses only one dimension of 'barring from use'; it under-cuts the supposed passivity of gazing at a spectacle by highlighting the active achievements of that gaze, the stern duty and effort involved in coming to full self-consciousness (see, for example, Inwood 1992: 186–8). Such an argument remains to be translated from the realm of Hegelian idealism into that of material practice and practical politics, as a counter to the equation of the passivity of the gaze with the political passivity of the gazing subject. For Lefebvre, the visual logic of 'abstract space' is a means of imposing an elite conception on the broad mass of the population, who are unable to articulate themselves by appropriating space in accordance with their own needs (Lefebvre 1991: 165). Similarly, Macnaghten and Urry's (1998: 187) tourists must take the English countryside as the tourist boards and planners conceive it, passively and unobtrusively acquiring its qualities. This is the antithesis of active engagement, of a participatory model of land use deter-mination, of landscape being shaped 'from below'. A counter to this image depends on articulating alternatives to a participatory democracy (Held 1987: 254–61) that equates political activism with direct involvement in decision-making (for an elaboration of such alternatives see, for example, Cohen and Arato 1992); and more specifically, on challenging the practicality of mass participation in the determination of rural land uses in predominantly urban democracies. A key facet of elaborating alternative models of political engagement is the discernment and enhancement of 'active' components in the superficially 'passive' behaviour of consumption. Such an analysis of visual consumption is an element of Thompson's (1995) refinement of the Habermasian communicative conception of democracy, in which he offers a positive account of media consumption. In Thompson's deliberative model, the rational consideration of alternative political courses in the light of evidence, as a precursor to voting under a representative system, is the central political act. The active reading of mass media is central to this process. While Thompson does not explicitly consider public sites as a mass medium – he rather interprets them as a context of face-to-face communication – it is clearly possible to place sites of public communication (such as museums, heritage centres, urban and rural heritage trails) under this heading. Heritage landscapes, as museal spaces with all the paraphernalia of presentation and interpretation, may be seen as one particular kind of communication medium – with individuals gathering to 'read' both the landscape and the bodily displays of others engaged in the act of reading, as part of a process of self-formation and reflection. There seems no *prima*

facie reason to suppose that such an act of reading is restricted to the aesthetic qualities of the landscape because – as outlined above – the landscape is embedded with codes drawn from many social contexts. An engagement with a landscape may simultaneously be seen as a reflection, perhaps inverted and ironic, on many features of social life. There is no requirement that this process be experienced as an explicitly political act nor that it be fully articulated. It is sufficient that the landscape and its embedded codes have been encountered in order intertextually and potentially to re-emerge at a later juncture.

Landscapes that are constituted as 'sites of memory' and stand as texts to be read in a deliberative process of democratic will formation, come within a sphere delineated by Habermas (1988) when he sketched out points of contact between Benjamin's project and his own communicative conception of democracy. Benjamin's concern with recovering the experience of the past, using the expressive resources of the present (for an analysis, see Honneth 1998) was annexed by Habermas as a corrective mechanism for a process of public will formation that might become empty without an 'influx of semantic energies from the past . . . a joyless reformism whose sensorium has long since been stunted as regards the difference between an improved reproduction of life and a fulfilled life' (Habermas 1988: 122). As these remarks stand, they are simply a programmatic recognition of potential, a recognition that the past might provide one resource to rescue the 'structures of practical discourse' from the flattening influence of a bland and soothing present. The resource envisaged is not provided by any arbitrary relationship with the past; in particular, the comfortable platitudes of the kind of heritage phenomena described by Lowenthal (1998) fall short of what is required. However, Samuel's (1994) corrective to overzealous heritage critique depicts a more vital relationship with the past within popular heritage pursuits. The outcome turns on the extent to which echoes of Benjamin's project – bringing to light fantasy images deposited in literature, art and everyday life, and thus expressing human needs from behind the layers of distortion built up over the development of modern capitalism (Habermas 1988: 117) – may be found in popular encounters with the relics of the past. This at least offers the possibility of a different lens through which to view the countryside, an alternative to that of countryside as parody, an 'Englandland' recreated as embodied sentiment (Macnaghten and Urry 1998: 180). This lens invites the view of countryside as a rural analogue of Benjamin's studies of the city (Gilloch 1996; Benjamin 1999), a ruin in which strange juxtapositions give insights into the past; not through sentimental evocation, but through a process of active recollection mindful of the limits of modern memory. Whether contemporary landscapes can support such a reading can only be revealed in detailed, specific studies.

The arguments assembled above are a fragmentary attempt to offer an alternative to the polarities and evaluative certainties of a heritage and tourism critique

based on an opposition between, on the one hand, spectacle and separation and, on the other, authentic encounter and bodily engagement. The aim is rather the construction of a more uncertain triangular interpretative figure. Two of the extremities of this figure are marked by transformed versions of 'authentic encounter' and 'commodified spectacle', transformed, because they lose their emphatic sense when extracted from their binary relationship and are revealed as historically constructed images. The third extremity is that of 'museal encounter' – heritage and landscape approached in a Hegelian spirit of active recollection. This figure is uncertain and ambiguous because these extremities only exist as images, specific interpretative devices limited by the traditions that give them sense, and because, as images, they continually threaten to collapse into one another.

Re-encountering the Tourist Landscape

The triangular figure outlined above may be used as an instrument with which to probe tourist landscapes for their ambiguities, and to reveal the multi-dimensionality of the tourist encounter. As an illustration, an approach to one particular site included in this study is outlined. Marks Hall Estate consists of a diverse set of woodlands clustered around the remnants of a country house (demolished in the 1950s – the great era of country house destruction) and developed over the last decade into a major tourism and leisure site with a visitor centre and ornamental arboretum. At first inspection – and its publicity leaflet reinforces the impression – this site seems to be an archetypal vision of 'English countryside' reconstituted as a tourist attraction. A routine set of cultural stereotypes are used to construct a tourist commodity: visitors are invited to 'discover the beauty' of a 'traditional English estate' set in 'unspoilt countryside'; they are invited to gaze upon a 'timeless landscape' (although 'timeless' seems to encompass 'ancient woodlands', a 'fifteenth-century barn' and a 'seventeenth-century walled garden') from a network of 'waymarked trails'; and then to rest in the visitor centre, with its 'gift shop and tea room serving light meals'. The tourist leaflet is not exactly a misrepresentation; its montage of picturesque views can all be located on the ground, and each of the attractions listed is present – but it is not quite correct. The problem is that the 'typically English' is seldom exactly that on close inspection, and details obtrude upon a tourist site that disrupt its incarnation of heritage clichés.

What the tourist leaflet does not mention, but a more thorough historical study (available from the visitor centre at a more forbidding price) does, is that this landscape has been transmitted into the present of the postmodern tourist experience through a turbulent twentieth century. This is nowhere symbolically more evident than in the line of electricity pylons that tower over the visitor centre in its

'lovely stream-side location'. These pylons might be dismissed as an unfortunate excrescence, but they continue to stand – as a physical reminder of the contest between traditional and modern visions of the English countryside fought around this issue in the interwar years (Macnaghten and Urry 1998: 37; Matless 1998: 44–52), and as a reminder that these visions continue to compete in the collision of commercialization and stewardship played out in this tourist landscape. A similar visual challenge to clichéd idyll is presented by the network of crumbling concrete tracks that cross the estate (partially hijacked as elements of the 'waymarked trails'). Immediate suspicion might fall on industrialized farming practices (visible in the surrounding farmland) but these have a different source, namely in the incorporation of the estate into a large airfield during World War II. Indeed, as the visitor walks through this 'timeless landscape', the occasional air-raid shelter may be found amongst the 'ancient coppiced woodlands', a disturbing inversion of what might be taken to be the settled continuities of country life – a shock effect that is not unlike that used by William Wyler in his 1943 documentary film *The Memphis Belle*, as he had his narrator declare, over a montage of English rural scenes, 'this is a battle front'. This shock effect is not restricted to direct relics of the past, as a seventeenth-century avenue leads, surprisingly and less than idyllically, to a light industrial complex that is both a legacy of airfield buildings and a pointer to the realities of a modern rural economy. The visitor is not left to makes sense of these experiences alone: interpretation boards within the visitor centre and a memorial obelisk set in the grassland of a woodland clearing (mown into a scale replica of the runway layout), set these obtrusions in context. Rural leisure is interleaved with memorial pilgrimages as British and US veterans revisit the site.

The wartime erasure of traditional patterns of use (a lazy formulation which should be undercut by the observation that other times had their upheavals – a Parliamentarian force was garrisoned at Marks Hall during the Civil War) provided a foothold for postwar reconstruction. The Forestry Commission, following its commonly reviled practice (Turner 1998: 254–58), obliterated the parklands surrounding the mansion, replacing the oaks (with one survivor that is now venerated as a 'great tree', in accordance with common touristic practice) with a plantation of pines. The tone of regret with which guidebook and tree plaque present this loss provides an ironic inversion of the lament for lost land uses that customarily accompanied emparkment (Williams 1975: 95–100). The pine plantation remains a key feature of the tourist landscape, despite the current vogue for 'native planting'. The arboricultural remit of the trust that administers the estate has permitted the preservation of a material memory of an era of urgent, production-oriented reconstruction as a 'North American' themed plantation. A deft interpretative touch has served to stitch the landscapes of war and reconstruction together in the shape of what might uncharitably be read as a piece of tourist kitsch

or an attempt to make a sober site 'child friendly'. A life-sized plywood moose gazes through coniferous woodlands on the approach path to the memorial obelisk, creating a hint of a North American landscape in East Anglia, a gesture of respect towards the US airmen remembered on its plaque, and raising questions about the links between place, landscape and belonging on a site with complex patterns of ownership and use.

A landscape of this sort, and it does not seem to be atypical of the sites studied (although it has escaped some of the manicured historical precision of National Trust properties), does not sit comfortably within any simple interpretative framework. Even the tourist materials in the visitor centre veer from one mode of presentation to another: leaflets couched in well-worn heritage terms, and a range of cute mementoes, sit alongside detailed guides to natural history; statements of scientific purpose, bolstered by connections with the Royal Botanic Gardens at Kew (to whom the estate was once, unsuccessfully, offered), which value the site in terms of species and habitat diversity, must jostle for attention with nakedly touristic 'special events' necessary for the continued vitality of the site. This is still an arena for the gaze, but it is a gaze that cannot help but move from relic to relic retracing a complex past through its surviving traces; it is a gaze that cannot fix upon a 'received image' of rural England, because that image is everywhere subverted. In one sense, it is a landscape for the ironic stance of Rojek's 'post-tourist', 'resolutely realistic' about the 'condition of outsider', and content with the intertextual collision of 'different facets and representations' of the site (1993: 177–9), and of a dauntingly complex rural past. However, this condition of being an 'outsider' is restricted to the Hegelian sense of estrangement from the inner life of the past. In another sense, this landscape is a text held in common, reflecting fragments of the relationship of a society with its past and the land – and one which enters the fabric, in different degrees, of each visitor.

Conclusion

On Dante's journey, the transformation of the forest landscape from a dark threat to a welcoming glade signified that he had undergone a redemptive transformation and enjoyed a new relationship with reality. In the above account, the tourist landscape is reinterpreted in the light of a transformation in the valuation of vision and visual consumption; however, this is not intended to imply that the tourist must undergo either a redemptive journey or a cultural re-education in order to see these landscapes in an enlightened way. Rather, it implies that the landscapes considered here, although they are institutionally 'on the tourist trail', are thin, elusive and underdetermined – capable of diverse interpretations and of articulating different aspects of the social experience of their visitors. These woodlands, of complex

historical provenance and contemporary usage, provide ambiguous support for critiques that assume an underlying essence of either vision or tourism, and the mode in which they are consumed is difficult to separate from the complexity of broader social processes and experiences. This argument is a restatement, in a landscaped version, of one of Camille's (1998: 47) principles concerning visual image and historical reality: a rejection of the generally accepted principle that 'the real is complex and the image can only ever be a simplification, or reduction, of it'. The construction of a landscape as a visual spectacle for the tourist, with its interweaving of conventional tourist devices and the relics of its past history, may – again to borrow Camille's (1998: 47) words in a fresh context – produce 'something structured from more contradictions and symbolically charged associations' than any 'real' landscape, innocent of touristic interpretation.

References

Adorno, T. (1967), *Prisms*, Cambridge, MA: MIT Press.

Benjamin, W. (1999), *The Arcades Project*, Cambridge, MA: Belknap Press.

Burnett, R. (1995), *Cultures of Vision: Images, Media and the Imaginary*, Bloomington, IN: Indiana University Press.

Camille, M. (1998), *Mirror in Parchment*, London: Reaktion Books.

Cohen, J. and Arato, A. (1992), *Civil Society and Political Theory*, Cambridge, MA: MIT Press.

Debord, G. (1995), *The Society of the Spectacle*, New York: Zone.

Gilloch, G. (1996), *Myth and Metropolis*, Cambridge: Polity.

Habermas, J. (1981), *The Theory of Communicative Action*, vol. 1, London: Heinemann.

Habermas, J. (1987), *The Theory of Communicative Action*, vol. 2, Cambridge: Polity.

Habermas, J. (1988), 'Walter Benjamin: Consciousness Raising or Rescuing Critique', in G. Smith (ed.), *On Walter Benjamin: Critical Essays and Reflections*, Cambridge, MA: MIT Press.

Harrison, R. P. (1992), *Forests: The Shadow of Civilization*, Chicago: University of Chicago Press.

Hegel, G. W. F. (1977), *The Phenomenology of Spirit*, London: Allen & Unwin.

Heidegger, M. (1993), *Basic Writings*, London: Routledge.

Held, D. (1987), *Models of Democracy*, Cambridge: Polity.

Honneth, A. (1998), 'A Communicative Disclosure of the Past', in L. Marcus and L. Nead (eds), *The Actuality of Walter Benjamin*, London: Lawrence & Wishart.

Inwood, M. (1992), *A Hegel Dictionary*, Oxford: Blackwell.

Jay, M. (1992), 'Scopic Regimes of Modernity', in S. Lash and J. Friedman (eds), *Modernity and Identity*, Oxford: Blackwell.

Jay, M. (1993), *Downcast Eyes: The Denigration of Vision in Twentieth-Century French Thought*, Berkeley: University of California Press.

Lefebvre, H. (1991), *The Production of Space*, Oxford: Blackwell.

Lowenthal, D. (1998), *The Heritage Crusade and the Spoils of History*, Cambridge: Cambridge University Press.

Macnaghten, P. and Urry, J. (1997), *Contested Natures*, London: Sage.

Maleuvre, D. (1999), *Museum Memories: History, Technology, Art*, Stanford: Stanford University Press.

Matless, D. (1998), *Landscape and Englishness*, London: Reaktion.

Rojek, C. (1993), *Ways of Escape*, London: Macmillan.

Samuel, R. (1994), *Theatres of Memory*, London: Verso.

Schama, S. (1995), *Landscape and Memory*, London: Fontana.

Sherman, D. (1994), 'Benjamin, Quatremère, Marx', in D. Sherman and I. Rogoff (eds), *Museum Culture: Histories, Discourses, Spectacles*, London: Routledge.

Taylor, C. (1975), *Hegel*, Cambridge: Cambridge University Press.

Thomas, K. (1983), *Man and the Natural World*, London: Penguin.

Thompson, J. (1995), *The Media and Modernity*, Cambridge: Polity.

Thrift, N. (1996), *Spatial Formations*, London: Sage.

Tsouvalis-Gerber, J. (1998), 'Making the Invisible Visible: Ancient Woodlands, British Forestry Policy and the Social Construction of Reality', in C. Watkins (ed.), *European Woods and Forests: Studies in Cultural History*, Oxford: CABI.

Turner, T. (1998), *Landscape Planning and Environmental Impact Design*, London: UCL Press.

Urry, J. (1990), *The Tourist Gaze: Leisure and Travel in Contemporary Societies*, London: Sage.

Urry, J. (1992), 'The Tourist Gaze and the "Environment"', *Theory, Culture and Society*, 9, 3: 1–26.

Urry, J. (1995), *Consuming Places*, London: Routledge.

Walsh, K. (1992), *The Representation of the Past*, London: Routledge.

Williams, R. (1973), *The Country and the City*, St. Albans: Paladin.

Williamson, T. (1995), *Polite Landscapes: Gardens and Society in Eighteenth-Century England*, Stroud: Sutton.

Wright, P. (1985), *On Living in an Old Country*, London: Verso.

Wyschogrod, E. (1998), *An Ethics of Remembering*, Chicago: University of Chicago Press.

Zimmerman, M. (1990), *Heidegger's Confrontation with Modernity*, Bloomington, IN: Indiana University Press.

–13–

tourist:pioneer:hybrid: London Bridge, the Mirage in the Arizona Desert
Daniel Jewesbury

Introduction

After it flows into Arizona from Utah, via the man-made Lake Powell, and then passes through the Grand Canyon, the Colorado River meanders westwards for several miles until, at the Hoover Dam, 20 miles east of Las Vegas, it heads south towards the Gulf of California. Along this last stretch, the river is known as the Lower Colorado, and forms the boundary between California to the west, and Arizona to the east. Three-hundred miles after passing the Hoover Dam, having flowed through three more dams *en route*, the Colorado, by now little more than a stream, leaves the US and makes the short journey across Mexico to the sea.

Almost exactly halfway between Lake Mead and the Mexican border lies Lake Havasu, another artificial lake, formed by the construction of the Parker Dam in 1938. When the lake was inundated, nearly 8,000 acres of reservation land belonging to the Chemehuevi Indians disappeared below the waterline.

In 1968, the American millionaire Robert McCulloch bought London Bridge and set about moving it to the Arizona desert. It had been discovered that the bridge, which had stood since 1831, was sinking into the bed of the Thames under the weight of the London traffic. A new bridge was erected on the same site, even as the old one was being dismantled and the stones numbered for shipping across the Atlantic. The bridge was reconstructed along a peninsula in the dry desert sand, with no river to cross and no destination. Upon its completion, a mile-long channel was dredged to allow the waters of Lake Havasu to flow beneath the bridge, turning the peninsula into an island, with the bridge its only access.

As a transposed Londoner myself, I've become extremely interested in the bridge's relocation and, in particular, in the way in which it has been used in an attempt to neutralize otherwise contentious narratives concerning the history and culture of white America. The bridge evokes a more palatable past than that which is the actuality of the South-West and of the American continent as a whole: most particularly, this means the systematic, violent erasure of the Native American. There are two dimensions to this erasure: the actual chronology of displacements

and dispossessions, and the process by which these actions were subsequently disavowed and omitted from the 'histories' of the area. I hope to show that London Bridge is instrumental in perpetuating these omissions. This chapter will examine the various myths constructed around the bridge and suggest strategies by which the symbolic power apparently vested in it can be seen in an altogether different light.

The Historiographic Gap and the Heritage of Silence

The area now known as Lake Havasu was originally the Chemehuevi Valley, a twisting, steeply sided creek through which the Colorado meandered, used by the Chemehuevi for farming and fishing. Through a number of state and federal statutes, the land was claimed by the US government, either passing eventually into private hands (such as those of Robert McCulloch) or being designated 'public land'. Numerous writers have noted the irony of protecting and conserving public land even while those who live on and from it are driven away (see *Chemehuevi Newsletter* 1968–73; Durham 1993).

Although Europeans first tracked up the Lower Colorado in the 1540s, it was not until 1853 that a claim was made to Chemehuevi lands by the US government, when the Californian side of the valley was declared public land (University of California 1976). In 1865, the Colorado River Reservation was established, between Blythe and Parker, to the south of the valley, and the long process of clearing the Chemehuevi from their lands was begun (Stewart 1968). Until this time, the Chemehuevi had farmed and hunted over an extensive area on both the Arizona and California sides of the river (for Chemehuevi songlines, see Laird 1976); however, by the end of the nineteenth century many of them had settled either in the Colorado River Reservation, or on the California side of the Chemehuevi Valley. It was here that the Chemehuevi Reservation was established in 1907 (University of California 1976).

In 1929, the Metropolitan Water District (MWD) was formed by the State of California, and in 1940, 7,776 acres of reservation land (the entire valley floor) were taken by the federal government and ceded to the MWD. Later that year, the Parker Dam was completed and the valley flooded. Although the land had been taken to a contour of 465 feet, the lake only ever reached the 450-foot mark. The Chemehuevi thus found that the shoreline was now out of bounds to them, and that no provision had been made for them to gain access to the lake. Further-more, various parts of the shoreline were subsequently declared wildlife reserves (*Chemehuevi Newsletter* 1968–73; University of California 1976). Today, the distant cities of Los Angeles, Phoenix and Tucson take a billion gallons of water from Lake Havasu every day.

It was not until 1970, two years after Robert McCulloch purchased London Bridge, that the Chemehuevi were legally recognized by the US government and compensated (at a rate of roughly thirty cents per acre) for the land lost under Lake Havasu (*Chemehuevi Newsletter* 1970).

This extremely brief account of the recent history of the Chemehuevi would not be found in a history of Arizona, nor even in a history of Lake Havasu City. There are several reasons for this 'historiographic gap'. Firstly, American historiography devotes itself to the activities of settlers, rather than to those that they encountered in the lands they settled. South-Western histories are commonly illustrated with the dotted-line routes of the first European adventurers; the textual material that they present suggests that even today it is impossible to find any information on the area, except in the contemporary accounts of those white pioneers. Thus, a reader of the standard texts on Arizonan or Californian history could be forgiven for thinking that *nothing happened* along the Lower Colorado in between the various expeditions of the Spanish missionaries and conquistadors, or later, the American fur trappers.

Secondly, there is the tendency for Western historiography to privilege written sources and to have difficulty assimilating other types of material. It is left to anthropologists to evaluate oral histories and territorial songlines, and to postulate when a particular tribe may have moved into an area or what their name might mean. The Indians are objects of study rather than historical agents. In short, anthropology approaches Native Americans as being *in* nature, rather than having any influence over it (see Stewart 1968; Kroeber 1974; also Durham 1993). Moreover, anthropology has been used to assert, disingenuously, that 'prior claims' to land sometimes have remarkably 'recent' origins, because of the peripatetic habits of a particular tribe or group.

Finally, it should be noted that, given the combination of the first two points mentioned, many native groups are quite uninterested in claiming their place within the canon of white history. Native histories, whether preserved orally or written down, are often kept within the reservation.

Coming back to the bridge, we can perhaps start to view its translocation as the completion of a colonial process: flooding the valley redefined the geography physically, erased existing habitats, but London Bridge *re*captures (captures again) colonized space, and reinscribes it. This time the capture is *conceptual*. History and geography have become malleable, mobilized in the service of the Great American Myth. The architect/artists Diller + Scofidio (1993: 43–6) put it this way:

> The tourist certainly yearns for the authentic . . . American tourism produces the authentic past with a fictive latitude in which literature, mythology and popular fantasy are blended together into the interpretation process called 'heritage' . . . Bypassing the limitations of chronological time and space, touristic time is reversible and touristic

space is elastic. Consequently, correspondences between time and space – between histories and geographies – become negotiable.

The bridge, although only 170 years old, is used to tie its white American visitors to a sense of continuous, uninterrupted civilization: a brochure published in 1971 by the McCulloch Corporation states that 'London Bridge . . . is history. It's drama. It's the human saga of 2000 years . . . London Bridge is made more of souls than of stone. And now it's here in the US' (McCulloch of London 1971). Similarly, Bonnie Barsness, of the Tourism Bureau in Lake Havasu City, told me that 'the bridge brings meaning and history to a community with a lack of history'. This constructed 'history' is imposed on an alien geography in an attempt to naturalize one group's presence, at the expense of other histories and geographies already there, and at the expense of the peoples from whom they were taken. This representation of history-as-heritage omits altogether the violence, both physical and institutional, by which the American West was conquered, reinscribed and re-presented. It is by no means clear *whose* this spurious 'inheritance' is supposed to be; nor what it is, exactly.

The bridge, then, witnesses a clash of so-called 'authentic' cultures: on the one hand, the suppressed and subsequently reinvented authenticity of 'Indian Country', now an integral part of the tourist marketing of Arizona; on the other, the imposed legitimacy of Old World history, but the violence of this effortless historical recombination, this clash, is obscured by a narrative of confusion, simplification and fabrication. The incorporation of the bridge into this landscape is one element in a totalizing vision of American heritage, even while the bridge is quite obviously out of place here: that displacement – or dislocation – itself becomes a defining factor in the articulation of new frontier narratives.

I don't think that it is appropriate to try to displace this vision, this set of discourses, merely to replace it with another, to try to 'recoup' some 'lost' history or culture. An effective critique must move beyond predetermined terminologies and strategies of oppositionality. I'm not simply trying to utter a counternarrative, rather to show how such narratives are flawed. 'Reality' and 'authenticity' are replaced in my examination of the bridge with fluidity, uncertainty, slippage: what I take to be a 'hybrid' approach. I want to explore the ways in which the bridge-as-sign doesn't work, to aggravate the unease of its relocation, its *dis*-location. It is not just the bridge that is dislocated; the space that it inhabits has been ruptured.

In the course of this chapter, I'll rehearse some potential approaches to the bridge. These define it either as a dysfunctional, but trite, tourist attraction, or as a means for the preservation of conservative authority in the midst of society's reorganization around consumption and 'the spectacle'. My own approach attempts to circumvent these absolute and rather disempowering characterizations, and instead suggest ways in which the bridge might be 'creatively misread'. London

Bridge is a 'radical space of exclusion', by which oxymoron I mean to suggest that it is a place marked by its uses in a dominant symbolic economy, but which contains the flaws by which it might be undone, conceptually and discursively. This, I will show, is an important qualification; it does not 'undo' itself, nor is it necessarily even an inefficient sign in its current mode. Its symbolic dismemberment requires, or gives the opportunity for, intervention, praxis, engagement. The 'mirage' project described at the end of this chapter is one such engaged creative misreading.

Some (Im)possibilities

The Stupid London Bridge

> It should go without saying that the *authentic attraction* itself cannot be purchased. Social attractions that have been purchased, such as the London Bridge in Arizona, and the ones that have been built up and promoted, such as Disney World, are not in themselves fake, of course. But because they represent the interests and values of only a small segment of society, a business or a community, they have little credibility as attractions, and they seem to be expensive gimmicks more than *true reflections of essential structures*. Sightseeing in a fragmented and spurious society has the quality of picking over a random collection of tacky souvenirs inflated out of proportion. Some sightseeing in America has this quality. *True attractions*, such as the *Mona Lisa* or Independence Hall, are not for sale. (MacCannell 1989: 157; my emphases)

A number of things spring immediately to mind in considering this account from a much-respected and influential text. Firstly and most incidentally, the reference to Disney World is apposite; Robert McCulloch's partner in the acquisition of London Bridge and the development of Lake Havasu City was C. V. Wood, the first employee of Walt Disney. Wood planned Lake Havasu City meticulously, poring over the *Yellow Pages* of countless towns to find out how many plumbers, electricians, carpenters, and so on were needed in settlements of different sizes. Calculating how many people would come to Lake Havasu, he attempted to engineer the perfectly balanced community from his telephone-book data.

Secondly, MacCannell's claim that London Bridge or Disney World cater to the interests of a 'small segment' of society is breathtaking. One could scarcely think of many business interests in the world larger than Disney; similarly, the ideological importance of sites such as London Bridge to the American tourist:pioneer imaginary should not be underestimated. As suggested earlier, American tourism, 'heritage' and history are crucially intertwined. Tourist sites of all kinds play an important role in constructing and maintaining the American myth of history and identity.

The final point relates to MacCannell's dependence on ideas of authenticity, of 'truth' and 'falseness'. These ideas hold little sway today, not only because of debates around 'hyperreality' and 'simulation', but also as a result of the anti-essentialist critiques offered by feminism and postcolonialism. It is irrelevant whether London Bridge is 'true' or 'fake' in the sense that MacCannell suggests. Furthermore, in making his statement that 'true' attractions are 'not for sale', he is apparently unaware of theories relating to the so-called 'spectacularization' of postindustrial society, and even of such a widely disseminated text as Walter Benjamin's 'The Work of Art in the Age of Mechanical Reproduction'. Benjamin, writing in 1936, discussed the impact of widespread, high-quality photographic reproductions on the 'aura' of great works of art, particularly mentioning the *Mona Lisa*. Benjamin believed that film and photography would democratize culture by displacing, or dispersing, the aura of uniqueness attached to the work of art (Benjamin 1992). Whether or not he was accurate in this prediction remains debatable; however, it is surely unarguable that the *Mona Lisa*, Independence Hall and all other great tourist attractions, even such natural wonders as the Grand Canyon, are nothing if they are *not for sale* (if they are not *for sale*). The commodification of the tourist site involves an *ideological* as well as a *financial* investment. Returns on one are dependent on the flourishing of the other.

MacCannell's abrupt dismissal of London Bridge is perhaps extreme, and perhaps expedient in the overall context of the structural analysis of tourist space that he expounds. What I am trying to demonstrate with my short critique is that it is far too easy to disregard London Bridge in favour of other apparently more 'worthy' or 'serious' sites. It might be interesting at this point to note the well known anecdote about the Americans buying the 'wrong bridge' (supposing that they were in fact getting Tower Bridge). Originally a joke by sometime Liverpool comedian Jimmy Tarbuck, this apocryphal tale now has the status of fact, always repeated as soon as the bridge is mentioned. It becomes 'fact' precisely because it's a good joke (back to interruptive antilogic again), because in the mind of the listener it *must* be true. Tarbuck's new myth displaces the unreliable history constructed by the Americans; yet by viewing the relocation as simply ridiculous, it conceals other, more serious, dimensions.

'New' settlements will obviously proceed in different ways from those that are hundreds or thousands of years old. It's important not simply to sneer at newness; the zeal of the pioneer:tourist faced by a hostile environment demands some understanding, most particularly of its peculiar psychopathology.[1] This is far from an apologia for colonialist violence; the reason why settler communities must be considered seriously is that their myths have constructed *a new reality*. Artist Jimmie Durham writes, 'Nothing could be more central to American reality than the relationships between Americans and American Indians, yet those relationships are of course the most invisible and the most lied about. The lies are not simply a

denial; they constitute a new world, the world in which American culture is located' (Durham 1993: 138). If we are to understand this culture and its claims, we cannot afford to dismiss its artefacts so readily.

The Fragmented London Bridge

The second possible evaluation of the bridge, which might conveniently be called a 'Marxist' one, views it in terms of a global capitalist spatial hegemony, a postmodern New World Order in which traditional understandings of space are subjugated to the ever more extensive demands of capital. As class-bound societies based on industrialized mass production give way, in the developed world, to flexible 'information economies' and spectacularized mass consumption, so identities founded on place (both within space and within a social order) become untenable. The bridge is symptomatic, in this model, of a widespread fragment-ation characteristic of postmodernism. Used by the inhabitants of Lake Havasu City to construct a novel 'identity' that is based on something other than the pre-existing history and geography, the bridge typifies the manner in which identity has become simply the parade of affect. 'Identity is increasingly based on images', writes David Harvey (1989: 289); and London Bridge is just such an image, a promiscuous 'image-commodity', in fact, endlessly replicated and disseminated in the tourist imaginary. Harvey goes on to wonder, '[I]f no-one 'knows their place' in this shifting collage world, then how can a secure social order be fashioned or sustained?' (Harvey 1989: 302). However tongue-in-cheek his talk of 'knowing one's place' may be, the phrase nonetheless betrays Harvey's greatest concern about postmodern society: the loss of class consciousness.

Fredric Jameson's analysis of postmodernism similarly concentrates on the fragmentation of society by capitalism, and the concomitant 'disorientation' of the individual subject:

> . . . this latest mutation in space – postmodern hyperspace – has finally succeeded in transcending the capacities of the individual human body to locate itself, to organize its immediate surroundings perceptually, and cognitively to map its position in a mappable external world . . . [T]his alarming disjunction . . . can itself stand as the symbol . . . of that even sharper dilemma which is the incapacity of our minds . . . to map the great global multinational and decentered communicational network in which we find our-selves caught as individual subjects. (Jameson 1991: 44)

Fragmentation results in the subject being unable truly to perceive his or her social situation in all its diverse complexity, according to Jameson. The subject thus caught cannot hope to act politically. London Bridge, as tool and symptom of this new social order, becomes therefore the catalyst for a kind of false

consciousness. Jameson (and Harvey) go further, suggesting that all politics based on 'sectional' issues (race, gender, sexuality), being themselves fragmentations of an economistic, class-centred analysis, are themselves productive of this false consciousness, concealing rather than exposing the nature of capitalist relations.

The solution to this predicament is for the subject to engage in 'cognitive mapping', an activity about which Jameson is peculiarly vague. It means, at its most basic, the drawing of new 'mental maps' that can encompass the suddenly expanded (and currently unrepresentable) space of social relations. Jameson stresses that he is *not* calling for 'a return to some old kind of machinery, some older and more transparent national space', (Jameson 1991: 54); and yet, in the same sentence, he foresees that cognitive mapping will comprise

> some as yet unimaginable new mode of representing [multinational capital], in which we may *again* begin to grasp our positioning as individual and collective subjects and *regain* a capacity to act and struggle which is at present neutralized by our spatial as well as our social confusion. (Jameson 1991: 54; my emphasis)

Just a couple of pages earlier, Jameson has made explicit that 'knowing one's space' is synonymous, or at least analogous, with perceiving one's place in the 'real' social order. He cites Althusser's 'redefinition of ideology as "the representation of the subject's *Imaginary* relationship to his or her *Real* conditions of existence"'. Jameson goes on to say: 'Surely this is exactly what the cognitive map is called upon to do in the narrower framework of daily life in the physical city: to enable a situational representation on the part of the individual subject to that vaster . . . totality which is the ensemble of society's structures as a whole' (Jameson 1991: 51; emphasis in original). Clearly, 'cognitive mapping' is a means of *regaining* the very thing whose loss has rendered postmodernism so powerful, so pervasive: *class consciousness*. In fact, as an activity whose aim is to transcend the fragmentation of the current social order, cognitive mapping *is* class consciousness (see also Deutsche 1996: 199).

As a feminist, Rosalyn Deutsche is scornful of Jameson's dismissal of 'sectionalism': 'Fragmentation, in his account, is self-evidently a pathology, and our ability to find our places in the world has been destroyed by late capitalism alone' (Deutsche 1996: 199). Deutsche insists that only by acknowledging difference can a radical politics hope to have some success, and then only situationally, in different formations at different times, depending on the objective. The cognitive map, 'as yet unimaginable', will remain so, because it is an attempt to construct a *totalized* view of perpetually changing relations.

Deutsche's responses to Harvey and Jameson centre on an understanding of space derived from Henri Lefebvre. Lefebvre describes social space as marked by an innate contradiction, between the socialization and the ownership of space.

Space is at once universal and fragmented: 'It is homogeneous and uniform so that it can be used, manipulated, controlled and exchanged. But within the homogeneous whole, which today spreads over a vast area, it is also fragmented into interchangeable parts, so that, as a commodity, it can be bought and sold' (Deutsche 1996: 75). Citing Michel de Certeau, Deutsche goes on to contend that '[e]veryday life is differentiating, situated, and involved while visualizing social discourses produce coherent knowledge by withdrawing from society and claiming an exterior position' (Deutsche 1996: 211). The 'visualizing' discourses of Jameson and Harvey, who seek to map the social relations of space as if they were fixed and as if there were a position from which they might be perceived in their entirety, are strangely circular: even while they condemn the spectacular consumption that marks the postmodern city, they attempt to construct an absolute, externalized view of the city, an image which can reveal the totality of relations that impinge on our lives and the spaces we inhabit.

Clearly, there is much in the Marxist analysis of postmodern social space that merits consideration, particularly the historical recontextualization of a condition often portrayed as 'without precedent'. However, a historicist-economistic approach that cannot countenance 'difference' also cannot fully account for the many conflicting pressures exerted on London Bridge. David Harvey asserts that his aim is to 'pull the condition of postmodernity into the range of . . . historical materialist analysis and interpretation' (Harvey 1989: 307). I would suggest that this alone, if it can ever be achieved, will be inadequate.

A Methodology in Three Strands

Rupture of Space, Rupture of Discourse – the Heterotopia

Michel Foucault's idea of the heterotopia, an 'Other Space' that unravels the fixity or continuity of all 'real' places, was proposed in a lecture he gave in 1967. The theory of the heterotopia has been appropriated by theorists of 'contemporary space', looking for a prepackaged methodology. As has been argued elsewhere, however, Foucault may have been more interested in the heterotopia as a rhetorical device than as some actually existing, readily identifiable space. I want to develop this idea, and from it to begin to describe my own approach to the bridge.

Foucault defines the heterotopia in the context of utopias, 'places' of the imaginary that have an association with the real world, but in 'inverted analogy' (Foucault 1998: 239), such as political or philosophical ideals. Heterotopias are real places, argues Foucault, which act against other real spaces, 'something like counter-sites, a kind of effectively enacted utopia in which . . . all the other real sites that can be found within the culture, are simultaneously represented,

contested, and inverted. Places of this kind are outside of all places, even though it may be possible to indicate their location in reality' (Foucault 1998: 239).

Foucault proceeds to describe, quite exhaustively, the various types and modes of heterotopia, through a highly idiosyncratic taxonomy of place and use that pulls in sites as diverse as the retirement home, the cinema, and the ornamental garden. He points out that heterotopias might be used in different ways during different ages and by different groups; nevertheless, he attempts to describe a definitive set of rules for their identification.

By examining the only other text in which Foucault spoke about heterotopias, *The Order of Things*, Benjamin Genocchio teases out a more suggestive understanding of the term. Genocchio begins by problematizing Foucault's proposed definition: 'Foucault's argument is reliant upon a means of establishing some invisible but visibly operational difference which . . . provides a clear conception of spatially discontinuous ground. Crucially, what is lacking from Foucault's argument is exactly this' (Genocchio 1995: 38–9). The taxonomy turns out not to be a handbook of heterotopias, but merely a list of some of their disparate qualities, an (intentionally?) incomplete catalogue.

Certainly, if one examines Foucault's various criteria one finds that the heterotopia is a many-faceted thing (Foucault 1998: 243, 233, 241). Looking at the range of 'either . . . or' statements that Foucault deploys, it becomes clear that almost any space can be termed 'heterotopic'. Any space involved in the validation of a particular group or culture, or for that matter any site where people participate in any form of collective cultural work, becomes a kind of heterotopia (this notion will reappear later in the context of tourism and the tourist 'site'). As Genocchio (1995: 39) points out: Scouring the absolute limits of imagination, the question then becomes: what cannot be designated a heterotopia?

Drawing out the different emphases (a 'literal', physical understanding in 'Of Other Spaces', a figurative one in *The Order of Things*), Genocchio (1995: 42) suggests that the heterotopia 'comes to designate not so much an absolutely differentiated space as the site of that very limit, tension, impossibility'. The heterotopia is itself *a heterotopic idea*. It is a rhetorical trope, which nonetheless can be used 'to inscribe instability into a given spatial order' (Genocchio 1995: 43).

It will not suffice simply to describe London Bridge as a 'heterotopia' and expect this mystification somehow to unravel all its ideological contexts. In order to exploit the full potential of the heterotopic *idea*, we must take this revised understanding back to the site of the bridge.

The Heterotopic Colony

Before moving on, I want briefly to return to considerations of the bridge as a 'colonial' site. Foucault (1998: 234) writes that the role of the heterotopia is either

to create a space of illusion that exposes every real space . . . Or else, on the contrary . . . to create a space that is other, another real space, as perfect, as meticulous, as well arranged as ours is messy, ill constructed and jumbled. This latter type would be the heterotopia, not of illusion, but of compensation, and I wonder whether certain colonies have not functioned somewhat in this manner.

Perhaps we might describe London Bridge as a 'heterotopic colony', talking of a lost order and of an order to come, a *spatial-temporal compensation*. Perhaps, also, London Bridge is a 'space of illusion', a space that allows us, if we wish, to examine social practices more broadly, in other less arresting sites. In other words, perhaps Foucault's distinction is only helpful insofar as it shows that spaces can operate in these two ways; he is wrong, though, to imply that a space cannot be both at once, that it cannot be pulled in different directions by different inter-pretations. Thinking of this illusory-compensatory role of the tourist site, John Urry (1995: 145) writes:

> Many of the objects of the modern tourist gaze are functionally equivalent to the objects of religious pilgrimage in traditional society. When people travel (make a pilgrimage) to the great tourist sites of the modern world, MacCannell suggests that they are in effect worshipping their own society.

In the oddly antirational space of 'heritage' is constructed the ambivalent subjectivity of the tourist:pioneer:hybrid. In the following pages, I will explore further a 'situational', temporal approach to the 'radical space of exclusion' that is London Bridge.

Edward Soja: Beyond Hyperreality, into a Third Space

In his book *Thirdspace* (1996), Edward Soja fuses the spatial studies of Henri Lefebvre, the postcolonial analysis of Gayatri Spivak and Homi Bhabha, and the theories of marginality developed by bell hooks and Cornel West, to construct a 'radical postmodernism' that recaptures space from the periphery, 'thirding' the centre and destabilizing its hegemony. Soja introduces his study of the 'exopolis', a term he coins to designate our postindustrial, postmodern, decentred anticities, characterized by their 'oxymoronic ambiguity, their city-full non-cityness' (Soja 1996: 238). Soja's project is dominated by his stated desire to move beyond exclusively 'materialist' or 'idealist', 'perceptual' or 'conceptual', historical or geographical approaches, and to arrive at a 'trialectic' where 'either/or' is replaced with 'and/also'.

Soja warns against the excesses of Baudrillard, whose nihilistic take on hyper-reality erases any distinction between 'real' and 'imagined'. For Baudrillard, the

terms 'fake' and 'original' are simply meaningless, the simulacrum itself having surpassed and obviated any 'original' there might once have been. Difference is annihilated, as signs proliferate endlessly, referring only to themselves. London Bridge paradoxically exceeds the hyperreality that Baudrillard and Eco describe (Baudrillard 1983; Eco 1995; see also Nunes 1995): it is the simulation that makes the original obsolete, only in this case, it's the original, too.

Soja asserts that a spatial politics can still be constructed in which difference and resistance are meaningful terms. The 'third space' is the theoretical outcome (or fallout) of 'exceeding' the binarism of the dialectic, but it is also the very (conception of) space in which the radical praxis described above is made possible.

The Bridge in Motion

As suggested earlier in this chapter, the attempt to use the bridge to legitimate certain constructed historical claims is flawed. It's not the denial or ignorance of violence which is the cause of this flaw – such a lack of awareness or interest is seen all over the American West, even if the degree to which it prevails here is unusual. The flaw is in the bridge itself, which sits too uneasily in its new context, its new surroundings.

In order to explain this further, I want now to introduce a third strand into my methodology, based on theories of the mobility and contingency of identity. My first source is Kathleen Cassity's (1954) reading of John Masters' novel *Bhowani Junction*. The novel, set in India immediately prior to independence, was an attempt to produce a complex, sympathetic portrayal of the Anglo-Indians, the children of mixed-race families who had been born and brought up in India. Their sense of 'home' was complex: they were not seen as Indians because they were from the privileged colonial classes yet they were looked down upon by the English themselves because of their mixed race, and could not meaningfully call England, a country that many had never been to, their 'home'. Cassity (1999) notes that in Masters' novel, Anglo-Indians find the elusive sense of 'home' aboard a moving train.

Paul Gilroy, in his book *The Black Atlantic* (1996), writes about the similar experience of black British and American people. Gilroy (1996: 4) settles 'on the image of ships in motion across the spaces between Europe, America, Africa, and the Caribbean as a central organising symbol for this enterprise'. Ships were 'mobile elements that stood for the shifting spaces in between the fixes places that they connected' (Gilroy 1996: 16–17; on ships as heterotopias, see also Foucault 1998: 244).

The idea of identity as being *in motion*, and being *found* in motion, rather than as something fixed, stable or continuous, is widespread. I want to suggest that the

bridge itself is perpetually in motion, between a number of points or 'shores', none of which is a true 'home'. Furthermore, I propose that as a site of dislocation, it is a fragile base for any claim of self-contained identity, and *productive* of discontinuity and fragmentation. The bridge is not a place, but a 'space between places'. It's no longer really 'London' Bridge, nor can it become 'Lake Havasu Bridge'. Its transposition opens up a rupture between 'site' and 'location'; one can stand on the bridge, as I have done, and identify particular points where certain events took place 8,000 miles away and 50 or 100 years ago. London Bridge is a metonymic, iconic representation of the Old World, but the whole that this part recalls is thoroughly constructed, yet the bridge isn't simply another bizarre American attraction, like the Pyramids of Las Vegas or the Parthenon in Nashville.

The bridge oscillates between four points in space and time; in addition to its relation to its former location, at the heart of Imperial London, and its current home, in the repopulated Arizona desert, it also, conversely, refers to present-day London and to precolonial Arizona; and it moves in all directions between these points, simultaneously. While it is used in an attempt to assert one identity, one unproblematic path between these points, the other paths return to complicate and upset the project, and to make unwitting hybrids of the contemporary tourist: pioneers. In addition, there's some sign that the newer inhabitants don't really attach the same significance to the bridge as did the original homesteaders of the 1960s, those who built the town out of the desert sand and planned its growth when it had only one road. The bridge that went nowhere is thus soon to be supplanted: on national holidays, the tourist traffic to the resorts on the island is so heavy that cars and 'recreational vehicles' back up all the way along McCulloch Boulevard, Lake Havasu City's main street. A new bridge, further up the channel, has therefore been planned to alleviate these tourist tailbacks. London Bridge is now just one aspect of a large, and rapidly growing, town. Its significance remains, but its totemic value as a bringer of meaning decreases slightly all the time, in inverse proportion to the town's accumulating 'real' history.

Applying the Methodology

I first visited the bridge in 1995 and shot some super-8 footage and 'assisted self-portraits' (made with the aid of the international tourist greeting, 'would you mind taking my photo?'). I returned there in 1999 to extend my research and to record the bridge more thoroughly. The pieces of work that I have developed in response to the bridge and its curious properties (a Web site, a series of photographs, and a digital video installation presented at the Project Arts Centre, Dublin in November and December 2000) all go under the title *mirage*. It's tempting to think of the bridge as simply a trick of the desert light, and when I've filmed and photographed it I've often borne this in mind.

The desert is unusually fecund as a literary and artistic metaphor (see Baud-rillard 1988; Bachelard 1994). One could see the 'mastering' of the Arizona desert, its flooding, its 'rehabilitation' as a productive space and its conceptual reinscription, as arising from a primitive psychological defence mechanism of imagining the desert filled with water (see Bachelard 1994: 206–7).

Mirage confronts the colonial fear of the sublime, inhospitable desert. It uses the bridge itself to reassert that which has been repressed in Lake Havasu City, demonstrating that London Bridge 'conceals so unsuccessfully that it . . . has more the useful incorrectness of a verbal slip – *pointing-to* the more it tries to repress the genocidal foundations of the great *can-do* nation' (Orange 2000). It is an attempt to hear the silent voice, the *heritage of silence*, which loudly proclaims its absence.

A number of narrative strands are employed in the piece. These are all concerned with dislocating the bridge, with 'repatriating' it, conceptually, to a new context. This 'third space' is neither London nor Arizona, neither Old World nor New. It is a further translocation that completes, farcically, the fabrication already surrounding the bridge. I have played on being a 'misreader' of the bridge, taking a too literal approach to its situation and recoding. I've collected historical and anecdotal material mentioning the bridge, as it stood in London between 1830 and 1970; I've also compiled descriptions and accounts of the bridge in fiction and poetry from the same period, for example, in Dickens's novels and stories or in T. S. Eliot's *The Waste Land*. Combined with both these strands are interviews with those involved in buying, moving and reconstructing the bridge, and those involved in servicing the tourist economy it has generated. These interviews have been conducted against the immediate backdrop of the bridge, one of them in a boat under the bridge. Finally, all of these intermixed strands are put into a questionable 'first person' voice by the presence of another Londoner (me) as interviewer, reader, performer, photographer and archivist, in front of and behind the camera.

Figure 13.1 Detail from Quicktime™ VR panorama, *mirage.htm* (1999).

mirage.htm

At the Web site *mirage.htm* (http://www.project.ie/mirage.htm), the first part of the project to be realized, selections from the various texts are juxtaposed such that it is not always certain what is 'fact' and what is 'fiction'. The second main element of the Web site is a series of 'virtual reality (VR) panoramas'. These panoramas, typically used by estate agents and property developers, are 360º photographic views, around which viewers can navigate using their mouse.

Mirage.htm takes this visualizing technology and disrupts the totalized view that it seeks to construct. The first VR panorama in the series is taken from the English Village beside the bridge; a 'hotspot' allows the viewer to link to a second view from the balustrade of the bridge. Upon opening this second view, however, one is transported not to the pavement on the bridge in Arizona, but to the exactly corresponding point on the new bridge in London (this new bridge having been constructed in the same place as the old one). The overall 'scene', which involves a journey across the bridge, is constructed of alternating views of London and Arizona, so that the viewer constantly shifts back and forth between 'contexts'; the 'locations', though, are exactly chosen so that one always ends up in the 'place' upon which one has clicked – but, simultaneously, 8,000 miles away from it.

The final panorama combines the two locations. A 360º view was filmed from exactly the same 'point' on the new bridge in London, and the old bridge in Arizona. These two pans were then spliced together around a vertical 'seam' in the image (a lamp-post on the old bridge) to form an impossible 720º panorama (Figure 13.1). If one is sweeping around the view of Arizona from left to right, the view of London thus 'wipes' across the screen from the right. However, when one returns to the 'seam', 360º later, it is now Arizona that wipes across the screen, and so on. Thus, an impossible, virtual 'third space' is fabricated, an 'unsettlement' of the bridge and its new contexts.

Mirage is an attempt to disprove logic with logic itself, a subversion that undoes, momentarily, the spatial hegemony in which we are all bound. In that hegemony, we can still be active subjects, and at the same time acknowledge, even embrace, the fragmentation that allows us to see the fragility of our social order.

Notes

1. Novelist Cormac McCarthy has restated the foundational violence of the West, that is the mundane, incessant, random violence by which it was 'won' (see McCarthy 1989). Werner Herzog has also explored this territory in his film about the exploits of the conquistadors, *Aguirre, Wrath of God* (1972); but both, crucially, also emphasize the psychological damage, the *self*-debasement, that the pioneer, or colonizer, suffers, in the subjugation of 'new lands'.

References

Bachelard, G. (1994), *The Poetics of Space*, Boston: Beacon Press.

Baudrillard, J. (1983), *Simulations*, New York: Semiotext(e).

Baudrillard, J. (1988), *America*, London: Verso.

Benjamin, W. (1992), 'The Work of Art in the Age of Mechanical Reproduction', in *Illuminations*, London: HarperCollins.

Cassity, K. J. (1999), 'Identity in Motion: Bhowani Junction Reconsidered', *International Journal of Anglo-Indian Studies*, 4, 1, http://www.alphalink.com.au/~agilbert/kat.html.

Chemehuevi Newsletter (1968–73), California.

Deutsche, R. (1996), *Evictions: Art and Spatial Politics*, Cambridge, MA: MIT Press.

Diller + Scofidio (1993), *Visites aux Armées: tourismes de la guerre / Back to the Front: Tourisms of War,* Normandy: F.R.A.C. Basse-Normandie.

Durham, J. (1993), *A Certain Lack of Coherence*, London: Kala Press.

Eco, U. (1995), *Faith in Fakes: Travels in Hyperreality*, London: Minerva.

Foucault, M. (1998), 'Of Other Spaces', in N. Mirzoeff (ed.), *The Visual Culture Reader,* London: Routledge.

Genocchio, B. (1995), 'Discourse, Discontinuity, Difference: The Question of "Other" Spaces', in K. Gibson and S. Watson (eds), *Postmodern Cities and Spaces,* Oxford: Blackwell.

Gilroy, P. (1993), *The Black Atlantic: Modernity and Double Consciousness*, London: Verso.

Harvey, D. (1989), *The Condition of Postmodernity*, Oxford: Blackwell.

Kroeber, A. L. (1974), *Mohave Indians*, New York: Garland.

Jameson, F. (1991), *Postmodernism, or, The Cultural Logic of Late Capitalism*, London: Verso.

Laird, C. (1976), *The Chemehuevis*, Banning, California: Malki Museum Press.

MacCannell, D. (1989), *The Tourist: A New Theory of the Leisure Class*, New York: Schocken Books.

McCarthy, C. (1989), *Blood Meridian, or, The Evening Redness in the West*, Basingstoke: Picador.

McCulloch of London (1971), *London Bridge*.

Masters, J. (1954), *Bhowani Junction*, New York: Viking.

Nunes, M. (1995), 'Baudrillard in Cyberspace: Internet, Virtuality and Postmodernity', *Style,* 29, 2: 314–27.

Orange, M. (2000), 'London Bridge in the Desert', in *Mirage*, exhibition publication, Dublin: Project.

Soja, E. W. (1995), 'Heterotopologies: A Remembrance of Other Spaces in the Citadel-LA', in K. Gibson and S. Watson (eds), *Postmodern Cities and Spaces*, Oxford: Blackwell.

Soja, E. W. (1996), *Thirdspace,* Oxford: Blackwell.

Stewart, K. M. (1968), 'A Brief History of the Chemehuevi Indians', *Kiva*, 34: 9–27.

University of California (1976), *The Chemehuevi Future*, Los Angeles: University of California at Los Angeles.

Urry, J. (1995), *Consuming Places*, London: Routledge.

Frightening and Familiar: David Lynch's *Twin Peaks* and the North American Suburb
Renée Tobe

Diane, 11: 30 a.m., February 24th. Entering the town of Twin Peaks. Five miles south of the Canadian border; twelve miles west of the state line. The mileage is 79,345. The gauge is on reserve – I've never seen so many trees in my life – Diane, if you ever get up this way, that cherry pie is worth a stop.

(*Twin Peaks*, pilot episode)

In the first episode of David Lynch's television series *Twin Peaks*, Federal Bureau of Investigation special agent Dale Cooper speaks these words into a hand-held, voice-activated tape recorder as he drives along a tree-lined North-Western highway. This particular stretch of road becomes familiar to regular viewers of the *Twin Peaks* television series. Like a tourist, Cooper views the passing seamless landscape with an air of objectivity. Cooper's interaction with the town precipitates his subjective involvement. The smoothness of Cooper's journey (especially compared to earlier disturbing scenes set in specified locations) conforms to American mythological themes, linking mobility to freedom (Eyerman and Löfgren 1995: 55). *Twin Peaks* is a fictional narrative set in an eponymous fictional town but filmed partly on location, and although the town does not exist, the notions that arise do. The viewers, familiar with the domestic soap-opera genre, safe at home in their own living rooms, explore the deeper structure that lies in the gap between the space of the expected and the actual. An investigation of the television series *Twin Peaks* offers insights into how and why that most prosaic of arenas, the North American suburb, can frighten and disturb. In television and film, contemporary settings, dramatic action and social realism create a convincing sense of the 'real'. Film makers manipulate viewer expectation of the mythic, placid suburb meant to be the most peaceful manifestation of domestic bliss and security. Many bizarre and macabre events are set in suburbia, a spatial boundary between city and country. These everlasting streets lined with conservative and conventional family homes depend on the automobile, with its capacity for combining an active journey with a passive visual experience. In film, suburbia represents a classless, faceless society where conformity and superficial goodness are paramount. Suburbia also

features as a locus of inaction, when its repetitive non-character is considered the cause of boredom and delinquency. Television viewing forms a component of everyday life. When the audience comprises both tourists and occupants of their own living rooms, with the television a hypnotic member of the family, this familiar scene becomes imbued with a fearful evocation of evil.

Critical and aesthetic distance may be a marker of those who can separate their culture from social and economic conditions of the everyday and those who cannot. There is no 'distancing', however, in the culture of everyday life, deeply embedded in its immediate social and historical setting. The study of material culture, developed at the same period as *Twin Peaks*, offers a place of convergence that generates insights to reveal more than any one specific discipline might provide. Miller suggests that material culture matters because it provides the means by which contradictions are resolved in everyday life (Miller 1987). Following Miller, we examine material culture as if parsing its grammatical structure; taking it apart to investigate the structure of how it goes together, we interpret how particular things come to have diverse meanings, depending on use and perception. We look at material culture to understand the nature of the material of the architecture, not only the style or history of it – although these are of course important –but also aspects of use and representational qualities. This explicates the tension between the purpose for which an object is designed and the symbolic meaning with which it is imbued through use, and through which it comes to be perceived. Lynch and Miller, mining the same territory in that period of conspicuous consumption, the 1980s, objectify the material of daily life and offer it up as a hard surface to be examined. As Miller demonstrates, material culture registers our human encroachment and trespass in otherwise natural surroundings (Miller 1987). A distinction between nature and culture is an important part of Lynch's oeuvre with his fascination with structuralism. Examining the material objects of daily life provides a means of examining our modes of occupation. Objects, such as the television set, the telephone or the automobile, help to achieve or symbolize our highest aspirations and comprise a part of our history that offers much to reflection.

Television and Touring in Everyday Life

Whether measured in hours or days, how one fills one's leisure time (when one is permitted to do as one pleases free from obligation) reveals crucial aspects of everyday life. Television enriches, enters, compacts, and, more importantly, represents the richly woven texture of the familiar routine (Fiske 1992). Analyses of images broadcast by television and the time spent viewing television complement investigations of how viewers conduct the business of the everyday. This may encompass walking, talking, shopping, cooking, moving about, in addition to what viewers do or make in their spare time or how particular products are used in a

particular way. Tourism, as a human activity that encompasses human behaviour, uses resources and interacts with economies and environments. Television viewing, a leisure activity equally involving human behaviour, correlates with economy through production and sponsorship. As De Certeau reminds us, such activities define our primarily visual culture that measures items and details by how they are perceived. By this means, the everyday transmutes communication into a visual journey (De Certeau 1992: 142).

Tourism and television have further aspects in common; both fall by definition under the heading of leisure and thereby possess comparable characteristics to do with the everyday. Although television viewing is associated with idleness whereas tourism seems to imply movement from one place to another, under the question of leisure (be it active or passive), both are activities undertaken for their own sake. Interesting and defining aspects of these two leisure activities include seasonality (in particular, the school season) and consumers' inability to experience the product before they commence their journey. While tourism involves physical movement to locales other than the normal living places, television tourism involves viewing or experiencing those places through the frame of the television screen. One gets 'lost' in reading or watching television as one gets lost in mindless observation of the receding landscape through the automobile window.

An understanding of the relationship or parallels between watching television from one's living room at home and watching the world pass by through a car window requires a brief look into the nature of the tourist experience. Looking at tourism conceptually (rather than technically) sets a framework for a deeper understanding of the subject. With its multifarious aspects, tourism eludes precise definition but though it may not be distinctly pinned down, it may be understood by description of the diverse forms it takes and effects it has on its participants. The essence of being a tourist implies an organized visit to things or places disposed particularly for that purpose. It implies the passive experience of an activity or place, as for art or architectural tourists, non-practitioners who attend private views, exhibitions, lectures, and events with otherwise no direct involvement. It also implies, for the purpose of recreation, an excursion from, followed by a return to, one's starting place. Further common threads in tourism relative to television include zoning or targeting certain aspects of the population, and market segmenting based on lifestyles. Users of both tourism and television are commonly passive and guided by established (if unstated) rules relating to how one 'uses' a culture. Tourists, like television viewers, may be venturesome or dogmatic, looking for something informing, for 'pseudo-events,' or to experience vicariously the life of others (MacCannell 1999: 104–6). Both tourists and television watchers are subsumed in categories according to the degree of excitement or 'culture' desired, the extent to which tourists/viewers seek something new, or whether they can or cannot be persuaded to change their ideas.

North American Suburbia and the Automobile

In the sense of passive voyeurism, tourism has much in common with film or television viewing. Baudrillard describes America (the expanse of the country, not the Manhattan of films and television), perceived at high speed through the windscreen of his car. He begins his book in classic road-movie style and takes in the US as though watching a television documentary. For Baudrillard, the windscreen of the car and the viewing screen are interchangeable, resulting in their shared objectivity. Baudrillard argues that we live in a simulated word and this is nowhere more true than in the realm of tourism (Baudrillard 1984). Film maker David Lynch describes the territory of the US in terms of a few 'all too recently pitched encampments scattered in the horror of the desert' (Chion 1995: 197). Baudrillard also compares television culture to the *disjecta membra* of human occupation, with viewers as refugees disassociated from place and caught up in a neutral flow of images. Baudrillard employs the term 'desert' as a metaphor for the disappearance of the community and culture. For Baudrillard (1988: 28), all of America (not just the creations of Disneyland or theme parks), as seen from his car, throws up aspects of a created illusion of absolute reality. These aspects represent a hyperreal dimension in which Americans fabricate the absolute fake in response to demands for the 'real thing.' Baudrillard admits he was not looking for the depth of European-style kinship structures, but for the America of pure circulation, freeways, desert speed, screenplays, and television.

Driving in America is a way of life. Families drive mobile homes around freeways without ever leaving, making their home in the non-places made for transit and transportation. Signs seen from the car on the freeway resemble a litany, giving advice on how to go through life (Baudrillard 1988: 53). The world outside the car passes as a film or television programme, whether it be desert (the Western) or city (a screen of signs and formulas). Due to its omnipresence in film and television, the American city seems to step directly from the picture screen. An understanding of America requires a movement from the screen outward toward the city (Baudrillard 1988: 56). Whereas Baudrillard compares the journey through the desert (with its infinite unfolding) to a film, suburbia, where one 'drives up, enjoys, and drives away again', resembles the episodic and encapsulated television show. Suburbia contains all life's experiences in bite-size form: time to work, time to shop, time to drive, and time to play, life compartmentalized and seemingly no opportunity for anything unsavoury to slip through the gap.

The manner of suburban occupation and inhabitation of the surrounding suburban areas and motorways is not necessarily the style for which they were intended. Motorways were designed to provide a quick and 'visually' clean way of getting from one seemingly unsullied place to another with the focus on the surface and not on what is hidden from view. This tension between the deceptively pleasant

façade and actual events taking place engages in a process that escapes the borders and boundaries delineating the appearance of good (Miller 1987).

Urry directs our attention to car ownership and the sign values of speed it entails as the single most important major item of individual consumption, close behind home ownership (Urry 1999). Due to the extended sprawl of North American suburban living, each family home requires at least one car. The transportation revolution (brought on by the railroad after the Civil War and continued into the twentieth century with the development of the automobile and the aeroplane) introduced speed as a metaphor for American culture. Car manufacturers played on the increased mobility characteristic of the American way of life in which movement indicates hope. Automobility was organized around the concern for cosiness in interwar family life as the recently planned new and implemented roadways and subdivisions ensured privacy for individual homeowners. Access to the privacy of the individual homes of the suburbs depended on newly developed systems of roads, highways, and subdivisions. Previous technologies of the railway and cinema relied on public transportation and public access, while the car interior and the television-centred living room are private spheres (Urry 1999). The new highway networks were adopted as both symbols of the country's technological advance as well as cultural symbols of freedom. Massive suburban tracts predicated low-density family housing with the large domesticated wildernesses of the front and back lawn, the production of domestic goods and a car to travel the often long distances to shop and to work. In Lynch's world, distance along motorways coincides with relative degrees of good and evil. For example, Shelley and Leo, two of *Twin Peaks'* least civilized characters, live furthest along the most remote highways, and Leo is represented by that majestic symbol of America's highways, the transport trailer. Some of the series' more grisly events occur in places so remote they may only be accessed on foot. This corresponds to the postwar notion that everything along the motorway must be pleasing to the eye of the invincible car driver (Urry 1999).

Televisual Lynch

The car shelters its occupants from humdrum everyday obligations, and presents a place where one may try on new identities. Locations in *Twin Peaks*, the television show, remain equally unspecified and anonymous, such as the Roadhouse, neither road nor house, but venue for meetings of those who may not, for whatever reason, meet in their own homes. Another significant non-location is the intersection frequently used to begin or end a scene. In film, 'the road' represents virility as self-discovery as well as anonymity (Eyerman and Löfgren 1995: 66). Lynch appreciates television accessibility where viewers remain in their own

homes, undisturbed by outside elements or others. According to Lynch, viewers watching television in their own homes are well placed for entering into a dream from which they are unable to turn away. The deliberate unhurried style of the title credits (reminiscent of the paintings of Edward Hopper) sets the viewer up for the compelling and often surreal slowness of the story about to unfold. Lynch feels that not only is television a leisure activity but also a medium where he can leisurely tell his story.[1] The slowness of the credits with which each episode begins, parallels the leisurely pace of the tourist, driving tranquilly while mindlessly observing the passing landscape. Among Lynch's films, *The Straight Story* (1999) moves with the same slow pace of the *Twin Peaks* credits. Time flows slowly because in the television series, Lynch has all the time in the world. The stream in the opening credits of *Twin Peaks* flows gently, continuously and harmoniously. Only life offers viewers more time to see unresolved incidents unravel than the television soap opera (Kaleta 1993: 141). Objects or places, whether seen on the cinema or television screen or out of the car window, are fetish objects, relating to the material fiction of the image. In his article on the familiar *vade mecum* of travelling, *The Blue Guides*, Barthes argues that to select only monuments suppresses the reality of place and people (Barthes 1973: 74–7). Following on from this notion of monuments as empty indicators of the social and cultural, Lynch focuses his camera on roadways and intersections. Locations in Lynch are places of transit or refer to going somewhere (Figure 14.1).[2] Lynch involves the viewers as tourists in their own culture, presenting the simulated reality in surreal form, making it seem more real. The viewer's task is no longer to recognize the similitude of an already acknowledged narrative or order, but to triangulate meaning between the fragments rendered through ritualistic perambulations.

Lynch plays with the permeation of lifestyles into the home and with the way that products become a direct extension of their advertising image. Television viewers may believe (quite accurately) that the film maker is being ironic. In a satirical take on the aestheticization of social culture (where the gap between the culture industry and everyday life closes more and more), Lynch assimilates idiosyncrasies of the television medium. Lynch directed commercials based on the works of great authors, using actors from *Twin Peaks* and broadcast throughout the series. These adverts seemed not to intrude on the show but to extend the surreal implications of Lynch on the screen. Surrealism is kitsch, and Lynch is never timid of the kitsch or of the surreal. He is not afraid to seem pretentious; this is how he expresses his surrealism. Lynch imbues familiar domestic interiors with a fearful evocation of evil. Dale Cooper, the FBI detective, investigates the crime of the murder along with the viewer. Lynch practised, intensified and ironized television and the living rooms where viewers watch it. Viewers feel they are 'in' because they recognize and understand the irony entangling the scene. The subtlety that draws viewers into the scene on the television screen seduces. The

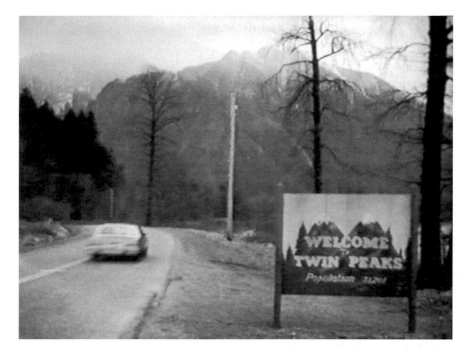

Figure 14.1 Twin Peaks, the town and the television series, flows as smoothly as a car along the highway (copyright Renée Tobe 2001).

more completely and thoroughly the interior set design conforms to the ideals of domesticity, the more it conforms to the lowest common denominator of the market to a mail-order catalogue vision of domestic furnishing. The viewer is immersed in a material world comprised of stereotypes and ironies that make the crime difficult to locate.

Twin Peaks

A seventeen-year-old schoolgirl, Laura Palmer, is found murdered on the riverbank of a small community. Dale Cooper, a FBI Special Agent, links the girl's death to previous killings elsewhere. His investigations uncover realms of narcotics, prostitution and perversity that are otherwise incongruous within the town's sheltered, orderly and untroubled appearance. A series of bizarre revelations and visions reveals Laura Palmer's murderer to be 'Bob', an evil spirit who has consumed Laura Palmer's father, Leland. He later murders Laura's lookalike cousin, Madeleine, but when Leland dies, 'Bob's' spirit lives on. Cooper enters an other-world dimension in order to confront this evil, only to be consumed by it himself.

Twenty-five disparate characters in a labyrinthine main plot and several tort-uous and difficult to follow subplots comprised the *Twin Peaks* television series created by David Lynch and Mark Frost and broadcast from 1989 to 1991.[3] Lynch makes the ordinary seem strange and disturbing. He suggests that viewers 'don't expect life to make sense but they do expect television shows to' (Kaleta 1993: 48). The television culture that dominates modern society erodes our sense of place (Meyrowitz 1985). Therefore, television directors and creators of television series need to reinstate place as an important aspect in their series. Lynch and Frost do this in several ways. First, they assemble the plot from a series of cards describing scenes, places, and people arranged so they flow as smoothly as Cooper's car along the tree-lined highway. Next, they ensure the series is littered with nostalgia-flavoured images of the America that might have been, the one from Lynch's North-Western childhood. In *Twin Peaks*, the name of the television series and of the town where it takes place, Lynch wished to create a world where good was evil and evil good.

Twin Peaks began one day when Lynch and Frost sat in a coffee shop at the corner of Laurel Canyon and Ventura (the coffee shop is an all important image in Lynch's oeuvre). The image of a body wrapped in plastic washing up on the shore of a lake suddenly popped into both their minds and become the point of departure of the series. Lynch composes with a series of vignettes, just as the landscapes that pass by in partial glimpses are a series of snapshots, piled hurriedly into the memory and literally recomposed in the account given after the trip in the travel-ogue or photo album. He begins with a series of 70 scenes on cards and puts them together to create a film.

Small-town America forms the setting for *Twin Peaks*, the television show. Filmed in several locations near Seattle, Washington, but mostly in television studios, *Twin Peaks* is set in a town without a Main Street.[4] The writers could not picture what could happen in the series until they made a map of the town, one they could mentally 'drive through' (Chion 1995: 103). Knowing where things were located helped to determine the atmosphere of what would happen there. Maps, like home, provide a fixed point so metaphorically, at least, tourists or viewers know where they are.

Suburban Values Within a Televisual Reality

Contemporary settings, dramatic action and social realism create a convincing sense of the 'real.' Lynch presents the viewer with a paragon of a stereotypical suburban house. His strategy subverts the spectators' usual safe distance from the material by colonizing the iconography or furnishings of that complacency; the viewer is expected to turn from the screen to discover the void of his/her own

living room. The viewers become the detective seeking out clues of meaning-lessness in their own lives. While the series was on the air, the question 'who killed Laura Palmer?' was celebrated in television and billboard advertising, and the *Twin Peaks* chat room became a hot Internet site. (This was 1989–90, early days on the Net.) As the primarily teen viewers gathered together to watch and discuss the show, their collective gaze, like that of tourists, involved a degree of conviviality and a slightly carnival atmosphere (Urry 1999).

The television screen acts both as a window and as a barrier, whatever the apparent transparency between the viewer and the unfolding drama. Viewers find the search for meaning not on the screen but within the living room where they watch television. The living room, like the car, is a place where one is always the viewer, as if the position of viewer were the essence of the spectacle (Augé 1995). Television's arrival in domestic space precipitated a vast production of discourses on the relationship between television, the home and the family. The privacy of suburban domesticity proffered a utopian illusion (Spigel 1992: 105). Television viewing, referred to by Urry as 'weightless travel', replaced leisure-based driving with the visual pleasure of seeing other landscapes and townscapes on the elec-tronic screen (Urry 1999). Television series depicting domestic situations proffer an illusion of the world into the home as part of a larger historical process in which the home was designed to incorporate social space. As Spigel argues, the theatrical quality of everyday life became a major organizing principle of the emerging television sitcom (Spigel 1992: 129). Lynch manipulates the viewers by drawing them first into his world through imagery and references, then through the story itself. An atmosphere of dark menace fills Lynch's suburbia. In television as in film, the notion of the audience is built in from the outset (Williamson 1994: 20). Lynch reflects viewers' lives back at them, then draws them in for a closer look. The distinction between representation and reality breaks down as codes of dress, behaviour and domestic decoration become disenfranchised.

The American House, Construction of an Ideal

Certain aspects of the television series deal with human nature whereas others are distinctly American. When North American viewers turn from the television they are, as it were, still in television and in the American Dream House portrayed on the screen. The disconnected, objective gaze of the television viewer corresponds to that of the tourist in the car. As Deleuze observes, this necessarily results when self-conscious clichés of the American action film fuse with the American Dream (1992: 210). Lynch describes *Twin Peaks* in a similar manner, as an American art, dealing with this American Dream (Kaleta 1993: 144). In the postwar period, media and advertising spread the notion that all Americans should and could own

their own homes. House owners desired communities and felt nostalgia for the past. Reliance on reason and rationality in all things formed part of the creation of America and the development of the 'American way'. The ultimate mode of dwelling came to represent the ultimate mode of living. Concerns as to appropriateness dictated with increasing rigour the design of American homes. In this sense, the reciprocity between identity and freedom of choice conflicts with the artificiality of the context in which any meaningful choice might be made.

The notions of fitness and propriety and the reification of decorum with visual attributes of décor carry through to the present day. Appropriateness finds its background in the tradition of the myth of the American Dream House that conforms to a concern for status. As Americans welcomed the possibility of living in houses that embodied the values of an advanced state of society, sometimes only a very thin line separated those who tried to better themselves from those who turned the same impulse into social climbing and a fascination with the world of fashion (Handlin 1979: 163). Spigel posits that postwar Americans, especially those inducted into the ranks of middle-class ownership, must to some degree have been aware of the artifice involved in suburban ideals of family life (Spigel 1998: 116). There is appropriateness as well to oneself and to society, and small-town society may have very strict dictates. In many suburban developments, all houses within the community must conform in form and style. In home design, a constant struggle takes place between innovation and tradition or convention. While in theory the good is kept and the outworn superseded, in practice there are other rules for building. The search for meaning through grasping at history perpetuates the myth that 'if it is old it is good'. Television viewers, like tourists, are increasingly attracted by representations of the mundane and ordinary, especially when presented as historically authentic or authentically historical (Urry 1990). Baudrillard argues that America, founded on Utopian principles, can be nothing but its own simulacrum, and the popular style of the road movie seems to support this notion. As in the road-movie film genre, Lynch constitutes *Twin Peaks*, both the town and the televisions series, around nostalgic references to moods and styles of the 1950s and 1960s (Eyerman and Löfgren 1995: 59). Certain locations such as Big Al's Gas Farm or the Double R Diner seem old-fashioned or from an earlier era. Lynch's camera romanticizes and historicizes everything from saw mills to gas stations, taking the viewer on a willing pilgrimage across America.

Architects, planners, and developers treat suburban domestic architecture as experimental seedbeds of public taste. With all of history from which to draw for inspiration, the result was often rows of 'traditional' houses, furnished with sophisticated domestic appliances. In R. Buckminster Fuller's Dymaxion House of 1929, the television set was placed in the 'get-on-with-life' room along with a radio phonograph and numerous domestic office machines that seemed as alien in 1927 as the house itself. Twenty years later, in the famous mass-produced suburb of

Levittown, New York, thousands of people purchased prefabricated Cape Cod/ ranch-style cottages filled with modern devices, including a 'built-in' television permanently embedded in the living room wall. The television set became a staple fixture in the American family home and a site for the discourse in which to play out and resolve conflicts about the way Americans should live as though they are tourists in their own homes, shopping for a lifestyle. American houses are designed and shaped specifically to embody the values inherent in society. An American society devoted to progress considered distinctions and differentiation such as a room's specificity to be a most significant characteristic. The particularities of domestic interiors, the fireplace (the hearth around which the family gathered), the sofa (where one entertains guests), the armchair (a place to curl up and read a book), indicate comfort and homeliness. The ground floor is designed for public consumption, whereas upstairs lies a realm of privacy, bedrooms, bathrooms and secrets, with the stair as the link between the two.[5] The concern with the privacy of the interior gives rise to an inflation of the circulation space between specified settings. The basement represents a secret land of another sort, the dark unknown place of a mechanical Hephaistos and threats of physical harm.[6] In between lie the living room, dining room and kitchen, front door and front hall, organized with a view to public presentation and opinion. North American doors were designed so that one person only could pass through at a time. In Lynch's film, the detective and the viewer enter the living room together, with equal alertness and caution. The living room must be entered using the same domestic etiquette with which we pass through life, governed by fear of others' disapproval, where good and bad are determined with the same moral cowardice as good and bad taste. In this room, where the public front of the family presents itself, its private morality is also deeply embedded.

The Suburban Living Room: The Basic Setting

Showpiece of the suburban house, the contemporary living room, also known as the sitting or drawing room, developed from the place of the family to the space of the representation of family values. The Palmer house represents the most pretentious of these values. Devoid of individuality and personality, the living room is like a decorator's showroom, more *House and Garden* than homely. It is also the scene of the murder of Madeleine.[7] The Palmer living room may be divided into two parts. On one side of the room, the furniture is arranged to give the viewer a better view of Bob's chase and capture of Madeleine. On the other, props obscure the viewer's vision although the long shots used to film the scene are traditionally employed by film makers to reveal truths and explain situations.[8] Large and rectilinear, the living room is entered on its transverse axis. Long

windows in several sections dominate the walls at the ends. As in most conventional television living rooms, where the room has only three real walls, most of the filming in each scene is from one direction only. There is no television in this living room, only the camera that occupies the remaining wall.

The deep focus used prior to the scene with Maddy and Bob gives the viewer a complete understanding of the layout, setting and characters. Through the extended eye of the camera, the viewer glimpses the Palmers' profound malaise. In this scene, Madeleine explains to her uncle and aunt that she plans to leave them to return to her home in Missoula, Montana. The layering of objects in the foreground builds up the suggestion of concealedness and transforms the room into a collection of domestic voyeuristic spectacles around which the viewers gather and gape (see Debord 1994). Each object in the room is imbued with meanings and references whose purpose is not to give meaning but to be recognized by the viewer who then feels included in the intentional irony. On the other side, the filming is at low eye level when the characters are sitting or standing (Figure 14.2). The camera stays at an intimate yet non-intrusive distance bringing the viewer into the scene as a participant. Normal camera distance in television is mid-shot to close-up, involving the viewer in an intimate, comfortable relationship with the

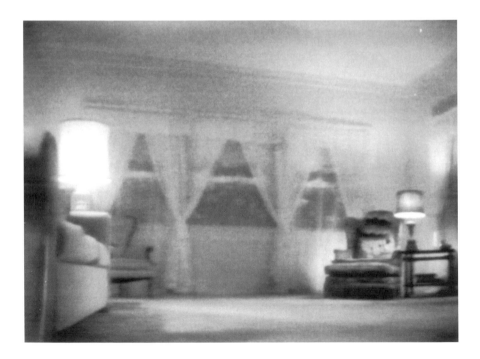

Figure 14.2 The television's eye view of the murder scene (copyright Renée Tobe 2001).

characters on the screen. In this scene, however, Lynch conveys intense discomfort and lack of true intimacy.

The extreme close-up of the attack scene conveys the sense of calamity and implication breaching the safe complacency of the living room. Tranquil pleasures of quiet television watching 'at home' become inverted and previously protected emotions exposed. The living room epitomizes the notion of the 'ideal' family in the 'ideal' home. The transparency of the window glass is denied by white chiffon drapes blocking any view in or out. The windows with their chiffon drapes frame not a landscape but a suburban street. The mirror reflects the window, focusing attention on the interior rather than on external elements. Like the car rear-view mirror (where things reflected may be closer than they appear), it is no surprise to attentive viewers that Bob makes his first appearance to the television audience here.[9] Through the use of screens and obfuscation, Lynch shows the thin layers of pretension he sees in contemporary culture.

The Death of Maddy

Madeleine's death is not a MacGuffin as is the murder of her cousin Laura but the vehicle through which the director reveals to the television audience the identity of the murderer. Bob's first appearance in the mirror disturbs. Lynch creates a Promised Land where everything is possible. You can have your daughter, kill her, have her again, and then kill her again. It is the American Dream hopelessly infected by disease. Lynch peppers everyday small-town life with everyday perversion, drug running, prostitution, domestic violence and murder. The small-town cleanliness, the freshness of youth, the wide open spaces of the North-Western frontier belie the corruption and crime that seem possible everywhere at every moment. The scene where Leland Palmer is revealed as the human form housing Bob, the series signifier of evil, has been described as one of the most frightening ever shown on network television. The viewer as silent witness to guilt that demands punishment is in collusion with the detective and director. When Madeleine walks into the living room, the lighting changes to signify the presence of evil. She screams and attempts to run away out of the living room. Leland Palmer lunges at Maddy and catches her in the hall. The television screen shows the doorway, framing a closed door in the entranceway, a space that gives access to adjacent rooms and, in American homes, is usually shaped to be open and welcoming. The hall here, a small anterior space of closed doors and a staircase, offers no escape. The viewer hears the sound of a struggle, and Madeleine and Leland reappear in the living room. The camera moves freely around the room, following the characters as they circle the room. The arrangement of furniture affords space for this chase scene.

Lynch employs a low hand-held camera and extreme close-ups in this scene. This style of filming is more often used in documentary film making and automatically situates the scene within an expected reality. The extreme close-up brings the viewer into the scene itself. The intimacy of the camera and manipulation of light and sound disrupt the barrier of viewer objectivity. The moving, low level of the shot and the moving camera push this scene into a realm of increased reality, intensifying both emotional discomfort and emotional levels in general experienced by the viewers, who, like tourists, make the best eyewitnesses for the murder taking place. While tourists look for unknown truths and philosophies and to broaden their minds and understanding, they rarely get this close to this sort of unpleasant scene that adds texture to the homogenized view presented to them.

Leland holds the limp and terrified Madeleine in an embrace. He disrupts the living room as a place where people keep their distance from one another and embarrassing emotions are concealed, as he kisses and bites her. This produces a feeling of intense discomfiture in the viewer. Photos of Laura over the fireplace flash past as Leland whirls Maddy round and round. The pictures on the mantelpiece capture a moment of the past and represent the homeliness of family life belied by the events taking place. Looking is desiring but Bob's eyes are closed as he dances with Madeleine, while the viewer watches with eyes open, colluding with the voyeuristic fantasy constructed by the director (see Virilio 1994).

The *Twin Peaks* production designer created interior spaces where perceptions of inside and outside were conflated (Nochimson 1992: 26). The pictures that appear on the walls and above the mantel (in earlier scenes) are landscapes and seascapes. They resemble the 'beautified' landscapes of the inter-state highways. One depicts pleasant rolling hills with a stag staring proudly at the viewer in the foreground. Along the top are printed the words 'Missoula Montana', Lynch's home town. This deceptively innocent image becomes a dark and menacing weapon as Leland/Bob smashes Madeleine's head into both the picture and the television screen. The bland landscape picture acts not only as murder weapon but provides an alibi for the killer. When queried as to Madeleine's abrupt disappearance, Leland replies that she has gone to Missoula. These are the clichés sown by Lynch throughout the scenes and which invite the viewer into the game of detection. At many stages of his investigation, Cooper makes the statement, 'break the code, solve the crime'. He refers not only to himself but gives advice to the viewers. The crime in *Twin Peaks* was never meant to be the murder of Laura Palmer. The real intention was to expose the underside of the town. The viewers are brought into close proximity with the violence of the death through the convex glass surface of the television screen as a window into another world. And like the car passenger driving past an accident, they slow down to get a better look, then move on.

In a particular kind of travellers' experience, one opens a door and catches a glimpse of the 'real world' lurking within, then returns to one's tourist activities while the aberrations remain fixed in the memory (MacCannell 1999: 56). *Twin Peaks* discloses the tension between the familiarity of the domestic world, as a symbol from which one may depart and safely return, and the frightening situation within. This resemblance of television watching to tourism is a symptom of Debord's alienated society where people observe life as a specific rather than engaging with it in a participatory sense. In visual media, North American suburbia predominantly represents this disenfranchisement. By framing itself entirely within the insulation of the television soap opera, Lynch's work proffers a view into the horror behind the curtain.

Notes

1. This contrasts with film, where the director introduces characters and their motivations, establishes the plot and winds it up in a set measure of time.
2. For more on Lynch's use of places of transit, see his films *Wild at Heart* (1990), a member of the 'road movie' genre, *Mulholland Drive* (2001), originally intended as a television series, and *Lost Highway* (1996), which not only has a thoroughfare in the title but also a hypnotically close-up, car's eye view of the road in the opening and closing credits. This image of the road featured previously in *Wild at Heart* and in *Blue Velvet* (1986) (as did many of the actors), and the speed of the car on the motorway balances the slowness of events taking place on the screen. Another place-of-transit film, Lynch's *The Straight Story* (1999), describes the true story of one man's journey across the US, on his lawn mower.
3. The creators continued a tradition of television series named after small towns such as Peyton Place, and Knott's Landing.
4. The waterfall shown in the opening sequence is in Snoqualmie Falls, Washington. The Lodge and generating plant are also real places. The Double R where Cooper drinks, consumes cherry pie and imbibes coffee is in North Bend, Washington.
5. The stair in the Palmer house rhymes with the stair in the Bates house in Hitchcock's film *Psycho* (1960). Laura's room occupies the same position at the top of the stair as Norman Bates' mother's room in the Hitchcock film.
6. Further examples of frightening or threatening basements are: the *Nightmare on Elm Street* series of films where Freddy emerges from the furnace; *Psycho*

where the mother is hidden and then discovered in the fruit cellar; any number of films where the babysitter goes down to the basement when the audience know she should not; even Tennessee Williams's play *Cat on a Hot Tin Roof* (Brooks 1958) where, in the basement, the male characters finally confront the truth that breaks down the pretence of the family structure.

7. Madeleine Ferguson is Laura's cousin who comes to stay with the Palmers in *Twin Peaks* after Laura's death. She looks like Laura and her name is a reference to double identity by way of Hitchcock's *Vertigo* (1958).

8. Other devices used by film makers are framing, focus, distance, movement, placing, angle and lens choice, and lighting.

9. Two mirror and fireplace references are: Lewis Carroll's book *Through the Looking Glass* when Alice wonders if there is a fireplace on the other side of the glass, and the film *Dead of Night* (Dearden 1945) where a strange room with a roaring fire in the grate is seen through a looking glass while no fire burns in the actual room.

References

Augé, M. (1995), *Non-Places: Introduction to an Anthropology of Supermodernity*, London: Verso.

Barthes, R. (1973), *Mythologies*, London: Granada.

Baudrillard, J. (1984), *Simulacra and Simulation*, trans. S. Faria, Ann Arbor: University of Michigan Press.

Baudrillard, J. (1988), *America*, trans. Chris Turner, London: Verso.

Chion, M. (1995), *David Lynch*, London: British Film Institute.

Debord, G. (1983), *Society of the Spectacle*, Detroit: Black and Red.

De Certeau, M., Girard, L. and Mayol, P. (1992), *The Practice of Everyday Life*, vol. 2: *Living and Cooking*, trans. T. J. Tomasik, Minneapolis: University of Minnesota Press.

Deleuze, G. (1992), *Cinema 1: The Movement/Image*, London: The Athlone Press.

Eyerman, R. and Löfgren, O. (1995), 'Romancing the Road,' *Theory, Culture and Society*, 12, 1: 53–79.

Fiske, J. (1992), 'Cultural Studies and the Culture of Everyday Life,' in L. Grossberg, C. Nelson and P. Treichler (eds), *Cultural Studies*, London: Routledge.

Handlin, D. (1979), *The American Home: Architecture and Society, 1815–1915*, Boston: Little, Brown.

Kaleta, K. (1993), *David Lynch*, New York: Twayne Publishers.

MacCannell, D. (1999), *The Tourist: A New Theory of the Leisure Class*, new edn with foreword by L. Lippard, Berkeley: University of California Press.

Meyrowitz, J. (1985), *No Sense of Place*, Oxford: Oxford University Press.

Miller, D. (1987), *Material Culture and Mass Consumption*, Oxford: Blackwell.

Nochimson, M. 'In the Body of Reality,' *Film Quarterly*, 46, 2: 22–34.

Spigel, L. (1992), *Make Room For TV: Television and the Family Ideal in Postwar America*, Chicago: University of Chicago Press.

Spigel, L. (1998), *Visions of Suburbia*, ed. R. Silverstone, London: Routledge.

Urry, J. (1990), *The Tourist Gaze: Leisure and Travel in Contemporary Societies*, London: Sage.

Urry, J. (1999), 'Automobility, Car Culture and Weightless Travel (draft)', published by the Department of Sociology, Lancaster University, at http://www.comp.lancs.ac.uk/sociology/soc008ju.html

Virilio, P. (1994), *The Vision Machine*, London: British Film Institute.

Williamson, J. (1993), *Deadline at Dawn: Film Criticism 1980–1990*, London: Marion Boyars.

–15–

Mountains and Landscapes:
Towards Embodied Visualities

Eeva Jokinen and *Soile Veijola*

Introduction

No landscape is a natural landscape, no matter how original, national or exotic it
may appear. There is always a cultural narration – writing and reading – involved.
This narration can moreover be conceived as an embodied one, following Donna
Haraway (1991) in her claim for the embodied nature of all vision, and, thereby,
knowledge.

Unlike narratives with linear textuality, such as an autobiography or a socio-
logical theory, a landscape does not use words or conventional grammar. Still, it
has a grammar and a glossary, and it bears intertextual references (Sironen 1995:
25). The elements of a memorable landscape consist of 'items of nature' as well as
human artefacts: buildings, paths, look-out towers. Often, perhaps always, 'nature'
and 'culture' intertwine: trees are moulded by human touch, fields cultivated and
– sceneries framed. Namely, from a human point of view, there is an off-screen
space in the scenery – just like there is one in a movie. We know there must be
something, and yet we do not know what it is. The camera recites the human eye:
both create the point of view of the subject, the one who sees.

In what follows, we explore certain cultural landscapes, guided by the following
questions: What kind of postures does a landscape suggest or even require from its
viewers? What does a landscape permit human beings to see, feel, know and do
together? How does the movement or stability of the viewers create a landscape?
How do tourist landscapes – in paintings, photos, brochures, perfect spots for
viewing, and forms of movement – maintain and normalize the arrangements of
power we live by?

This essay is a collage of autobiographical and other narrations. We distance
ourselves from cause-and-effect explanations and choose, instead, a more config-
urational line of analysis. Henning Eichberg (1984: 83–4) has phrased the aims of
such an analysis. For instance, in the case of tourism, one could study what the
configurations of space, time and the body – always socially organized – tell about,

and add to, the surrounding culture and society. What kinds of bondings and cravings are at work when, say, climbing a mountain with a view?

Staying East

Frontal Space as Future

When thinking of the landscapes I have been living in, I notice that my sense of self has been strongly moulded by embodied movement. And stagnation. I have vivid memories of running in the forest. I was an addicted skier in my pre-adolescence and went along the tracks through snowy landscapes, on wooden skis and with cane sticks in my hands. I also skied in the dark. It was never too dark to see – my eyes adjusted to darkness – but the landscape was different.

I also climbed trees. I was a lonely child, and climbing trees was among the things that I could do even by myself. I remember the colours, especially the colour of the pine stem in April, when the sunshine late in the evening made it burn; and I remember the smell; and I remember the feeling of *being safe*. Later, during my student years, I felt terrible living in a tiny apartment. Nowadays, living in a house of my own, I still wake up properly only if I have time to exercise for fifteen minutes – looking at the trees in my backyard.

Visuality has been, in a way, secondary in my identity formation while movement and bodily sensations have been primary. But this is not all true. Namely, what one sees depends dramatically upon the posture of the person who is seeing. Something stays behind, something is 'off-screen' – or in the darkness – even if it is in front of the looking subject. Not to mention that there is also something in the back space. For Yi-Fu Tuan, frontal space is primarily visual; it is perceived as the future, whereas the rear space is in the past (Tuan according to Bale 1995: 37).

Indeed, frontal space is not only visual. It is the space where one can walk forwards, move towards, reach for things, grasp and act on them. Frontal space is perceptual space with depth, while what is behind is 'unseen'.

Hence, visuality, of all the senses, is the most embodied one: what we see depends on our posture and position. In contrast, we can smell, touch and taste the same things in various positions. Paradoxically, the visual is often considered to be less embodied than the other senses.

I was born and lived almost 20 years near the border between Finland and the former Soviet Union. The border towards the East was closed. We did not use the term 'iron curtain' at home but, later, after I had moved to Central Finland, I slowly began to realize that I had lived in a certain position – a posture actually – formed by international politics. My frontal space which is, according to Tuan, primarily visual was west and south; my rear and past was situated eastward. I did not know

anyone living in the East and I did not know what kind of life there was. I could not *see*. The border did not frighten me, it was merely opaque in a strange way.

My imagination was bent by force towards the West. We travelled south and west and I saw what there was.

Know Your Country

Thanks to my parents' trust in the educative capacities of domestic tourism, we also made Sunday trips to nearby 'attractions'.

Figure 15.1 shows my family: my mother, father, and little brother. I was about 10 years old and wanted to take this picture just like it is. The mountain in the

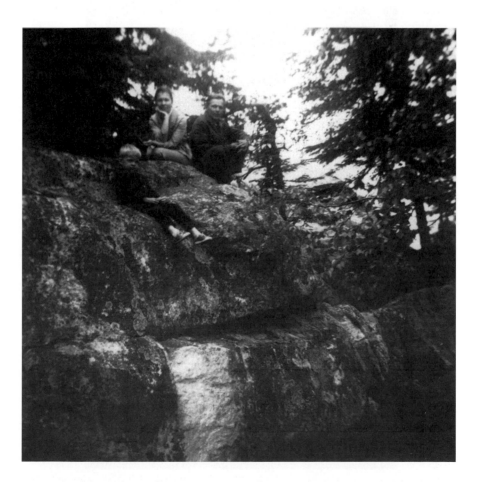

Figure 15.1 Koli from below. Photograph from the family album of Toini Taskinen, the mother of one of the authors (reproduced with permission).

Figure 15.2 Koli from the top I. Photograph from the family album of Toini Taskinen, the mother of one of the authors (reproduced with permission).

Figure 15.3 Koli from the top II. Photograph from the family album of Toini Taskinen, the mother of one of the authors (reproduced with permission).

photograph is the Koli, one of the most famous Finnish tourist sites. The site was made famous by nationalist artists and later by tourism promoters, as a sight to be seen.

Figures 15.2 and 15.3 were taken by my father and mother, and in them you can see the national scenery from the Koli. They adopt the 'right' point of view in looking at the scenery. From the top of the mountain, we can see the rock, the lake, some pines and the horizon. Whereas the photo I took is taken the other way round, from a culturally 'wrong' position, possibly because I did not know the convention yet.

There is, in fact, an interesting parallel change in the convention concerning the Koli as a sight. It was only after the late nineteenth century that the Koli got the reputation of a mountain with a charming view. Before that, the Koli was visited by travelling noblemen because of the *abyss*: a cleft in the rock, a peculiar 'formation of nature'. The cleft horrified local people, because evil powers were supposed to inhabit it. Thus, visitors were instructed to pacify demons by throwing a coin into the abyss. The nationalist artists, nevertheless, changed the orientation and made Koli into a mountain to be climbed on and experienced (Oinonen-Edén 1984).

The 'useless climbing' on mountains and gazing at the scenery has an elevating social history. In 1335, the poet Petrarca climbed with his brother up to Mont Ventoux. It was, perhaps, the first time in history that someone developed 'a longing for an intense experience of a scenery, which would be worth remembering', as Esa Sironen (1995: 25–6) formulates. It is a new motif, later to be found especially in Romanticism (Ritter 1974; Berg Nielsen and Sloth 1984: 214–15; Sironen 1995: 25–6).

Inventing Koli as a mountain with a scenery, able to intensify experience and worthy of remembering, takes place during the time when Finland was born as a nation and various social, political and economic orders were modernized. The sight, that is the future, was important, while the rear and back were premodern. Just like the frontal space, also what is *up* is in the future form; *below* is past and profane (Tuan, in Bale 1995: 37). A view from the mountain symbolized the brave, modern, new, autonomous world. A view from below – like from the dreaded cleft – is premodern and childish.

The view from the top of the mountain, downwards, suggests a posture that is proper when symbolizing an autonomous and brave new nation that has just begun to maintain an upright position, like a mammal or human child that has learned to walk. Paradoxically, maybe, it is also a master's view, favourably experienced alone. It is as near God's eye as a human can get without machines. God, too, descended to the mountain top to meet the chosen few.

There are rarely any human beings in the numerous paintings of the Koli, which suggests that the painter is a person alone. In some pictures, however, there is a female figure, who is more or less a part of the national scenery.

We know from a variety of studies that sexuality and gender are often used in nation building (Yuval-Davis 1997; Juntti 1998; Johnston, Longhurst and Morin, 2001). Women are the biological and cultural reproducers of new citizens. Women are, on the one hand, made responsible for the morals of both man and woman and, on the other hand, objects of sexual control. Maidens, young women, are symbols of innocence and purity. The Finnish Maiden was the symbol of the nation that was pure and innocent, yet intimidated by the 'evil Russia' (Valenius 1999). Juha Siltala shows, in his study of the mental history of Finnish nationalist opinion leaders, how the whole set of nationalist ideas was practically based on sexual difference. Moral superiority, purity, and maternal qualifications were invested in females, who were to heal the imperfections of their publicly strong and influential husbands. At the same time, individual women were 'changeable' as persons, merely part of the generic feminine (Siltala 1999).

The scenery from the top of the Koli seems, thus, to be well in accordance with the historically masculine tendencies to master, conquer, see from above, something else that is historically female: nature, wilderness, mysterious. In this way, certain sceneries are masters' views. Simultaneously, the sceneries from the mountains promise an intense experience, maybe a moment of being part of nature. The scenery, Nature, takes the human being into her embrace – like a mother, a woman. Historically speaking, this is the scenery of the *son*.

A Place in the Tree

The above is not to argue that it is not wonderful to climb mountains, and especially the Koli, regardless of the sex of the subject. Here I am, at the age of 12, enjoying the highest point on the top of the Koli (Figure 15.4).

As I mentioned, I was eager to climb trees. Although I was high in the tree, I felt safe, as if sitting in a comforting lap. I know now I was not the only child to search for autonomy and peace in trees. In children´s books, there were many children who had tree huts with retractable rope ladders, where they could be safe from grown-ups, at least from their mothers who, in children's books, were usually not very skilled climbers. (Later, I was informed by my mother, who could climb very well, that the village folk had regarded me as an odd kid because I spent time in the trees, even though I was *a girl*. My embodied being and doing were thus disciplined by them. I am grateful to my mother for not telling me this at the time.)

Esa Sironen believes that 'everyone of us has a mountain'. It might be the one and only mountain, or a series of them; and there are outer mountains as well as inner ones. 'In mind and reality, we return to these places, at times, and for many reasons' (Sironen 1995: 20). I believe, too, that we all have a mountain or mountains. Moreover, I would like to list two other places which we all may have; they

Figure 15.4 In the tree on the Koli. Photograph from the family album of Toini Taskinen, the mother of one of the authors (reproduced with permission).

are inspired by the history of Koli and my experiences of climbing trees. I suggest that we all have an abyss, too, although it is less admitted and promoted than the mountain. We have places where we want to hide, especially if we are sad, melancholy – *down*: places such as clefts in the rock, caves, deserted cellars. Between them, the mountain and the abyss, there might also be something *third*: a lap. This might be a place in a tree, or a sunny spot in the forest. Standing or sitting by the sea, the river, or a lake, and looking and listening to it.

The visual aspects of the mountain, the abyss and the lap differ from each other. The embodied posture of the subject is different. From the mountain downwards, one masters the sight and reaches, on the best of occasions, something that we might call a sublime experience. In the abyss, one consumes pleasurably scary, but safe, emotions. One cannot be seen in the abyss, but what does one see there? Mere

darkness? Perhaps a tiny streak of light? What does one hear? How long does it take for a coin thrown in to make a sound? The embodied experience is, nevertheless, different from that of the mountain. The visual perspective is either upwards or inwards: being in the middle of the darkness. The lap, for its part, orients the entire body in all dimensions. In the lap one sees, inward and outward, and is being held, while being out of reach of others. The *sight* from the lap is social and connected with other beings. At the same time the lap is a *site*: a throne, a seat of power – even if the lap is a tree.

So far, I have conceived experiences of different places as stagnant ones. One gazes at the scenery from the mountain, sits in the lap, or is introspecting oneself in the abyss. However, movement in space is an important aspect, too. Climbing a mountain, descending to the abyss, or nestling into the lap are not only images of places: they are narrations with plots, subjects, objects and a space to move in, and to stay still. They confront the moving subject with riddles and obstacles. The scenery narrates the moving subject, who, in turn, narrates the scenery while moving.

A scenery as a narration has also an acoustic element. The voice or the music of the scenery could be separated into two dimensions: the 'real' sounds, like the rustling of the leaves, the rumble of the waves, the noise of the cars and children, or the voice of silence. These constitute the first dimension. The second dimension consists of mental voices that belong to a certain view: a highbrow tourist in Koli begins to hear the fourth symphony of Jean Sibelius because it is commonly believed that this symphony *is* the voice of the Koli, unmediated. A less highbrow tourist might pick up a tune from the nationalist hymn, *Finlandia*.

Thus, a landscape creates also a rhythm which, at least in some cases, flows through the subject.

The Return

Almost thirty years later, I travel to the Koli with my son and daughter. Before the trip, we have read on the Internet that Koli is nowadays a site for 'nature, romance and downhill skiing'.[1] The picture on the website's opening page was familiar enough to me: the scenery from the mountain, with the rock, pines and the lake, no people. I tell my children that I am writing an essay on Koli and the old photographs. I start to teach them that certain impressive sceneries, like that from the Koli, *speak* to tourists about nationalism, history and culture. At the same time, they force tourists into conventional postures – male, middle-aged, standing, staring at nature from above – and it is not easy to get rid of these scenes, and to find new ways of perceiving the beauty of the landscape or of being in it, living it. The commercials that recycle and reproduce the old conventions are not of any help, I lecture. My daughter, 12 years old, suggests that I try standing on my head.

I take them to the abyss. The advertisement informs: 'Koli also enjoys long traditions as a honeymoon destination. Come to Koli, drop a coin into "Sacrifice Chasm" and seal the future with your dearest one'.[2] My children and I do not feel the need to seal our future because we find it already sealed, but we drop a coin anyway. It clatters downwards, *koli koli* . . .

Going North

The Snow Ride

My mountain is the Aavasaksa in Ylitornio, on the Finnish side of the north-west border between Sweden and Finland. The mountain has figured in more than just one travel journal written by European travellers, writers and scientists, visiting Lapland during the last few centuries.[3] Among them, Pierre de Maupertuis, a philosopher and mathematician, climbed the Aavasaksa around 1736 to inspect the progression of the sun (Outhier 1946). He wanted to solve the question of the flattening of the poles and to find out the form of the Earth at the point of the North Pole.

Zacharias Topelius, a father figure for the young Finnish nation in the nineteenth century, arrived on top of the mountain to describe the view from the Aavasaksa in more literary terms: as one of our national landscapes. But, for him the Aavasaksa was not only a view to look at with national pride but also a social site, a *meeting point* of all nationalities:

> There is no need to travel any further to the north to see the sun at midnight in midsummer. That is why many travellers from Finland and other countries gather here every summer, at the time of the solstice, to look at the sun at the heart of night, and many of them have carved their names on the rock as a memory, so that the cliffs and stone slabs are full of names here. (Topelius 1981: 36, trans. SV)

The Aavasaksa has played a role not only in planetary, national and international relations but also in the very modern ones themselves. The mountain arises wondrously in the distance on the first page of *The Tourist* by Dean MacCannell (first published in 1976), the book to establish critical studies of tourism. MacCannell cites the first modern poet, Charles Baudelaire who, for his part, was probably familiar with the journey of de Maupertuis:

> 'Have you then come to the point of such torpor, paralysis, that you are not happy except in your pain? If it is so, let us flee toward countries that are analogous to Death. I have it, poor soul! We shall pack our trunks for Torneo, the North of Sweden. Let's go further still, to the extreme end of the Baltic; still further than life, if this is possible; let's install

ourselves at the pole. There the sun grazes the earth obliquely, and the slow alternatives of light and night suppress variety and augment monotony, this half of nothingness. There we could take long baths of shadow, while, to give us diversion, the aurora borealis would send us from time to time their pink sheaves, like reflections of fireworks from Hell.

Finally my soul explodes, and wisely cries to me: "Anywhere! Anywhere! Only let it be out of this world."'[4]

I myself entered 'Torneo' considerably later than Topelius, de Maupertuis, or the echo of the poor, chilled soul of Baudelaire, but with no less personal significance. It was the early 1970s and I had arrived from my home village, Ii, 100 kilometres south of Ylitornio, in a bus full of smug slalom skiers from our school, none of whom I knew in person.

Tumbling downhill at an alarming speed and with dreadful style, I had no idea of the steep cultural history of the mountain, nor any eyes for the view that opened up before me, or rather rushed towards me. It was my *heimat* and I could not picture it as a destination of travel, a subject of natural sciences, or an inspiration for modern European poetry. I merely wanted to learn to ski downhill, which, hopefully, would have an effect on my social position at school, and thereby on my personal identity. I was 16, and that was all I needed.

Reaching the Top

As I was trying to get down the Aavasaksa without breaking my neck, the goal of Veikka Gustafsson, so far the only professional Finnish alpinist, is considerably grander. He wants to conquer the world's 14 highest mountains, those rising over 8,000 metres, having so far climbed seven of them. (There are under 15 people in the world who have done the same.)[5] For Gustafsson, it would not be enough to carve his name on a cliff, as it was for the early tourists and travellers of the Aavasaksa. Veikka's climbs belong to a discourse in which the goal is to have the map, not the mountain, rewritten – by having a previously unvisited peak named after one. In doing this, Gustafsson has succeeded once: a peak in Antarctica was named Mount Sisu.[6]

What basically happens up there, when Veikka Gustaffson treks yet another peak, is that he and his partner (usually Ed Viesturs) crouch down against the howling wind for about 10 minutes, then stand up in turns to pose for a photo and after that, it is the next camp and resting-place they start to think about on their way down.

The landscape of Veikka and Ed is hardly a romantic landscape (Tarasti 1990: 159–62), in the way Topelius and the other travellers have seen the landscape of the Aavasaksa: something one can immerse oneself in, by means of the sublime

gaze, and project one's sentiments and thoughts onto – at best, as a shared experience with someone. It is too bad that the experience of having a peak named after you cannot be shared since a peak can only be named after one person. The image of the *silent companion* is indeed, and unavoidably, evoked in the narrative of the alpinist as a mastering subject – who finds himself at views to store and to remember (see Pratt 1993).

> The target is, hence, the Mera in Khumba which Petri climbed in 1985 and Jussi in 1992. Unfortunately, they climbed the wrong mountain, just like thousands of others. No one has compared the official coordinates of Mera with the map but the Mera itself has been preserved *untouched* . . .
>
> *First climbs* in Khumbu are nowadays rare so the project is being followed enthusiastically around the world.[7] (italics added)

Even on the adventures of today's alpinists, there is usually a team of porters and cooks involved whose names are not listed as part of the expedition; at least, not after the authentic reports of heroes have been transformed by the media into headline news for the public. Why should they be? After all, these porters and cooks are trekking up and down the mountain as part of their job . . .[8]

Veikka Gustaffson (incidentally, his first name being a diminutive of 'little brother'), is praised for his natural – physical – talent for mountaineering (something to do with his red blood corpuscles), in addition to his mental characteristics which are 'persistence, cold nerves and avoidance of unnecessary risks'.[9] Clearly, a 'well-nourished, well-educated, free mind', as Virginia Woolf (1928/1963: 98) once described a spirit not restricted by body, sex or skin colour. This kind of a mind has traditionally, through the long history of Western art, literature and science, dwelled in a white male body (Dyer 1997). In contrast to the white man's body as the container of spirit, intelligence and endurance, the bodies of women and non-whites have represented gender, colour and flesh.

Not only the subjects but also the space at the mountains is sexed. Feminized, first purified and then penetrated, space of travel and conquest, it provides the scene for writing yet another history between men – this time by means of extreme sports. The movement, varying intensity and energy of the dynamic space (Eichberg and Böje 1997: 56) of mountaineering and ski-racing support the quest of a masculine subject. 'Mother nature had decided to hamper our journey by a wind and a constantly thickening snowfall.'[10]

However, the memory of my slalom exercise at the Aavasaksa makes me want to go beyond the beaten track of postcolonial criticism. I want to find out if there is any other way to understand the experience of Veikka – and, why not, mine.

A Social Landscape

Landscape is too flat, too one-dimensional a concept, to apply to the space created for and by bodily movement and relation. Landscape is something to be hanged, exhibited, displayed on the wall, as Rosalind Krauss (1999: 193–209) states. On the other hand, a *view* 'speaks to the dramatic insistence of the perspectivally organized depth' (Krauss 1999: 199) and engenders, thereby, a *position in space* from which to view a landscape. This is epitomized by the standard example of the meaning of the word in the dictionary: 'a lovely (familiar, typical) Finnish view opened up before me'.

Niels Kayser Nielsen (1999: 283–4) adds space and movement to this definition by noting that if 'we move a few steps further, the perception of space is changed immediately . . . we realize that we are capable of knowing that space in a new way. We are able to create a new space by moving.'

Originally, the development of visual technologies in the 1850s, in the form of stereoscopes, for example, invited a modality of viewing where 'the mind feels its way into the very depths of the picture' (Krauss 1999: 198–9). But is the *depth* of the landscape the only 'other' dimension to be studied, apart from the composition of the panorama? Is the mind the only thing that feels its way? What about the modality of conquering or feeling the landscape by movement, in changing positions and postures – be it a mountain, a rupture or the bosom of a meadow?[11]

Indeed, Gustafsson and other athletes of extreme sports of the present day approach mountains differently from those who climb only to see the landscape opening up from a fixed point for viewing, from a look-out tower. The athletes, too, like Petrarca, are 'performing and experiencing something wholly new' (Sironen 1995: 2). One could describe this relation in terms of *sportscapes*, which for John Bale are landscapes *'given over solely to sport'* (italics original), aiming at 'the optimal sporting environment within which performances in different places could be meaningfully compared' (Bale 1999: 48).

In this sense, mountains are no longer *places* (Tuan 1977) with personal memories and histories, for the snow riders and trekkers. But there is also evidence to the contrary. For some people, certain peaks are 'more places' than others. The ones over 8,000 metres high, for example, are places which certain people, in the course of their two-year trekking project, consider relatively holy and sacred.

What is the sacredness of these mountains for the trekkers about? Is it the sacredness of one's own mountain, as part of a *heimat*, an object of craving and longing? Or is it the sacredness of an object of *lust*, which needs to be intensively experienced here and now? Thinking of those mountaineers who keep on climbing higher and higher mountains, it could also be the sacredness of an object of *desire*, which dissolves as soon as the object is possessed and used (see Franzen 1992).

I suggest there is some kind of lust or craving at work when athletes of extreme sports test their limits against 'mother nature'. The space created by movement is not an abstract space, a mere sporting environment, made for and by individual and comparable performances. Perhaps there is another heart to the matter: in extreme sports you are, at last, or once more, somebody with weight, balance, force, endurance and life. You experience a heightened awareness of boundaries: testing and learning to know yours, as well as those of the environment, in the dynamic space of wrestling, gripping, balancing – and surviving (if you do not make mistakes). Like Jacob, you wrestle with the angel all night, in order to wrest a blessing and a new name from the encounter, rewarded by the confirmation: *you have prevailed.*

A day at the office can offer nothing of the kind: sitting all day at a desk, unconscious of most of your body. The only thing a false move can result in is tipping the coffee over the keyboard. Can you *endure* that?

There is another sacred dimension in the climb of Veikka Gustaffson, Ed Viesturs and others: the sacredness of *belonging*, this time in the extreme, but voluntary, life on the mountains. In the mountains, you are on a stage where those who belong are bonded in a particular way: through teams, co-dependence and competition. During the time set off for the activity, other relational possibilities are postponed. Those who belong focus intensely on a single relational modality: that of teaming up with other climbers to whom they are roped, in order to win oneself and the powers of nature together. The experience is not only that of belonging to a group, but extremely – and primordially – belonging to it through relying on it, being held by it, for safety and life. All this time, you also hold others.

This kind of temporal and, according to some, postmodern bondage has been metaphorized as being part of a *postmodern tribe* (Maffesoli 1996) – in contrast to more long-lasting and binding solidarities based on, say, nationality or local identity. Maffesoli's tribe is not the same as the tribe of anthropology, for which tribal life has always implied division of work and raising families in certain institutional arrangements. The *tribus* of the leisure world of the Winterlands and Summerlands creates, in contrast, a social order by means of a single activity, be it climbing or descending the mountains, sailing or diving the seas, trekking or riding the deserts. The snow, sand and water riders create settlements and encampments and a fleeting social order around their pursuit. They are the new leisure class, for which leisure is work, and work is leisure.

The Extreme Pilgrims

The figuration of the *pilgrim* has journeyed through a number of theories of tourism and is going strong even in theories of the modern and postmodern

condition in general. In the account of Judith Adler, *Mobility and the Creation of the Subject* (1992), for instance, pilgrims escaped the world to the desert, following religious motifs and abandoning their bodies. In his infamous book, *The Tourist*, Dean MacCannell described tourists as modern pilgrims who believe in restoring images and moments by photographing, but who unfortunately destroy the 'authenticity' of these very objects with their smart cameras. But in today's *extreme pilgrimage*, New Technology meets Nature – innocently.

The extreme pilgrims adventure in a world in which your every step can be followed, by yourself and by your fans all over the world. *You never walk alone* (see Nagbøl and Bale 1995). With a Global Positioning System (GPS) glued to your wrist, you can see 'with the precision of being at a tennis court' *where you are* in this world.[12] (With less emphasis, perhaps, on *why* you are.) You are a solid unit of technological devices, mental traits and physical attributes. You can be everywhere with everyone all the time. There is no way *out of this world* anymore.

Except for some, who find Baudelaire's exit.

An experienced Finnish alpinist disappeared in Tibet. Noora is still being searched for on the mountain.

A top alpinist from Helsinki, Noora Toivonen, disappeared on Friday at the top of the sixth-highest mountain of the world in Tibet. The search on Sunday did not succeed and the hopes for Toivonen surviving alive after nearly three days and nights in severe conditions are fading . . .

Climbing the top of the Aconcagua in the Andes in 1999, Noora wrote of her heavy climb in her diary published in the journal *Skimbaaja*: 'I knelt in snow. I felt tired, having an eleven-hour long climbing task behind me. No shouts of joy or other outbursts of emotion, I was only halfway through the journey. After the obligatory peak-photos, the return journey started to weigh more and more on my mind. Even though there were only four hours till dark, no one had yet started getting down.'[13]

For Noora, mountaineering would have meant reaching the top and managing to get back down again. Some extreme pilgrims, however, perform the pilgrim route horizontally, and without technology. An ancient, eight-hundred kilometres long pilgrim route from the border of France to Santiago de Compostela in Spain, with the monasteries along its route, is being restored for travellers. René Gothoni, a Finnish scientist of religion, states in a Finnish evening paper[14] that pilgrimage is turning into a fashion phenomenon of the twenty-first century. According to Gothoni, the route to Santiago de Compostela attracts many walkers because 'there is, after all, the physical side to it, too; it is a bit like an activity holiday! I would like to go myself but where do I get three months for it?'

Spirit and body are finally conjoined even in Christianity. Religion has turned into sport, sport into religion. Wrestling no longer requires an angel.

Moving the Mountain

In Italo Calvino's novel *The Baron in the Trees* (first published 1957), a 12-year-old boy named Cosimo runs away from home up to a tree, having had enough of parental authority and discipline.

> Cosimo was in the holm oak. The branches spread out – high bridges over the earth. A slight breeze blew; the sun shone. It shone through the leaves, so that we had to shade our eyes with our hands to see Cosimo. From the tree Cosimo looked at the world; everything seen from up there was different, which was fun in itself. The alley took a new aspect, and so did the flower beds, the hortensias, the camellias, the iron table for coffee in the garden . . . In the distance was the sea where a boat was idly sailing – and beyond, a wide horizon. (Calvino 1959: 13–14)

'Everything seen from up there was different', and it 'was fun in itself', reported Cosimo to his brother. When writing the essays on the mountains and other landscapes of our childhood, we, too, experienced the salience of a viewpoint. However, on sites with a cultural, national and political history, the alternative viewpoints are seldom just there to be chosen freely. Furthermore, the movement of the viewer is ignored both in national galleries and tourism promotion. But Cosimo advanced from tree to tree and acquired new points of view.

Theoretically, in the concept of the 'point of view', one could distinguish between focalization, ocularization and auricuralization (Smelik 1998: 61–5). *Ocularization* refers to seeing. Cosimo saw some things from the tree: flowers, a coffee table. But he did not want to see his little brother, who had let him down; so he looked away. *Auricularization* refers to hearing: Cosimo heard his father shout: 'You'll see as soon as you come down!' Cosimo did not want to see that either, and he said: 'I'll never come down again!'

Ocularization and auricularization, the sensual objectivities of seeing and hearing, are not insignificant when analysing the relationship between the subject and the landscape in tourism. Tourists cannot see more than what is in their sight. The same is true with voices. Downhill skiers and snow boarders hear the voice of the snow under their movements; the Koli tourists hear the birds and the wind. There also are mental voices: songs, symphonies, the voices of schooling and education, parental nagging and so on.

Focalization, the sensual subjectivity of experiencing the world, is, however, the most important aspect in constructing the point of view of a tourist. The term comes originally from narratology and literary studies and refers to the way in which events are transmitted to the readers, or spectators, in an always mediated way, from someone's perspective (Genette 1980; Bal 1985). Focalization is, thus, the connection between the subject of vision and that which is seen (see Meijer

1993: 275). We know of Cosimo's travels in the trees only what his little brother, the narrator, tells us. But it is not only in literature that narratives are told. We live in the flow of grand and less grand narratives. They accompany us whether we want them to or not. Media, social institutions and human ties create, recycle and echo those narratives.

If we, for instance, travel to famous Finnish national mountains like the Koli or the Aavasaksa, we already know about them through books, friends, family photos, tourist guides and catalogues. When we climb up, we narrate the mountain for ourselves. But a totally new and fresh focalization – and thus a new connection with the mountain – is not easy to reach.

For Sironen, there is no scenery without a human aspect. 'It is only through the mind of the observer that the scenery gets its attributes' (Sironen 1995: 21). Or, in the words of Tarasti, landscape is 'the part of nature/culture, *the border zone*, which culture examines from its own area and on which it projects its own structures and positions' (Tarasti 1990: 157).

And, we could add, there is no scenery without the aspect of embodiment. It is only through the body of the observer that the scenery gets its attributes. The border zone between culture and nature in the landscape *happens*, is practised through and within embodied subjects who inhabit the landscape, move and feel (in) it, smell it, yield to its forms and curves, or fight them.

If there is no scenery without a human and cultural aspect, there is unavoidably in every scenery a gender construction, a sexual difference, a sexed order. The movement of making meanings and differences of and on the world is sexed: active revealing, seizing and conquering are considered masculine; passive, hiding and stagnant 'movement' is signified as feminine (Irigaray 1985). The masculine subjectivation tends to conjoin with becoming a hero, the feminine with becoming a mother (or a girlfriend).The feminine has the capacity to nurture, conform and heal. Thereby it encounters the male capacity to be, not always heroic but also – frail. *Mother nature hampers*, and rebuilds for one the first environment to climb up on and against: the lap of the mother.

A landscape is a construction which builds differences in gender, age, class, ethnicity and sexuality, and, thus, its viewer and subject. She who views and moves is not always solitary, as literature, paintings, film industry and brochures suggest. There are various bonds, families and imaginary relations involved. The visual and embodied experience of the tourist does not always follow the linear narrative of entering, seeing and conquering. The one who moves and gazes touches the scenery in different ways, sensualities and modalities: with passion, arrogance, violence – playfulness.

A Footnote

I am sitting on the top of Pyhätunturi, Holy Mountain, struggling a little to bind my right foot to the board. It is my first day on the mountain without an instructor. I look up and watch the undulating white and blue scenery around me. Happiness strikes me and I am ready to feel my way along yet another surface of this mountain. I sense the snow – the frozen white wings brought by the storm. It is like sliding on whipped cream. I sail. I surf. I dance. I do the 'helicopter'.

Thanks

We are deeply grateful to Judith Adler for invaluable and substantial comments on the conference paper, Marja Keränen for the help in restructuring it and Henning Eichberg for comments and suggestions. We also thank Bob FitzSimmons for checking the language of the first version and Hannu Väärälä for sharing his knowledge on extreme sports, Lena Salmi and Jukka Mäkelä for taking Soile snowboarding in spring 2000. The photos are from Toini Taskinen's family album.

Notes

1. http://www.lieksa.fi/yri/hotkolie.htm.
2. http://www.lieksa.fi/yri/hotkolie.htm.
3. Lapland was described by Tacitus around 100, Fransesco Negri in 1666, Jean François Regnard in 1681, E. D. Clarke (who was accompanied by Thomas Malthus) and Giuseppe Acerbi, both in 1799. See Paasilinna (1965).
4. Baudelaire, C., 'Anywhere Out of this World – N'importe où hors du monde', reprinted as epigraph in MacCannell (1999: xxix), trans. J. Flower MacCannell.
5. http://www.veikka.com/veikka/veikka.html (accessed 2 May 2000).
6. More specifically, its was named after the famous Finnish quality of character, *sisu*, 'guts', which also happens to be the name of a Finnish pastille factory, Veikka's sponsor.
7. http://www.rakka.net/arkisto/uutiset/tuoreet/oo1. . .tuore_uutinen.php (accessed 2 May 2000).
8. 'A group of four of us had hired a Nepalese agency to organize the climbing permit, internal flights, porters and food and soon after arriving in Kathmandu, we set off for Lukla . . . We soon met up with our porters and cook team, the

only mishap being that my rucksack got into another group's luggage and headed off down the Everest trail. It was an anxious hour or so before it was found.' (http://www.mtn.co.uk/features/mera1-1.htm) Not even the top class adventurers can escape the mundane problems inherent in tourism . . .

9. http://www.veikka.com/veikka/veikka/html (accessed 2 May 2000).
10. Mikka Pyykkönen. http://www.rakka.net/arkisto/artikkelit/2000.05.01. Hikez3,_verta_jayhtz3_hymyz3.php (accessed 2 May 2000).
11. Even in landscape painting, one can distinguish between static landscapes and those in which the movement of the observer has been internalized in the painting, be it movement in time or in space (Tarasti 1990: 185).
12. 'Combining sport watch, barometer, altimeter, compass, thermometer and heart rate monitor in one 60-gram wristwatch-sized instrument . . . Furthermore, those Wristop Computers are loaded with different logging systems and ways of reading the accumulated data, making them useful in analysing the climb and providing a means of giving proof to claims of summiting, just to give an example.' http://www.kuvalehdet.fi/realmera/sponsor.htm (accessed 2 May 2000).
13. http://www.iltalehti.fi/2000/05/08/20000508_uuv01Tiibet.shtml.
14. *Ilta-Sanomat*, an afternoon paper (22 April 2000), Viikkoliite: 4.

References

Adler, J. (1992), 'Mobility and the Creation of the Subject: Theorizing Movement and the Self in Early Christian Monasticism', paper given at the International Congress on Tourism, Nice, France, 19–21 November 1992.

Bal, M. (1985), *Narratology: Introduction to the Theory of Narrative*. Toronto: University of Toronto Press.

Bale, J. (1995), 'Spaces, Places and Landscapes of Sport: Thoughts From the Writings of Yi-Fu Tuan', in S. Veijola, J. Bale and E. Sironen (eds), *Strangers in Sport: Reading Classics of Social Thought*, Department of Social Policy, University of Jyväskylä, working papers 91: 33–50.

Bale, J. (1999), 'Parks and Gardens: Metaphors for the Modern Places', in D. Crouch (ed.), *Leisure/Tourism Geographies: Practices and Geographical Knowledge,* London and New York: Routledge.

Berg, Nielsen K. and Sloth, E. K. (1984), 'Det romantiske – et møde med dødens landskap' [The Romantic – an Encounter with the Landscape of Death], *Turisme og Reiseliv: Arbejdspapirer fra NSU*, 20: 212–91 (Nordisk Sommeruniversitet).

Calvino, I. (1959), *The Baron in the Trees [Il barone rampante]*, trans. A. Colquhoun, San Diego, New York and London: Harvest.

Dyer, R. (1997), *White*, Routledge, London.

Eichberg, H. (1984), 'Join the Army and See the World', *Turisme og Reiseliv: Arbejdspapirer fra NSU*, 20: 78–97 (Nordisk Sommeruniversitet).

Eichberg, H. and Böje, C. (1997), *Idrotspykologien mellem krop og kultur* [*Sports Psychology Between Body and Culture*], Herning: Idrotsforsk.

Franzen, M. (1994), 'Lust och längtan till svenska städer', in A. Linde-Laursen and J.-O. Nilsson (eds), *Möjligheternas Landskap: Nordiska kulturanalyser,* Nord 21: 12–27.

Genette, G. (1980), *Narrative Discourse*, Ithaca: Cornell University Press,

Haraway, D. (1991), *Simians, Cyborgs, and Women: The Reinvention of Nature*, New York and London: Routledge.

Irigaray, L. (1985), *Speculum of the Other Woman*, Ithaca: Cornell University Press.

Johnston, L., Longhurst, R. and Morin, K. M. (2001), '(Troubling) Spaces of Mountains and Men: New Zealand's Mount Cook and Hermitage Lodge', *Social and Cultural Geography* 2, 2: 117–39.

Juntti, E. (1998), 'On Our Way to Europe: Finnish Women's Magazines and Discourse on Women, Nation, and Power', *The European Journal of Women's Studies* 5, 3–4, November.

Krauss, R. (1999), 'Photography´s Discursive Spaces', in J. Evans and S. Hall (eds), *Visual Culture: The Reader*, London, Thousand Oaks, New Delhi: Sage.

MacCannell, D. (1999), *The Tourist: A New Theory of the Leisure Class*, new edn with foreword by L. Lippard, Berkeley, Los Angeles and London: University of California Press.

Maffesoli, M. (1996), *The Time of the Tribes: The Decline of Individualism in Mass Society*, London: Sage.

Meijer, M. (1993), 'Countering Textual Violence: On the Critique of Representation and the Importance of Teaching Its Methods', *Women's Studies International Forum*, 16, 4: 367–78.

Nagbøl, S. and Bale, J. (1994), *A View of English Football: Sport and Sense of Place*, trans. M. Drewsen, Department of Social Policy, University of Jyväskylä, working papers 85.

Nielsen, N. K. (1999), 'Knowledge by Doing: Home and Identity in a Bodily Perspective', in D. Crouch (ed.), *Leisure/Tourism Geographies: Practices and Geographical Knowledge*, London and New York: Routledge.

Oinonen-Edén, E. (1984), 'Kolin taiteilijakareliaanit: Selvitys' ['The Karelian Artists of Koli: A Report'], Lieksa: n.p.

Outhier, R. (1746), *Journal d'un Voyage au Nord: En 1736 & 1737*, Amsterdam: Outhier.

Paasilinna, E. (ed.) (1965), *Laaja Lapinmaa: Valikoima Lapin kirjallisuutta 2*, Hämeenlinna: A. Karisto Osakeyhtiö.

Pratt, M.-L. (1992), *Imperial Eyes: Travel Writing and Transculturation*, London: Routledge.

Ritter, J. (1974), *Subjektivität: Sechs Aufsätze*, Frankfurt am Main: Suhrkamp

Siltala, J. (1999), *Valkoisen äidin pojat. Siveellisyys ja sen varjot kansallisessa projektissa* [*The Sons of the White Mother. Morality and Its Shadows in the National Project*], Helsinki: Otava.

Sironen, E. (1995), 'Reading My Landscape', in S. Veijola, J. Bale and E. Sironen (eds), *Strangers in Sport: Reading Classics of Social Thought*, Department of Social Policy, University of Jyväskylä, working papers 91: 19–32.

Smelik, A. (1998), *And the Mirror Cracked: Feminist Cinema and Film Theory*. Houndsmills and New York: Macmillan and St. Martin's Press.

Tarasti, E. (1990), 'Maiseman semiotiikasta' ['On the Semiotics of a Landscape'], in *Johdatusta semiotiikkaan. Esseitä taiteen ja kulttuurin merkkijärjestelmästä* [*Introduction to Semiotics. Essays on the Systems of Signs in Art and Culture*], Helsinki: Gaudeamus.

Topelius, Z. (1981), *Maamme* [*Our Land*], Porvoo, Helsinki: WSOY.

Tuan, Y.-F. (1977), *Space and Place: The Perspective of Experience*, Minnesota: University of Minnesota Press.

Valenius, J. (1999), 'The Maiden in Distress: Gender and Sexuality in the Construction of the Finnish Nation 1908–1914', paper presented at the annual meeting of Women's Studies, Tampere, 19–20 November 1999.

Woolf, V. (1928/1963), *A Room of One´s Own*, Harmondsworth, Middlesex: Penguin.

Yuval-Davis, N. (1997), *Gender and Nation*, London and New York: Sage.

Index

Index